CW00797518

Simone Forti

Also by Ann Cooper Albright

As author:

> *How to Land: Finding Ground in an Unstable World* (2019)
>
> *Engaging Bodies: The Politics and Poetics of Corporeality* (2013)
>
> *Modern Gestures: Abraham Walkowitz Draws Isadora Duncan Dancing* (2010)
>
> *Traces of Light: Absence and Presence in the Work of Loïe Fuller* (2007)
>
> *Choreographing Difference: The Body and Identity in Contemporary Dance* (1997)

As editor:

> *Moving History/Dancing Cultures* (with Ann Dils, 2001)
>
> *Taken by Surprise: A Dance Improvisation Reader* (with David Gere, 2003)

Publication of this book is funded by the
Beatrice Fox Auerbach Foundation Fund
at the Hartford Foundation for Public Giving

Simone Forti

improvising a life

Ann Cooper Albright

Wesleyan University Press
Middletown, Connecticut

Wesleyan University Press
Middletown, CT 06459
www.wesleyan.edu/wespress

Text and photographs unless otherwise noted
© 2024 Ann Cooper Albright

All rights reserved

Manufactured in the United States of America

Designed and composed in Adobe Garamond
by Chris Crochetière, BW&A Books, Inc.

Publication of this book is funded by the
Beatrice Fox Auerbach Foundation Fund
at the Hartford Foundation for Public Giving

Library of Congress Cataloging-in-Publication Data
available at https://catalog.loc.gov/
cloth ISBN 978-0-8195-0109-7
e-book ISBN 978-0-8195-0111-0

5 4 3 2 1

For Isabel,
who is busy improvising her own wonderful life

Contents

Acknowledgments

Although I have known Simone Forti for most of my dancing life, I didn't think to write a book on her until my mid fifties. This project has been a wild and wonderful ride. I would like to begin by extending my heartfelt gratitude to Simone Forti for living such an inspiring life as a dancer, improviser, and artist. This book has been a pleasure to work on, and Simone has been wonderfully generous to work with. Watching, reading, conversing, moving, reflecting—these experiences have been animated by Simone's delightful kinesthetic imagination. As I have traced her path through the decades of her multifaceted career, I have been continually enchanted by the magic of her indefatigable curiosity and creativity.

When I started this project, I knew it would be fun to interview many of Simone Forti's associates and former students, but little did I realize the wealth of insight I would receive from speaking with such interesting dancers, improvisors, artists, and curators. These amazing folks have shared with me the magnetism of being in Simone Forti's orbit. Thanks to all the people I interviewed or spoke with, including (in no particular order) David Zambrano, K.J. Holmes, Steve Paxton, Kirstie Simson, Pooh Kaye, Carmela Hermann Dietrich, Sarah Swenson, Claire Filmon, Mara McCarthy, Judy Hussie-Taylor, Athena Christa Holbrook, Dorit Cypis, Elizabeth Zimmer, and Elliot Gordon Mercer. In Italy this past fall I was able to meet Fabio Sargentini (the gallerist who gave Simone space to work in 1968 when she was in Rome, licking her wounds from a disastrous breakup) and his assistant Elena Giacalone. Both were extremely helpful and entertaining,

as was Silvia Sorri in Florence. I am so grateful to Eric Nordstrom, who offered to videotape every minute of Simone's October 2013 intensive workshop and performances in Portland, Oregon, for me, and whose short film on Simone, *Standing on Gold*, is a lovely introduction to her teaching and artistic legacy. Thanks as well to Kora Radella, my fellow improviser in Ohio, for talking to me about her experiences watching and learning from Simone, and to Carla Mann for helping me locate historic materials at Reed College.

Two decades ago, David Gere and I collaborated on a book about improvisation (*Taken by Surprise: A Dance Improvisation Reader*). A photo of Simone Forti graced the cover, and we were both thrilled by her contribution to the collection of essays. David lives in Los Angeles and teaches at the University of California, Los Angeles. Not only was he instrumental in introducing Simone to a new generation of students and dancers there, but he quickly affirmed the importance of this project when I first suggested I might want to write a book about her. Since that time, David has been sweetly supportive, at times offering me a place to stay while in LA, and always encouraging me when we meet for dinner as our lives permit. My colleague in Dance Studies, Anurima Banerji, was kind enough to let me stay in her apartment in Westwood (a mere two blocks from Simone's house) for a week in 2019. Also in the LA region, my thanks go to my dear friends Deidre Sklar, Mary Herzog, and Kirk Andrews for rescuing me from my landlocked midwestern habits and affording me an opportunity to walk by the sea.

It has been a recent pleasure to meet Mara McCarthy, the director and head curator of The Box gallery in LA, who has been critical in shepherding Forti's work out into the wider world of art institutions. Many thanks to her and Box/Forti assistants Jason Underhill and Catherine Vu for their conscientious cataloging of Forti's archives and help accessing performance videos during the Covid-19 lockdown. Jason has been especially helpful with his insider knowledge of the art museum world, about which I know little. His wonderful stories about collaborating with Simone in recent years were also insightful. I am deeply grateful to the folks at the Getty Research Institute who

helped facilitate my entry and research, even though the Forti archive had not been fully processed because of their extended Covid-19 shut down. These staff include Sarah Sherman Clark and Ted Walbye; the latter was incredibly helpful with accessing images from Simone's archive. Thanks to Alex Sloane and Rebecca Lowery, the curators of the "Simone Forti" exhibition at the Museum of Contemporary Art in LA, for inviting me to the various openings, and to Hon Hoang for sharing his photographs with me. Special thanks to Chelsea Gaspard, one of the performers in the Dance Constructions in that LA show, for talking with me about her experiences working with Simone.

I had never been to Salzburg, Austria, before I visited in July 2014 as Simone Forti was preparing for her first major retrospective. Many thanks to Sabine Breitwieser, who was then director of the Museum der Moderne Salzburg and the primary curator for the extraordinary exhibition, "Simone Forti: Thinking with the Body: A Retrospective in Motion." The beautiful catalog that she assembled remains to this day the most encyclopedic review of Forti's dance career and artwork. Thanks to Christine Forstner for providing me with images of that event, as well. While in Salzburg, I had the great fortune to meet Susan Quinn, who founded Salzburg Experimental Academy of Dance and whose dancers were incredibly inspiring in reconstructing Forti's dances. It was a real pleasure to return the following year to teach there and get to know her better. I also spent a lovely afternoon with Megan Metcalf, whose 2018 dissertation on the acquisition of Forti's Dance Constructions by the Museum of Modern Art in New York City was a helpful resource as I worked through my final chapter on Forti's legacy.

I had two wonderful research assistants while working on this project. Thanks go to Rebecca Janovic, who spent a summer valiantly researching artists whom she had never heard of and whose enthusiasm for contact improvisation fed our friendship through the past three years. I am also immensely grateful to Alana Frey Reibstein, another former student, who not only transcribed almost every interview but also helped with research in LA venues while she was living there. I am supremely thankful for her companionship while spending long

days in the Getty and for her driving me around LA to visit The Box and Simone, not to mention a host of other good times talking and eating together. I look forward to reading her writing as it emerges in these next few years.

Thanks to the folks at the Centre national de la danse in Paris for giving me access to hours and hours of Simone's workshops and performances, and to Jason Lange who pitched in and helped transcribe an interview at the last moment.

In NYC, I have been lucky enough to have very good old friends who have offered me a place to stay while I was visiting the city to research and attend Forti's performances over these past years. Thanks to Ellen Graff and Katherine Bourbeau. The staff at the Jerome Robbins Dance Division at the New York Public Library for the Performing Arts was (as always) wonderful at helping with my research. Special thanks to Linda Murray, the director of the division, for helping me access materials during Covid-19 and for facilitating seeing old VHS tapes that were in the queue to be digitized. Daisy Pommer, a specialist in the division, helped, as well. My work last year with Linda and Daisy on Critical Mass: CI@50 contact improvisation conference was a wonderful opportunity to develop these interesting and enjoyable friendships further.

At Oberlin College, I have benefitted from the generosity of the library staff. Thanks to Barbara Prior, Kay Spiros, Megan Mitchell, Joseph Maiville, Bill Ruth, and the director, Valerie Hotchkiss, for making me feel welcome, helping me find obscure art journals from the 1960s and 1970s, and allowing me to (once again) inhabit a scholar's study on the fourth floor. The refuge of that small space with purple walls has facilitated my writing this book in ways that are hard to describe. I am also deeply indebted to Julie Standen from Azariah's Café for being curious and cheerful and keeping me supplied with caffeine. Thanks also to Hannah Kinney and Samuel Adams to talking to me about the particularities of the art museum world. Oberlin has supported this project in many ways, most directly through research funds from the dean's office, several H. H. Powers grants, and through a 2019 Research Status Faculty Fellowship. That year I was also hon-

ored to receive a Guggenheim Foundation Fellowship for work on this book. I am deeply grateful for all these kinds of support—both emotional and financial.

Like all books that document the history of an artist's life, this one has benefitted from many wonderful writers and scholars. I acknowledge two of them here—both amazing women who passed tragically before their time. To Sally Banes (1950–2020), a dance scholar who threw her boundless energy and body into her work documenting postmodern dance in the 1960s and 1970s in NYC, I feel indebted for a model of passionate engagement. To Nancy Stark Smith (1952–2020), whose belief in the importance of writing about improvisation in all its myriad forms and whose editorship (with Lisa Nelson) of *Contact Quarterly* for forty-five years provided a venue for artists such as Simone Forti to talk about their work, I honor your dedication. I hope, in some small way, to continue that journal's vision of being "a vehicle for moving ideas."

It has been a while since I published with Wesleyan University Press, and it feels great to be back. I love working with that small crew of book enthusiasts housed in an old white wooden house at the edge of a field in Connecticut. I treasure my longtime working friendship with director Suzanna Tamminen, who has championed my work from my very first book and whose support helps me to love writing about dance. I am also super excited about working again with Chris Crochetière, a designer with BW&A Books. Her imagination about what can happen between two covers is delightfully refreshing. Thanks to the press's anonymous readers, and to Jim Schley and Elizabeth M. Seyler for shepherding the manuscript through production and holding me to their high standards. This book project has been constructed on a deep foundation of support of all kinds, not the least of which is provided by my very cool and loving family. Thanks to Tom and Cyrus, and to Isabel, to whom this book is dedicated. I treasure the opportunity to witness you all as you improvise the next stages of your lives.

Introduction: Living Histories

It was a lovely June afternoon in 2018. I had been in Los Angeles for a few days, hanging out with and interviewing Simone Forti, who graciously allowed me to peruse her personal archives. I would return the following year to systematically read through five decades' worth of her notebooks and personal journals before they were packed off to the Getty Research Institute. But that bright day we climbed into Simone's old car and set off for Goose Egg Park in Santa Monica, California. Once there, we joined a group of people, old and young, practicing "push hands," a form of partnered Tai Chi. Simone had recently revitalized her practice of Tai Chi, which she had studied intensively in the early 1970s. As I worked with her, I could feel her arms and back respond to decades of tracing circles—in the air in front of her, on the floor of her studio, and on paper. Simone introduced me to the basic format, standing in front of me and teaching me how to maintain contact between our hands and forearms while feeling the movement of energies cycling back and forth. The general idea is to be receptive rather than reactive, using flow and yield in response to one's partner to transform their force and redirect their energy. Once I had gotten a sense of the exchange, she became a little more determined in her sparring. It was wild to experience firsthand this small, 83-year-old woman with a shaking head and trembling hands (a result of her Parkinson's disease) surprise me with feisty moves and cunning timing as she tried to push me off balance.

For me, this moment aptly captures what was inspiring about the process of writing (and improvising) this book on Simone Forti's life

and work. Getting to witness with my body—indeed to feel in my bones—Simone's physical responsiveness and her kinetic imagination was an amazing experience. That afternoon left in my system traces of her extraordinary curiosity as well as her strong determination, charming wit, love of moving, and personal exuberance. I was inspired by and sought to honor this irrepressible energy as I gathered research materials, immersed myself in performances (live and on video), and began to craft the language that could best perceive, describe, analyze, and reflect the stunning and diverse body of work that constitutes Simone's improvisational legacy. The play between adjective and verb in "Living Histories," the title of this introduction, says it all. As an artist in her ninth decade, Simone both has lived through many histories and still "lives" history through her body and in performance. Over the course of writing about this extraordinary movement artist these past few years, I, too, have lived these histories, and the traces of that embodiment—my dancing as research—weave their way through each chapter.

Simone Forti's artistic career has spanned more than six decades, from the early 1960s to the 2020s. In this time, she has lived through major wars, assorted cultural revolutions, extremely varied artistic trends, three marriages, and several changes in residence. Her creative influence is expansive, bridging both improvisational dance and experimental art worlds. Although she is most often figured as part of 1960s Minimalism in art and the beginnings of postmodernism in dance, I find these critical frameworks too narrow. Instead, I document and analyze the impressive breadth of her improvisational dance career, which includes not only the Dance Constructions of the early 1960s but also animal-inspired pieces of the 1970s, group choreographies from the mid-1980s, ongoing collaborations with live musicians such as Charlemagne Palestine, and works that combine speaking and dancing, not to mention her twenty-first-century forays into video dance. I have found that no one historical period or aesthetic principle can accommodate the extraordinarily compelling range of her dance practice. While charting the contours of her lifetime of work and the different contexts in which she created work, I also find myself

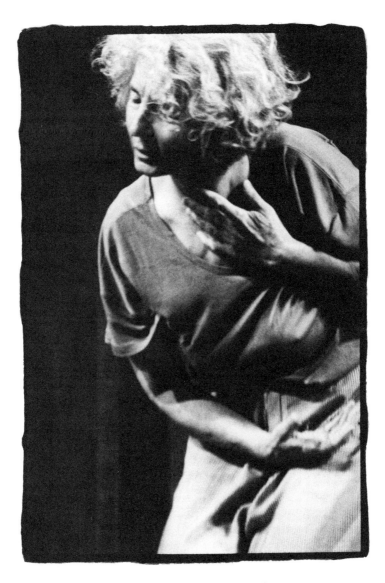

Close-up of Simone Forti performing at Highways Performance Space, Los
Angeles, 1998. Photo by Carol Petersen. Getty Research Institute, Los Angeles
(2019.M.23).

drawn to addressing the bits and pieces that frequently get left out, those quirky performances found in the margins of traditional (art-) historical discourses—the ones that are too emotional, too weird, or simply overlooked by critics and curators, such as her marvelous group work of the late 1980s.

In her early journals and her seminal first book, *Handbook in Motion* (1974), Simone Forti contrasts her Dance Constructions from the early 1960s with her adventures in the late 1960s and 1970s by calling them either "conceptual" or "vibrational." In my own analysis of her career, however, these ideas are always enfolded within one another. Like the parasympathetic and the sympathetic nervous systems, one aspect may be more visible at a certain moment in time, but the other aspect is nonetheless present, underlying and supporting. I have found that even her most conceptual pieces have an element of vibrational energy weaving throughout their simple scores, and her wildest open improvisations rely on a strong conceptual framework.

Dancing and thinking—the conceptual and the vibrational—are always interwoven in her improvisations. Uncovering how those strands are entangled, reading closely between their lines, made writing this book particularly intriguing.[1]

Because I situate myself as both a scholar and a dancer whose career is focused on improvisational practices, I intentionally focus throughout individual chapters on Simone's real appetite for dancing. Although she has been repeatedly quoted as saying "I am an artist, and movement is my medium," I contend that dancing is more than simply another medium for her artistic vision. Rather, movement captured Simone Forti—body, mind, and soul. For much of her life, she relished the powerful experience of pushing with her whole body and feeling its force. She loved using momentum as well as stillness in her dancing, and she frequently experienced moments of blissful transcendence while responding kinesthetically to the forces of

the world around her—whether they were trees and wind, songs and soundscapes, animals and people, or history and politics.

"Simone is an artist, an elderly woman, . . . She has been a bohemian, then a beatnik, a hippi [*sic*], now a senior citizen" (80N).[2] Written just months after her mother died at ninety-nine in November 2003, this excerpt from Simone Forti's journal signals a backward gaze towards her own history, whose gravitational force becomes increasingly powerful as she ages. At the beginning of the twenty-first century, Simone Forti was riding the dual waves of the popularity of her Logomotion teaching and News Animations within dancing communities, as well as the increasing interest in her early Dance Constructions among art museums. In her own words, she had become a "star," and, supported by the artworld-savvy administration of The Box gallery in Los Angeles, her drawings, paintings, sculptures, and Dance Constructions can be found in major collections worldwide. As was clear during the rehearsals for the most recent re-performances of the Dance Constructions at the Museum of Contemporary Art (MOCA) in LA, younger artists are deeply inspired by her presence and her work.

Although her oeuvre is certainly rooted in her specific generational and socioeconomic experience as an artist coming into her own in mid-twentieth-century America, there are critical aspects of her career that transcend those historical contexts to speak to contemporary twenty-first-century concerns. These include: a) her powerful experiences of partnering with nonhuman forces, particularly her embodied research into animal movements, including quadruped and winged creatures, and her interest in cross-species communication; b) her profound ecological consciousness (especially her attention to climate change) evident in her environmentally immersive Land Portraits undertaken with Simone Forti and Troupe from 1986–1991; and c) the increasingly activist and political content embedded in her Animations performances over the last thirty-odd years.

While this book is not a formal biography, I have tried in the following chapters to trace the broad textures of Simone Forti's life as it

intersects with her work as a movement artist. This means following a life journey that encompasses moments of inspiration and desperation, love and loss, professional success and personal disappointment. There are many beautiful and interesting threads in this living fabric, and I found myself drawn to images of weaving and textiles even before I learned that generations of the Forti family had operated woolen mills outside of Florence, Italy. Textiles, particularly woolen ones, have a certain heft and feel. It is this dense materiality that I return to again and again, finding in its weighty substance both flexibility and strength. Like Simone, cloth is wonderfully resilient: It rips and can be mended; it moves and yet can bind. I also think of my own approach to writing this book in terms of weaving. As I pass over and under the visible artifacts—the photos, scores, drawings, videos, and her memoirs and notebooks—I interweave my own corporeal perspectives, including the physical memories of learning and dancing with Simone. This element of kinesthetic awareness may be less obvious than the more analytical strands of my scholarship, but it is necessarily woven throughout. That is to say, I can't watch Simone perform without feeling her movement in my body. My embodied perception is the warp that holds together this weave of writing about Simone's dancing.

The decision to write a book on Simone Forti arrived serendipitously. I had been traveling abroad and had grabbed an old paperback version of Laurie Lisle's 1980 biography of Georgia O'Keeffe. As I finished it on the plane ride back, I was thinking about the circuitous life journeys of women artists in twentieth-century America. While waiting for a connecting flight in Chicago, I spontaneously called David Gere, my friend (and coeditor of *Taken by Surprise: A Dance Improvisation Reader*), to tell him I was thinking of writing a book about Simone Forti (whose image had graced the cover of our 2003 book). Without a moment's hesitation, he replied that he thought it was a great idea and that I was absolutely the person to write it, as I could do so from a dancer's as well as a scholar's perspective. And so, my fate was sealed.

Before that exchange with Gere, I had known Simone for many

years, having taken classes with her at her Broadway loft in New York City during the 1980s and through Movement Research in the 1990s. Later, I participated in her workshops at A Capella Motion in Northampton, Massachusetts. While living in NYC, I reviewed her performances for *Women and Performance* journal. I have seen Simone perform many times in numerous venues, including a loft space, a SoHo gallery, various museums, and theatrical stages large and small. In the fall of 2000, I had also been invited by Pooh Kaye to participate in a Nuit Blanche tribute to Simone in Paris, France. In addition, I hosted intensive Logomotion residencies at Oberlin College in 2005 and 2015. As a writer and improviser myself, I am particularly drawn to her integration of speaking and moving. Getting to witness the play of her lively mind and bodily intelligence in performance is almost always a magical experience. In short, I was a big fan.

The thing was, I was in the midst of finishing another book (*How to Land: Finding Ground in an Unstable World*) and, therefore, had to put this project on the back burner, so to speak, giving my ideas time to simmer and stew in a way that Simone, never one to rush into things, would most likely appreciate. Despite this commitment, I continued to follow her amazing renaissance over the past decade as galleries and museums clamored for her early work.[3] I was fortunate to be able to attend many of the Dance Constructions rehearsals for her first major retrospective in 2014 at the Museum der Moderne in Salzburg, Austria, as well as witness their iterations at the 2018 blockbuster show "Judson Dance Theater: The Work Is Never Done" at the Museum of Modern Art in NYC (MoMA). Most recently, I was overjoyed to see the opening weekend events at her 2023 retrospective at the Museum of Contemporary Art in LA.

Over the past decade, I have had the privilege and the pleasure of walking and talking, eating meals, and spending time in Simone's presence, including recording six formal interviews about her working and personal life and loves. Finally, several years ago I had the opportunity to turn my full attention to this book by way of a Guggenheim Foundation Fellowship. This was months before Covid-19 shut down public access to libraries, museums, and archives, temporarily

curtailing my research and travel plans. While I was stalled in my re-search because of lockdowns, Simone continued her artistic activities, producing paintings on the paper bags in which her groceries were delivered and sharing poems with friends. It was a delight to follow her activities via Zoom and online. Fortunately, in the spring of 2022, I was able to again visit Simone in Los Angeles and finish my research at the Getty Research Institute, and that fall I traveled to interview curators and trace aspects of her life and work in Italy.

Since I follow the major contours of different moments in her life's work within the following chapters, I will not repeat those discussions in this introduction. Instead, in the following pages I explore other themes, including the legacy of her Italian Jewish family and the cultural contexts surrounding the development of improvisation in postmodern dance. I will, of course, briefly sketch the evolution of her life-long improvisational practice. It is no coincidence that, as I look towards my own sixties, I chose to write a book about a woman artist whose multifaceted career has continued to reinvent itself in every decade. Even in the twenty-first century, when she entered her seventh decade, she did not slow down. Not only did her Dance Construc-tions become widely sought after in exhibitions around the globe, but she also began to work in completely new areas, including collaborat-ing with her assistant Jason Underhill on a series of site-specific videos.

These new adventures in improvising and making took place even as the effects of her Parkinson's disease were becoming more pro-nounced. I fondly remember one performance in 2016 at the Electric Lodge in Venice, California. When Simone came out to introduce the show, her head and one hand were shaking quite noticeably. She simply acknowledged that she has Parkinson's disease and told the audience, "It doesn't bother me, and I hope it won't bother you," be-fore walking off the stage. While performing, her concentration was so intense that her head did not shake at all. This kind of artistry, re-silience, fortitude, and generosity inspires me, providing a wonderful model as I improvise the next stage of my own life.

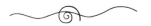

Simone Forti was born on March 25, 1935, to Milka and Mario Forti. The family (including her older sister, Anna) lived next to the Arno River in Florence, Italy, in a house filled with beautiful prints, art books, and leather tomes of literature. Her mother's ancestors came from Russia and Poland via Paris, the city in which her maternal grandparents met. Her father's family had been established in Florence for many generations and, by the twentieth century, were an integral part of the city's cultural (as patrons of the arts) and economic (as woolen merchants) vitality. Hers was a well-to-do, worldly, and artistic family. Like many Italian Jewish families of their class, they were also secular, focused on a rational, progressive humanism that extolled science and promoted the arts. In a 2009 notebook, Forti reflects: "I am Jewish, I know because we had to escape. I ask mother about God, she says spirit is everywhere. I ask father about Judaism, he tells me about Freud, Marks [*sic*], Einstein" (108N). Although Forti identified as Jewish throughout her life, neither she nor her family were particularly observant or religious in a traditional sense. (Later, however, Forti will claim to have a connection to a "secular Jewish mysticism" in common with her collaborator Palestine.) Forti has always located the spiritual dimensions of her life in art or nature. This attitude was not uncommon in her milieu of Italian Jews, where living culture was more important than inherited religion.

In fact, after their official emancipation by the Italian government in 1848, many Italian Jews became progressively assimilated into the larger civic fabric of Italian society. Religion was considered a private family affair, a personal choice guaranteed by the state. It was not unusual for Jews to marry outside of their faith, and some converted to Catholicism. For many Italian Jewish people, especially in the educated and professional classes, one's public identity revolved around a growing patriotic consciousness and a sense of belonging to the newly unified Italian nation-state. Often, Italian Jews played important roles in city commissions and as government officials, including Luigi Luzzatti, who became Prime Minister in 1910 (the first Jewish prime minister in Europe). Even in the early 1920s, at the beginning of Benito Mussolini's Fascist government, Jews held prominent positions.

In his book *The Jews in Mussolini's Italy: From Equality to Persecution*, Michele Sarfatti notes that, unlike the more rural Italian Catholic population, close to 70 percent of the male Italian Jewish population was engaged in an urban professional occupation or in commerce (particularly in textiles, as was the case with Forti's family). Jews were a very small minority of the overall population in Italy (1.1 in 1,000) and their influence was generally welcome, not considered particularly threatening.[4] In Florence, for instance, there were fewer than 3,000 three thousand Jewish people within the larger city population of 300,000 in the mid-1930s, and yet a number of these families, like the Fortis, were renowned patrons of the arts and funded theaters and schools. Many Jewish men, including Forti's father and uncles, fought valiantly for Italy in World War I and considered the country their rightful homeland. Although Italian Jews were not subjected to the same kinds of official governmental regulations enacted by the Nazis until later, they were increasingly excluded from positions of power and prestige throughout the 1930s, a trend that Sarfatti writes was "characterized by an intricate combination of [media] propaganda and [official] circumspection."[5] As antisemitism swept across the country (and the continent), Italian Jews were increasingly portrayed by the Fascist media as liberal antifascists, a political stance that quickly became synonymous with being unpatriotic.

In his discussion of Italian political developments in the early twentieth century, Sarfatti elaborates on the context in which Jewish identity shifted from a religious category to a racial one. Like its European neighbors, Italy justified its colonial expansion into Africa in terms of racist ideology in which black Africans were considered less developed than white Europeans. For a long time in Italy, Jews were not classified as a race but rather a religious minority, free to practice their religion in peace. However, as Sarfatti notes: "In the course of the Ethiopian campaign [1935–1936] Italy witnessed the beginning of the transition from the infringement of religious equality and the autonomy of Judaism (including the progressive removal of Jews from public positions) to the persecution of individual Jews and their rights."[6] In *Benevolence and Betrayal*, his ethnographic history

of five Italian Jewish families under Fascism, Alexander Stille charts a myriad of different responses to the growing Fascist threat to Jews, including a deep refusal to believe that one's country would turn against one's community. Some Jews joined the Fascist party, others became militantly anti-fascist and went underground to work for the resistance. Even within one family, there were often radically different reactions to the changing political landscape. This was the case in the extended Forti clan, in which some family members worked for the resistance, some left for America, and some elders were sent off to live incognito on farms in the southern countryside, protected by Catholic workers. Stille notes that wealthier Jews tended to be more assimilated into the wider Italian culture, with networks of friends to help and country houses to which they could retreat.[7]

Forti's early notebooks, writings, and performances do not refer to her Jewish heritage, but this changed after her father died in 1983 and she began to construct a powerful mythology around his decision to get his family out of Italy before it was too late. Mario Forti famously read multiple newspapers a day, a habit to which Simone Forti would attribute his awareness of growing limitations. Her father also managed his family's international woolen business. Through his supply networks in Great Britain, he was most likely able to move money out of the country before Mussolini's government shut down that possibility. Recognizing the growing threat to their safety and wellbeing at the end of 1938, Mario Forti packed his wife, the kids and their nurse into the car, strapped skis on top, and joined the line of holiday vacationers traveling to Switzerland. Because her mother was pregnant and later ill, the family stayed in Bern, Switzerland, for six months. While there, her nanny took three-year-old Simone and her sister out to see the city's famous bears. Located in a gully under a bridge, the bears would open their mouths, and people would pour milk over the bridge into their mouths. This was the beginning of a life-long attentiveness to bears, the creatures that an adult Forti would claim as her totem animal. Sadly, the baby (Nicoletta) died in infancy. Once her mother was well, the family immigrated to the United States.

After landing on the east coast in 1939, Mario bought a new Buick

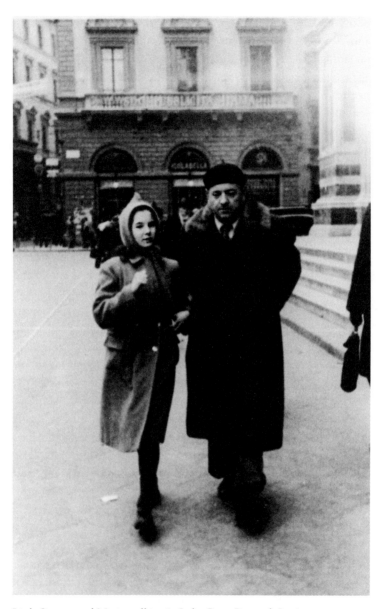

Little Simone and Mario walking in Italy. Getty Research Institute,
Los Angeles (2019.M.23).

and drove his family out to LA, where he set up a business and proceeded to invest (wisely) in real estate. Although newly arrived in America, the family kept to their European and artistic habits. Forti remembers weekend afternoons when cousins would come over and everyone would draw from a live model. The girls also had French lessons from a woman in the neighborhood. When she was twelve, the whole family returned to Italy. While her father stayed on for another seven years, her mother and the girls went back a year later to resume their life in LA. Forti remembers that her elegant, multilingual mother really blossomed during this time, becoming a popular interior designer and consultant, working for an elite Hollywood cliental. During his absence, Forti wrote letters to her father, a practice that she continued, even after her father died. The short preface to a chapter entitled "Father, Daughter," in her 2003 collection of writings *Oh, Tongue*, states:

> In Naples people speak with their dead. Enlist their help. As a Florentine Jew, I too speak with my dead. I love them, and they help me clear my mind. (2003b, 13)

These letters and imagined conversations with her father are dotted throughout her notebooks and memoirs from the 2000s onwards. Her memories of those exchanges are invoked in many of her performances, as well.

Forti has often commented that she doesn't like her mythology about her family disturbed or contradicted. As she ages, however, she has become increasingly interested in the entanglement of her family's history and larger political and economic currents. The oft-repeated heroic story of her father becomes more complex as she learns details about their business practices and the less benevolent aspects of a frankly paternalistic approach to manufacturing. In her 2018 memoir, *The Bear in the Mirror*, Forti discusses Silvia Sorri's sociological thesis, which focuses on the Forti family's woolen dynasty. Sorri was a graduate student whose grandmother worked for the Forti family mills in the early twentieth century. Forti's 2018 memoir also includes a full five pages of Forti's reading notes on this book in facsimile. In

a letter to her collaborator Carmela Hermann Dietrich dated January 31, 2008, Forti explains her interest:

> I'm finding out a lot more about the year we returned to Italy, after the war. There was more going on about the factory. I didn't know that. Laws of compensation to the Jews had been passed. And there was a struggle between the Forti who had sold under duress at a fraction of worth, and the Count Galletti, or some name like that, who had bought the factory for next to nothing under the fascist regime. According to one account, from the point of view of the workers, the factory could had been salvaged. The workers had saved a lot of the machinery from the bombardments by hiding it in an underground cavern. The immediate post war was a time for decisive action to modernize and get things going again. It seems the laborers whose fathers and grandfathers had worked there, loved the factory. And needed the work. But the Forti and the Galletti were focused on their conflicts. And the factory was never restarted.[8]

Both Sorri's thesis and Forti's response to it reveal the complex relationships between Catholic workers and Jewish management in mid-twentieth-century Italy. When I spoke with Silvia Sorri in September 2022, she told me an incredible story of the kind of mythology that had proliferated around the Forti family at that time. Apparently, during World War II, when the Allies—Great Britain, the United States, and the Soviet Union—were bombing that region in Italy, the Forti workers would tell one another that there was no reason to be concerned. Mario was now living in the US, and he would make sure that they did not bomb his own factory town! This kind of remarkable faith in their absent "padrone" is striking and indicates the intertwining of communal narratives that official histories may not always reveal. For instance, Forti recalls that her mother allowed her sister to wear a (Christian) cross necklace given to her by another family, saying that it was pretty and a gift, so why not?

When she returns to California at the end of the twentieth century, Forti reconnects with her sister Anna, who lived in the Bay area.

Forti describes an afternoon spent with her sister going through old photos and sharing reminiscences of their childhood in Italy. Since Anna was considerably older, she had more vivid memories, including cherished ones of playing with the chauffeur's son. Highlighting both the emotional attachment and the class (dis)connection in her memoir, Forti explains: "Anna said she grew up spending a lot of time with the Frediani family and playing with their son. And that it was understood between her and the boy that someday he would be her chauffeur. That was just a fact of life" (2018, 78). Much later in her life, Forti meets the driver's son when she visits the town La Briglia. She describes the experience in another letter to Hermann Dietrich:

> I was very moved. And the feel of his hand. I can still feel that thick, strong, soft, big hand. I remember the feel of my father's hand, which I also loved, which was kind of cool and soft and sensitive.[9]

Forti also writes about visiting her Italian half-sister—"When father was very young, long before he met my mother, he'd had a romance with his mother's young secretary, and a child had been born"—and entering the gates of the factory to the shouts of "The daughter of Il Signor Forti is here!" (2018, 52). With its worker housing (complete with kitchen gardens), community theater, and other amenities, La Briglia was truly a company town, and Forti's visit back to that place evoked childhood memories of walking through the cavernous vaults with their piles of raw and recycled wool. The generosity of her great grandfather towards his workers, however, did not survive the push for efficiency in manufacturing nor the takeover of the factory by a Fascist manager, and the business was increasingly embroiled in class as well as political conflict.

In the twenty-first century, Forti looks back at her youth and early adulthood, threading themes of the Jewish diaspora, the Italian upper class, and her extended family throughout her writing practice as well as in her Animations performances. Preparing for a performance in Montreal in 2016, she writes in her journal: "I lately have two themes I might begin with. The twisting of histories, each people's histories

Simone Forti performing News Animations, Ala Gallery, New York City, 1989. Photo by Peter Moore © Northwestern University. Getty Research Institute, Los Angeles (2019.M.23).

and how the moment must be seen differently as a moment in this history, that history." She adds: "I love to twist my body into this inter-weaving [of] histories" (119N). In the letter to Hermann Dietrich cited above, Forti claims, "I feel there's something in this material that is not just a family portrait, but a vantage point for looking at history." In *The Bear in the Mirror*, Forti dedicates a chapter to "This Tribe" and remarks on the plethora of books that complicate her own mythic narratives of her Italian Jewish family.

> I've gathered so many books by family members on Father's side, all about the family. Stories about their lives, the development of their religious beliefs, my grandfather Giulio's philosophical treatise, some books including the political times the family lived through, some books about the factory, the woolen mills, which was the business of part of the family. And books by factory employees, doctorate [*sic*] dissertations about the factory that include oral testimonies by factory laborers. (2018, 47)

As she lets all these words wash over her "like a waterfall," Forti recognizes that she is part of this tribe of people who try to make sense of their lives by writing memoirs.

This 2018 memoir is both dedicated to family and driven by familial relations. Unlike *Oh, Tongue*, which was published in 2003 (the autobiographical parts of which focus almost exclusively on her father), *The Bear in the Mirror* honors both parents. About her father she writes lovingly: "There is a tenderness that I feel for my father, that I feel in the woods or by a rushing brook, the sounds, light through tress, roots tangled dark in the cave-like places along the brook's banks, breathing in that cool, damp energy" (2018, 16). Unusually, it also features a chapter on her mother, Milka. Born in city of Salonika (at the time a part of Turkey) to a French mother and Italian/Russian father, Forti's mother grew up in Cairo and Zurich, and Forti delights in describing her as a "vivacious, strikingly beautiful, elegant, multilingual woman" (2018, 57). She relishes the fact that her mother was so worldly, equally at home in California or Florence. In another section, Forti describes her mother's love of languages, which she passed on

to Forti at a young age. She then adds wistfully: "In mother's earlier old age she would slip from language to language to language and I would slip around with her" (2018, 61).

Forti accompanies her mother throughout her last days, reading aloud to her, even though, as Forti writes: "Mother long beyond following meaning but sensing the meaning of being read to. And the grace of the sound" (2018, 62). There is also a full-page photograph of Forti with her mother in *The Bear in the Mirror*. Surrounded by tree branches in a garden, Simone and Milka stand side by side with their arms around each other, facing the camera. The similarity of their smiles and facial features, as well as the slight awkwardness of the posed moment, reveals their complicated relationship. One is an older artist, dressed in loose, flowing pants with a baggy sweatshirt and sandals. The other is an impeccably dressed woman of a certain generation who would never leave home without her pearls and stockings. While they represent differing generations and aesthetic tastes, they seem to share a sense of contentment with their lives.

On May 5, 2009, Simone Forti performed in Marseille, France, with Claire Filmon, a French friend and collaborator with whom Forti had earlier traveled back to Bern to visit the famous bears and her younger sister's grave. The evening begins with a solo by Filmon, and then moves on to one by Forti before they interweave their narratives. The connecting theme is stories of their fathers. Filmon had recently lost her father, with whom she'd had a complex relationship. Forti has often referred to her father in performance, repeatedly recalling his love of chess; his smooth, cool hands; his habit of walking contemplatively with hands behind his back. At one point during her solo, Forti takes a deep breath and slowly presses her hand down towards the floor. She speaks in French "*Il était le racine.*" (He was the root.) Suddenly, she throws her arms up in the air and rises on tiptoes, reaching towards the sky, her hands circling in the air above her head as she bursts out with "*Maman était les feuilles.*" (Mother was the leaves.) Returning to the lower position, she intones that her father would say it is important to do this and this, and then rising up again and walking forward, arms open to the sky, she tells us that

her mother would go off and do it. Her mother was so capable. She knew how to get things done—in many different languages. This moment is striking for the exuberant gestures and light, joyful energy that Forti exudes in talking about her mother, a family member whom she rarely talks about in performance. Soon, however, Forti arrives at a powerful stillness as she mentions her father's deathbed, describing the profound calmness of that room that smelled slightly of Jean Naté perfume. As Forti ages, she digs deep into the history of her Italian Jewish family, whose lives begin to resonate with her more and more.

Delphine Horvilleur is a French feminist rabbi whose spiritual talks on podcasts during the Covid-19 pandemic captivated a broad public struggling to deal with the trauma and uncertainty of lockdowns, deaths, and the eerie absence of normal life on the streets of Paris. Her popular book *Vivre avec nos morts: Petit traité de consolation* (2021) weaves Jewish texts throughout her discussion of contemporary issues, including the terrorist attacks on the Bataclan theater and the Charlie Hebdo offices. In one striking passage, she notes that the Hebrew word for generation is *"dor." Dor* is constantly invoked in prayers signifying the crucial role of family interconnectedness, the vital importance of handing down knowledge from generation to generation. Horvilleur is particularly aware of the imminent passing of the last generation with personal experience of the Holocaust. Intriguingly, she describes how etymologically, the word *dor* comes from the action of weaving baskets. To be strong enough to hold heavy items, baskets are woven from the bottom up. Each strand must be intertwined with the previous one. Extending the metaphor, Horvilleur points out the parallel importance of interweaving between human generations, regardless of one's religious affiliation.[10] Honoring past generations helps us understand the importance of cultivating future generations.

Throughout her life, Forti acknowledges the importance of learning about and reflecting on the generations that came before her. This is true of her blood family as well as her artistic clan. She repeatedly expresses gratitude to her teachers, including Anna Halprin (improvisation), Robert Ellis Dunn (composition), and Marshall Ho'o (Tai

Chi). While Forti never had children herself (a situation that made her sad for a long time), she has cultivated different generational connections, mentoring many important dance and visual artists throughout her life. Within dance communities around the world, Forti is revered as a generous and inspiring teacher. Even as her Parkinson's increasingly affects her mobility, Forti maintains an abundant curiosity that feeds her ongoing interest in collaborating with younger artists. She will often teach a workshop as part of an artistic residency, inviting her students to join her in some aspect of the performance. In her most recent retrospective at MOCA in 2023, she endeared many younger artists who flocked to her side after the showings of her Dance Constructions, eager to introduce her to friends and family.

More than many of her peers, Simone Forti has committed herself to the dynamic of kinesthetic responsiveness at the heart of improvisational dancing. Throughout this book I argue that, for Forti, improvisation was more than a dance form or even a performance form. It was, rather, a life practice—a way of being in the world. Improvisation is slippery. Etymologically, the root of the word means "unforeseen" or "unexpected." The appetite for dwelling in a space in which one is open to new possibilities requires a physical and psychic vulnerability that draws on a potent mix of curiosity and courage. Honing one's perceptual skills, including a sophisticated ability to be at once external and internal—available to the world and yet intensely grounded in an awareness of one's kinesthetic experience—is crucial. This work requires a patience and a willingness to pay attention—both on the part of the performer and on the part of the audience. In the essay "Animate Dancing," Forti explains the improvisational texture of her performances:

> I like to think of rehearsal or preparing for performance as a wave that will crest into the lap of the audience. A great deal of dancing goes on in the studio, getting an idea going, getting into the swing of it. The performance should be full of discovery. Yet even as it requires an unobstructed carrying through on impulse, it also requires keeping an outside eye. (2003a, 56)

This witnessing of self and world is based on a three-dimensionality of sensate attention that invites the audience into the performer's worldview. The magic arrives when the performer shifts between initiating and following, agency and vulnerability, mobility and stability. As Forti describes it:

> I love the tension of staying focused on the heart of what my dance is, while being pulled and finding myself responding in unusual ways, intuitively taking into consideration the quality of concentration, the energy and timing, the music of my partner. (2003a, 57)

Watching Forti navigate all these elements in performance makes for a thrilling experience. As it emerged in the environment of the late 1960s and early 1970s, the use of improvisation transformed from being a method of generating new movement material for choreography to being a performative practice in its own right.

For a long time in dance, improvisation has been seen as the opposite of considered choreographic choice. It is often seen as free, spontaneous, nontechnical, wild, or childlike. As Danielle Goldman notes in *I Want To Be Ready: Improvised Dance as a Practice of Freedom*, "All too often, discussion of improvisation and freedom in dance literature assume that freedom from dance conventions entails freedom from social conventions or political norms in general, when in fact the relations between these spheres are dynamic and complex."[11] Instead of being off-hand or trivial (what an old-school modern dance teacher of mine once called "noodling about"), dance improvisation requires intensive training to recognize the embedded expectations of ability, gendered behaviors, class position, and the like, that are a part of one's corporeal legacy. It takes abundant self-awareness to know one's aesthetic preferences and physical habits. As anyone who has ever participated in one of Simone Forti's intensive workshops can attest, Forti has a deep kinesthetic focus and formidable concentration that power her improvisational stamina. Staying present and responsive in the moment is a kind of physical mindfulness that comes from consistent practice.

The first chapter of Susan Leigh Foster's book on the improvised choreography of Richard Bull is entitled "Genealogies of Improvisation." Charting the multiplicity of influences on the practice of improvisation in the 1960s and 1970s, Foster references Brenda Dixon Gottschild's critique of histories of postmodern dance that elide the seminal influence of Africanisms and African American culture. In her book *Digging the Africanist Presence in American Performance: Dance and Other Contexts*, Gottschild writes: "The coolness, relaxation, looseness, and laid-back energy; the radical juxtaposition of ostensibly contrary elements; the irony and double entendre of verbal and physical gesture; the dialogic relationship between performer and audience—all are integral elements in Africanist arts and lifestyle that are woven into the fabric of our society."[12] Building on Gottschild's point, Foster expands the African American legacy of influence on improvisation to include a hybridity of forms. "The calm suggested in Asian practices coincided with the detached cool of Black art. These powerful aesthetic stances also mingled with a Latino aesthetic of spontaneity, [. . . and] Native American artistic practices and theorization of spirit-world-person integration as inspiration and justification for their work."[13] These scholars and others have rightly pointed out the exclusionary and racist biases (conscious or not) of much mid-twentieth-century NYC downtown art. Often these artists appropriated, as radical or experimental, artistic practices that had been a core part of African American aesthetics for years, including the profound influence of jazz music on the avant-garde scene.

These histories are also part of Forti's legacy, and she acknowledges the impact not only of her teachers but also popular culture, including African American music and social dancing. In speaking of the formative influences in her early career, Forti references her apprenticeship with Anna Halprin and the influence of John Cage's thinking as it was transmitted through the teaching of Dunn. George Lewis is a wonderful composer, musician (trombone), installation artist, and improviser, not to mention a professor at Columbia University. His 1995 essay on improvised music after 1950 juxtaposes the influences of Charlie "Bird" Parker and Cage.[14] Reading this comparison, I found

examples of Forti's oeuvre that could be aligned with both Parker's and Cage's approaches. About what he terms the "challenge of bop," Lewis describes how the underlying harmonic sequence was reworked over and over, sometimes to the point of total abstraction. There are many examples of Forti repeating and reworking movement themes or sequences, sometimes abstracting them to the point where they lose their representational context. Cage's focus on indeterminacy and chance procedures, while briefly intriguing to Forti, was not as important to her as his interest in truly hearing a sound. Cage has noted that he was interested in listening to a musical note without already knowing what compositional sequence was going to follow. As a result of listening to simple tones, he began to include random everyday sounds in his musical compositions. Forti's ability to incorporate stillness and simplicity, as well as her welcoming attitude towards interruption and coincidence, is emblematic of both Cage's conceptual teachings and the vibrational possibilities of jamming together in a jazz session.

As others have noted, improvisation was very much alive in the 1970s. Besides the development of contact improvisation, there were many dancers working with musicians and in dance theater. In discussing this creative milieu, Lisa Nelson of *Contact Quarterly* claims: "There was a lot to develop in the early seventies, there were so many different efforts with improvisation in dance, it was like a virus, Judith Dunn [and] Bill Dixon, Grand Union, Dianne McIntyre's Sounds in Motion, Daniel Nagrin's Workgroup, all were happening at the same time. It was like an explosion of activity and some of those efforts continued for many, many years."[15] In a 2000 notebook, as she was drafting a short statement to send to Gus Solomons for an essay on improvisation, Forti writes, "I like to compare improvisational dance performance to jazz. Its special nature is that thoughts are unfolding in the moment, with many considerations being balanced at once" (75N). Despite the tendency for improvisation to become what Daniel Fischlin and Eric Porter in their book *Playing for Keeps: Improvisation in the Aftermath* call a "master trope" for the avant-garde, Forti's improvisational practice expands over the years to invite reflection,

accept ambiguity, and even critique the cultural myopia of her own situation. In a 2017 notebook, she pens: "My little life, my nice little life. I am privileged . . ." and then in a following page, "I am white and financially secure" (119N). As Forti ages, she becomes increasingly aware of her own privilege and increasingly (although sometimes hesitantly) political.

Forti's improvisational practice draws from a variety of cultural influences, including her committed study of Tai Chi in the 1970s. Improvisation has offered a lifeline to Forti, who has famously articulated her approach as a "dance state" or a "state of enchantment." It is worth quoting the passage in full:

> There's something I experience that I call the dance state. It is a state of enchantment. As in chant. Or the French *chanter*, to sing. A kind of being be-songed. I have experienced it as a state of heightened awareness where one possibility after another presents itself as an unfolding path. As I rise, sink, and turn, my eye catches the shadow play of leaves on the far wall, suggesting the next move. I think it's a state of being. Like sleeping, figuring out, or panicking are. The dance state can occur in performance or choreographed work. Improvisation depends on it. When it's flowing very strongly, it is as if an angel were dropping the improvisation into your lap. When it's not, you have to bring your skills into play in a more methodical way. It still works. But part of becoming an improviser is getting to know what material is currently inspiring you to the point that it can induce this state. (2003b, 130)

Clearly this state of being present and available in motion takes time and practice to cultivate. By the time she found the right words with which to articulate her concept of a "dance state," Forti had been developing her improvisational practice for decades. It is precisely her dedication to improvisation as a way of navigating the world rather than maintaining a static artistic identity that keeps Forti engaged in creating new work. Her performances and writings resonate

across disparate contexts, speaking to dancers and visual artists, not to mention audience members, young and old alike. The chapters of this book focus on the many different aspects of her diverse oeuvre, including circling, crawling, animal movement, and land portraits, as well as her News Animations, Logomotion practice, and more recent large-scale, high-definition videos. Since Forti's approach to her art is so interwoven with changes in her life, I track their mutual influence when appropriate. Quotations from the writings of Simone Forti herself are noted with in-text citations, while quotations from others are cited with endnotes.

Simone Forti grew up in LA, in the (then) sprawling Hollywood Hills, where her family had a modern house with a garden. She graduated from the local Fairfax High School and then spent two years in the Pacific Northwest, studying at Reed College in Portland, Oregon. When she was twenty, Forti moved with her first husband, the artist Robert Morris, to San Francisco, the home of the burgeoning Beat movement. There, she found her way to the Halprin-Lathrop studio on Union Street to study dance. Soon, however, Halprin moved out to Kentfield, California, and her newly built outdoor dance deck. Forti followed her to the lush landscape between mountains and sea, reveling in the rare opportunity to dance in nature.

Forti has often mentioned loving the outdoors and how she draws movement material from nature. The formative years with Halprin dancing in open air clearly inspired her, and she continues to find sustenance from working outdoors. In an amazing montage of different moments of Forti dancing with trees, conjuring their roots and branches and the texture of their bark with her movement, filmmaker Pooh Kaye has captured her unique sensibility, her ability to channel multiple senses—sound, taste, touch, sight, smell, and movement— through her body. Similarly, in a 2021 interview, Danspace director Judy Hussie-Taylor describes taking a hike with Forti in Colorado. "I was like, this is amazing. Her whole body was, I don't even know how to say it, she was touching everything, all the trees and the bark . . . [it] was such a revelation, just watching her move through the

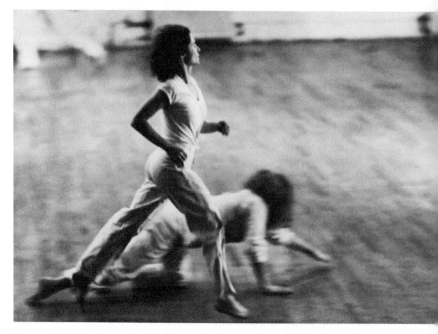

Simone Forti running, with Sally Banes crawling, in *Planet*, PS1, New York City, 1976. Photo by Peter Moore © Northwestern University. Getty Research Institute, Los Angeles (2019.M.23).

world."[16] For Forti, the natural world of mountains, trees, brook, and wind is an animate environment, filled with both visible and invisible forces that inspire her movement.

My first chapter traces the arc of Forti's life and dancing as she moved from California and her work with Halprin to a downtown NYC artistic milieu. While living in NYC, Forti writes about how much she misses being in nature and how much easier it is for her to find inspiration when moving among the trees and mountains. Forti goes to Central Park to climb the rocks and occasionally out to the mountains around the city, but the concrete cityscape increasingly weighs her down. Soon, however, Forti exchanges her focus on the vibrational energies of nature for the more conceptual focus of the avant-garde contexts surrounding her. She participated in Dunn's

(in)famous composition classes taught at the Merce Cunningham Studio in 1960–1961 with many of the dancers who would form Judson Dance Theater. Although she was never a member of that group, Forti worked briefly with Trisha Brown and more extensively with Yvonne Rainer and Steve Paxton (both of whom performed, along with Morris, in her early concerts). Like her peers, Forti embraced the rich cross-fertilization of visual art, sound, and movement brewing in NYC at that time. While doing so, these artists radically disrupted modern dance conventions of expressivity and technical virtuosity. They also embraced the body as a site of artmaking in general, heralding the inclusion of live bodies in gallery installations and ushering in the advent of performance art.

In outlining the historical and aesthetic contexts in which Forti found herself, I trace not only her life and work with Morris and the development of her renowned Dance Constructions, but I also map out her role in the Happenings performances of her second husband, Robert Whitman. By doing so, I offer an alternative her-story to the prevailing narrative that associates Forti almost exclusively with Morris and Minimalist art. Indeed, I argue that she learned a lot from working with Whitman's unique theatrical sensibility, including how to juxtapose radically different images while providing the audience with just enough coherence to follow along. This chapter also follows Forti as she returns to Italy in 1968 in an effort to distance herself from the NYC scene and recover from the disastrous implosion of her second marriage. I take the opportunity provided by her life circumstances to parse the question of feminism and examine Forti's lifelong reluctance to call herself a feminist.

My second chapter, "Forces at Play," charts the development of what I call Forti's improvisational poetics (which I describe as a blend of the conceptual and the vibrational) in the 1970s. These include her many improvisations composed of variations on circling and crawling, as well as her studies of animal movement. I draw extensively on her first memoir, *Handbook in Motion*, to explore the impact of her experiences at Woodstock and living a hippie life. Once she returns to California in the early '70s, she immerses herself in the study of

Tai Chi with Marshall Ho'o and absorbs the atmosphere at California Institute of the Arts (CalArts), where she occasionally substitutes for Allan Kaprow. There, Forti initiates an open forum for improvisation called "Open Gardenia" and develops what would become a life-long collaboration with the musician Palestine. Later, Forti was invited to Halifax, Nova Scotia, Canada, by Kasper König, the founding director of the Press of the Nova Scotia College of Art and Design, to write a book. Another robust and radical artmaking environment, the college functioned like a sister school to CalArts, employing many of the same artists to come and teach workshops. Although she struggled with the process of writing (König wanted her to focus on her Dance Constructions while she wanted to explore the effects of her adventures at Woodstock and her life in its aftermath), Forti enjoyed the learning environment and became close to some of the artists teaching there. In Halifax, Forti again was able to dance outside, taking pleasure in the locals stopping to observe her doing Tai Chi among the trees.

My third chapter, "Tuning," focuses on the role of sound and music in Forti's work, both in California and when she returns to NYC in the mid 1970s. This includes her years-long romantic and professional relationship with musician Peter Van Riper (her third husband), with whom she performed around the world. I argue that Forti's ability to tune in to the forces around her includes a special awareness of sound in the environment. Listening, getting inside the sound, becoming sound—these are all practices that inform her improvisational practice, from pieces such as *Accompaniment for La Monte's "2 sounds" and La Monte's "2 sounds"* (from her Dance Constructions concert) to her most recent album, *Hippie Gospel Songs*. Forti talks, sings, tones, screeches, and hums in performance. Sound creates a cacophony of possibilities, and over the years Forti explores many of them, often in collaboration with musicians and composers such as Palestine and Van Riper. And yet, sound is one area that is seldom explored in the critical reception of Forti's oeuvre.

Aside from her early Dance Constructions, which sometimes involved four or five people climbing, walking, or hanging, most people

think of Simone Forti as a solo artist or one who collaborates with a live musician. Her group dances are largely ignored by critics and historians. My fourth chapter takes up this little-known area of Forti's career as I analyze some of her early forays into group work, such as *Planet* (1976) and *Estuary* (1979) and then turn to her work with Simone Forti and Troupe in the mid 1980s through the early '90s. This is a time when Forti is again drawing inspiration from natural environments and, with her group, creates a series of land portraits. Beginning with *The Foothills* in 1986, Forti and Troupe cultivate a method of building pieces by immersing themselves in a site and learning about the natural history and geology of the place, as well as investigating the human history embedded in that area. Improvising their impressions for one another, they would then interweave these images into a set sequence that still allowed for improvisation and spontaneous interaction. Often Forti would take the stage in a solo, talking and moving through a story of the land and its people. This was a moment when Forti was spending more time in the country, eventually leaving her loft in NYC and moving up to Mad Brook Farm in rural Vermont, the site of the troupe's powerful evening-length piece, *Green Mountain.*

"Animating the News," the title of my next chapter, is an analysis of one of the most interesting aspects of Forti's improvisational prowess. Moving and speaking in performance is quite difficult, and Simone Forti does it brilliantly. Talking the news is one way in which Forti begins to digest the death of her beloved father and the need to find a new way to work after the breakup of her marriage to Van Riper. From News Animations to Gardening Journals to the more recent Animations, Forti navigates the world through the interface of her body and her mind. In the late twentieth and early twenty-first centuries, she creates improvised performances that combine life situations, politics, bodily experiences, and humor in fascinating ways. As dance scholar and curator Wendy Perron extolls, "Her art embodies both the conceptual strength of minimalism and the curiosity of exploratory improvisation, with her own sly wit thrown in to ensure a dose of radical juxtaposition."[17] It is this potent interweaving

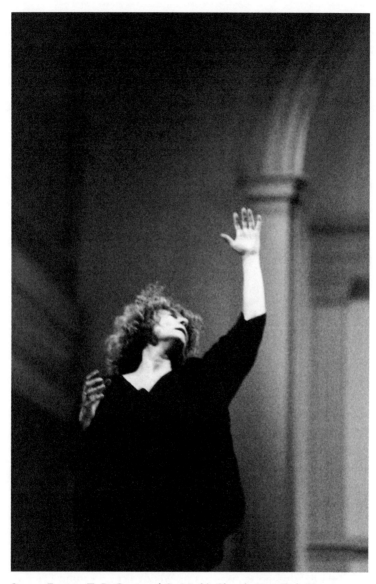

Simone Forti in *To Be Continued,* St. Mark's Church, New York City, 1991.
Photo © bill leissner.

of speaking and moving—that intricate braiding of ideas, current events, and kinesthetic dynamics—that I call her "engaged poetics." By interweaving language and dancing, Forti finds the perfect venue for her emerging political activism. This chapter also discusses Forti's development of what she terms "the workshop process" and the importance of her pedagogy in helping her students define their own movement research.

My final chapter is centered on the construction of Forti's legacy in the twenty-first century. After decades of critical neglect, Forti found herself very much in demand as art museums and galleries raced to shore up their collections with examples of performance work from the 1960s. Since 2010, Forti has firmly entered that canon with a series of one-woman shows at galleries worldwide, including a major retrospective in 2014 at the Museum der Moderne Salzburg. The Dance Constructions have been showcased in the 2018 exhibition "Judson Dance Theater: The Work Is Never Done" at the Museum of Modern Art (MoMA) in NYC. Her work was an integral part of the New York Public Library for the Performing Arts' 2017 exhibition "Radical Bodies: Anna Halprin, Simone Forti, and Yvonne Rainer in California and New York, 1955–1972" and a 2021 exhibition at the Centro per l'arte contemporanea Luigi Pecci di Prato in Italy, and she was honored in a career retrospective at the Museum of Contemporary Art in LA in 2023. In 2015, MoMA officially acquired the Dance Constructions, provoking interesting questions about the nature of artistic ownership within the elusiveness of ever-changing improvisational performance scores. In this chapter, I analyze the ways in which these pieces are marketed and reconstructed, attending to how they are "fixed" as works of art and the many afterlives that they (especially pieces such as *Huddle*) continue to generate. I also critique several curatorial choices that highlight their connections to Minimalism at the expense of an appropriate cultural sensitivity to how those "raw" materials might be read in the twenty-first century.

While Forti's work is enjoying international exposure with shows in Switzerland, Italy, Germany, France, Sweden, Brazil, Spain, and The Netherlands (among other countries), she also becomes very much

a part of the Los Angeles contemporary arts scene. The twenty-first century is a time when Forti has moved back to LA (originally to take care of her aging mother) and experiences an extraordinary renaissance in her professional activities and her own creativity. She teaches regularly in the dance program at the University of California, Los Angeles and meets new collaborators, including Hermann Dietrich, Sarah Swenson, with whom she started a performance and writing collective called The Sleeves (also including Terrence Luke Johnson and Douglas Wadle), and Jason Underhill, as well as McCarthy from The Box gallery. She also starts writing avidly, taking part in readings at literary arts center Beyond Baroque, where she meets Fred Dewey, who helps her put together (and publishes) her 2003 collection of writings, *Oh, Tongue*. In addition, Forti begins to work with McCarthy, who represents her extraordinary body of work in a way that makes sense in terms of the art world's value system. Beginning in 2009, The Box has sponsored no less than five solo exhibitions of Forti's work, the most recent in spring 2022. After examining how institutions have packaged her legacy, I return to the importance of the person-to-person transmission of her work, affirming through interviews with students new and old how inspiring it is to work with this living legend.

I began this introduction with an experience of moving with Simone. I want to end it with another experience of watching her perform, this one narrated to me by Paxton in a 2022 interview.[18] When I asked him to tell me a story about Simone, he described a solo she did in Colorado in the early 1970s. She had recently injured her ankle and thus had someone sit by her feet to stabilize her legs while she moved exclusively with her upper body. Over time, reaching with her arms and gaze up and away, she seemed to evoke the solar system and enormity of endless space. Paxton began to get a sense of witnessing something uncanny, something he called "witchy!" such that the hairs on his body stood up. He recalls: "I came away feeling like I had one of the deepest experiences of performance, there was something essential in that performance. Yeah, essential, and provocative of harmonic changes in me." Although there was nothing in the "content"

of the improvisation to suggest the mystery of the universe, there was
something about her performance that evoked it. Paxton attributed
this profound experience (which he remembered perfectly fifty years
later) to her earnestness. "Simone is a very earnest performer. So,
when you see her looking around, you don't feel like she's trying to
make an image; you feel like she's looking around, she's emmeshed
in herself and what she's doing."[19] Simone's magical ability to inspire
wonder is precisely what so many people have found enchanting in
her performances and workshops. As in Paxton's amazing story of her
performance, that cosmic reality is readily transferred to her audience,
moving them from the physical to the metaphysical. This book argues
that the true legacy of Simone Forti's work is not her Dance Construc-
tions of the 1960s (important though they were), but rather the model
she provides of improvising a vibrantly rich artistic life inspired by the
movement of many worlds.

Movement Is Her Medium

I'm a dancer of sorts. Or rather I'm an artist and move-
ment has been my medium ever since as a child I used to
roll down our garden in the Hollywood Hills.

<div align="right">SIMONE FORTI, 2018</div>

It is a story that has been told many times. It is the story of a dancing apprenticeship, marriages to different male artists, an extraordinary milieu of experimentation and collaboration in downtown New York City, and the interweaving of west coast and east coast perspectives on making work. The tale of Simone Forti's artistic coming-of-age has been repeated over the decades in countless interviews and reiterated in essays, books, assorted performances, and extensive documentation by The Box gallery, the Museum of Modern Art (MoMA) in NYC, and the Museum der Moderne Salzburg in Austria. As it has become institutionalized, the narrative of her aesthetic journey from the 1960s to the present has settled into a relatively seamless account. It is a story of a brilliant and radical innovator of forms, yet it is often told in a manner that covers over the jagged edges of many creative challenges, gaps in confidence, and interpersonal frictions.

Most of these accounts are retrospective, written in the twenty-first century just when art museums around the world have sought to bolster their collections with performance work from the 1960s, including Forti's series of Dance Constructions, which were formally acquired by MoMA in 2015. (The story of their commodification is told in this book's final chapter, "Constructing a Legacy.") Enabled to a great extent by representation of Forti from 2009 onward by The Box gallery in Los Angeles, this establishment recognition is

wonderful—and long overdue. It also frames her oeuvre in particular ways, presenting her Dance Constructions from 1960–1961 as seminal to the development of task-based postmodern dance. Set on the pedestal of Minimalism and linked to the work of Robert Morris and Judson Dance Theater, these early works have become "masterpieces," artworks to be celebrated and acquired.

In terms of Forti's life trajectory, however, these pieces were made early on in a career that continued to evolve through many different stages, leaving them (with the notable exception of *Huddle*) behind for decades. Seen in retrospect and valued now because of their connection to groundbreaking trends in the art world, the Dance Constructions are very often positioned as the highlight of her artistic trajectory. Their afterlife continues to both delight and haunt Forti, for as much as she enjoys the attention and fame, she also has expressed frustration at being forced to return, time and time again, to only one aspect (basically one year) of her total oeuvre. The canonization of the Dance Construction has now overshadowed aspects of her long career that are, to my mind, critically important to understanding her work as an improvisational dance artist. Without diminishing the Dance Constructions' importance, I will provide other ways of seeing what Simone Forti was up to in downtown NYC during the 1960s.

In this chapter, I am interested in telling a parallel history—one that details Forti's love of dancing. Rather than frame her early work only in terms of Minimalism in art or think about bodies as objects arranged in space and time, I focus on the dynamics of physicality involved in Forti's movement explorations. That is to say, I describe the *how* as well as the *what* that happened in these events—I attend to the vibrational as well as the conceptual sides of her artmaking. And, in some case, I also venture into the *why*. Of course, this historical journey takes us over some familiar territory, including Forti's apprenticeship with Anna Halprin and her intimate associations with visual artists Morris (to whom Forti was married from 1955 to 1962) and Robert Whitman (to whom Forti was married from 1962 to 1968), her participation in Robert Ellis Dunn's composition classes, and her working relationships with Judson Dance Theater dancers Yvonne

Rainer, Steve Paxton, and Trisha Brown. Yet I also hope to point out aspects of her artistic development that are often passed over. For Simone Forti, art and life—making and living—are inextricably intertwined. Thus, the story I tell draws on her extensive journals and autobiographical writing to fill out the contours of her thinking and doing during this critical first decade of her creative trajectory.

In the first of two oral histories that was recorded in May 1994 (before Forti moved back to LA) and is now archived in the Jerome Robbins Dance Division at the New York Public Library for the Performing Arts, Forti reminisces about her early dancing experiences.[1] As a child of nine or ten, she and a friend played music and danced around the living room. She vividly recalls one time when they put on the record of Edvard Grieg's "In the Hall of the Mountain King" from his *Peer Gynt* orchestral suites. "We were dancing demons, which was great because we were kids and we had all this energy. And I remember we were running up and down the couches and jumping and leaping over the furniture and just being demonic" (1994, 14). The dark, dramatic music brought up all kinds of fascinating images of witches and goblins. As a young girl, Forti had been advised to take up dancing with an eye to helping her very flat feet. In true American modern dance fashion, the main teacher conducted a series of classes in ballet, tap, Mexican, and so-called Oriental dance styles. Forti fondly remembers especially loving the opportunity to snake her arms expressively and performing in the year-end recitals at a veteran's hospital in LA.

Although brief, this early dance experience was clearly formative. As a young girl, Forti had an appetite for gesturing dramatically and getting caught up in the flow of movement. Throughout her life, Forti refers to the fact that she had "grace" or was "graceful," even if she had trouble following complicated steps or memorizing movement sequences in technique classes. While she dropped dance classes after a few years, she continued to dance with friends, improvising to their poetry. In the oral history with dancer and writer Louise Sunshine, Forti describes hanging out as a teenager with her best friend:

With Mary Lou [Dorfman] I remember being draped on the
walls and stretching and twisting and looking dramatic. A lot of
emotion going on, I'm sure. I was full of crushes that were unre-
vealed so I'm sure a lot of sort of aching in the heart, you know,
like bringing that out through the arms and stuff. (1994, 14)

In high school, Forti returned to dance, gratefully choosing it over
gym classes to fulfill her physical education requirement. Her dance
teacher was unusually progressive and open-minded, allowing the
students to improvise freely to their favorite records and to create
their own choreographic studies. Forti was clearly the beneficiary of
an enlightened approach to movement pedagogy, one that gave the
students enough skills to be excited about learning new coordination
but not enough to indoctrinate them in one aesthetic or technique.
It was an approach that used the end of the class period for open,
improvisational dancing. Forti recalls:

We did the kind of dramatic romantic things that teenagers
would respond to. And again, there was the matter of just
cutting loose and letting movement come out. I think that
was really important for me in keeping on looking for dance
classes [later in life] that I had a good experience with that.
(1994, 8)

Another time the class composed a dance theater piece based on a
tribal hunt scene and, much to her delight, Forti was chosen to be the
sacrificial animal. Intriguingly, in view of her later work with animal
movement, Forti embraced her role in this high school dance drama
with gusto, exclaiming:

I got to die. And so it was very dramatic and wonderful, and I
finally ended up on my back with all fours up, you know, like
claws. After a lot of writhing and having these spears all in a cir-
cle thrown at me. I must've been pretty good to get to be in the
center there of the circle. And I think good in a way of expres-
sively good. (1994, 13)

Connecting these fragments of memory, one senses the breadth of Forti's dancing as a teenager. Her physical pleasure encompassed exuberant running around and dramatic gestures, and she had a sensibility that relished performing. It is this zest for moving that continued throughout most of her long career in dance, regardless of her compositional or improvisational focus at any given time.

Simone Forti went to Fairfax High School, a top-rated academic school at the time. Indeed, the list of famous alumni include a virtual who's who of Hollywood producers, film stars, politicians, and musicians (including members of the Jackson 5). For instance, Grammy Award-winning musician Herb Alpert (who was born March 31, 1935, six days after Forti) remembers the high-quality musical instruction available at the high school and attributed some of his professional success to the seriousness with which the arts were taught.[2] Fairfax High School was situated in a large modern building with an expansive front lawn where students could socialize before and after classes. Once rural, the area where the high school was located became increasingly developed in the mid-twentieth century. The Fortis were part of a migration of families westward from downtown LA. Many of these families were Jewish, and by the time Simone went to high school the student body at Fairfax was predominantly Jewish. In fact, it was the first public school to offer a modern Hebrew language course. Many of the teachers there were also Jewish—and leftist.

Later in life, Simone Forti would claim with some embarrassment that she did not participate in the civil rights or anti-war demonstrations during the 1960s and early 1970s. Although her family itself was not overtly political (a stance that she attributes to being immigrants and resistant to rocking the boat in their new country), she was peripherally involved in the vibrant intersection of art and politics forged in the wake of World War II through her high school boyfriend, whose father was a union organizer.[3] In various interviews, Forti mentions tagging along to attend hootenannies, where she would join the group singing, stressing that she knew all the union songs. This was one of her first experiences of the transformative power of a large-scale group activity (something she would find particularly compelling at

the Woodstock festival in 1969). In an interview in 2015, Forti commented that her mother wouldn't let her follow her boyfriend to the University of California, Berkeley, for college, perhaps because the campus was considered too radical for her family.[4] Nonetheless, one of the reasons she chose to go to Reed College was because of its liberal (and artsy) reputation.

Forti cites the Jean Cocteau Cinema as another formative influence in her high school years. Situated just down the street from her home, the movie house was dedicated to screening experimental and surrealist films such as those by Jean Cocteau and Salvadore Dali. Forti would go there with her best friend, Mary Lou, but the real thrill was hanging out in the lobby and absorbing the alternative social scene. Forti recalls, "And I was seeing all those women sort of dressed in browns and dark greens and wearing beads, all earth colors [. . .] and [they] had their hair in buns or ponytails. They were Bohemians, and I knew that that's what I was going to be" (1994, 10). In the face of post-war conservatism, the Bohemian culture, with its folk singer/composers such as Pete Seeger and Woody Guthrie and its explicit countercultural lyrics, created a community of resistance that engaged both overt political organizing as well as cultural proselytizing.[5] Forti remembers loving the fun, social spirit of these events. She also attended evening community folk dances, where she and her friends would tend to get a bit wild, running around and swinging partners with a great deal of momentum. (In her first oral history, she uses the term "terrors" to describe their youthful disruptions.)

In addition to her dance teacher, Forti fondly remembers a remarkable high school biology teacher who dedicated Friday classes to asking her students what they most wondered about. After hearing each student's question or interest, her teacher would introduce them to the area of science or research that would help them find the answers. Forti has described how empowering it was as a young person to be put in charge of the research inquiry. Instead of making the students memorize facts in biology or steps in dance, the teachers at Fairfax High School cultivated a sense of curiosity about the world, placing the students' inquiries at the center of their enlightened pedagogy. Judging by the success of many of their students, they must have

instilled a real sense of confidence in the youths, as well. This curiosity about the world and the desire to learn by researching one's own movement experience is what Forti found fascinating about working with Halprin. It also becomes an integral part of her own teaching style, what she would later call "the workshop process."

Simone Forti enrolled at Reed in the fall of 1953. She spent two years studying there before decamping with her soon-to-be husband, Morris. (Although she did not actually graduate from Reed, the college alumni magazine would claim her as a 1957 graduate.) Inspired by her high school experience in the sciences, Forti expected at first to major in biology. She was disappointed, however, when she found out that the introductory biology course was focused almost exclusively on memorizing names and phyla, a form of learning that doesn't particularly suit her intellectual strengths. In an interview with the alumni journal, Forti describes her youthful college self:

> I really was interested in the humanities, but basically I don't think I was really cut out to be a student. If I didn't agree with the philosophy I was reading, I couldn't bear to read more [of] it. If I loved it, I wanted to run around on the lawn.[6]

She dabbled in dance, which had just moved from the umbrella of Art and Humanities to the Department of Health, Physical Education, and Recreation. Dance remained under the auspices of physical education until 1967, when it moved to a newly created Department of Arts. Nonetheless, a quick glance at an early 1950s *College Handbook* for Reed (created primarily for incoming first-year students) reveals a very progressive and encouraging artistic milieu.

Like many liberal arts colleges at the time, Reed was committed to cultivating original work. The college sponsored a continuum of performing opportunities, from organized events directed by faculty to informal, student-run performances. These were dubbed, with a certain amount of irony, "unsupervised modes of expression." Even the official classes and performing arts groups were open to all students. Under the heading Dance, the handbook refers to modern dance instruction and states: "Classes are open to all interested students, who are encouraged not only to learn the traditional modes of the dance,

but *to develop their own individual style*" [emphasis added].[7] Even
the Music division, often one of the most conservative areas of arts
training, advertises "from Bach to Be-Bob" [*sic*]. In fact, the student
handbook tells us, one of the most popular series was entitled "Sound
Experiments," which routinely filled the Student Union with audi-
ences from the city of Portland, Oregon, coming out to hear nationally
recognized musicians and contemporary composers of "new" music.

This freedom to engage (or indulge) in one's own preferred mode
of expression was deeply empowering. Forti remembers crafting a solo
in college in which she slowly bent backwards and came up to center,
and then slowly, slowly sunk to the ground. It took a long time and
a great deal of control, but she relished that experience as a simple,
singular event, as if she were a statue melting into the floor (1994, 17).
Morris was in the small audience, and they married shortly there-
after. Trisha Brown (who would later work on improvising rule games
with Forti in NYC), however, lamented the lack of technical training
and rigor in the Reed students when she taught dance there in the
late 1950s. Fresh from her undergraduate schooling at Mills College,
Brown noted that "the nature of the student body at the time was
irreverence mixed with a complete lack of training and discipline."[8]
Besides her brief stint in biology, Forti dabbled in visual art as well as
dance but seemed unsure where to fully commit her energies.

The 1954 *Griffin* (Reed's yearbook) has a page devoted to Abington,
the dorm where Simone Forti lived in her first year. In the second row
of a group photograph stands a nonplused looking nineteen-year-old
wearing a plaid button-down shirt with her dark hair pulled back
away from her face. Forti displays little affect, but her eyes reveal
a slightly mischievous glint. Judging by the spontaneous smile and
sideways glance of the young woman standing next to her, Forti may
have just cracked a joke or made a snide comment. Later in the year-
book, Forti is listed in the program as part of the scenery crew for a
play titled "Children of Darkness." Overall, it seems that Reed during
the mid-1950s had one foot in established traditions and one foot in a
progressive world of avant-garde art and social change. For instance,
the student handbook advises women students that jeans and slacks

Abington dormitory page from the 1954 Reed
College *Griffin* yearbook; Simone Forti is shown
in the bottom photo. Courtesy of the Reed Col-
lege archives.

are considered not only acceptable but standard dress code, and it
goes on to suggest that women students aim for practical and durable
clothing that is warm. This is a far cry from the kinds of advice given
about clothing at East Coast colleges. At the same time, however,
the student handbook repeatedly calls these young women "girls,"
and there are quite a few pages in the yearbook that feature formal
dances for which waltzing couples have donned fancy dresses and
suits. Intriguingly, there is also an action shot in one of these pages
of people dancing apart from one another with bent-over torsos and
splayed arms—clearly moving low and fast to a swing rhythm or some
early rock and roll.

Like many young women of her generation, Forti was caught in a double bind of gender expectations. On the one hand, she had abundant intellectual and artistic resources at home and was encouraged to pursue her interests. On the other hand, there was a social and familial assumption that she would marry and raise a family, supported by a husband. Her father once told her that, unlike him, she was free to pursue her artistic inclinations because she did not have to support a family. (Of course, what was unspoken was that being an artist was possible only if it did not interfere with her duties as a wife and mother.) While Forti references many conversations with her father, she rarely talks about what her mother had to say on this topic. Yet Forti's mother thrived in the years when her husband was living in Italy after the war. This was a time when she crafted an independent career as a cosmopolitan interior designer, one sought-after by many of the Hollywood elite. When her father returned to live permanently in the United States, her mother ("naturally") left her job and returned to being a housewife and fixing her husband lunch. Highlighting a similar mid-twentieth-century gendered sensibility, Brown acknowledged that the emphasis on teaching in the dance department at Mills College was due to the cultural attitude that it was a good "auxiliary skill," compatible with a conventional marriage and home life. Despite these pressures from society, young women interested in a life dedicated to movement as a medium had a plethora of examples of strong, independent women in modern dance. After leaving college and moving to San Francisco, Simone Forti would meet one of them.

Of the many images of Simone Forti taped to the wall of my scholar's study in the library, there is only one of her in her twenties, with long, dark hair. It is an enlarged image of a snapshot of a young woman standing on a deserted beach, staring into the distance. The weather is cold; the sky is overcast. There is one other lone figure near the water's edge, presumably her husband, Morris. Part of a series of black-and-white photos of the newly married couple, this image is deeply compelling to me because of its existential overtones. Unlike the other shots of the couple standing next to one another or sitting on a piece of driftwood and holding hands, this one focuses on Forti's own experience. Dressed in a black sweater with her gaze

Simone Forti, with Bob Morris in the distance, ca. 1955. Getty Research Institute, Los Angeles (2019.M.23).

off to the right, Forti stands alone, her fingers delicately holding some small object in front of her body. She seems wistful, her attention suspended by the faraway. This photo was taken some time after she left college and before she began working full time with Halprin. It shows her in a moment of indecision when she wasn't sure of her next step. She was probably scared, but, as Forti likes to remark about

these times when she is confronting the unknown, it was a *good* kind of scared.

It is always difficult for young women to chart their desires and determination on the sea of society's expectations. Forti was no exception, particularly because for many years she was ambivalent about the intersection of her working career and married life. What we do know is that she followed Morris when he left college to move to San Francisco. After deciding that an academic career was not for him, Morris returned to his earlier desire to be an artist and started painting abstract expressionist art in earnest. Forti also decided to try her hand at being a painter. In a wonderfully whimsical and performative interview that was staged as part of Ellen Webb's and David Gere's Talking Dance Project in 1990, Forti describes her early days in their loft.[9] Apparently, Morris, who was four years older than Forti and seriously focused on making abstract expressionist–inspired work, told Forti that "she couldn't just stand around staring out of the window and eating peanut butter all day." It was time to get down to business, so he taught her how to stretch the large canvases that were popular in the wake of Jackson Pollock's action paintings. Tongue firmly in her cheek, Forti tells of putting together a life-sized white rectangle and then lying down on it to take a nap. Upon waking up, she leaned it against the wall and started jumping up and down and throwing paint at it in the manner of abstract expressionism.

Although drawing would always be a part of her life, Forti never really considered herself a painter or even primarily a visual artist. In an interview with dance critic Claudia La Rocco published in *The Brooklyn Rail* in 2010, Forti explains her ambivalence about pursuing a career in painting:

> I grew up in a house full of books of reproductions of Renaissance Art. When I first dropped out of college with Bob [Morris], I was painting for about six months. I think painting can knock me out like few other mediums, but maybe because of that, because I've seen painting and continue to see painting that I just find so transcendent, I didn't feel I could do that. I didn't

feel I could really, let's say, compete with the heavy painters. But I felt that in dance I had something to offer. My sense of movement.[10]

It is important to point out that, unlike her models of strong women living a fulfilling life in dance (such as Halprin), the art scene was (and arguably still is) very male dominated. Forti may have felt, even subconsciously, that becoming a visual artist was less of an option for young women in the 1950s. In any case, it was her appetite for movement that led Forti to take some dance classes at the Halprin-Lathrop studio on Union Street in San Francisco.

Simone Forti met Halprin in 1956, just as Halprin was breaking away from the confines (both ideologically and geographically) of the Union Street studio she had shared for a decade with fellow modern dancer Welland Lathrop.[11] Halprin had trained with Margaret H'Doubler at the University of Wisconsin, Madison. A pioneer in dance pedagogy, H'Doubler was not interested in imposing a classic style or specific technique on her students. Rather, she facilitated each dancer finding the way of moving that best suited their body and temperament. Drawing on the philosophy of her mentor John Dewey, H'Doubler believed dance could cultivate an experience that was personally transformative. Halprin absorbed H'Doubler's focus on exploring anatomically based movement but expanded that practice into a broader social framework. For Halprin, the physical body could be considered a microcosm of the larger community, and she was interested in the interpersonal relations between self and other, as well as self and the larger environment. Raised in an observant household, Halprin combined her strong sense of spirituality with the progressive politics of Reform Judaism and stirred in a good dose of environmental awareness. She eventually produced dance rituals designed to heal people and the earth.

When Simone Forti began seriously working with her, Halprin had recently moved her dance life from her studio in San Francisco out to her home in Kentfield, California. Halprin's husband, Lawrence Halprin, was a visionary architect focused on melding built

structures and the landscape, and he and the designer Arch Lauterer created an outdoor dance deck located fifty feet down the slope from their house.[12] Built among the madrone trees and surrounded by a grove of redwoods, this amazing space combined elements of sky and earth, gravity and air to inspire dancing that moved *with*, not only *in*, nature. Rather than a static object, the deck became a partner in the creation of a unique way of moving and living. In her biography of Halprin, dance scholar Janice Ross claims that "the deck is not architecture as a statement so much as architecture as response," creating a "theatrical space in the midst of raw nature. Walls are replaced by trees, the ceiling is a canopy of trees and the sky, and the sounds of this space are the muted calls of birds, the fluttering of leaves, the hum of insects."[13] Motivated by this extraordinary space for dancing, Halprin pursued her vision of a working artistic community by inviting theater artists, dancers, and musicians (including La Monte Young and Terry Riley) to come and create together.

Forti regards Halprin as her first real mentor and speaks of her four years studying and performing with her as an apprenticeship. In her memoir *Handbook in Motion: An account of an ongoing personal discourse and its manifestations in dance*, Forti reflects on that first day of Halprin's workshop: "It was the first time a teacher had really captured my imagination, and the first time I knew I would always do a lot of dancing" (1974, 29). More and more, Halprin was instigating movement exploration in her classes rather than teaching traditional technique. This suited Forti just fine, as she no longer had to worry about the turnout of her hips or whether she would remember a particular movement combination from one class to another. She was able to shift her attention from doing the steps to using movement as a form of research—a way of finding out about the world. Describing this stage in her life, Forti notes: "Whether or not I had stayed with her vision, I really got a sense of what it is to have a vision" (1994, 22). For instance, Halprin's classes might begin with anatomical explorations of the movement of the shoulder blade, and then extend that kinesthetic focus outward to movements of the arms or the arms in relationship to the branches of the trees overhead. Tracking sensation

in their bodies, the dancers extended the feel of a movement to the feel of the environment. Muscles could motivate a gesture but so could the wind or the sound of the trees.

One of the most important tools that Halprin provided to her students was how to use the natural environment as a springboard for movement. In an interview with Ross, Forti specifies:

> She taught the process of going into the woods and observing something for a period of time, and then coming back and somehow working from those impressions. [. . .] So she led us to this awareness of somatic sensations in response to perceptions outside so that the inside and outside of us would be working together.[14]

This practice of observing one thing for a long time and then translating that experience into movement requires a physical mindfulness in which the dancer has a deep sense of embodied perception. Through these kinds of open-ended somatic investigations Forti acquired the ability to be fully present in her movement and in the moment, a skill that makes watching her perform an amazing experience. Forti also recalls a memorable example of this kind of magical ability to become what one sees when she describes Morris participating in an exercise led by A.A. Leath:

> He had observed a rock [for half an hour]. Then he lay down on the ground. Over a period of about three minutes, he became more and more compact until the edges of him were off the ground, and just the point under his center of gravity remained on the ground. (1974, 31)

That ecological sensibility combined with Halprin's attention to what she called "kinesthetic awareness" cultivated a state of receptivity that Forti would later call a "dance state" or a "state of enchantment." For Forti, this new sense of responding to the world through her body—rather than learning how to master steps—was liberating, and she dove into dancing with a passion and commitment that had alluded her previously. Forti giddily remembers dancing all day and well into

the night. "I have memories of lying on the deck, then convulsing with such energy that I'd just pop up into the air and fall down again. Then, from however I'd landed, I'd convulse again and pop up and fall down again and again" (1974, 31). Her body was so enlivened to this avalanche of movement stimulus that she would often wake up kicking a leg or thrusting an arm out from the bed.

In addition to feeling her body and her imagination thrive within this new movement research, Forti was learning how to work with other dancers and the natural environment. She uses the term "witness" as a way of articulating the dual state of being completely physically involved in what one was doing and simultaneously tracking what was evolving in the whole group. In *Handbook in Motion*, she writes:

> Our basic way of working was improvisation following the
> stream of consciousness. We worked at achieving a state of
> receptivity in which the stream of consciousness could spill
> out unhampered. But at the same time a part of the self acted
> as a witness, watching for movement that was fresh and good,
> and watching the whole of what was evolving between us. [. . .]
> Sometimes there seemed to be some obvious association, or some
> cause-and-effect relationship. Often there was a coexistence, a
> juxtaposition of qualities or concerns, from which would emerge
> a third quality, the quality of the space between those two coex-
> isting spaces. (1974, 32)

One of the most memorable exercises in group dynamics that Halprin gave the group of dancers working with her was very simple in its instructions but quite complex in its execution, something that Forti would later reinvent in some of her own improvisational structures. For instance, Halprin told the group to begin walking in a circle and not worry about keeping to a single file line. Sitting above the dance deck, Halprin watched patiently as the group eventually accelerated and then slowed down, repeating these waves of moving faster and slower before eventually collapsing on the dance deck after several hours. These simple directions can produce incredibly beautiful danc-

ing as people suspend motion or speed up in response to the larger dynamic of the group.

Even before she broke away from traditional forms of modern dance technique and conventional methods of choreographing for her ensemble, San Francisco Dancers' Workshop, Halprin had been using improvisation in her children's classes. According to Ross, this was quite a radical move at a time when the usual focus was on preparing young bodies by teaching them the basics of dance technique such as turnout and triplets.[15] After being asked to lead some creative movement sessions at a local nursery school, Halprin organized the Marin Children's Dance Cooperative in 1948 (which she ran until 1970). This nonprofit organization required parents to participate in their child's movement education and provided employment for some of Halprin's full-time dancers, including Leath and Simone Forti.

Halprin was interested in facilitating a functional, non-stylized approach to movement and in unleashing the imaginations of her young charges. She articulated her pedagogy in a series of treatises published in journals such as *Dance Magazine* and her own magazine, *Impulse*. In a 1996 interview with Ross, Halprin explained the importance of improvisation in working with younger dancers.

> My whole concept in working with children was to have them appreciate their aliveness. [. . .] Kids have to grow up believing they are just fine the way they are. I did this through improvisation because with improvisation you aren't right or wrong, you just are.[16]

Sometimes the young students worked in pairs, with one child guiding the movement of another. In this way, Halprin was able to encourage the same melding of somatic awareness and witnessing that Forti says is fundamental to developing a group's improvisations.

Once she made the commitment to work with Halprin full time, Forti quit her day job and began teaching children's classes. In *Handbook in Motion*, she briefly mentions leading modern dance classes at Dominican University of California, in San Rafael, but it was the children's classes in Marin County that most interested Forti and

helped her find her voice as a teacher. In her first oral history, Forti describes one class for eleven- and twelve-year-old kids that was officiously titled "Poise and Pose" and that she irreverently referred to as "Poison Posture."

> I was having them do things like go across [the studio], you know, imagining that their pelvis is a basket and go across the room like dropping all the apples out the back and then dropping all the apples out the front and starting to get some mobility, actually. Just different images to have them get mobility and improvisation to have them get comfortable with themselves, because the theory was at that age you get very uncomfortable. (1994, 20)

Forti's words here echo Halprin's priorities for teaching, but they are also imbued with her own sense of humor. Unlike Halprin, however, Forti recalls making elaborate lesson plans on the Greyhound bus as she traveled from home to class to Halprin's dance deck, a journaling practice that she maintained well into the twenty-first century.

Although she toyed with the idea from time to time, Forti never started a formal school. She has, however, crafted a method of proposing movement research that draws on her experiences teaching young children while she was dancing with Halprin and later when she taught nursery school in NYC in her mid-twenties. On several of the pages from her journals reproduced in facsimile in *Handbook in Motion*, Forti writes about teaching in ways that reveal connections between play, movement, and a state of heightened flow in improvisation. At the top of one page, she writes "play made permanent" and underlines the phrase as if she were saying it aloud—as if it were a kind of mantra. On a following page, she segues into a riff that simmers in frustration with her role as an authority figure responsible for a certain mode of behavior that "they," the adults surrounding her, insist is appropriate.

> I can't manage the externals of the teacher role. I can't seem to take on the ear-marks [*sic*] of the bourgeois adult. They think I'm

childish. No. It's not childishness. It's just an other way of being.
If I were fifty I couldn't do like they do. No it's not childish-
ness. It's an other way of being. Not a better way, but they seem
threatened. (1974, 51)

In California, Forti learned this "other way of being" at the same
time that she learned to hone improvisation as a tool for teaching,
bringing together what she called "kinesthetic movement intelli-
gence" and using props or scores for her students' dancing explora-
tions. Unfortunately, the rigor of that method was not always visible
from the outside in, and Forti's casual demeanor combined with her
improvisation-based playful pedagogy obviously struck the nursery
school administration as insufficiently authoritarian.

In her role as a teacher of young children, Forti had ample op-
portunity to watch and absorb the simple games that kids invent for
themselves. She noticed that if a child finds a certain way of swinging
their arms or is satisfied by a sudden drop to the floor, they will do the
movement again and again, honing their pleasure through repetition.
Forti has always been interested in what she calls the "roots" of dance
behavior across various species, often recognizing dance in the ram-
bunctious sparring of young bears or the serious play of young kids.
Forti explains her perspective:

> When you are little and you're just starting to feel the possibil-
> ity of the upwardness and you kind of hop, hop, hop on your
> ass, you're giving yourself a little bit of a ride. You're enjoying
> that ride. You're enjoying the energy, the sensation of that mo-
> ment. I think that's part of dance behavior. But playing with
> movement is a big thing that all developing mammals certainly
> [do]. (1994, 28)

As a teacher and a student of Halprin's, Forti used movement as a
form through which to research her own experience in the world. In
other words, she danced in order to find out.

Inspired by the natural setting of the dance deck, Halprin became
increasingly interested in seeking out other, unusual sites for merging

movement and place. *Hangar* (1957) was a dance/film staged on the steel beams of a vast cargo depot under construction at the San Francisco International Airport. In her book on Halprin, Ross narrates the genesis of this work. One day, Norma Leistiko (a dancer in Halprin's group) found the site with her boyfriend, who knew the filmmaker Bill Heick. Exploring the site's mammoth structure, they became intrigued with the possibilities. The next weekend, Halprin and five of her dancers (including Leistiko and Forti), as well as the film crew, returned to the building site. Regarding the final seven-minute film, Ross describes the interchange between bodies and I beams. "Crouching, reaching, gesturing both toward the hangar and, in geometrical semiphoric arm movements, away from it, Ann and her five dancers start to echo in their bodies and their actions the visual rhythms of the three-story orange steel skeleton of the hangar. 'Reading' the hangar as if it were the 'score' for their improvisation, they seem to be communicating with the hangar in full-body sign language."[17] Black-and-white photos of the dance show the dancers dwarfed by the massive structure, their bodies sometime receding into the shadows cast by the afternoon sun. Although Forti mentioned in her interview with Ross that she didn't like doing the piece and thought it was dangerous, it does set an interesting precedent for some of the Dance Constructions that Forti would later craft—on a much more human scale.

For Forti at this time, the task-based functional movement and the architectural design focus of that site-specific work was not as kinesthetically appealing as more whimsical approaches to the juxtaposition of images, such as Halprin's 1959 *Trunk Dance*. Performed by Halprin, Forti, Leath, and John Graham (who had trained as an actor and introduced the group to verbal improvisations), this dance theater work was a witty improvisatory romp that incorporated set, unusual costumes, and movement, as well as language. By then, Halprin and her group, San Francisco Dancers' Workshop (SFDW), had begun to include spontaneous interactions with spoken words. The addition of costume and text, although used randomly, opened a whole world of narrative associations and cultural connotations that incorporated social meanings and power dynamics within a more abstract move-

ment vocabulary. The unpredictability of the evolving improvisation set the stage for odd and often comic juxtapositions. Forti has always been fond of what she calls "good nonsense" or non sequiturs. Of this time, she recalls: "And I think the more something would slightly unhinge our mind or unhinge the minds the more delightful it was" (1994, 24). She likens this layering to the collage aesthetic of Dada or Surrealism but adds that SFDW's work did not have the morbid edge one so often finds in that work. Memorably, she declares. "We were California kids. It was sort of surfer surrealism" (1994, 25).

In a typed manuscript entitled "The Nez Plays," Forti describes the different elements that are layered in this kind of an improvisation, including proprioceptive awareness, kinesthetic impulse, environmental setting, and narrative possibility. Interestingly, she uses the term "unfolding" to acknowledge the ongoing development that is *enacted* but not *directed* within an improvisation. "Concentration is the becoming attuned to the enmeshed interplay of all these elements so that they might be allowed to interact in an unfolding"[18] Nez is Zen spelled backwards. It encompasses the focused attention of Zen within the random chaos of theatrical improvisation. In her 2003 collection of writings *Oh, Tongue*, Forti explains:

> I called it doing the Nez plays. It wasn't Zen but it seemed related to Zen in the frame of mind that was required in its continuously becoming conceptually unhinged. The kinetic, gestural, and verbal impulses would go like skipping stones on the surface tension of the mind till one struck at such an irresistibly absurd angle and you knew "That's it." And you did it. You chose that impulse in the midst of all the other crystallizing and vanishing absurdities. (2003b, 116)

Although this short manifesto-like manuscript begins in a distant, scientific voice ("The human structure . . ."), the third paragraph reverts to a personal "I" that evokes the rhythm of Forti's life at the time. "My world takes its appearance from my constant shifting of focus and becomes an overlapping of different worlds of meaning existing in the same space."[19] Forti's interest in this "unfolding," "overlap-

ping," or "juxtaposition" of images is certainly what attracted her to the Happenings in NYC, most particularly the early work of Robert Whitman. Rather than a passing phase whose influence dissolved as Forti matured and moved from the West to the East Coast, this multifaceted training in somatic awareness, image juxtaposition, and brilliant comic timing would continue to be a trademark of Forti's performing, most especially when she returned to using language again twenty years later.

In addition to working with Halprin, Forti facilitated with Morris a weekly gathering of artists to explore interdisciplinary approaches to movement and live action. In an interview with Lauren O'Neill-Butler in *Artforum*, Morris explains its genesis. "I became involved with Simone in setting up a workshop in San Francisco to explore areas of performance and dance we both felt were ignored by Halprin. We met with a small group of dancers, painters, musicians, and poets on Sunday evenings where we experimented with sound, light, language, and movement in a workshop situation."[20] Each week a different artist would lead the session, proposing a question or an area for the group to explore. This was art practice as research, a model for venturing into new conceptual territory that Forti would draw on for years to come.

At the same time, Morris was becoming more and more interested in radically disrupting the conventional focus of painting as an object displayed on the walls of art museums. Aware of Halprin's interest in deconstructing the proscenium stage as the honored venue for dance performances, Morris made a similar intervention in visual art, blurring the distinctions between the process of making a work and the end product. Incorporating live action (and live bodies) refused the idealization of a final static art object and highlighted the ephemeral conditions of its construction. Even before he officially stopped painting, Morris was exploring the texture and weight of paint, playing with physical gesture and gravity as part of the work itself. Both Forti and Morris felt the need to strip away layers of aesthetic stylization to focus on functional movement at a very basic level. They wanted to do more with less.

Forti and Morris moved to NYC in 1959. Morris stopped painting and instead immersed himself in reading (and writing) critical theory, eventually completing a master's thesis at Hunter College in 1966. The appetite for improvisation that drew Forti to Halprin's teaching style was missing in NYC dance classes. Indeed, it was the lack of engagement in one's own movement research that disappointed Forti about the dance technique classes available there. She once exclaimed with more than a hint of exasperation: "Martha Graham did her research, Merce Cunningham did his research; but you didn't get to do research in classes. I'm not an instrumentalist; I'm a composer." [21] At first, Forti shared a studio with dancers Nancy Meehan and Rainer. The three young women would get together and improvise, although Forti was less interested in working with technical skills than the other two.

In her memoir *Feelings Are Facts: A Life*, Rainer quotes a 1961 letter to her brother, Ian, in which she describes a strong-willed Forti who couldn't abide being told to hold her stomach in or how to move. "Simone will have none of this nonsense. She has no patience with technique building, with the daily drudgery of the dancer. She demands of herself that all movement have an immediate and highly personal and unique character, and she resents having to adapt to the movement directions of anyone else, even for the duration of a class. Strong head, that one." [22] Steve Paxton also remembers that Forti was particularly fierce about her interests and needs at this time, describing her as "argumentative and opinionated, especially in the early days—[she] just wasn't going to put up with any East Coast hierarchy"). In a written reminiscence published in the Museum der Moderne Salzburg retrospective catalog *Simone Forti: Thinking with the Body*, Paxton mentions seeing Forti after a Cunningham class. "I saw her on her hands and knees. She was crawling. I was curious, marked the moment: was she returning to basics, the roots of movement?" [23] Paxton's intuition was correct; Forti was returning to basics, compelled by a desire to connect with her own gravity and weight. She wanted to strip away the theatrical trimmings of dancing to find a clear, functional purpose for her movement.

Although this aesthetic position came to be defined as a minimalist

sensibility, it was really connected to fulfilling an emotional need to understand who she was. Forti speaks of how she was depressed some of the time in those days and how using the physical strength in her arms to push against something often made her feel better. Similarly, when Forti talks about the impact of seeing Eadweard Muybridge's serial photographs of human or animal movement, she underlines her "need" to feel that resistance in her body. In her notes for the MoMA acquisition, she writes: "The man, his movement, made sense and there was beauty to it. I made the dance constructions out of the need to feel things as simple and basic as the gravitational pull between my mass and the rest of the earth, or a need to push and pull and climb." [24]

In discussing her artistic transition from San Francisco to NYC, Forti also highlights the influence of the Gutai group, a Japanese avant-garde collective that brought performative actions into art installations and brought these experiences out into open, public spaces. Forti was particularly struck by photos of Saburo Murakami's 1956 work *Passage*. Staged as part of the second Gutai Art Exhibition, this piece comprised a series of large paper sheets stretched across rectangular frames. Murakami blasted through them one after the other, fracturing the complacency of the canvas by leaving the shards of his action in the ripped paper remnants. In her first oral history Forti remembers their impact on her.

> So one photograph I remember was a series of paper stretched on frames, like paper doors, let's say, set up out in the woods or outside somewhere, one after the other. And the action was to walk through that series, breaking one, breaking the next, breaking the next, breaking the next. And it really contrasted to improvisation which was made up of one kind of movement quality after another and another. (1994, 32)

Although she still enjoyed the adrenaline rush of dance classes, Forti felt the need to simplify her compositional palette and spent time alone in the studio working with stillness and the placement of objects in space. Forti recalls: "I'd sit in one place. And I had a roll of toilet paper somewhere else and I had a shoe somewhere else and

a chair somewhere else. And I'd go sit somewhere else and I'd move the toilet paper to another spot" (1994, 33). Rainer recalls witnessing this Zen-like meditative practice of arranging spatial environments.

> Around this time I saw Simone do an improvisation in our studio that affected me deeply. She scattered bits and pieces of rags and wood around the floor, landscape-like. Then she simply sat in one place for a while, occasionally changed her position or moved to another place. I don't know what her intent was, but for me what she did brought the god-like image of the dancer down to human scale more effectively than anything I had seen. It was a beautiful alternative to the heroic posturing that I felt continued to dominate my dance training.[25]

In this oft-quoted passage, Rainer focuses on Forti's role as a "dancer"—that heroic figure on stage. But to my mind, Forti was doing more than bringing the dancer down to earth, she was drawing on her years of moving on Halprin's deck in the woods to merge her body into the larger environment, albeit that of a downtown loft. Forti chose her stillness as a meditation that opened perception—a way of witnessing a world. Her presence was striking for Rainer because she was *inhabiting* the space rather than dancing in it.

In a short essay published later in her career, Forti hints at another kind of teacher in the evolution of her research into creating a landscape with objects and physical stillness. "I've watched my cat choose her placements in space with an uncanny sense of elegance. In fact, it was in collaboration with her that I first began working on a study called Doing-being, which consists of positioning in space, and the timing of the re-positioning" (1984, 12). There is a wonderfully Zen-like attitude in these scenes of Forti sitting and arranging her environment. The witnessing of one's presence as part of a larger whole combined with the ability to concentrate on one simple task suggest that Forti understood the interpenetration of mobility and stability, change and repetition with a level of sophistication unusual for a twenty-five-year-old. That sensibility primed her for the teachings of John Cage as they were translated in the classes of Robert Ellis Dunn.

Invited by Cage to teach a dance composition course at the Merce Cunningham Studio in Westbeth, New York, in the fall of 1960, Dunn initiated a series of workshops that transposed some of Cage's scores and ideas and presented them to a group of dance artists, including Forti. Dunn had studied music theory and composition at the New England Conservatory in Boston. He also taught accompaniment for dance at the Boston Conservatory of Music where he met and worked with Cunningham. Moving to NYC with his (then) wife, Judith Dunn (who joined the Cunningham company), Dunn enrolled in Cage's New School course entitled Experimental Composition. For Cage, teaching was about making yourself available and opening possibilities for the class to explore together. His students remember receiving the gift of permission to experiment. Like Cage, Dunn encouraged students to engage in their own research. He gave them compositional problems (such as one based on the metrical structure of an Erik Satie piece) and introduced them to Cage's score *Imperfections Overlay.*

Forti was impressed by this indeterminate structure that presented a bridge between free-form improvisation and total control of the outcome. In *Handbook in Motion* she reflects, "In retrospect, I find that "Imperfections Overlay", [*sic*] with its graph, was my first exposure to a still point of reference that gives a footing for a precise relationship to indeterminate systems. I had the feeling that the resultant piece would be a kind of ghost or trace of all the elements involved, including the original sheets of paper, and the air currents through which the plastic sheet had glided" (1974, 36). Dunn proposed that the members of the class focus on describing and analyzing what they saw rather than evaluate it. Freed from (self) critique, everyone made lots of work, eventually showing some of it to the public. Forti describes feeling as if she had finally found a community of like-minded artists in NYC.

Dunn's classes offered a very different model of artistic inspiration in dance. Unlike the mystical light emanating from Isadora Duncan's solar plexus as she stood alone in her studio (which had a powerful influence on the ideology of a unique and original choreographic voice

in modern dance), Dunn taught his students not to be precious about their output. He famously instructed them to make a three-minute piece and not spend more than three minutes on creating it. In order to fulfill this assignment, Forti realized she had to be clear about both the concept and the process through which that idea would materialize. In *Handbook in Motion*, she sums up the impact of this new way of working. "Realizing that one could choose the distance between the point of control and the final movement performed, I came to see control as being a matter of placement of an effective act within the interplay of many forces, and of the selection of effective vantage points. This made me start trying to take precise readings of points of control I was using, and wanted to use, and to what effect" (1974, 36). Inspired by the possibilities of providing instructions without dictating the outcome, Forti began conceiving of game-like structures for movement.

When discussing this period of her life in interviews, Forti will open her arms wide and then bring her hands together, clasping them in front of her chest. One hand represents her beginnings with Halprin and their forays into improvisational performance, including props and language. The other hand is her work inspired by Dunn's course. Forti affirms that both influences are critical to her artistic career, suggesting that they merged in her oeuvre. And yet, there were distinct tensions between these two visions. In her interview with La Rocco, Forti sums up the differences. "Anna's work was more expressionistic—in a kind of abstract expressionistic way. It was a lot about the heart opening, whereas in Dunn's class it was about the mind getting a little blown and tickled."[26] Forti was not alone in getting her mind "blown." As well as the colleagues who performed in Forti's early work, such as Marni Mahaffey, Paxton, Rainer, and Ruth Allphon, Dunn's classes included David Gordon, Brown, and Deborah Hay, all people who would soon become part of Judson Dance Theater. Then, too, there was the exciting energy bubbling around the Cage/Cunningham cohort, including composers such as David Tudor, Christian Wolff, and Young and artists such as Robert Rauschenberg and Jasper Johns. In her book *Greenwich Village 1963*, Sally

Banes writes of how these artists created a "village" in the city, their informal bonds providing networks that led to all kinds of interesting interdisciplinary collaborations. She sums up this open, adventurous sensibility: "art was seen as a social space that united work and play to produce freedom"[27] This was also a time when downtown artists were experimenting with new forms and finding new venues to show their work.

Ever since the independent "Ninth Street Show" in May 1951, downtown artists have been renting spaces and curating shows of their own and their colleagues' work. In the prologue to her fascinating and massive 2019 tome *Ninth Street Women: Lee Krasner, Elaine de Kooning, Grace Hartigan, Joan Mitchell, and Helen Frankenthaler: Five Painters and the Movement That Changed Modern Art*, Mary Gabriel tells the story of that ground-breaking event. This was a moment when a group of visual artists decided to produce their own show instead of waiting to be invited by the uptown museums and galleries that seemed to have a monopoly on the art world. This defiant act of renting their own venue (albeit temporarily) and curating a massive collection of new American art was a natural extension of the comradery forged by informal gatherings in the Greenwich Village neighborhood where they lived. For Gabriel, what was significant about this situation was the fact that women artists were shown, some for the first time. Besides the paintings of artists such as Franz Kline, Robert Motherwell, Rauschenberg, Willem de Kooning, and Jackson Pollock, there were those of Lee Krasner, Helen Frankenthaler, Grace Hartigan, Elaine de Kooning, and Joan Mitchell. When Forti and Morris moved to NYC at the end of the 1950s, this same spirit of cooperation thrived in these downtown spaces, but now they extended to SoHo and the East Village. What was different in the 1960s was the intense cross-fertilization between artists of all stripes, including musicians, dancers, and poets, as well as visual artists.

Looking back decades later, Forti tells Dorit Cypis, a fellow artist and colleague from her Nova Scotia days:

We weren't necessarily collaborating but we were informed by each other's practices and we were sitting in bars together and having parties together. It was more about working with the urgency of ideas and using whatever materials were at hand—whether it was your own body or a piece of rope. As a dancer it would come naturally to me—I want to climb up a hill—okay, lean a board on the wall and you've got an incline. This became "The Slant Board." In fact, I was really hungry to be climbing. Another Dance Construction was "The Huddle," where 8 or 9 people clumped together like a small mountain, taking turns climbing over the top. The mass of people always stayed coherent as one form and the audience could move around viewing it from different angles.[28]

At this point in her life, Forti thought of herself as an artist, working with many of the same concerns as other artists, even though movement was her chosen medium. Through the connections to other artists working downtown, Forti was invited to share an evening with Claes Oldenburg and Jim Dine at the Reuben Gallery, the site of Allan Kaprow's seminal *18 Happenings in 6 Parts*. Six months later, she would have a concert of her own work at Yoko Ono's loft in a series curated by Young.

From December 16 through 18, 1960, Simone Forti (then Morris) presented two pieces—*Rollers* and *See-Saw*—as part of a "varieties" series at the Reuben Gallery. Dine and Oldenburg presented, too, but Forti was the only woman to show work in that season of Happenings and assorted events at the Reuben. Forti had just finished an intensive stint performing in Whitman's *The American Moon,* which ran in the same space November 29–December 7. The event was billed as "the second of the NEW HAPPENINGS series," and the flyer for *The American Moon* includes an announcement of the "VARIETIES" showcase, advertised as "short pieces by member artists." Forti built her two contributions to this showcase from the methods she had been working with in Dunn's class. The works were ideas, roughly sketched

Reconstruction of *Rollers* (1960) in Salzburg, Austria, 2014. Photo by Rainer Iglar. Part of the retrospective exhibition *Simone Forti: Thinking with the Body*. Courtesy of the Museum der Moderne Salzburg.

in, and she had minimal rehearsals before the pieces were performed before a small but enthusiastic audience. (Forti would be suspicious of their clapping since she felt that they were a very insider crowd who liked her work because it was associated with certain important artists such as Cage and Young.) While many critics place these two works as precursors to her Dance Constructions staged the following spring, I am interested in how they can be considered a bridge between various interests, including the frisson of danger that appealed to her in Whitman's work. In a letter to Halprin, Forti talks about Whitman's *The American Moon*, writing, "It'll take many pages of writing to describe it but I think it's changed me more than any dancing I've experienced here."[29]

Both *Rollers* and *See-Saw*, which Forti presented into this century,

take inspiration from playground activities of children, albeit with an edge of adult mania. In this performance, *Rollers* featured Forti and Patty Mucha sitting in wooden carts mounted on swivel wheels with ropes attached to three sides. They were pulled around by selected audience members who quickly became exuberant about the possibilities of momentum as they swung the carts around the small space. In what she calls "instructions" for *Rollers*, published in *Handbook in Motion*, Forti explains: "The three ropes fastened to the boxes seem to create a situation of instability, and in no time the boxes are careening wildly. For the singers in the boxes, this produces an excitement bordering on fear, which automatically becomes an element in their performance" (1974, 44). Writing to Halprin, Forti described the various comments she got from the audience, including a suggestion that the piece be viewed from above. The fact that folks were giving her feedback like this hints at the informality of these events, more like a showing of works in progress than an intentional statement of an aesthetic platform.

Rollers was followed by *See-Saw*. Forti's knees were bothering her at the time (possibly from performing in *The American Moon*), and she limited her participation to running the lights and a final cameo appearance singing what she called a desert song. Performed by Morris and Rainer, this duet on a seesaw was an inherently theatrical piece, and it was performed with the audience on one side. Forti often likens her other Dance Constructions to sculptures and encourages the audience to walk around them while they are being enacted. However, in this piece the elastics that were attached to the seesaw's wooden plank and the adjacent walls foreclosed that possibility, and the audience watched in place.

At twenty minutes, *See-Saw* was twice as long as Forti's other Dance Constructions. Despite Rainer's and Morris's theoretical attachment to pedestrian or task-based activities, neither of them was what one might call a "neutral" performer. They both had a performative intensity and a sense of theatrical presence, and it is likely that the audience read the work as being about an emotional relationship. Forti herself talks about the piece as "reflecting domestic life," and

until the twenty-first century it was traditionally performed by a man and a woman. The theatricality is confirmed by Rainer's recollection of what she called the "climax" of the piece. "The piece had a climax, the outcome in rehearsal of Simone's throwing a jacket on the floor and ordering me to 'perform that!' at which I had a screaming fit on my end of the seesaw (don't ask why) while Bob read an art magazine to himself at his end."[30]

In *Handbook in Motion*, Forti gives minimal instructions for most of her Dance Constructions in one paragraph. However, she devotes two pages and three photographs to *See-Saw* (which was reprised in her spring 1961 concert). The first paragraph outlines the structural elements of the set; the second describes the piece as it was performed by Rainer and Morris. Morris enters in a black trench coat carrying a long plank with which to build the simple seesaw structure. Rainer then enters, also in a black coat. They take off their coats "revealing red sweaters and shorts." In the third paragraph, Forti flips back to a more impersonal tone.

> For a long time they simply see-sawed [*sic*] up and down. Then they did several combinations of movements which shifted the balance. The possibilities are endless, for the whole structure of plank and performers rests on one point, making its equilibrium as sensitive as a pair of scales. Any change in the arrangements of body parts, the slightest change of position by either performer, affects the balance of the entire setup. Holding the see-saw [*sic*] level, or controlling the degree of tilt in either direction, requires a coordination by the two performers of actions of compensating effect on the equilibrium. (1974, 39)

Forti then returns to describing the specific performers:

> A section followed in which Yvonne tossed and turned, throwing herself around and shrieking as she rode the see-saw [*sic*] up and down. Again, during this section, the lights were going off and on. Bob pulled a copy of Art News out of his pocket and read aloud in a monotonous, self-contained voice. Towards the end

the lights stayed on, and Bob and Yvonne stood side by side in the center of the board, their arms around each other's shoulder. They balanced the board by shifting their knees, causing it to balance gently back and forth. (1974, 41–42)

Given the tightness of the community that was present in Ono's loft for Forti's two "varieties," it would be difficult, I imagine, not to believe that *See-Saw* reflected a domestic situation that "hung in the balance" as Forti drifted away from Morris and became increasingly attached to Whitman and his work. Although the Dance Constructions are often referred to as precursors to Minimalist task-based work, it is clear from Forti's description above that these pieces could be read in multiple ways—both as formal structures for action and as environments for human behavior. To Halprin, Forti wrote that *See-Saw* had "the awkwardness of something that is no longer what it used to be but not yet what it's going to be."[31] *See-Saw* was caught in the middle of different compositional impulses—in between playground and stage, humorous and serious, pedestrian and emotional, life and art.

More than fifty years later, as Forti was preparing materials for MoMA's eventual acquisition of her Dance Constructions, she specified that, unlike the other constructions which could be simply taught and restaged, *See-Saw* had to be re-created each time. She even suggested the possibility of working with an outside director. Forti called the instructions a "framework for a theater piece" and noted that the duet "essentially consists of the performers' relationship as they collaborate on anticipating the see-saw's equilibrium."[32] Besides the physical (and emotional) balancing act required by the structure itself, *See-Saw* usually begins with a direct, face-to-face gaze as the two performers mount the wooden plank. In most performances of the work that I have witnessed, the performers hold one another's gaze as they climb on either end, often with smiles in recognition of the need for cooperation. Even if they are not looking directly at one another later in the piece, they still need to be aware of each other as even the slightest adjustment of position or weight can greatly impact the situation.

Simone Forti and Steve Paxton performing *See-Saw* (1960/1969) in the
Festival Danza Volo Musica e Dinamente, Rome. Photo by Claudio Abate.
Courtesy Fabio Sargentini, Archivo l'Attico.

There is a photo of the original 1960 performance of *See-Saw* in
which Rainer and Morris are standing side by side (but facing op-
posite directions) holding hands. Although they are both looking
down, they are clearly focused on proprioception, not vision, atten-
tive to the slightest shift of the other person's weight. Paxton, who
performed *See-Saw* with Forti in Italy in 1969, remembers that the
piece was about the negotiations of balance between two people. But
any implications regarding what that relationship entails are for the
audience to imagine. Interestingly, he distinguishes between drama
(which Forti actively discouraged) and character (which was undeni-
ably suggested, nonetheless) and describes how one can "imply rather
than perform overtly." Paxton also reflected that it was "one of those
spaces where I felt inhibition but no direction."[33] He notes that the
situation in *See-Saw* was all-consuming and required that the dancers
deal with the precarious act of balancing, in which a sudden shift of

weight could send one end of the seesaw to the ground. In photos of the 1969 performance of *See-Saw* at L'Attico gallery in Rome, Paxton and Forti are clearly focused on this play of equilibrium. Their knees are bent, hands out in front to balance as they attempt to keep the seesaw parallel to the ground. Another photo shows them facing one another, holding on with both hands and leaning slightly away from their centers. Forti has one foot behind to stabilize her, but Paxton looks as if he would fall backwards if she were to let go of his hands.

Invited by Young to be part of the spring Chambers Street series, Simone Forti presented her first evening-length concert in NYC on May 26 and 27, 1961. Entitled "Five Dance Constructions and some other things," this performance was a bold move for someone who had only recently turned twenty-six. Many histories of postmodern dance consider Forti's early work seminal to the groundbreaking work of Judson Dance Theater. In these writings, Forti's Dance Constructions are often packaged as a unified series, with short descriptions of each piece that are usually paraphrased from Forti's own writing in *Handbook in Motion*. For this book, I have chosen to discuss these pieces individually and across several chapters, choosing to position them thematically as well as chronologically. Thus, while I analyze *See-Saw*, *Slant Board*, and *Hangers* (and briefly mention *Rollers*) in this chapter, I focus on *Two Sounds*, *Censor*, and *Platforms* within the context of a chapter on Forti's relationship to music and sound. In the final chapter, in considering Forti's artistic legacy, I elaborate on *Huddle*, Forti's favorite Dance Construction and one that has continued to be a part of her teaching and performing throughout her long career.

With this approach, I aim to mitigate what I consider a myopic focus on Forti's relationship to Minimalism through an artworld lens and through the theoretical writing of critics such as Richard Wollheim and artists such as Morris. I take each piece of the Dance Constructions seriously as discreet events that may be related to other events in the same concert but are not simply a bunch of building blocks for one aesthetic stance. Their connection to Minimalist art and anti-narrative postmodern dance had to do with reframing how we look at simple movements and the impact of that kind of witness-

ing on the viewer's body. The works are crafted from sensory experiences of movement, and they are about kinesthetic perception. For instance, Forti recalls that the sensation of using her arms, whether crawling or climbing, helped her feel connected to her weight—helped her, in fact, "get a hold on her life."

In the months leading up to this 1961 concert (which would have a deep impact on her peers in dance and later define much of her legacy), Forti was ambivalent about the whole downtown art scene in general. In her journal entries from that time and in letters to her mentor Halprin, Forti describes feeling lost, a little depressed, and tired of what she believed were separate factions who dismissed the work of folks outside of their clique. Forti may have felt caught between the Morris, Rainer, Dunn conceptual/Minimalist faction and the more impressionistic work of the Happenings folks, particularly the work of Whitman, which she admired and would increasingly support. One journal entry in *Handbook in Motion* reflects this dis-ease:

> No convictions. And yet I go on. Thinking about "art." Why?
> [. . .] Art isn't a physical interest for me any more like it was when
> I was dancing. It's just a role which more or less continues. Yes
> I'll be doing a loft concert. That does interest me. (1974, 52)

Forti remembers her trepidation as she dropped the flyers for the show into the mailbox. Once sent, she realized there would be no backing out, she would have to go through with the concert.

Many of the ideas for Dance Constructions came to her as physical structures to be played upon, and her sketch of the layout of the loft space does suggest an adult playground. Morris helped her build and rig the different sections, and he would later recycle the lumber for his own environment titled *Untitled (Passageway)*, which was staged in June at the same venue. Forti was both excited and somewhat unclear about her aesthetic direction. She was moving away from the open improvisations she did with Halprin but less sure of what kinds of movement potential were enabled by the structures she was envisioning. In another journal entry she writes: "I prefer to see something rather than many things in composition. If there is a composition at all I

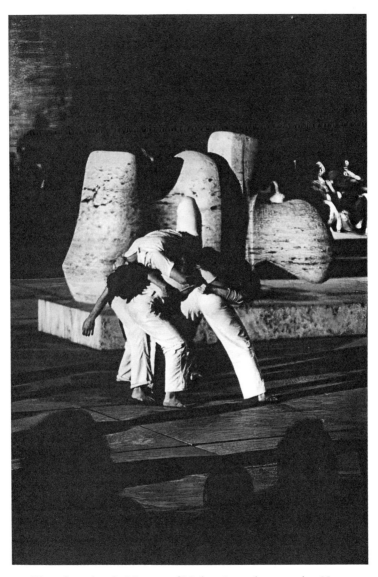

Huddle performed in the Museum of Modern Art sculpture garden, New York City, 1978. Photo by Peter Moore © Northwestern University. Getty Research Institute, Los Angeles (2019.M.23).

prefer to see something happen, some radical change take place in the course of the "piece" rather than to see many varied shiftings" (1974, 53). The experimental work that emerged directed her attention in that satisfyingly singular direction, even if it meant less joyous dancing.

Later in her career, as major art institutions were becoming increasingly interested in her series of Dance Constructions, Forti wrote a longer introduction to these pieces that articulates a clear conceptual basis for the work, retrospectively covering over any awkwardness or insecurity about her fledgling efforts. It was reprinted in *Simone Forti: Thinking with the Body*:

> The Dance Construction create circumstances for direct, non-stylistic action. All except one require some structure that the performers interact with or that supports their action, such as platforms to get under for the piece *Platforms*, or a ramp to climb on for *Slant Board*. In *Huddle*, the performers themselves become the structure they climb on. The pieces tend towards steady state rather than having an arc of development, and they are meant to be placed in space much as sculptures, and more than one can be in the space, happening simultaneously. The supporting structures can have a presence in space even in moments when they are not being performed on.[34]

Frequently, Forti refers to the Dance Constructions as "both dances and sculptures." Her language here owes much to Sally Banes's analysis of Forti's career in her book entitled *Terpsichore in Sneakers: Post-Modern Dance*. Banes was one of the first dance scholars to engage critically with Forti's oeuvre, and her very astute analysis laid the groundwork for subsequent discussions of Forti's work. (Part of the same NYC downtown milieu, Banes performed in Forti's 1976 dance *Planet*.) Of that concert in Ono's loft, Banes writes: "By spreading the locales of the constructions and 'other things' around the loft, Forti both changed the spectator's physical relationship to the dancer and eliminated time-consuming scene changes. The performance became a straightforward presentation of activities, almost as if those activities

were objects, arranged the way objects might be in a gallery, where the spectator is free to move closer or farther away."[35] It is true that, compared to the dramatic narratives of modern dance, these works were relatively "straightforward" in their presentation of a pedestrian body and more commonplace activities (no pointed feet or extended arabesques here). And yet, it is very easy to pass over the actual physicality of these works by assuming that we understand what "direct, non stylistic action" looks like or feels like. These are human bodies, after all, and their presence necessarily has an affective impact on the viewer, even if they are not consciously expressing emotions.

The first piece in that famous 1961 concert was *Slant Board*. This Dance Construction took place on an 8-foot by 8-foot square piece of plywood that was positioned against a wall at a 45-degree angle. There were six knotted ropes hanging from the top that the dancers used to climb up, down and across the board. In *Handbook in Motion* Forti specifies that the "movement should not be hurried, but calm, and as continuous as possible" (1974, 56). In her notes for MoMA's acquisition of the Dance Constructions, Forti calls the piece "a study in simply doing." She also comments that the piece plays on the tension between deliberateness and impulse as the performers pass over and under one another on their independent journeys up and down, and back and forth across the slope, where "compositions emerge by chance, in a sense, framed against the wooden plane."

Usually performed with three or four people, this piece should last ten minutes, but sometimes it lasts for less time because it is quite strenuous to perform.[36] Bending at the elbow and using one's biceps to hold on to the ropes is very tiring. Dancers need the relief offered by extending their arms and leaning away from the board, using their weight as a counterbalance. For instance, in a photo from a 1968 performance of *Slant Board* at L'Attico, Forti is pictured leaning away from the board, holding onto the rope across her shoulder such that her back is straight, and it is her alignment, not her arm muscles, that holds her upright. Similarly, one can use the rope around one's waist to support a resting position. In this respect, it is interesting

to compare several reconstructions of *Slant Board* to see just how important some physical awareness of the balance of muscular effort and structural alignment is for surviving this work.

In the ArtPix video of the 2004 show at the Geffen Contemporary at MOCA (released in 2009) for instance, several of the performers become quickly tired because they are always moving up and down by pulling the rope towards them, rarely allowing their arms to extend. When *Slant Board* was performed as part of Forti's solo exhibition "Here It Comes" at Vleeshal Markt and Vleeshal Zusterstraat in Middelburg, the Netherlands (2016), the three performers were much more adept at leaning out against the ropes, frequently using their whole bodies to jut out at an angle. Visually, this action looks stunning, and physically it is much easier to hold for a while. In addition, these pauses allowed the three performers to coordinate their positions, and the shifts of timing between moving and pausing became another element in the structured play of the piece. Similarly, in the 2023 exhibition at the Museum of Contemporary Art in LA (MOCA), one group of three *Slant Board* performers was truly tuned into one another, and they would find interesting moments to sustain their stillness. This kind of crafting from within the ongoing improvisation is what makes these works visually compelling.

Remembering the impact of those 1961 performances in which he participated in both *Slant Board* and *Huddle* among "other things," Paxton notes the "shock" of being in such a "metaphor-free zone." They were not told how to perform but rather simply given instructions for what to do. And yet, in a 1982 article in *Contact Quarterly*, Paxton also recalls:

> Simone told us (the initial cast) that she worked hard to have an idea and wanted to see those thoughts without other people's ideas mixing in. One might imagine that *Slant Board* was foolproof, but Simone's remark indicates that we were goofing on her material. The effect of Simone's remark had been to make me eager to work with her idea and not my own. But upon the slant board or in the fountain of people, I noticed I was constantly

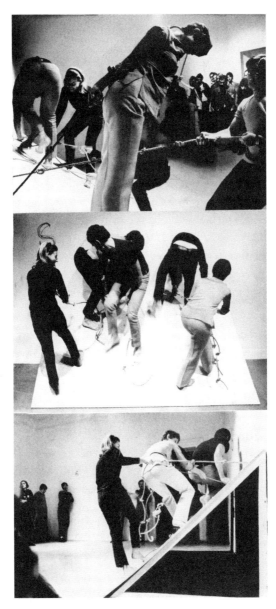

Slant Board performed at Galleria l'Attico, Rome, 1968.
Courtesy of Fabio Sargentini, Archivo l'Attico.

making choices. [. . .] Someone began to move, and soon we were involved in making choice after choice, each choice amplified by the sense of will which accompanied it. Continuity was a choice. Stopping was a choice. Each interaction with another performer was a combination of choices.[37]

What Paxton called "absorption-in-process" answered the question of *how* to perform. For *Slant Board*, at least, that absorption has a lot to do with the physical stamina required to continue for ten minutes.

Other Dance Constructions used twine rope to stage movement activities, *Accompaniment for La Monte's "Two sounds" and La Monte's "Two sounds"* (which I will talk about in detail in the chapter entitled "Tuning") and *Hangers*. In *Handbook in Motion*, Forti describes *Hangers* in rather dry terms:

Five ropes are required, each tied to form a long loop hanging from the ceiling to within a foot of the floor. Hanging in each rope stands a person. [. . .] the hangers are instructed simply to stand passively. There are four "walkers" who are instructed to walk, weaving in and out among the hangers, and among each other. (1974, 61)

For the 2015 official acquisition by MoMA, Forti reduced the number of ropes to three, specifying that they should be situated in a triangular arrangement. She also describes the quality of the piece and the performers' attitude. "This is a rather serene piece, with the hangers simply offering their weight and mass while the walkers amble around, brushing their way through the spaces between the hangers and between each other. An important element of the piece is the performers' alert, pedestrian presence."[38] Unlike *Slant Board*, which is so physically demanding, *Hangers* is more psychologically demanding. It requires that one find the right mix of serene and alert. This is not an easy task, as there is a tendency for the performers to appear zoned out, moving or standing like automatons rather than being meditative, their facial expressions blank rather than neutral. Staying present and available to being witnessed while attending to the small

movements of your body in response to the jostling of people moving around you is a real somatic skill, belying the notion that "untrained" dancers can accomplish this work without a significant introduction to the experience.

In her notes concerning the teaching of Forti's Dance Constructions, Sarah Swenson (MoMA's project coordinator for reconstructions) discusses the need for a lot of rehearsal time and in-person instruction, not only written instructions or directives via video or Zoom. She further details the physical and mental discipline required. "It is an intense process of educating, not only in the physical education of the works, but the mental focus required to perform them, the particular energy of each [piece], and about Simone's attitude and thinking about them, as well as further education about Simone as an artist and her revolutionary contribution to the dance and visual art worlds. I make it a point to convey that they, the people, are the art." [39] In terms of teaching *Hangers*, Swenson discusses how this piece came out of a period of depression and its impulse was Forti's need to "just hang and exist as a mass." Swenson notes that it is important for the performers to be both internally-focused on their own experiences and yet still be open to being observed by the audience and aware of one another. She also mentions the obvious connotations of the ropes in *Hangers* to hanging oneself, an implication that Forti might be less willing to consider.

Having looked at archival photographs from the 1960s, as well as more contemporary images and videos of reconstructions of the piece, I believe that of all the Dance Constructions, *Hangers* has the most variation in performers' approaches to the experience. There are casts who seem to understand the expansive quality of near stillness, the need to release into the support of the rope and feel the slight variations of shifts of weight. This is hanging as liminal—a suspension of time and space. Other casts (and this could also be a question of maturity as performers) seem more checked out, existing in a daze or seeming to circle around aimlessly. One photo from the 1968 performance at L'Attico shows everyday people standing in the ropes. It is striking to me that their expressions (at least the ones we

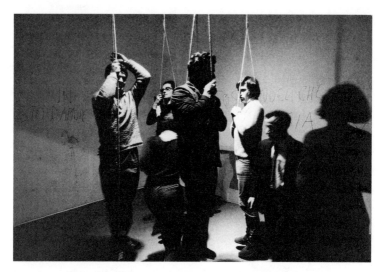

Hangers performed at Galleria l'Attico, Rome, 1968. Courtesy of Fabio Sargentini, Archivo l'Attico.

can see) really do look serene. The woman in back with glasses looks beautifully relaxed, while the younger man to the right seems to be perfectly content to be literally hanging out.

A younger cast of dance students who reconstructed the work at the Centre national de la danse in Paris, meanwhile, struggled with this aspect of the work. The 2015 video of that showing lasts less than three minutes, and by the end everyone looks as though they are going through the motions without feeling their weight or movement anymore. One reason may be that, in this reconstruction, the three ropes were hung quite close together, and there was a lot of jostling as the walkers squeezed through the small openings and circled tightly around the small space. One could contrast this with an image from the 2014 reconstructions by students from the Salzburg Experimental Academy of Dance who were part of the Museum der Moderne Salzburg retrospective. There, the ropes were hung right next to a wall of windows looking out to the park. The photograph of *Hangers*, with the natural daylight shining in, looks like a landscape in which the hangers are suspended versions of the trees visible outside.

Reconstruction of *Hangers* (1961) in Salzburg, Austria, 2014. Photo by Rainer Iglar. Part of the retrospective exhibition *Simone Forti: Thinking with the Body*. Courtesy of the Museum der Moderne Salzburg.

For her 2023 retrospective at MOCA, Forti was able to be present for the teaching of this work, together with Swenson and Carmela Hermann Dietrich (official MoMA teachers of the Dance Constructions). After watching earlier run-throughs of *Hangers*, Forti changed the instruction for the walkers. Rather than turn one's shoulders to slide between the people hanging, she suggested that they keep going broadside, such that the walkers would frequently push into the hangers, making them swing out with much more momentum. The hangers would then sometimes hit a walker as they swung back. The whole dynamic of the piece changed in these cases. It was quite exciting to see how these scores, although now owned by a museum, were not static museum pieces but rather living demonstrations of Forti's creative impulse that keeps seeing new possibilities, even in work she made six decades ago.

Interestingly, Forti acknowledges that the meaning of these pieces can change, depending on the context. In a 1981 interview with Meg Cottam for the Judson project produced by Bennington College, she draws parallels between a game of billiards and her instructions for various Dance Constructions. Forti describes how the ball moves according to the force and momentum of the initial hit and suggests that one can initiate the play but not really control the outcome. Similarly, she adds, "you give the instruction, then it goes . . . according to the instructions, according to the nature of the people, according to the nature of the space, according to the time in history and the kind of framework the people have in themselves, the framework you've given."[40] Given the six decades between the original Dance Constructions in Ono's Chambers Street loft and their twenty-first-century reconstructions, it seems important to recognize that these pieces will necessarily need to be responsive to shifting cultural contexts and embodied meanings.

At the time of their premier, Forti's Dance Constructions were experienced as catalysts for later experiments in task-based postmodern dance. Paxton refers to Forti's 1961 concert as "a pebble tossed into a large, still, and complacent pond" and adds: "The ripples radiated."[41]

Rainer also considered Forti's work galvanizing but notes, "Yet it seemed that a vacuum sealed that evening for over a year until her performers could get the Judson Dance Theater up and running."[42] The vacuum that Rainer mentions intrigues me: Why didn't Forti continue in this vein?

In *Handbook in Motion*, Forti simply says that she shifted gears to become a wife, homemaker, and helper to her new husband, Whitman. But her journals reveal a deeper ambivalence about a burgeoning art scene in which people were becoming increasingly intent on staking out artistic territories and professional reputations. In a telling page of an early journal, Forti fills the page with the words "pride" or "proudly," occasionally crossing out and rewriting words, such as "pride ——— and fragmentation" and "a world focused more on pride than happiness" (14N). On the following, mostly blank page, she pens cryptically, "caged in the loneliness in an insular self-image." Later in this journal, Forti makes a distinction between the dancing she loves and the Dance Constructions she made and (for a while) left behind. "Perhaps I've shyed [*sic*] away from the pieces because they always come with that acrid smell that in high school used to warn me that I was about to raise my hand to set everyone straight on the issue in question" (14N).

It strikes me that discussions of Forti's oeuvre rarely explore her experiences working with Whitman's multidisciplinary performances or Happenings. Art historian Liz Kotz concurs when she writes: "In our historical desire to align Forti with Minimalism, art historians have almost systematically neglected Forti's entanglement with the emotive, imagistic, and even animistic aspects of Whitman's work. Yet these qualities are integral to her aesthetic."[43] In a memorable and witty comment in the 1990 Talking Dance Project interview with Banes,[44] Forti compares Judson Dance Theater to a dry martini, noting that its aesthetic was cool and cerebral. Happenings, on the other hand, she calls imagistic, more concerned with poetry and heart, and "sweeter, like a tobacco that was more aromatic." In choosing to spend the next five years of her life assisting Whitman in constructing his

visual spectacles, Forti thus chose to follow her senses, leaving her conceptual pieces behind and entering a world of image and wonder constructed with an often rudimentary, do-it-yourself sensibility.

Whitman's *The American Moon* ran from November 29 through December 4, 1960, at the Reuben Gallery. It was the first work of Whitman's in which Forti performed, and it took place less than two weeks before the "VARIETIES" showcase in which she premiered *Rollers* and *See-Saw*. In June, Forti had seen Whitman's *E.G. (An Opera)* at the Reuben and had approached him, mentioning that she had done similar work in California. She was enthralled by the mixture of formal tasks and illusion and offered to help him in a future project. In a letter to Halprin, Forti wrote that she felt "very related" to Whitman's work and noted that his *The American Moon* "changed me more than any dancing I've experienced here."[45] Whitman's aesthetic of collaging surreal figures with non-stylized movement must have appealed to what Forti called the "Nez" (slightly unhinged) sensibility that she loved in Halprin's work. But she also responded to the edge of danger and surprise in his pieces. In her first oral history, Forti mentions slam dancing as a physical parallel to Nez, although she notes that it seems more "serious" than the playful slamming around that animated the Happenings. She adds:

> [I]t wasn't about hurting yourself. It was more about scaring your mom. But it wasn't even. More about seeing fireworks maybe. That kind of excitement. Only being the fireworks. It was positive. Although maybe it did—people would argue—maybe it did have an edge of danger. But kids approach danger with enthusiasm. (1994, 49)

Forti, who was twenty-five in 1960, enjoyed throwing her body around in space. Earlier in the oral history she compares her body to clay and speaks about how she liked flinging it across the room. Whitman also thrilled to that edge of abandon and risk. Talking about his work at that time retrospectively, he claims: "I wanted something physical, almost painful, passionate . . . it had to look threatening, menacing."[46]

Whitman's *The American Moon* is also the first piece that he documented with film so that he could reconstruct the work, and it is that film followed by clips of interviews with his collaborators that helps to flesh out written descriptions of the work.[47] Even though the term was not used widely at the time, I would call *The American Moon* immersive theater—a situation in which the viewer was plunged into another world that was not only visual but also haptic. At the beginning of the piece, cast members led the audience into six separate viewing bays (sometimes called caves) set up like mini screening rooms positioned like spokes of a wheel leading away from a central hub. The performing area was visible through a plastic sheet that functioned as a membrane separating the audience from the center. With white pieces of paper attached, the membrane served as a patchwork screen for a film that was projected separately in each bay. (In her recollections, Forti pointed out how hard it was to find six projectors at that time.) The audience was able to see both a film of creatures roaming through the woods and the same mythical figures moving in the center. This kind of transposing of time and place across two realms was typical of Whitman's approach to mixing mediums. Eventually, the plastic sheets were pulled away so that the audience could see one another and the fantastical figures parading between them. Towards the end of the performance, the audience was gathered in the center of the space, and the top of the enclosure was removed to reveal a man (artist Lucas Samaras) on a swing just above their heads.

One of the moments in the performance that Forti remembers fondly took place in the center arena. Whitman rolled like a log across the floor from one side, and Forti rolled across from the opposite side. When the two bodies met, Forti rolled smoothly over Whitman and kept going; he finished his trajectory, too. They repeated this maneuver several times before they both stopped in a low plank pose, supporting their bodies on their toes and forearms. Then they popped around the floor in little increments. Forti recalls that the instructions were to "heap around," and she compares their movement to that of water striders on the surface of a pond. This moment is intriguing to

me as rolling across the floor and leaping are very strenuous, full-body motions, and yet they were done in slightly formal wear: Whitman in a sports jacket and Forti in a sweater and skirt.

This uncommon movement done in everyday clothing was juxtaposed with the wild, almost mythical figures that paraded around and the bundles of cloth that swung from ropes throughout the performance. Dressed in layers and layers of cloth, the surreal creatures wavered between friendly and threatening as they loomed throughout the space. In his very precise textual documentation of *The American Moon* published in the 1966 anthology *Happenings*, Michael Kirby notes: "The piles of cloth on the floor became animated and rose as three separate figures. Moving about the central space and into the openings of the tunnels, the three figures could be surmised to be costumed performers, but their shapes and movement were decidedly nonhuman."[48] There was definitely a ritualistic element to this work, almost as if the audience were undergoing a rite of passage together. In an essay intriguingly entitled "eating and dreaming: Robert Whitman's 1960s happenings," David Joselit sums up the audience's experience thus: "The price of spectatorship in Whitman's art is digestion *by* rather than *of* the piece."[49]

Whitman has written that he wants his works to be "stories of physical experiences." In *The American Moon*, he staged events that displaced normal time and space, creating an environment that was mythic, dreamlike or, for some spectators, hallucinogenic. Commenting in the *Playback* video, fellow performance creator Claes Oldenberg calls the piece "claustrophobic" and mentions that "Bob had a tendency to increase intimacy by wrapping people in space." Certainly, there is an interesting and critical tension between the fanciful images and the material process of creating them. These otherworldly figures may fly around, but the audience witnesses the pulleys and people off-stage manipulating them, as well. In Whitman's spectacles, the audience sees both the illusion and the mechanics. Photos of the performances reveal just how small these spaces were, with folding chairs set up smack next to the performers. Whitman also loved to hang

curtains and cloth over the audience, enclosing them in a tent-like space until the very end of the show.

Two and a half years later, in March 1963, Whitman produced another evening-length group piece entitled *Flower*. This work was also filmed for documentary purposes, this time in 16-millimeter color. Although Whitman begins the twenty-first century commentary with the caveat that the film wasn't the same as a performance in terms of timing, presence of the audience, etc., this documentation does give us a sense of the kinds of imagery he was working with throughout the piece. Unlike *The American Moon*, the images in *Flower* are patently representational. There is a metaphoric throughline that insistently connects flowers, women, and female sexuality. Forti begins her own remembrances on the 2003 video by acknowledging that "*Flower* has a feminine element, [. . .] going into the dark space, it's womb-like." The first section of the piece is performed in semidarkness, punctuated by bright flashes of light. Some of the imagery is abstract and mysterious, such as the slow rising up to the ceiling of a string of cloths tied together. And yet, there are two events in that first part that comprise an odd mixture of violent and liberatory energies. The first is a vigorous struggle between a man (Walter De Maria) and a woman (Trisha Brown) in which they try to strip off the multiple layers of clothing on the other person. Again, Kirby's textual documentation of the event is useful here.

> Suddenly two people burst out from between the curtains where the simultaneous movie and slides had been shown. Holding on to each other, they spun into the space between the spectators. They were a man and a girl—the man in ordinary street dress with a coat or jacket and the girl in slacks and a bulky sweater—who were pulling furiously at each other. The man was able to yank off the girl's sweater, revealing another one (or a shirt) underneath, and it became apparent that each was simultaneously trying to pull off the other's clothing. Jerked this way and that, perhaps falling, the pair battled, spinning around the space. The floor became littered with sweater and shirts that

had been forcibly removed. Although the man was usually more successful, the girl did not give up her own strenuous attempts to remove his jacket and sweaters; then, without any apparent winner, the pair, who had worked their way back to the front of the room, disappeared through the curtains.[50]

In her comments in the video, Brown said this event was a "simple task" given to the performers, but the result was anything but straightforward. On the one hand, this section is reminiscent of Forti's *From Instructions* score that was part of the "other things" in her 1961 Chambers Street concert. "One man is told that he must lie on the floor during the entire piece. Another is told that he must tie the first man to the wall [. . .] As the men's instructions are conflicting, the result is a physical conflict" (1974, 66). On the other hand, the gender difference in the conflict in *Flower* holds very different connotations. In his discussion of this moment, Joselit suggests that "this action evokes a strong and profoundly unsettling passion, whose charge— whether of love or hate—remains murky."[51] Whitman acknowledges that these are the moments that can be considered "horrifically sexist" but claims that the work was meant to be the opposite, demonstrating, in fact, his esteem for women. Forti insists that "It looks like great fun. They're not hurting each other. It's very energetic."[52] Nonetheless, as even Kirby's documentation attests, there is a power differential operating in this physical struggle.

Another scene follows in this first section of *Flower* that is also unsettling in its resonances of violence against women. In this bit, a man carries first one and then another large bundle out and lays it on the ground. Eventually, the audience becomes aware that there is a head at one end and two legs peeking out of the other end. He then sets the figures on their feet, and they look a bit like life-sized pumpkins. The women remain oddly passive, occasionally hopping like inert bunnies here or there. Then the man comes over and rips open a seam in one woman's big round belly and starts frenetically pulling out crumpled paper. He then goes over to the other woman and does the same. The women's arms are enclosed within the costume and their faces are

immobile. They neither look at the man nor at one another while this is happening. Kirby describes the action in detail:

> [H]e roughly seized the front of one of the pear-shaped costumes and ripped it open. He reached inside, pulled out crumple newspapers, and scattered them on the floor. The girl remained motionless, her face blank. The man crossed to the other girl and tore open the front of her bulging cloth covering. Again he pulled out crumpled newspaper. Faster and faster, he moved back and forth between the two impassive figures, grabbing out armfuls of newspaper, flinging the paper out violently onto the floor, burrowing into the lower recesses of the container and scattering the stuffing in all directions.[53]

Joselit refers to this moment as "a violent and brutally sexualized act of evisceration" and adds: "The impassive expressions of the women, suggesting their alienation from the depredation of their prosthetic bodies, only heightens the illusion of violation."[54] In her comments at the end of the 2003 video, Forti acknowledges the sexual imagery without seeming to recognize the implicit violence of this act. "When the ball girls get torn open, it seemed important that the ball costume had an opening so you could slide hands into it and rip it open. It had a very vaginal kind of quality." A few minutes later, the visceral quality of this violent scene shifts as all the other performers come onstage and start throwing the crumpled papers at one another and into the air like kids enjoying a pillow fight.

Even though the second section of *Flower* was lighter in atmosphere and included a promenade of the flower girls in luxurious satiny dresses, the women still maintained blank, impassive faces, never acknowledging one another even as they passed within inches of each other. The only time these flowers "girls" smiled was at the very end of the performance when they came out from behind a curtain and threw flowers into the audience, as if in a wedding celebration. I am curious about how *Flower* was received by the audience in 1963 and then in 1976 when it was reconstructed for Whitman's retrospective at Dia Art Foundation. Whitman asserts that nobody in the original

audience seemed to feel "personally challenged or threatened."[55] And yet, Paxton, who performed for Whitman on several occasions, notes that Whitman often used performers as objects in a larger visual tableau and suggests that the women's bound and impassive movement quality was similar to that of models on a catwalk, where the viewer has no clue what they are each feeling.[56] Interestingly, Forti considers the first scene, in which the man and the woman have what she calls a "tussle," true to the 1960s women she knew who were feisty and athletic and more equal to men. She considers the second half closer to 1950s glamour. "And as the piece progressed, it goes into this erotic, glamourous, uterine and flower, ending with a white lily, which is like purity, which then gets covered with this black sheet, then covered by the flowered curtain. A lot of curtains hiding the mystery [of female sexuality]."[57]

In the preface to *Happenings and Other Acts* (a republication of Michael Kirby's 1963 anthology), Mariellen Sandford describes the 1960s and how women performers were sexualized, called "girls" (even in Kirby's attempt at an objective description), and often positioned as objects onstage.

> The issues raised by the sexist language shouldn't be swept under the rug. The second-class status of women was an important aspect of that historical period, both in the art world and in society at large. I think it is critical that we maintain an awareness of the situation as it really was in order to keep what came after in historical perspective.[58]

She continues by recognizing how many women performance artists (such as Carolee Schneemann) created work that directly responded to their sexualization and exclusion from the art world. In the 1950s and 1960s, being married to a male artist often meant subjugating one's own career while supporting his. This was certainly true of Forti's relationship with Whitman, which lasted until her early thirties.

I have sometimes wondered whether one of the reasons dance scholars rarely talk about Forti's work with Whitman is that they are basically following her lead presented in *Handbook in Motion*. In this

autobiographical recitation, Forti sums up in one dry paragraph what could only have been an emotional rollercoaster.

> That week of being sick in bed had been a week of being sus-
> pended between two homes. Bob Morris and I had broken up.
> I married Bob Whitman. The elevation tune was the last piece I
> was to do for some time, for my interests turned to being a wife
> and right-hand helper in my husband's theater pieces, and trying
> to have a family. (1974, 71)

In this 1974 story of her artistic career to date, she does not talk much about her work in Whitman's performances nor her later experience in helping to organize the seminal "9 Evenings: Theatre and Engineer-ing" at the 69th Regiment Armory in NYC. Her reticence in talking about her second marriage was due no doubt to layers of personal tragedy and trauma, including a couple of midterm miscarriages and a personal betrayal that hit Forti very hard. Despite the anguish that is evident in her journals ("It's strange. I've gotten over the loss. I can't get over the betrayal.") (60N), Forti rarely blames Whitman for persuading her to leave her own career and help him with his. Even though it ended badly, their marriage started with a real sense of hope and possibility. One 1961 journal entry is dedicated to her position as a "home maker" and repeats "home . . . home . . . a home . . . a home . . ." (49N). In a 2015 interview with me, Forti relates how they connected:

> And he was having a hard time in his marriage, and I was having
> a hard time in my marriage, but it hadn't occurred to me to
> leave, and he started really bombarding me with, you know, if I
> get together with him, we'll be happy, we'll have children, it'll be
> a joyful house. And I, I'm not especially a feminist, I could see
> at that time especially, I could see that maybe I could be happy
> being an artist wife and supporting his work. I loved his work. I
> always had a role in the making of it, and having children, and
> um [*pause*] I, maybe I hadn't realized how much he would want
> me to not do my own work.

Forti has always affirmed that she loved Whitman's theatrical sensibility and learned a lot from working with him, including how to play with the juxtaposition of radically different images that are nonetheless cohesive—a skill that she would use to wonderful effect later in her career.

Although she is deeply proud of being a successful woman artist, Forti is ambivalent about feminism and has always refused to call herself a feminist. She recognizes that the financial support of her family has given her a sense of economic privilege and thus believes that she has never had a "need to become militant" about being an independent woman. In her interview with Forti, La Rocco states that she considers Forti's work from the 1960s as being feminist work, and Forti stridently disagrees. "I don't think so. If you find a certain sensuality and you feel that that's feminine, maybe it was feminine work." Later she asserts: "I'm not so against paternalism," suggesting that there was a time when the home was a "rich, elaborate place" where women "were as influential as the men but in a different realm."[59]

In a 1968 journal entry, when Forti was languishing in Italy and found out that her divorce from Whitman was final, she writes about having to change her name and laments that her only choice is to go back to her maiden name. A telling page from another, later journal entry contains nothing but variations on her signature, written over and over again. The top line begins with the words Simone Forti in cursive, after which come ellipses, then she scripts Simone Morris and then Simone Whitman. Then come a series of her first name written with illegible squiggly marks after them, almost as if she were opening the possibility of other last names and other husbands. In a different style pen (and potentially later in time), she circles Simone Forti several times and scrawls "This is it!" next to her name (16N). In fact, Forti would use her own name professionally from now on, regardless of her marital status. Like many women of her generation, Forti's sense of herself as an artist, a collaborator, and a romantic partner evolved over the decades. In the late 1960s, she writes: "I guess in a sense the main thing I do is to be a woman. And my main

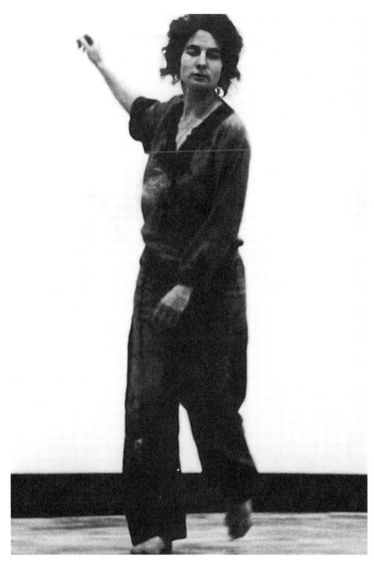

Simone Forti performing *Illuminations* at Galleria l'Attico, Rome, 1972.
Courtesy of Fabio Sargentini, Archivo l'Attico.

joy and work is to be a very special mirror for a man" (60N). By the twenty-first century, Forti had a much more nuanced sense of her own strengths as an artist and a teacher, even as she lamented not having a lover or life partner later in life.

During the summer of 1968, Forti joined her parents for a family trip to Italy and decided to stay in Rome for a while. The physical separation from the NYC art scene, combined with the psychic distance from the emotions associated with the dissolution of her second marriage, gave her the space to reimagine her creative process. "I had decided to try and break out of my loneliness, to get off my ass and see what I could do. [. . .] I was talking about showing my pieces—selling my wares aggressively—demonstrating that I was serious and knew my business" (60N). In Rome, Forti met Fabio Sargentini, a young gallery owner who was deeply interested in experimental art, including arte povera and new approaches to gallery installations. Over the course of many all-night conversations, Forti introduced him to the interdisciplinary work she was involved with in NYC, including the performances that brought visual artists into collaboration with musicians and dancers. The way Sargentini relates it, meeting Forti was one of those extraordinary events that changes the course of one's life. She opened a new world for him, helping him see outside of the narrow definitions of visual art.[60] No longer was his domain as a gallery owner limited to objects that could be viewed aesthetically, arranged thematically, and bought and sold.

Inspired by Forti's narration of the NYC downtown art scene, Sargentini began to incorporate time-based practices and public events within his work as a gallerist. One such event was "Ginnastica Mentale" (mental gymnastics) in which Sargentini installed gym equipment in his gallery and invited the audience to come and participate with the performers. Soon, he acquired a new, massive garage space that could be used for large-scale installations. Forti introduced him to different artists, and together they would curate some of the first experimental music-and-dance festivals that brought American performance artists such as Rainer, Brown, Paxton, Hay, Riley, and Young

to Europe. These included a 1972 festival that featured Brown, Laura Dean, Philip Glass, Joan Jonas, Rainer, and Reich, as well as Forti and Charlemagne Palestine. Working alongside these artists, Sargentini learned all about the mechanics of staging performance—including lighting, movement choreography, and audience placement—an important foundation for the black box theater he later incorporated into his gallery space on the Via del Paradiso in Rome.

In the fall of 1968, Sargentini gave Forti access to his L'Atttico gallery in the mornings before it opened to the public. There, surrounded by whatever art was then installed on the walls and in the space, she began to work on a series of movement studies inspired by watching animals in the Rome zoological garden, Bioparco di Roma. In *Handbook in Motion*, she recalls:

> Being a little lonely in an unfamiliar city, I took to spending a lot of time at the zoo. I found myself falling into a state of passive identification with the animals. [. . .] Yes, I felt a kinship with those encapsulated beings. In the afternoons, I watched them salvage, in their cages, whatever they could of their consciousness. In the mornings I worked alone on a dance called "Sleep Walkers." It was the first time in years that I allowed myself to be led by feedback from my body sensations." (1974, 91)

Her journal from that time shifts among sadness, anger, and a sense of new horizons. "I began working again and with some energy after years not making any art. I found I could forge out in a direction even when I was afraid I was directionless" (60N). Forti mentions arranging to do a concert, and in October 1968 she presented her work at L'Attico. In addition to her animal movement studies, Forti reprised three Dance Constructions: *Slant Board*, *Hangers*, and *Huddle*. Her journals reveal how satisfied she was with making work based in her own somatic awareness and kinesthetic appetite. "But somehow I didn't want to think up any new pieces. No longer accepting my head as my work space, I started using the gallery as my studio" (1974, 91). Moving away from a conceptual approach, Forti returned to her

love of dancing, finding a renewed sense of vitality in motion. Despite her sense of desperation at times, Forti's sojourn in Italy was good for her self-esteem and her professional career. Returning to the country of her birth, she found a renewed sense of curiosity and life force. This research into the movement of bears, seals, and other four-legged creatures would animate her work for years to come.

Forces at Play

Simone Forti begins her 1974 memoir, *Handbook in Motion*, with a series of short movement descriptions interspersed among various thin-lined sketches. These "movement memory snapshots," rendered in image or text, dot the otherwise blank pages like big rain drops splashing intermittently on the sidewalk right before a thunderstorm arrives. On page 8, for instance, a mere thirty-seven italicized words float on the page. At the very bottom is the sentence: "Late summer in the Sierra Nevadas, a giant fir spiraled nearly imperceptibly back and forth on its axis." Surrounded by a field of white, these written or drawn memories are suspended on the page and in time, offering the reader an opportunity to contemplate the easily overlooked moments of everyday life. On the facing page, Forti recalls another miracle of pedestrian movement "I saw a man in pyjamas [*sic*] walk up to a tree, stop, regard it, and change his posture" (1974, 9). These short descriptions capture fleeting interactions between forces of nature such as the wind, plants, and animals (including humans), offering up subtle exchanges of energy between two animate beings as a kind of dance for the reader's contemplation. Forti finishes this prologue with a magical anecdote.

> I held a large grasshopper in my open hand. It swayed from side to side as we gazed into each other's eyes. We sustained this alignment of sight through an exact correspondence in our movements, which created a certain resonance between us. We danced together like this for many minutes. I had just saved its life and we were very curious about each other. (1974, 13)

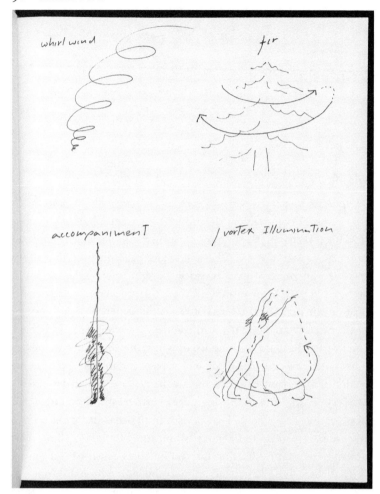

Page from Simone Forti's 1972 Notebook (7N). Getty Research Institute, Los Angeles (2019.M.23).

Subtitled "An account of an ongoing personal discourse and its manifestations in dance," *Handbook in Motion* was first published in 1974 by the Press of the Nova Scotia College of Art and Design as part of its newly inaugurated series "Source Materials of the Contemporary Arts." My copy, which I must have acquired when I was in my early

twenties, is close to falling apart from decades of reading. I realize now that it was one of the critical texts (along with Isadora Duncan's *My Life*) that galvanized me to pursue a life of dancing. Unlike Duncan's autobiography, however, *Handbook in Motion* still inspires me. This collection of life experiences, musings, drawings, little vignettes, and improvisational scores is a remarkable and often poetic assemblage of language and motion, or rather, language *in* motion. It is the kind of book one returns to time and time again.[1]

This chapter traces Forti's trajectory from the late 1960s to the late 1970s, a decade in which she cultivated the idiosyncratic movement investigations and developed the unique physical vocabulary that would sustain her improvisational performances for many years to come. Although she never entirely separated herself from her conceptual art-making days (even as she divorced the artists/husbands with whom she worked at that time), Forti became increasingly interested in what she calls "the vibrational"—exploring the sensations of different dynamic forces. These forces—including gravity, momentum, the wind, the ebb and flow of a wave form within landscapes, the movements of animals and plants, even music—are rarely directly visible. Instead, we experience them as internal sensations or external forces. We can't see the wind, but we can witness its effects on the sand of a beach or the trees in the woods. Tuning in to her body at the level of feeling, Forti returned to some of the kinesthetic awareness explorations and open improvisations that she had encountered in her time with Anna Halprin. Motivated by her own somatic curiosities, Forti's dancing moved beyond the stage or studio to include the whole world as a life-sustaining force. Caught up in the whirlwind of the Woodstock festival scene, she drew sustenance from her experiences dancing to rock music and living with others in a receptive and spontaneous manner.

In the late 1960s, Forti also began to play systematically with centrifugal and centripetal forces, banking into figure eights and honing her use of the circle as a simple, yet dynamic foundation for solo and group improvisations. She continued her animal studies, grappling with four-legged locomotion, including crawling and hopping. Move-

ment was the basis of an exchange between herself and other creatures that refused the hubris of humanism and forged a material practice that many contemporary academics interested in "posthumanism" would do well to study. Central to these investigations were her ideas about flow and force, animism, and what she would come to define in increasingly precise terms as "the dance state" or "a state of enchantment." In a draft of a letter to Indian classical singer and raga master teacher Pandit Pran Nath (with whom Forti briefly studied singing), she writes, "With a sense of relief, I'm returning to dancing as to an old friend" (16N). Even though much of Forti's critical reputation is built on her Dance Constructions, it is my contention that the period from the late 1960s to the late '70s covered in this chapter is the decade in which she clarified her sensibility as a mover and forged her creative path as an improviser and a performer.

Located in Halifax, the Nova Scotia College of Art (its moniker from 1925 to 1969) was a small provincial school with meager resources that had struggled for years to provide studio arts training to Canadians in the region.[2] The focus on a traditional arts curriculum (such as figurative drawing and landscape painting) shifted abruptly when in the late 1960s the college hired Garry Neill Kennedy as its first full-time president. Aware of the radical impulses rippling out from the postwar art worlds in the US and in Europe, Kennedy introduced a more innovative curriculum by bringing in experimental artists as both permanent faculty and visiting instructors.

American artist John Pearson, who taught at the college from 1968 to 1971, recalled just how open the curriculum was at the time and credited the administration for encouraging collaboration across the different artistic disciplines.[3] Kennedy also secured government funding for a vocational focus on printing that, in turn, allowed the college to design a lithography workshop and establish the Press of the Nova Scotia College of Art and Design. Kasper König was founding director of the Press of the Nova Scotia College of Art and Design, and he originally commissioned Forti to write a book documenting her Dance Constructions with an eye to their impact on the New York

City art world. By the time that *Handbook in Motion* was printed in 1974, the press had published writings and journals by artists such as Donald Judd, Michael Snow, and Claes Oldenburg; composer Steve Reich; and Forti's dance colleague Yvonne Rainer.

In order to focus on the writing project, Forti spent much of 1972–1973 living in Halifax, facilitating movement workshops for the students and hanging out with the other artists living there at the time. She was particularly close to Fluxus poet and performance artist Emmett Williams, who was leading a "Language Happenings" course. One of the more memorable events during those early years was a marathon reading of Gertrude Stein's 1925 novel *The Making of Americans* that apparently lasted for forty-eight hours and included students, faculty, and the public, reading and listening, drinking massive quantities of coffee, and sometimes sleeping on-site. Williams's wife, the artist Ann Noël, also taught at the college. The creation of *Handbook in Motion* took quite a while as Forti balanced her desire to articulate many of the embodied experiences of her recent time at the Woodstock festival and in California and König's mandate that she focus on the development (and legacy) of her Dance Constructions. (According to one story, when König initially rejected the manuscript, she simply put it in a drawer for several months and then resubmitted at a later date.) In an interview included in Kennedy's massive anthology *The Last Art College: Nova Scotia College of Art and Design, 1968–1978*, Forti recalls the tensions of these differing expectations. "I was interested in my change of perception. I had to reconcile the vision represented by my early '60s minimalist work and this new experience I just had through acid."[4] Describing her life as a "hippie," Forti mentions learning to "flow with the flow" and experiencing "wave forms" that are normally filtered out of our everyday experiences. Summing up these differences in perceptual categories, she speaks of her efforts to parse the relationship "between the conceptual and the vibrational"—between her work of the early 1960s and what she was interested in exploring a decade later.

This ambivalence shows up in a fascinating page from her 1972

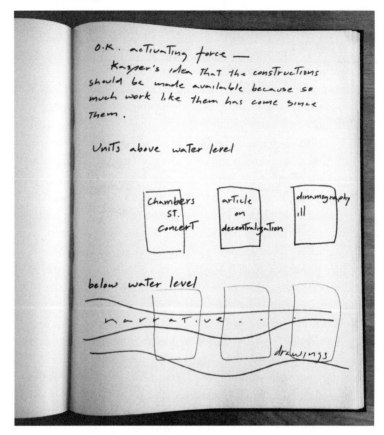

Page from Simone Forti's 1972 Notebook (7N). Courtesy of The Box.

journal (7N). One can almost feel Forti's determination to get down to work as she writes in bold ink at the top of the page: "O.K. activating force—"

Underneath that first line, she reiterates her charge: "Kasper's idea that the constructions should be made available because so much work like them has come since then." Forti then blocks out three rectangles that she titles "units above water." These include "Chambers St. concert" and one intriguingly called "dinamography." Directly underneath this section is a drawing of the subterranean forces pulling

her "below water level." Wavy lines weave through a series of blocks
with the word *n a r r a t i v e* flowing like an undercurrent of thought.
I interpret this stream as a reference to the experiential life-writing
that Forti threads in and out of her discussion of the Dance Construc-
tions and other, more recent movement explorations in *Handbook in
Motion*. It is telling that, embedded in her stories about Woodstock,
about dancing to rock music and living communally during this time,
she alludes to the frustration that she felt with her role in that often-
competitive (even if casual) NYC art world. She speaks of a kind of
freedom in being able to dance without being placed in a category.
"I didn't have to especially identify myself as one who danced, so I
was left free to delve into dancing and to function in the ways I knew
best" (1974, 22).

A few pages later in her journal, Forti writes, "from construc-
tions to dinamography." Underneath, two columns of words stand
side by side. On the left is a list of the constructions: "huddle, slant
board, platforms, face tunes." On the right is a list of her more recent
movement explorations: "line, circle, molimo, crawling." Most likely,
"dinamography" is a phonetic spelling of the word "dynamography,"
a term used in sports science to indicate the measurement of force and
pressure in an athlete's performance, registering key moments such
as starts, take-offs, or running stride. Given the fact that Forti has
often mentioned being inspired by Eadweard Muybridge's studies of
both human and animal gaits, this interpretation makes sense. In fact,
Forti refers to developing her own dynamography in *Handbook in Mo-
tion* and in her journals. On page 125 of the former, there are a series
of drawings, most of which are irregular oval shapes with the word
"measure" contained in the center. She writes of "tuning measures"
and of "finding a measure." A central force that Forti "measures" in
her dancing at this time is what she calls "vortex." In a journal, she
adds:

> Vortex is the oldest. It consists of running around in a small
> circle leaning inwards towards the apex. The centrifugal forces
> counterbalance this inward leaning. Vortex grew out of circling.
> (17N)

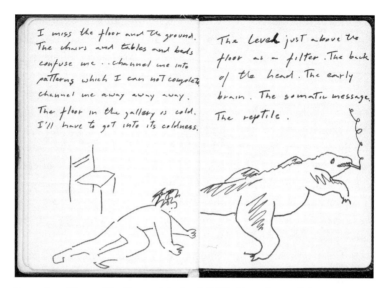

Pages from Simone Forti's 1972 Notebook (7N). Getty Research Institute, Los Angeles (2019.M.23).

Later in the same passage, she writes, "At the time I first started vortexing, I was smoking and dancing. Vortex plays on the hypersensitivity to dynamics that comes with smoke. I can lose myself in the vortex. . . ." (17N). Losing herself in the dancing, in the play of forces available in ongoing motion is something that Forti cultivates during this time. This sensibility includes a deep appreciation of the energetic exchange of movement between animals, as well.

If we go back to the two columns discussed above and take a cue from her interest in the interrelationships between the left column and the right one, that is to say the connections *between the conceptual and the vibrational,* we might also imagine that "dinamography" is an investigation into the dynamics of moving like our ancestors—crawling like a dinosaur. This possible mis/reading is alluded to in another journal entry in which Forti is discussing her physical need to stay close to the ground. She writes: "I miss the floor and the ground. The chairs and tables and beds confuse me . . . channel me into patterns which I cannot complete." On the facing page are four

brief but critical phrases: "The back of the head. The early brain. The somatic message. The reptile." Poised just underneath these words is a wonderfully witty sketch of Forti crawling behind a crocodile-like creature who is smoking a joint. The implications are clear—Forti is interested in going back to the basics of movement, to feeling herself close to the ground and reconnecting to gravity and momentum. This was research, in fact, that she had begun many years earlier. At this pivotal point in her career, however, these early movement experiments become increasingly distilled as she commits herself to sustained kinesthetic inquiry into the dynamic forces of mass and gravity, effort and momentum. She also develops a somatic fascination with animal movements, particularly the study of locomotion on all four limbs. Over time, these improvisational explorations cultivate a deeper way of being in the world, one that recognizes both visible and invisible forces at play, structuring her life as well as her art.

Throughout her life, Simone Forti has sketched as a way to research movement. When she was young, her father used to take her and her older sister, Anna, to the Los Angeles Zoo to draw the animals. In her essay "Full Moves: thoughts on dance behaviors," Forti remembers that the two girls "were always especially pleased when our sketches caught a sense of their movement" (1984, 7). Expanding on that early training, her notebooks are filled with sketches emphasizing energetic pathways in animals, plants, and landscapes. In the late 1960s and early '70s, she was formulating her approach to movement explorations as a kind of improvisational play among different forces, and she captures these dynamic moments with a mark, curve, arrow, squiggle, or wavy line. Some sketches might present more abstract shapes, such as a circle inscribed as "orbit" or a sideways S with the words "changing orbit" next to it. Other pages show more realistic renderings, such as one with a drawing of a fir tree whose branches are marked by a subtle spiraling back and forth, or a naked woman (possibly Forti herself) dancing exuberantly with arms spread wide, or a sea lion wriggling on its back, or even the dynamic expansion of a whirlwind as it takes off from the ground.

The immediacy of sketching is deeply felt; it allows Forti to anno-

tate the forces she was exploring in her own dancing—*to focus on the vibrational rather than the conceptual.* Page after page of sketches, as well as her journal writings, make it abundantly clear that she feels the echoes of those forces in the gesture of her hand. For Forti, drawing mediates the dialogue between the world and her body. Nowhere is this more striking than in her sketches and descriptions of the animal movements that would become integral to her dance practice during this decade.

In her essay "Simone Forti Goes to the Zoo," Julia Bryan-Wilson also highlights the critical importance of Forti's drawings of animals for her own movement explorations. She explains: "The durational and physical medium of drawing was crucial to this project, as it allowed her hand and arm to enact movements similar to those she was recording."[5] Forti's journals from that summer in 1968 are filled with quick drawings of animals with the movement of their breath or their particular method of rising and lowering to the ground indicated by arrows and lines of direction. Sometimes these images are accompanied by extensive movement descriptions. For instance, she describes in analytic detail how a goat uses the weight of its head and neck to pull up first to its knees and then onto its feet. A later entry registers how a goat tilts its head onto a horn when lying on its side (28N). Three pages of sketches done in quick succession show a goat in different positions, including one particularly astute study that traces a serpentine line from the top of the animal's head down the bony spine to the end of its tail. Many of these drawings and descriptions focus on the use of the head to initiate a movement such as a turn or even a leap into the air. This gesture of an animal's head thrown up and leading backwards into a turn is one that Forti will return to again and again in her solo improvisations. It is clearly a movement that resonates with her own sense of corporeality.

Bryan-Wilson uses the term "transcribe" to indicate the layers of attentiveness in Forti's observations. "Her animal drawings, with their lively lines, show her attempt to transcribe in graphite and ink the pliability of animal bodies, to capture how the relationships among their parts can change fluidly with every gesture."[6] The term "drawing"

usually refers to a category of work in art historical terms. Looking at Forti's journals, including the powerful images of moving forces described above, I would prefer to use the term "sketching," because it is more suggestive of a process than an outcome. Sketches are rarely meant to be "finished products," and even though assorted museum curators may eventually consider these sketches artistic renderings to be framed and collected, their purpose for Forti at this time was to capture an experience—a momentary flash of connection with an animate force—as part of her own movement research. Sketching is something done quickly, without too much attention to exact form or perfect line. Sketches link the actions of the pencil, hand, arm, and ultimately the spine to the eyes of the person drawing in a way that goes beyond mimetic representation. It is about instinct rather than reflection. Forti herself alludes to this distinction in a brief journal entry: "A thing I love about this format is how it deals with sense, *not with representation but with recognition*" (17N, emphasis added). The importance of recognition (as opposed to representation) emerges as a critical theme in Forti's investigations of the forces at play in animal motion. It also indicates the shift from a hierarchical subject/object relationship to a mutual sense of exchange.

For art critic John Berger, drawing is also a process of discovery. In his evocative essay "The Basis of All Painting and Sculpture is Drawing" (originally published in 1962), Berger claims that the act of drawing forces one to "look differently"—that this meeting of hand and paper marked by a line is, in fact, the consummate act of perception. He writes: "A line, an area of tone, is important not really because it records what you have seen, but because of what it will lead you on to see."[7] Berger's essay is a fascinating mix of reflections on his personal practice and references to art theory—internal sensation and its translation into a line or idea. Across sentences that veer from poetic to analytical, Berger narrates his own experience sketching a live model while also reflecting on the process of image making. He is less interested in the shapes he is making than in the existential implications of those dynamic lines. In language that aligns with the central argument of this chapter on Forti's artistic evolution, he

writes of finding "the energy of the pose" and capturing the "vertical force" of a stance. As he draws, Berger enters into an intimate dialogue with the figure he is discovering. Rather than a subject drawing an object, it is a collaboration. His words echo the ways in which Forti is also swept-up by the forces animating her drawing/dancing. Although he primarily uses the term drawing, Berger is interested in the same vibrational exchange that animates Forti's sketches. In language that parallels Forti's "recognition" rather than "representation," Berger translates the visual aspect of his two-dimensional drawing into a three-dimensional somatic experience. "I entered into the receding spaces and yielded to the oncoming focus."[8] For Berger, as for Forti, drawing or sketching allows for the kind of perceptual responsiveness in which the individual with pencil or pen is open to a vital dialogue between sight and body, one that can transcend the frame to connect with another figure energetically. Berger continues: "I saw and recognized quite ordinary anatomical facts; but I also felt them physically—as if, in a sense, *my* nervous system inhabited *his* body." I argue that it was precisely this kind of energetic witnessing that compelled Forti to not only *see*, but also *feel* the forces at play when she went to the zoo in Rome.

In the summer of 1968, Forti was lonely and living in a city new to her. Witnessing the animals at the Rome zoo, even across the bars of their enclosure, gave her a needed sense of kinship with other living beings. In "Full Moves" she explains how movement can be a resource for creatures who are enclosed, an opportunity to improvise variations on their repetitive pacing back and forth. She mentions watching a small brown bear walking, hesitating, and then turning, remarking on its use of nose and head to swing just past the last boulder. She continues: "From time to time she would bypass her mark, gazing around as she paced out one of the less frequented loops in her pattern. It struck me that she had been able to regularize a matrix out of which she could improvise variations. And it seemed that this use of space was a real enrichment of the environment . . ." (1984, 8). Like the animals she was observing at the zoo, Forti felt like a displaced creature trying to use movement to make sense of the circumstances

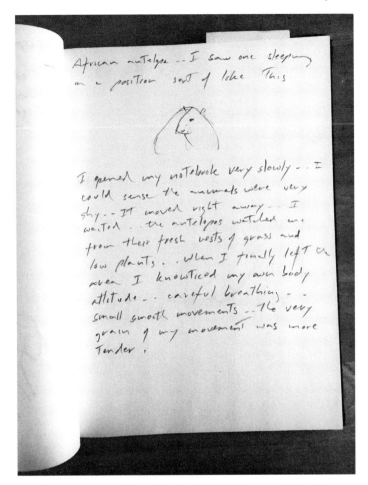

Page from Simone Forti's 1976 Notebook (22N). Courtesy of The Box,
Los Angeles.

of her life. "Often, when the situation in which I live out my human
patterns has been disrupted, it's through movement that I still know
myself. It's through movement that I can still feel my connectedness,
at least to gravity" (1984, 10). Not only was Forti studying the physical
behavior of animals, but she was also absorbing what she calls their
"inner attitude" (1984, 7).

It is interesting how often Forti has attempted to write about her experiences witnessing animals at the zoo. It is something she returns to again and again, a topic that recognizes both the powerful relationship between two live creatures and the cultural economy of that exchange. Bryan-Wilson describes Forti's relationship with the animals in the zoo in terms that also cross over between the physical and metaphysical realms. She notes: "[S]he was consistently moved by the creatures she drew and studied—moved as in stirred, or touched, as well as in shifted, or altered."[9] Reflecting on her experience in Italy during the summer of 1968, Forti describes that intricate combination of movement behavior and emotional charge in her witnessing.

> I remember first watching the polar bear swinging its head. That is, its head and neck and shoulders, the fulcrum a ways down the spine, or in this orientation up the spine, its nose the furthest end of the arc. I was moved. And it's this being moved which has always been a signal for me, a signal that I'm recognizing something, the enactment of a process, or a state of being. It seemed to me that the bear was taking care of itself in a way that I could understand. Lately I've become aware of the relationship between the movement of the body's parts, and the well being [*sic*] of the internal organs, and the feelings involved. And certainly, along with the great shoulders and neck and head, the heart and lungs were swinging as well. [. . .] Why did my heart identify with its heart? It just did. (1984, 10)

In *Handbook in Motion* Forti mentions that some people might suggest she was "anthropomorphizing" her relationship to animals, but I find that she is neither naïve nor evasive about the unhappy reality that many of the animals she is witnessing are stuck in cages. She parses the question of whether an elephant (or a bear) in captivity is fully that animal if their enclosed and artificial environment insists on a very different movement experience. Of course, her response to the question of captivity changes over the years depending on her

personal circumstances. In Rome, the very fact of their captivity is one of the bases for the powerful connection she feels. In a journal entry from 1974, Forti acknowledges these multiple layers.

> I've used the zoo two ways. For observing movement mechan-
> ics and for observing the spiritual phenomenon of dancing in
> captivity. [. . .] See how the crocodile sinks into the ground. See
> the gazelle. And always speculations from as far back as I can
> remember . . . speculations based on observations because the
> accepted maps seem unbelievable considering the dense co-
> incidences I've lived through and the unquestionable communi-
> cations that have passed between me and other things, animals,
> rocks. These speculations I call dance-fiction for dance is my
> matrix and my laboratory. (59N)

The "accepted maps" that Forti alludes to in this passage are the ways of seeing that Berger analyzes in another essay (published fifteen years after "The Basis of All Painting and Sculpture Is Drawing"). In his essay "Why Look at Animals?," Berger elaborates on an historical critique of zoos and pets that claims they originated in the nineteenth century precisely when working and farm animals were beginning to disappear from many people's daily lives.[10]

This shift was and still is the result of growing industrialization, urbanization and, of course, the alienating work of capitalism. But it is also deeply connected to the separation of mind and body, man and animal, that, in the western world, goes back as far as seventeenth-century philosopher René Descartes. Berger argues that even as zoos become the place to "look" at animals, we can't really "see" them fully, since these creatures have already been rendered "absolutely marginal" to our economic and cultural ideologies (as have peasants and small farm owners, the only group of people still working side by side with animals). But if we return to Berger's claims about drawing transcending the merely visual ("I also felt them physically—as if, in a sense, *my* nervous system inhabited *his* body"), it becomes possible to use drawing (or sketching) and dancing as a (meta)physical and

three-dimensional matrix that opens the possibility of a real exchange between two animate beings.

When Forti goes to the zoo and watches the sea lions playing in the water and showing off for the zookeepers, for example, she recognizes what she calls "movement play," which she considers the primal "roots of dance." She distinguishes between movements per se and dancing in terms that merge the physical and the metaphysical. "It wouldn't be the beauty of movement that would make me say that I was watching dancing, but rather the inner attitude of the animal. [. . .] The inner attitude I mention has to do with the rest of the life of the individual" (1984, 7). Forti not only attempts to take on the movement vocabulary of different animals, she tries to comprehend—to understand with her own body—the corporeality of that creature's experience. Describing the African antelope at the zoo, Forti writes about their shyness and stillness as they watched her drawing. Leaving, she recognizes a difference in her own physicality. "I knowticed [*sic*] my own body attitude . . . careful breathing . . . small smooth movements . . . the very grain of my movement was more tender" (22N). This adoption of some aspect of the animal's movement allows her to connect across the bars of a cage to their existential being, what she calls the "inner attitude" of the creature in front of her.

Forti's journals and writings are dotted with anecdotes of an animal recognizing she was taking on some of their movements and approaching her from across the moat or bars of its cage. For instance, Forti recalls:

> I remember once watching a land turtle eating, being struck by how the jaw closed very slowly but opened with a sudden snap. As I watched, I tried it with my own mouth. The turtle stopped for a moment and looked at me. It must have perceived a familiar flicker of movement, just enough to release a spark of recognition." (1984, 14)

Bryan-Wilson articulates the difference between representation and recognition—between mimesis and the kind of embodied witnessing with which Forti engages. "She puts herself through the animal's

paces with full awareness of her own human envelope; that is, she appropriates its ritual of 'passing the time of day' not to perfect an imitation but to reframe and re-perceive the organization of her own body."[11] The movement research that Forti was pursuing at the Rome zoo in 1968 became the basis of work during her second evening of performances at the L'Attico that summer. (The first evening was dedicated to her Dance Constructions.) Bryan-Wilson comments on the fact that Forti titled this solo *Sleepwalkers* or sometimes *Zoo Mantras*. "Both are indications of altered states, but as a sacred utterance a mantra points to a realm of communication somewhat outside of normative language, one that, with repetition, leads to greater insight."[12] Forti's new-found fascination with movement repetition and the way altered states can lead to different kinds of awareness of the forces at play in the world was about to expand exponentially as she returned to the US in the summer of 1969.

Intriguingly, the prose narrative of *Handbook in Motion* begins not with her Dance Constructions, nor with her animal studies, but with the 1969 Woodstock festival and Forti's experiences of moving in and out of musical environments and various housing situations. Spontaneous gatherings in tents, barns, cabins, and vacant houses provide the communal backdrop for a year-long exploration of physical and metaphysical coincidences. As she returns to the US and finds her way as a dance artist, Forti rides the waves of cultural tides and personal change. In recounting her life during this period, she is quite frank about the fact that many of her experiences were mediated by drugs. Most historians and critics tend to relegate this period of her life to a brief, awkward phase of experimentation, which they pass over quickly en route to her later improvisational collaborations with musicians or other dance artists. But I believe that her explorations of altered states of consciousness provided by psychedelics, among other drugs, afforded her the opportunities to deeply experience the vibrant interconnections between people, landscapes, and animals—to sense the impact of all these physical forces moving together in the world. Remembering one such moment, Forti writes:

One morning I stood on a big round rock and put a heavy rock on my head. I was willing to be still, balanced on the rock and balancing the other rock on my head, but in order to keep it together I had to keep a very slight movement, a tiny dance, going on between the two rocks. That went on for many minutes. No one else was awake. (1974, 22)

I want to pause here for a moment to consider this "tiny dance." I recognize, of course, that one reason I am so struck by this paragraph is that it parallels Paxton's notion of the "small dance," a practice with which I have engaged during my many years teaching contact improvisation. First explored in the early 1970s as he was crafting the physical training that would sustain this new form, the small dance (sometimes called "the stand") allows one to focus on the internal movements necessary to stay upright. Although contact often involves big movements and massive displacements of weight, the dynamic and acrobatic dancing is supported by the fine tuning of one's sense of balance and proprioception. Standing with one's eyes closed, one quickly becomes attentive to the subtle shifts of muscle and bone that make this exercise into a "tiny dance." In the narration to "Chute," an early short compilation video about the development of contact improvisation. Paxton comments:

Standing still is not actually still. Balancing on two legs demonstrates to the dancer's body that one moves with gravity always. Observing the constant adjustments the body makes to keep from falling calms the whole being. It is a meditation."[13]

Personally, I find the subtle variations of movement in the small dance infinitely fascinating, which is perhaps why I decided to go outside and feel for myself what it was like to stand on a big rock with another one balanced on my head. It took me a while to relax into the situation and find the connection (and not over-adjust my head when I felt the rock tipping to one side). But once I did, I felt a compelling dialogue between gravity and the air surrounding me, between my body and the stones at either end. I sustained this balancing dance for what

felt like a long time. Interestingly, as my body became the conduit for lines of force from sky to earth, I felt the moment as geological—more as a spatial landscape spreading out before me than as a journey through linear time.

The kind of movement meditation in Paxton's "small dance" and Forti's "tiny dance" is not dependent on drugs, of course. But it does require a willingness to shift one's primary perception from vision to sensation, allowing for a certain responsiveness to the ways in which different kinds of energies manifest in the world. Nearly all of the improvisational practices developed by Forti, Paxton, and others in the 1970s begin with minimal movement, either standing or lying on the ground, slowly rolling, or walking as a meditation. Many times, these tuning exercises are done with the eyes closed in order to calm the nervous system, opening up a reflexive kinesthetic imagination that operates underneath our conscious mind and can attune to other kinds of information. The discipline involved is not about taking charge of one's body through muscular control but rather about learning how to feel, hear, touch, and, ultimately, dance with the many (sometimes invisible) forces at play in the world.

In the months leading up to the fiftieth anniversary of Woodstock in the summer of 2019, there was renewed discussion of the possible therapeutic uses of psychedelics, including LSD and psilocybin (commonly called magic mushrooms), in severe cases of depression, anxiety, addition, and post-traumatic stress disorder (PTSD). Although the popular vision of the Woodstock generation is often one of hippies using drugs to drop out of society, many individuals (both then and now) have found that psychedelics actually promote a deep sense of interconnectedness (often described as a sense of oneness) with other beings in the world. Michael Pollan discusses the actual science behind this common expansion of consciousness in his book *How to Change Your Mind: What the New Science of Psychedelics Teaches Us About Consciousness, Dying, Addiction, Depression, and Transcendence.* Neurologically speaking, there is a shift of chemical pathways in the brain, with a drop in the activity of the posterior cingulate cortex, which corresponds to our willful, often self-critical mind, and an

opening of new pathways between regions of our brain that do not habitually connect. These differences can produce a porousness of the ego and a heightened awareness of the interconnections between touch, sound, smell, and kinesthesia (sensibilities that often remain in the background of our consciousness), explaining the frequent experiences of synesthesia that people have while taking psychedelics.

In describing his own embodied research into psychedelics, Pollan writes at length about his new-found willingness to think about mystical experiences. Deeply skeptical at first, he begins to shift his attitude. ". . . I have no problem using the word 'spiritual' to describe elements of what I saw and felt, as long as it is not taken in a supernatural sense. For me, 'spiritual' is a good name for some of the powerful mental phenomena that arise when the voice of the ego is muted or silenced."[14] This openness can be awe-inspiring or deeply unsettling; a lot depends on the situation in which the drugs are used. Contemporary trails of these drugs are rigorously controlled, and there are trained guides and behavioral therapists assigned to each subject, supporting and soothing them whenever the experience becomes overwhelming. Their role is similar to that of community elders or spiritual guides in cultures wherein these substances are ritually ingested as part of initiation rites or divination ceremonies. In the summer of 2019, John Hopkins University established a new Center for Psychedelic and Consciousness Research. In an article about its mission, center director and neuroscientist Dr. Roland Griffiths recognized that the psychedelic experience can be "existentially shaking." But it is precisely that experience of disorientation that can prompt people to shift negative mindsets and potentially dismantle destructive habits.[15] In short, tripping can be a frightening experience. Or it can be an enlightening one—as it clearly was for Simone Forti in the summer of 1969.

It is difficult to describe the environment in which a million people tripping together find themselves. But I perceived a set of mores regarding the sharing of space and fate which seemed to form a whole integrated way. I fell in love with that way, and remained with it for a year. (1974, 16)

Although this passage from *Handbook in Motion* points to the difficulty of summoning the right words to evoke the particular mix of music, drugs, and love at Woodstock, Forti does just that, I would argue. For instance, the paragraph before the one quoted above describes in vivid detail the merging of personal space and interpersonal pathways, highlighting the critical importance of nonverbal communication as she navigates the sea of people on the hillside.

> To get from one place to another you had to walk right among them. No one shifted or moved to make room, you could always find a place just big enough for your foot. And you would step right down, you didn't have to nod and demonstrate that you weren't going to step on someone's hand. [. . .] They'd leave their hand just as it was, you'd put your foot in the available space and go on to your next step. (1974, 16)

I find this a remarkable description of the kind of awareness and flow absolutely integral to improvisation. The trick is to stay relaxed and find the possibilities without becoming too self-conscious or overly accommodating. It's about being attentive without becoming predictive—about reading people's bodies and not presuming what is on their minds.

The summer of 2019 was filled with nostalgia for what Woodstock has come to symbolize in the history of American counterculture. Memorials and celebrations of its fiftieth anniversary included waves of commemorative essays, vintage photo spreads, and interviews with folks from the audience, as well as some of the musicians who had performed. There was even a brief attempt to pull together a twenty-first-century version of this historic event. What became clear from all this media attention was the fact that, despite the eventual arrival of rain, mud, and food shortages, Woodstock had an extraordinary impact on many people's lives. One participant called it "a mark in cosmic time," while another one, Katherine Daye, now a Florida librarian, described a memory of a moment "when the music was so mesmerizing, so internalized, that I became the music I was listening to."[16] Forti herself recalls:

If you were in one small group you'd mainly hear your own music. But you'd also hear the music coming from down the hill, or from across a small canyon. And as I danced, my body was enough on some kind of automatic pilot that all these musics came together, somehow merged into a pattern that included them all in a dynamic, rolling kind of falling together. (1974, 15)

Words such as "all-encompassing," "automatic pilot," "mesmerizing," and "internalized" suggest a trance-like state, a release of individual positionings into a communal sense of space and a riding of surrounding sound waves. This kind of connectivity is an essential aspect of what used to be considered "the sublime" and psychologists now call "the flow experience." In his seminal book *Flow: The Psychology of Optimal Experience*, Mihaly Csikszentmihalyi defines flow in terms that echo Forti's many descriptions of being swept up in a movement exploration. He explains that it's a state of attention in which "[c]oncentration is so intense that there is no attention left over to think about anything irrelevant, or to worry about problems. Self-consciousness disappears, and the sense of time becomes distorted."[17] In a chapter entitled "The Body in Flow," Csikszentmihalyi references sociologist Émile Durkheim's notion of "collective effervescence" to describe the immersive and sensory experience of rock concerts such as Woodstock.[18]

Later in her discussion of her Woodstock experience in *Handbook in Motion*, Forti describes another example of this meeting of music and movement. Witnessing a Black man moving in front of a fire one evening, she writes: "The drums kept going, and he was doing a bouncing kind of stomping, left, right, left, right, left, right, his spine tilting from side to side. It seemed like a tuning, a finding of certain forces, . . ." (1974, 15–16). In his book *Judson Dance Theater: Performative Traces*, Ramsay Burt points to the above description as an example of the white avant-garde's appropriation of African American culture and accuses Forti of a "naïve" belief in "an ahistorical pre-modern past."[19] Without reading very carefully, Burt consigns Forti to a stereotypical and racist mindset. "It is as if this black man dancing naked

to drumming around a fire at night was returning to some mythical, 'primitive,' magical African context." While I appreciate Burt's larger argument about the appropriation of Black dance and music within the primarily white counterculture of the '60s, I find his reading of this moment both bizarre and simplistic. (To begin with, nothing in her text describes this particular man as naked.) Rather, I believe Forti's discussion of his repetitive movement being like "a tuning, a finding of certain forces" is a recognition of the state of being swept up, a melding of self and sound that was a hallmark of the Woodstock experience for many people.

Clearly, music was one of the forces at play during the festival; another was the extraordinary sense of kinship and cooperation among participants. Forti claims that "Love was our totem" and describes the feeling as "an emotional posture of continual dilation" (1974, 17). She also speaks of "absolute openness," "absolute multi-directional vulnerability," and "an absolute lack of fear of uniting" (1974, 15). This trinity of "absolutes" is striking and suggests an almost sacred exchange. Given the historical distance of half a century (not to mention the disastrous fraying of civil discourse in America), it is tempting to dismiss Forti's language here as utopian nonsense. Obviously, not everyone experienced the same level of bliss. Later in *Handbook in Motion*, Forti herself remarks on her neglect of the larger cultural and economic contexts.

> In retrospect, I've come to think that the strangest part of my Woodstock experience is that I had no sense of how it was based on conditions of economic privilege. [. . .] Riding on checks from home, on gifts, scavenging and finding a wealth of refuse. It was beautiful, and it left us free to explore many ways. But it wasn't the messianic vision I took it to be. (1974, 102)

The fact that Forti decided to begin her book with a discussion of her Woodstock experience—though she later recognizes the class-based context of its joyful frolicking—suggests that she had found something important still percolating in her system several years later. It seems that having spent a little more than a decade focused on being a

wife and working with two different artists/husbands, Forti was open to rethinking her life and charting her own creative interests. Her experiences in Italy and at Woodstock and its aftermath gave Forti the needed space and time away from the NYC scene to develop her own artistic identity as a mover and a maker.

If love was a key term for Forti, so was "coincidence," defined in her writings as a sort of cosmic force in the world that she trusted to give her direction.

> To flow was to relinquish a great deal of control over who and what you were going to come into contact or stay in contact with. You did this by suspending all plans until each moment presented itself. [. . .] One result was a very high incidence of co-incidence. I came to think of coincidence as harmonic overtones of occurrence and as twilight guideposts. (1974, 17)

Forti's use of the term "coincidence" registers across the physical and the metaphysical. As the coming together of forces, coincidence suggests the dynamic synchrony of both material objects and cosmic concurrences. Something as simple as two people passing each other on the street or a group of folks weaving in and out of one another (as in her classic workshop warm-up, *Scramble*) could provide a structure for playing with coincidence and spontaneity in the studio and in everyday life. On a more spiritual level, Forti was also perceiving manifestations of coincidence. In her journal from 1970, she writes of "receiving guidance from the cosmic spirit" and mentions her desire for a "faith that doesn't require that anything be knowable" (16N). Tellingly, she uses a small i when referring to herself, as if she were receiving rather than willing. "Rather, i would believe that identity is diffused" (16N). She also begins to consult the I Ching for direction in times of indecision or personal transitions. This melding of the physical and the metaphysical soon blossoms into a serious interest in circles as a kind of cosmic form, manifest in both the Star of David and Arabic numerals. One page of a journal from this time that was on display in Forti's 2023 MOCA retrospective begins with the word "devotion" at the top and ends with a large circle at the bottom of the

page. In between are the words "I always felt that insight would set me free and I always turned to dance for insight." Even in her Woodstock days, Forti thought dance had aspects of a mystical numerology.

In *Handbook in Motion*, she offers a wonderful description of playing with weaving her upper body very fast in a figure eight. With great precision she recalls,

> I could do it only if I got the exactly correct dynamic and rhythm going—the exact amount of thrust in one direction that I could then recoil and bring back in the other direction and just keep it weaving back and forth. I couldn't have done one side of the movement without the other side. It was like jumping onto a ride. [. . .] So I rode the figure-eight [*sic*]. (1974, 19–20)

The figure eight is a meeting of two circles, a mobius strip of dynamic momentum produced by the dialogue between thrust and coast, effort and release. Perhaps this life-long research into circles began with her hand, training the pen or marker to perfect the gesture that would continue the line as it cycles round and round. In a series of drawings called *Illuminations* (this is also the title of her ongoing improvisational work with musician Charlemagne Palestine), she has traced a circle multiple times.[20] Usually there is a ring of six even circles with a seventh in the center. This is the foundation for the star of David, and Forti often highlights with a thick pen the various triangles that can be made within that shape. She will draw two separate circles overlapping the one in the center, creating the possibility of tracing a figure eight as well. Sometimes, she draws circles end to end, as in the series of screen-print posters for the early performances of *Illuminations* in California in 1971. Although two-dimensional images, these circles are clearly the result of multiple tracings of a hand going around and around—visually, they almost breathe with an innate physical potential.

At one point in an early 1970s notebook, Forti describes the form of the circle as a kind of "home base element."[21] She continues: "I must have found the circle as a natural resolution between the desire to propel myself continually, and the reality of working in an enclosed

space. I found that the circle became an arena for certain questions that I was struggling with regarding spiritual identity" (14N). In its completeness and its ongoing-ness, the circle encompasses at once a finite space and an infinite dimension. Tracing the circle became, for Forti, a moving meditation, a balance of forces that could sustain her physical curiosity and her intellectual interest. In another journal entry from 1971, Forti composes a poem that doesn't mention circling explicitly but alludes to her fascination with deepening her experience of this form.

<blockquote>
dancing as a personal offering

one movement

long repeated

decending [*sic*] deeply into one movement

learning one movement until it is well tuned

being sustained by one movement

meditating on one movement (30N)
</blockquote>

Circles, of course, are perfectly situated between "the conceptual and the vibrational," between the material and the immaterial, indeed, between the physical and the metaphysical. Although she was quite intrigued by the formal elements of the circle, including their role in mathematics and mystical traditions, it was the physical experience of circling and the play with gravity and momentum that ultimately sustained Forti's interest during this time. Her discussion of circling in *Handbook in Motion* is extraordinary in its algorithmic detail. Reading it, one's body cannot help but be pulled along in its dynamic wake.

> I started working on an action in which, as I exhale, I give in to centripetal force. And as I inhale, well, I don't know what it is, maybe my center rises, but suddenly I'm much more under the sway of centrifugal force. And I loop in and out of the circle on my way round and round. If I allow a kind of a whiplash in my spine, it effects my trajectory, compounding an S form into the repetitive wave patterns. If I extend my inhalation as far as I can,

I find myself in a dynamic eddy just at the very edge of the circle, and I can drift into a backwards loop before exhaling and being again drawn towards the center and going on. I found that if I stepped very quickly round and round in a small circle I could lean very steeply in towards its apex. Almost strangely so. And it seemed that I could isolate nearly all the effort to my legs, and that I could abandon most of my weight to a waving flame-like energy that seemed to be rising up the center of the vortex. (1974, 136)

As we have seen, repetitive movement can act as a kind of mantra for Forti. In a short article for *Avalanche*, an arts journal from the mid-1970s, she writes: "At times I've escaped an oppressive sense of fragmentation by plunging my consciousness into cyclical momentum. For myself, I've thought of it as gathering my concentration or centering; in short, as a rudimentary kind of prayer" (1974b, 22). Certainly, circling became one of the physical mantras that she would return to over and over as a form of movement meditation in her improvisational performances. Similarly, Forti would reprise the crawling work based on animal movements that she began in Rome again and again over the course of many decades.

Walking back and forth or around and around in a circle, moving in and out of the ground, rolling or hopping, Forti used repetition to play dynamically with the forces of gravity and momentum, as well as the infinitely variable articulations of the head, spine, and limbs. The sequencing from striding to crawling and back up again; the use of her head as a fulcrum connected to her upper body; her ability to deeply fold into her hips, squat on the ground and then propel herself in the air; and the relationship of her spine to her limbs—all are aspects of her movement vocabulary that come from her research at the zoo. But her capacity to go beyond these individual movements to articulate a particular behavior, a personal circumstance, is what draws the audience into witnessing her dancing explorations. The appetite for this kind of intricate and sustained movement research remained a key element in Forti's artistic practice, even as she distanced herself from

the communal and transient lifestyle she had "preached with a kind of Bible-thumping energy" while cavorting in the woods of upstate New York (1974, 107).

In 1970, Forti returned to southern California, finding herself in a shared house with artists Nam June Paik and Alison Knowles, who were both teaching at the California Institute of the Arts (CalArts). Established in the 1960s by Walt Disney and his brother Roy, CalArts was one of the first programs to combine the visual and performing arts in one professional school.[22] Although it was interdisciplinary, the ethos at CalArts was fairly traditional until the late 1960s, when it was radically reconceptualized by Herbert Blau, who was hired as provost in 1967. Blau was an avant-garde theater director and writer whose vision of devised, interdisciplinary performance called for an ongoing laboratory environment in which designers, directors, actors, musicians, composers, and media artists came together to create work. Blau was much less interested in providing a finished work for the audience than he was in the act of making work together. While he famously opened his six-to-eight-hour marathon rehearsals to the public, he rarely chose to stage a finished production, a practice that quickly drew resistance from university administrators interested in publicity shots and ticket revenue.

In 1971, CalArts moved into its permanent home in Valencia. Interestingly enough, at this time CalArts operated very much as a sister school to the Nova Scotia School of Art and Design. Many of the same artists, musicians, and performers traveled back and forth between southern California and Halifax. For instance, CalArts hired a number of Fluxus artists to teach, including Emmett Williams, who was also in residence in Halifax while Forti was there working on her *Handbook in Motion*. Another crucial figure at CalArts was Allan Kaprow, with whom Forti worked on several Happenings in NYC. Forti would occasionally substitute for Kaprow at CalArts, and she took various classes and workshops there, as well. Another figure that taught and performed at CalArts and at the Nova Scotia School of Art and Design in the early 1970s was Palestine, a sound and installation

artist with whom Forti worked periodically throughout the 1970s and '80s and again in the twenty-first century.

One class that Forti followed at CalArts was Tai Chi, taught by Marshall Ho'o. This soft martial form would become a sustained practice for Forti; indeed, it is the only kind of consistent physical training she pursued on and off for the next fifty years. A charismatic teacher, Ho'o popularized Tai Chi for the American market, appearing on TV and teaching all around the country. Ho'o emphasized the gentle, relaxed quality of circular movements, arguing that this physical/spiritual practice was the best antidote to the hustle and bustle of modern life. In the early 1970s, he taught Chinese history and Tai Chi at CalArts and worked in the office of the dean of student life at one point. In an interview with me, Forti recalled taking as many as five classes a week. "I was taking his classes at CalArts, his classes near Hollywood Boulevard, his classes at Bronson [Canyon] park. I was really studying it. I continued to do it for some years."[23]

When she became his student, Forti was processing yet another life transition, and the clarity of the form seemed to provide her with a physical practice that nourished her body and soul. Recalling this time in *Handbook in Motion*, she writes:

> I focused a lot of energy on Tai Chi. This study acted as a bridge between my stoned head and my straight head. It's hard to say how this was, but it was. Tai Chi is a discipline distilled from centuries of understanding, and yet it seemed to speak to the matters which concerned me when I was stoned. Maybe what appealed so much to my spirit was the combination of a close-up view of the very grain of dynamics, together with a sense of sensibleness and a clear position of personal will. (1974, 107)

What Forti was finding in her study of Tai Chi was an awareness of the form as an ongoing practice, one that is constantly renewed in the process of doing it. In a journal entry from her time in Nova Scotia, Forti mentions the difference between making "pieces" (most likely referring to her conceptual artwork such as the Dance Constructions)

and dancing as a way to access and "contribute my fire and my equilibrium." This last comment speaks to the vibrational aspect of her increasingly refined embodied practice, to which she commits herself more and more fully.

> I found that I could work on Tai Chi with the same absorption with which in my days in Woodstock I used to sit and watch the fire. In practicing every day, I was making friends with my inner strength. And I was developing a degree of ease and control in my movement that I had never before known and that eventually became the base for my own dancing. (1974, 107)

Moving in public spaces gives Forti the opportunity to experience her bodily motion as both meditation and performance. Forti writes of practicing Tai Chi outside in the crisp fall days in Canada and being aware of folks stopping and watching, and then moving on. "The other day I was aware of a small boy sitting in the grass a way off, watching, lost in thought" (1974, 114). This total engagement in her experience (internal) while simultaneously being willing to be seen (external) becomes a hallmark of her improvisational practice. Forti excels at creating a sensate world that she generously opens to the audience. In "Full Moves," Forti writes: "As I've experienced it, my witnessing self becomes amazed at the articulations and variations of attack and equilibrium with which my body enters into relationship with the forces of gravity and momentum" (1984, 8). Animated by the play of forces in these worlds she creates, Forti nonetheless retains an outside awareness of the audience's perspective as she crafts her dancing from a mix of physical sensation and compositional sensibility. She speaks of performing as a kind of channeling of the connections (and coincidences) to which she astutely directs the audience's attention. "I have the feeling of being a hostess to the audience, that what I do should communicate to them. It should be readable."[24]

Filmed in 1974 by Andy Mann in the NYC studio Forti shared with Van Riper, "Solo No. 1" is a good example of Forti's movement interests at this time. It is hard for me to imagine what it would be like to see this solo in performance without having first read her dis-

cussions of her movement explorations as they seem to directly inform her dancing. After a brief exchange with the videographer about the length of the tape, Forti begins walking upright in a wide circle. Her footsteps provide the soundtrack, and her gait remains steady as she traces the circumference of the space again and again. Eventually she enters the center of that circle, hesitates for a moment, and then switches direction, outlining her new trajectory with a loosely out-stretched arm.

Minutes pass, and Forti seems completely absorbed in the pathways she is tracing. Sometimes her hands lift slowly in front of her body and her focus follows their easy rise while her back arches ever so slightly. These small additions rarely develop further, however. Rather, they appear briefly and then simply dissolve as Forti returns to walking in a counter-clockwise circle. Only very gradually does the viewer perceive that her torso is beginning to lean in towards the center of the space. With her left arm raised, Forti moves fully into the centripetal momentum. She almost falls, regains her balance, and turns to ride that force once again. Slanting further and further as she loops around the edge, she suddenly plops to the ground and immediately begins crawling on hands and knees around her original circular pathway. In an essay published in *The Drama Review* (now *TDR*), Forti describes this moment: "I can lean so far as to cradle my head against my arms and shut my eyes as my legs go faster and faster until I bank too steeply, cross the threshold of equilibrium, fall bang on to the floor and crawl away without a break in pace" (1975, 38).

If the first half of her seventeen-minute solo is focused on circling, the second half references her animal movement studies. Like a four-legged creature, Forti has the uncanny ability to move with an effortless springiness in her joints. Crawling slowly, attentively, she eases into the deep flexion of her hips and sits back, turns, and then reaches her arms out to propel herself forward into crawling again. At times Forti looks like she could be a cat stretching or a baby first learning to crawl, and she takes her time, showing off the shift of her torso with each stretch of her arms forward. She crawls on hands and knees, shifts to hands and feet, then walks upright, easing back and

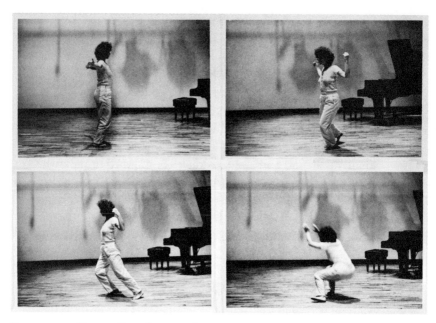

Four images of Simone Forti dancing solo, ca. 1974. Getty Research Institute, Los Angeles (2019.M.23).

forth across the evolutionary spectrum. Forti describes an important transitional moment when she returns to a two-legged position from crawling, still playing with the echoes of that motion in her torso.

> Then I stand up by stepping back with my hands until my weight is completely on my feet and I've become erect in a standing stride. I set my feet together and adapt part of the crawling-breathing coordination to this standing position. I reach up and pull my arm down again, one arm and then the other, letting my back arch slightly as I reach up and hump slightly as I pull my arm back down to waist level. As I arch, my weight shifts towards my toes. As I hump, my weight shifts back towards my heels, and I rock this way, back and forth. (1975, 38)

Once, she stops, squats deeply, and then suddenly leaps forward like a frog. The movement is startling in its size and effort, especially com-

pared to her casual striding in an even, contralateral gait. Towards the end of the dance, a wild energy shoots through her body as Forti begins to whip her head from side to side. She plays with this swinging motion while crawling and then while walking, letting the movement grow to affect her whole torso. Then, just as suddenly as it started, the wild energy drains out of her body and she calmly returns to circling. The dance ends as it began, with Forti casually walking over to the edge of her studio.

As a performer, Forti is not particularly interested in projecting to or for an audience. In "Solo No. 1," she never faces directly forward to address the audience, nor do her arms or legs reach fully into a typical "dancerly" extension. Her movement vocabulary tends towards the relaxed energy of Tai Chi, wherein the joints maintain a gentle openness and soft bend. With her internal focus, she signals to the viewer that we should attend to the motion as it ripples through her body rather than notice any one pose or gesture. Over time, our attention becomes cued to watching the forces move through her, and she takes her time feeling them accumulate. The repetitive walking movements that comprise the beginning of "Solo No. 1" and much of her dancing at this time allow the audience to observe her as she constantly shifts facings, giving us a three-dimensional sense of her evolution through the different phases of circling, striding, and crawling. Her movement palette requires patience and a willingness to allow subtle variations to unfold over time.

For some dance critics (and, presumably, some audience members) the work can feel boring. In a review of an improvisational performance with composer/musician and graphic artist Peter Van Riper, Daniel Cariaga dismisses Forti's dancing, calling it "repetitive, largely uneventful and of small visual interest."[25] On the other hand, many observers remark on her focused presence. Writing for the *Soho Weekly News*, Sally Banes (a sympathetic viewer to be sure) describes her presence as "so calm and deliberate that as she moves from one action to another, switching tempi and energy levels, one remains totally absorbed in watching her."[26] Highlighting the importance of understanding Forti's process in creating work, another review by

Lewis Segal begins with a quote from Forti and ends with a revealing summary of the tensions at stake.

> A Forti program resembles an energy-efficient perpetual motion machine more than vividly individual and contrasting episodes; that bothers some audiences. Anyone with or without dance training might duplicate her effects; that threatens some dancers. You can't even tell whether what she does is improvised or formally choreographed; that annoys some critics. But there's a vision in her work, the same search for resources to enrich Western theatrical dancing that has given modern dance in the post-Cunningham era its most innovative, most exciting, and most frustrating moments. Her work may exalt the rudimentary but it is important and can be fascinating—like a drop of plain water in which a whole world can be found. If you bother to really look.[27]

Learning how to look at Forti's process of building movement across a structured improvisation is an acquired skill. Perception is a key factor in how critics and audience members approach the way Forti slowly accumulates her physical vocabulary. Dance critic Marcia B. Siegel makes an interesting point in this regard as she describes a particular quality of Forti's performing. "Forti can look awkward sometimes, or as if the movement is thrown away, but she has a special kind of exactitude, an inner sense of proportion and energy as they fit her body."[28] Repetition allows Forti to be directed in her research, but it also allows for a sense of curiosity about each new enactment of a gesture or movement. Her writings about her explorations are incredibly articulate, yet she recognizes that "it is in the heat of action that the logic of the movement reveals itself" (1975, 38). Although she was using a very specific palette of movement options in these early solo explorations, Forti was also playing with subtle variations within the movement, and this requires a willingness to follow each progression closely. Watching Forti's work at this time required patience—it was a meditation.

Later in her "A Chamber Dance Concert" essay, Forti describes a

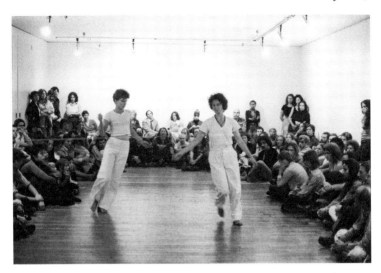

Duet with Simone Forti and Pooh Kaye, Sonnabend Gallery, New York City, 1974. Courtesy of Pooh Kaye.

duet with choreographer and filmmaker Pooh Kaye that premiered at the Sonnabend Gallery in NYC in September 1974. The dancing referenced in her description seems built along the same trajectory as "Solo No. 1." The dancers trace a circle while moving in opposite directions. Arms extended, they move around the same center before shifting to a figure-eight pattern, sometimes surprising each other with near collisions. Forti connects the circles they are tracing to what she claims is "a kind of dynagraphic [*sic*] potential" in these basic actions. In articulating her personal sense of a numeric cosmology as a basis for the dancing, she writes:

> The next figure to be added is the ellipse, containing the twin circles of the figure eight, and the women bank acutely around its ends. This ellipse is the zero. From top to bottom is the one. And from Arabia came these numerals, which are tracings along the lines and circles of the star. Picturing the tracings on the floor, the women stride the numbers out upon the circles. As their con-

centration deepens, their glance is lifted from the ground, their bodies banking from curve to curve, righting down the squares and diagonals. (1975, 38)

In an interview more than four decades later, Kaye points to the kind of "exactitude" that Siegel references in Forti's movement. Working in the studio together, Forti and Kaye explored how the slightest shift in axis would lead into banking which, in turned, led them into circles—some small, some large, depending on the degree of tilt. Kaye mentions that Forti was "very physically clear" about these investigations, even as she did not teach movement phrases directly. Kaye recalls: "when she was teaching me banking, she was very specific about it, you know mechanically specific."[29] As these investigations of banking, circling, and tracing the Arabic numerals on the floor morphed into the palette for a dance, the stakes were raised for the dancers. Kaye uses the metaphor of a "game" to describe the intensity of the mental and physical investment in this work. "So, the game is the relationship of the two people creating the numbers, the figures, on this figure eight. So, you know, you make the figure eight and then you draw a one, and then you draw a two, and then you draw a three, and you can always collide with some interesting moment." For Kaye, this improvisational approach that elaborates strategies of moving rather than defining and teaching steps per se, was deeply inspiring. Although she questions whether these explorations were particularly compelling to watch, she speaks to how amazing they were to perform. "I don't think it was ever very interesting to look at, but it was intellectually fantastic."

Having worked at first with only one other dancer in 1974, Forti proceeded to add a third dancer, Terry O'Reilly, for a series of performances in Tokyo during the Dance Today '75 festival in 1975. There is a video of *Red Green* from a performance at the Seibu Theater that allows us to see Forti's movement vocabulary of circling and crawling develop into a fully-fledged trio. Van Riper, who accompanies the dancing, sets the casual tone of the performance by walking over to his composer's corner carrying in a set of bells, walking offstage,

and then returning with a soprano saxophone, among other sound-making objects. These include two rubber hoses that he begins twirling with enough force to produce a whirling sound as he paces back and forth. Van Riper recedes into the background as the dancers begin circling the stage one by one, each hewing to their own orbit.

Soon, their orbits begin to intersect, and, over the next few minutes, the audience witnesses an entire constellation of overlapping trajectories as the dancers gradually speed up. We can see the dancers move around a circle, tracing the force of their banking as it pulls another dancer into their orbit. It is like watching millions of years of the galaxy in fast forward. There are marvelous canon effects as one dancer is drawn behind another, and there are bursts of momentum as one dancer spins into a tight vortex to avoid a collision, only to be catapulted out into the stratosphere. At times, they lean into the back of one another's outstretched arms, creating a joint diameter that stabilizes their leaning without breaking their pace. The smoothness with which they move in and out of contact while orbiting is infinitely fascinating. Eventually, the three dancers interweave in an intricate pattern of intersecting figure eights, banking further and further until Forti spins into the ground and initiates crawling, signaling a shift into another movement exploration.

As Van Riper plays his soprano saxophone over a series of sustained background tones, the three dancers crawl and sometimes roll around the stage. Each person has a different kind of crawl: Kaye moves slowly and languorously, stretching each hand out as she reaches forward with a movement that ripples down her arched back while she crouches low to the ground. O'Reilly shifts seamlessly from hands and knees to hands and feet to striding on feet and back down again, while Forti crawls, sits back and observes the space, and then crawls again. The pace slows down considerably as each dancer explores a single movement action: crawling, rolling, or striding. Van Riper's score fades, and the resulting silence focuses the audience's attention on the sounds of feet, hands, and breath. There is an ebb in the flow; time and space widen, and what becomes important is less the interaction between the dancers than the action of each gesture as it ripples

through individual bodies. Like "Solo No. 1," *Red Green* ends with bursts of dynamic movements: the dancers leap, spin, hop, and jump erratically before they spin off to animate one another. Oddly enough, these energetic sparks never build to a group dynamic. Rather than add to a collective action as satisfying as the intertwined circling at the beginning of the work, these last actions pop out of nowhere, and then dissipate as each dancer resumes their own trajectory in the space.

In the context of Forti's animal observations, it is interesting to consider a longer video version of "Solo No. 1" that includes almost seventeen minutes of filmed footage of the grizzly bear section of the Central Park Zoo in NYC. Here, we see three large bears pacing compulsively in a pretty cramped space with a small pool in the middle. The filming follows one bear for a while as it moves back and forth and weaves around the other two creatures in the enclosure, one of whom is in the pool, cooling off. The bear lumbers to the edge of a series of boulders and launches its upper body into the air, using that thrust to swing its head up and over, turning on its back legs and landing on all fours to continue in the opposite direction. Given that the footage was shot in the summer months and that Forti's *Avalanche* article was published in December of that year, it is likely that these are the bears she describes in the article.

> The three [bears] lumbered back and forth among each other, doing a movement which made me single out this trip to the zoo as worth reporting. It was a way of turning: from standing on hind legs reaching the head back and twisting it around, tipping the weight and kind of twirling half way around while falling back on all fours. It looked like great fun; they had probably learned it from each other. (1974b, 20)

This is a movement sequence that we see in "Solo No. 1," and it is similar to a description of a polar bear by Forti that I quoted earlier in this chapter. I suspect the dynamic of this action is what Forti was trying to capture on video. But there is something about the filming that focuses on the relentless pacing in a way that I find quite difficult to watch for so long. Judging by the voices in the background, I

believe Mann shot this section and includes as audio background the various conversations that happened while he was filming. In addition to many intriguing comments by teachers, kids, and passersby, it includes an exchange between two men about why the bears are so obviously anxious. "They're nervous because they're doing life to infinity" one man says, referring to their literal imprisonment. The other man responds, "Yeah, I understand, animals should be free." (Forti herself has acknowledged that she eventually had to stop going to the zoo, because it became increasingly difficult to ignore the depressing effects of their captivity.)

Right after the shots of the three bears in the zoo, the video cuts to the same footage of "Solo No. 1" that I discussed earlier in this chapter, only in this context, the circling and the crawling seem, at first, to suggest a parallel world of containment. After watching the grizzly bears move back and forth on the video, the viewer might believe Forti's circling echoes their pacing to some extent, as if she were walking the edges of an enclosure. But the calmness of her demeanor is radically different from their compulsive motion. Forti takes her time with each variation, testing the balance and momentum when she flings out an arm or tosses her head. She is playing with the forces of thrust, gravity, and momentum within a field of her own making, while the animals featured on the video before this solo are being forced to mobilize in a situation outside of their control. This conceptual juxtaposition between animal subjugation and human creative agency in the video strikes me as odd, and I am not exactly sure of its artistic intention. Unlike so many of her live improvisations with animal movement that emphasize the continuity of human and animal circumstances, this video separates their lives.

What is clear, however, is that in her live performances, Forti's moving body rarely references the movement of animals in the zoo in any literal manner—she is not trying to imitate them. Rather, she transposes a sense of their physical embodiment to her own corporeality. Dance critic Siegel writes that Forti's movement style in the 1970s did not directly imitate animals but rather moved with what she calls a "heightened awareness of body surfaces."[30] Review-

ing Forti's *Jackdaw Songs*, Siegel reiterates this distinction between imitating and embodying. "I think she's able to get into the mind of the animal as well. This means folding back layers of her own evolutionary development to revive some of the faculties no longer needed by Homo Sapiens—long distance eyesight, for instance, or an acute sense of smell and hearing."[31] Forti's research observing animals move, whether in the zoo, in nature, or at home, gives her a deeper sensibility regarding the forces that animate the world. She internalizes impressions concerning their state of being as well as a particular movement vocabulary. Forti considers this part of a complete ecology of self, body, and world, one shared by people, animals, and plants. Witnessing animals, Forti distinguishes between representation and recognition—between mimesis and the feeling of their inner (e)motion. "I never copied any of the movements I saw, but rather abstracted certain structural aspects, working them out in the laboratory of my own body" (1984, 11).

Forti articulates this action of taking impressions into her body as a kind of "animism"—thus bringing an intriguing perspective on the whole question of mimesis and anticipating twenty-first century discussions concerning the Anthropocene.[32] In "Full Moves," she writes:

> Animism is a process of identification with a spirit very foreign to one's own, a recognizing of that spirit and coming to understand it by activating that part in one's self which one has in common with it, even if it's a part one is usually not in touch with, a gear in one's system which one doesn't usually engage. If there is a great deal of faith that there is common ground between living systems, a mimicry of the smallest detail can spark the process of identification. (1984, 14)

Here, Forti references the Latin meaning of the term "anima" as something more potent than a material physicality, as something closer to spirit or soul.

In an interview with choreographer and scholar De Spain two decades after "Full Moves" was published, Forti again calls her process animistic. "I think what I do probably is pretty animistic. I take on

Simone Forti's Movement Workshop announcement, 1974. Getty
Research Institute, Los Angeles (2019.M.23).

the spirit of animals, plants, dynamics, whole wars, and just become
them. And then I play out the details and the dynamics that are in
there."[33] In describing Forti's performative persona, De Spain uses
the term "inhabited"—a wonderfully apt term for the sense of im-
mersion in another's reality that Forti can embody while dancing. In
a similar vein, Forti has been known to refer to this as "channeling"
another being—not only their movement but also their "inner atti-

tude." Both of these words, like Bryan-Wilson's notion of "mantra," suggest a metaphysical as well as a physical experience. Forti meshes her notion of animism with her desire to mark coincidence as a cosmic alignment as she speaks of the "dense coincidences I've lived through and the unquestionable communications that have passed between me and other things, animals, rocks" (14N). Animism, for Forti, is about perceiving a force and then meeting it with one's own movement, like catching a ride on a wave. Neither passively copying that energy nor actively controlling its direction, she focuses on the possibilities of mutual engagement. It is a question of moving and being moved as a dialogue—that continual looping back and forth of inspiration and vibration.

Since many of Forti's early performances have not been well-documented, it is revealing to look at and think about these animate exchanges in terms of a 1977 video collaboration between Forti and poet/artist Anne Tardos. At first viewing, "Statues" strikes one as an odd compilation of separate shots in which Forti's movement is placed alongside the architectural details of buildings, plants, and the sounds of a chime. Unlike "Solo No. 1," which is shot from an audience's perspective, "Statues" creates a space of reflection rather than action; Forti's dancing is part of a larger landscape rather than the sole focus of the video. The fifteen-minute video begins with a close-up of a metal chime swaying in the wind. Aside from the background noise of the traffic on the street, the irregular tinny sound of the chime is the only musical accompaniment for the visual tapestry of different shots. After the title credits, another close-up of a brick wall slowly pans out to reveal Forti standing on a pedestal, swinging her whole body from side to side. As her upper body drops and rises, Forti plays with the lofts of her head and loose curly hair, emphasizing each suspension with a slightly different rhythmic syncopation or movement gesture.

The next shot finds her doing the same movement but in a different location—outside on top of a roof. A long pan of the wet roof follows as Forti slowly rolls across the length of it. Next, we return to the inside of Forti's loft, and there is a beautiful section in which

she is standing in front of a large window and arching backwards, sequentially rippling her arms towards the sky. In the next shot, Forti is seated, perched on the tips of her sitz bones, with her legs and arms reaching towards the sky, mirroring a snake plant placed right next to her. Clearly this plant is more than a prop, it is a collaborator in the work. In her prose poetry chapbook *Angel*, Forti extolls the "fibrous tongues erect and curled for catching rain" of her dark succulent snake plant in one entry (1978, 4). Later, she describes how even a plant can inspire her movement:

> And in the company of the snake plant one
> can balance on one's back, reaching limbs, leg
> and arm and arm and head and leg reaching
> upward among each other snaking slightly (1978, 23)

The video ends with a final close-up of Forti's face as she slowly shifts from one profile to the other, concentrating on some kind of meditative inner state. Although I do not want to overread this video, the pacing in combination with the repetitive, minimal movement vocabulary suggests a visualization of Forti's concept of animism—of moving and being moved by the sounds, wind, plants, and landscape of her studio environment. It captures an aspect of her belief in the vibrational power of these exchanges, and it was an important enough work for her to revisit and revise the video twenty years later, in 1999.

The receptivity cultivated by the kind of improvisational dancing Forti was engaging with at this time has a deeply meditative quality. It entails a sense of vulnerability and a willingness to open oneself up to new directions. At once sensorial and internal, this state of being is nonetheless visible to an audience. For instance, in her review of Forti's performance at the Sonnabend Gallery in the December 1974 issue of *Dance Magazine*, dance critic Elizabeth Kendall comments (as do many reviewers) on Forti's incredible concentration and calm presence. Of Forti's crawling in the performance, she writes: "I don't think she was dancing about an animal; I think she was listening to forces."[34] Experiencing this "play of forces" or finding the sense of

animism in the person, plant, or animal parallels Forti's earlier explorations of altered states at Woodstock and the years immediately following that experience.

These are the years when she focused on honing her awareness of vibrational possibilities, those underground currents of energy that one can feel but not always see. Her dedicated study of Tai Chi—as well as her participation in extra-ordinary events such as those mediated by drugs, dancing to music for long periods of time, and living communally—filtered their way through her muscles and bones to create an appetite for dancing that laid the foundation for what would become her life-long practice in improvisational performance. This was when Forti was beginning to articulate her central idea concerning what she calls the "dance state" or a "state of enchantment."

One of the earliest references to Forti's conception of a dance state is found in a notebook entry wherein she reminisces about the communal dancing she did at Woodstock. This state of dancing (perhaps not unrelated to a state of sleeping) is something that almost everyone has experienced at one time or another. Social dancing is the most obvious example, but she also witnesses it in children moving unselfconsciously and in animals playfully frolicking. Forti decides to try to "create the conditions for this dancing to happen" by engaging in a serious study of that state. In an early 1970s notebook, she reflects: "And when I'm in a dance state, the movement that comes out through me enchantes [*sic*] me. It can be very simple movement, but it always comes with a sense of wonder and is one of life's more delicious moments" (14N). As she continues to explore ways to induce this enchanted state of dancing, Forti connects the etymology of the word enchant to the French word *chanter* (to sing) and speaks of the dance state as "a kind of being be-songed" (2003b, 130).

Over the course of a decade of writing, she refines the terms of this engagement from a magical condition to a meditative state to a definition that intersects with a more general state of flow wherein "you arrive at a certain concentration and then it's not an effort to do what you're concentrating on doing because your whole system is flowing in that direction."[35] This dance state is a powerful state to

enter, a situation in which there is both intense focus and yet a sense of wonderment at what is unfolding moment by moment. As she hones her definition of the dance state, Forti evokes its hallmarks in terms that also align with her interest in the magical coincidences so common in improvisation.

> I believe the dance state to be a certain gear, a certain pattern-ing of the neuro-chemical system among the many patternings or gears in the repertoire of the living being, as are the states of sleeping, or of concentrating on a problem or of sexual arousal. Intense pleasure is one of the earmarks of the dance state. I've thought of the term enchantment because of its root, chante, or to sing. To be enchanted, or conditioned by song. And certainly music is a great releaser of the dance state. But enchantment implies a passive state, while the dance state is active. It's an activation of motor intelligence. And a feedback that stimulates one to move, brought by the experience of the movement itself. As I've experienced it, my witnessing self becomes amazed at the articulations and variation of attack and equilibrium with which my body enters into relationship with the forces of gravity and momentum. And this is true whether the movement is a sponta-neous outburst or gesture, a living exploration of certain aspects of movement or of imagery, or the execution of a pre-established sequence of movements. (1984, 8)

In *Oh, Tongue*, Forti further explains what the dance state feels like from the inside.

> I have experienced it as a state of heightened awareness where one possibility after another presents itself as an unfolding path. As I rise, sink, and turn, my eye catches the shadow play of leaves on the far wall, suggesting the next move. I think it's a state of being. [. . .] The dance state can occur in performance of choreo-graphed work. Improvisation depends on it. When it's flowing very strongly, it is as if an angel were dropping the improvisation in your lap." (2003b, 130)

This "dance state" allows Forti a simultaneous internal focus and external awareness that is deeply powerful to witness. In her retrospective essay "You Make Me Feel Like a Natural Woman: My Encounters with Yvonne, Simone, Anna, and Trisha," dancer and writer Wendy Perron relates the story of Forti doing a spur-of-the-moment improvisation for students at the end of an intensive workshop she was teaching. "She instantly got into the zone," Perron recalls. "Suddenly out of nowhere, tears came to my eyes. [. . .] I think it was the sheer power of the concentration that she mobilized—and that she demanded of us, the onlookers—that brought me to that state."[36]

I, too, have been amazed by Forti's solo performing—her incredible focus combined with a generous presence. It can be quite extraordinary to see how she moves from one image to another, one movement motif to another, and then finds a way to tie them all together in the end. To this day, I can remember an impression I had, if not the specific details. Fortunately, I have a practice of writing informally about performances right after seeing them. I begin an entry from October 22, 1988, with "When you watch Simone, it's like seeing a novel come alive in front of you—watching a moment and then recognizing its twin or antecedent later—piecing the bits together like a quilt." I attempted in this entry to draw a distinction between the traditional projection of dancers in performance and the real sense of aliveness that Forti embodies to my young mind. With candor, I note: "There's a bit of a mess out there—a nice mess that I like quite a lot—you don't know what she is doing, what animal she's trying to be exactly—but some moments are intense, like when she comes forward and kneels down and stretches her arms and just breathes fully so you can see the air moving her body as if she were affected by the breeze."

Like Perron, I find Forti's ability to enter the dance state deeply inspiring. I recall one occasion in April 1989 when Forti was performing in the Salvatore Ala Gallery space in SoHo. There happened to be a festive opening in the art gallery across the hall, and various folks would wander into the space where she was performing, completely unaware of what was going on and talking loudly. The tension started to mount as the audience wasn't sure whether to intervene or ignore

the rude interlopers and hope that they would figure it out. I vividly remember how Forti just stood up in the middle of what she was doing to address the strangers and told them it was hard to perform when they were being so loud. A spilt second later, she just dove right back into the improvisation without missing a beat or seemingly perturbed in any way. I later wrote about her extraordinary powers of concentration and ended my notes with: "Simone has quite a bit of spark."

In the fall of 1971, while she was studying Tai Chi with Ho'o and teaching periodically for Kaprow at CalArts's new Valencia campus, Forti arranged to use the cafeteria space for a series of open improvisational jam sessions on Friday evenings that she called Open Gardenia. In the spirit of the times, it was a pretty informal affair, and Forti quickly sketched a little poster that she hung on the bulletin board of the cafeteria. She invited musicians and movers, friends and acquaintances to come and join in or simply witness what might transpire. There is not much documentation of these events besides a brief mention in Banes's *Terpsichore in Sneakers* and some tantalizing journal entries in *Handbook in Motion*. Like many improvisational jams, it took a little while to catch on, but eventually Open Gardenia served as an important space for gathering potential collaborators, including her life-long association with the composer/musician Palestine.

In *Handbook in Motion*, Forti calls Open Gardenia an "open market-place [*sic*] where people could find each other" and appreciates the fact that there is something truly grassroots and communal about the situation. This kind of open improvisational jam requires a certain amount of patience and a willingness to sit with an attentive focus as people arrive and warm up their bodies, instruments, and artistic imaginations. Perhaps responding to some negative comments, Forti mentions in another journal entry the importance of keeping an open mind. "People criticize open-ended open to everyone improvisations saying that the music that results isn't very good. It's true in most instances, it takes a loving pacience [*sic*] to wait for the moments of clarity and power" (14N). By January 14, 1972, however, she describes a very beautiful session in which the whole experience was beginning

to "season," and folks were better at tuning in to one another's vibrational energies.

I believe that the experience of Open Gardenia connects to the many ways in which Simone Forti was experimenting with moving and living, discussed in this chapter. Producing a weekly event such as Open Gardenia allowed Forti to continue to hone her skill at—and desire for—an open format in which dance and music could cohabit in new ways. Over the course of the fall and winter, Forti learned how to be totally absorbed in her own physical research (circling being a main concern) while simultaneously tracking and interacting with what else was happening in the space. This balance of awareness between the music and movement allowed certain moments to surface from the general cacophony of the event. Events could be supported by the others stepping back energetically to provide a baseline for a solo or a duet. Similarly, certain moments could filter through that the whole group took up and reinforced, creating a joint action that swept across the floor.

This play between the individual and the collective is marked by an intriguing group of drawings in one of Forti's journals from that time. Composed on several pages are a series of couples facing off head-to-head, arms pushing into each other's shoulders. The viewer can almost feel the force with which they are pushing against one another. They look a bit like bulls fighting. Then, right next to these drawings is another of two people next to one another, arms around each other's shoulders with left legs lifted in synchrony, as if they were in the middle of an Israeli folk dance. At first, I thought these images reflected the push hands martial style of Tai Chi. But now I wonder whether they might also be a visual representation of an improvisation in which the play of forces can bring people (dancers and musicians) together in a mix of coincidence, friction, and flow.

Even as she moved back to NYC in the mid-1970s and began an ongoing collaboration with Van Riper, Forti never lost the immense pleasure she took in playing with whatever forces were available at a given moment—the essence of her improvisational practice. In her essay "Animate Dancing: A Practice in Dance Improvisation" Forti

Page from Simone Forti's 1970 Notebook (16N). Getty Research Institute, Los Angeles (2019.M.23).

compares composition and improvisation—the conceptual and the vibrational. "Perhaps choreography is like oil painting. And improvisation more like watercolor where the immediacy of the mark, or gesture, is an important part of the poetics" (2003a, 55). In this chapter, I have shown how Forti's life experiences during the late 1960s and early '70s brought her into a state of being in tune with the animated energies she experienced in the world. Across multiple life transitions, she strove to cultivate a practice that balanced a deep somatic focus with an open improvisational inquiry.

In a journal entry that sums up resolutions about her craft at the time, Forti circles three crucial elements: discipline, adventurousness, and faith. Like many contemporary dancers of her generation, she was interested in divination—in consulting forces just beyond our comprehension of cause and effect—including consulting the I Ching.[37] Although the following words could be a result of such a reading, I prefer to think of them as a recipe for preparing to enter Forti's "dance state." A facsimile of this page from Forti's notebook has hung in front of my desk while I have been researching and writing this book, and I have attempted not only to understand the import of these terms for Forti, but also, in some ways, to be guided by them.

> I prepare . . . tune myself.
> tai chi (discipline)
> meditation
> diet
> I expose myself
> wander
> listen (adventurousness)
> look
> I act
> flow
> the way will present itself
> (faith)

Weaving these strands of discipline, adventurousness, and faith together, Forti created an improvisational poetics that blended curiosity with focused movement research—the vibrational with the conceptual—an approach that has helped to sustain her dancing throughout her career.

Tuning

For the opening of her 2014 retrospective at the Museum der Moderne Salzburg in Austria, Simone Forti performed her 1961 solo *Accompaniment for La Monte's "2 sounds" and La Monte's "2 sounds."* The museum is housed in a contemporary building perched on the edge of a small mountain overlooking the center of town. Given the quaint Austrian character and narrow streets of the historic quarter right below the museum, it is a bit surreal to take the elevator up to the top and emerge into the vast concrete lobby of the distinctly modernist structure. To one's right is an equally immense staircase that leads up to the main galleries on the top floor. Halfway up these stairs is a broad landing. Light from the bay of windows at the top of the stairs shines down, illuminating the gray stone floor. A very long, thick rope hangs suspended in a loop, echoing the plumb line of the rock-face on which the building sits. A small crowd gathers as an assistant helps Forti step into the loop about a foot off the ground. Forti places one foot in the loop and her hands on either side of the rope while the assistant winds her in a clock-wise direction. As La Monte Young's loud, incredibly brash 1960 recording of *2 sounds* fills the space, Forti spins with a velocity that makes the audience gasp with fear that Forti (who was seventy-nine at the time) might slip out and fall. Forti, however, remains perfectly calm in the midst of this violent winding and unwinding. Over time, her revolutions slow down until there is just the slightest twist from side to side. Once still, she shifts her hands and adjusts her gaze, maintaining a focused but open demeanor as she listens, suspended in a vortex of sound.

Originally recorded in Anna Halprin's studio in 1960, *2 sounds* is an example of what Young called his "live friction sounds." As its name suggests, *2 sounds* features two continuous sounds: a drumstick drawn across a gong, and the scraping of metal cans on a glass window. Played at top volume, this thirteen-minute, eleven-second recording is so loud and relentless that its sound actually takes on a material density, what John Schaefer, a music critic and producer of "New Sounds" syndicated radio program, calls "a physical mass—or better, the actual physical movement of the sound waves."[1] There is certainly a peculiar grating quality to it, what one contemporary audience member called "excruciating." Young and Terry Riley were serving as Halprin's musical directors during her 1960 summer workshop. Halprin owned a reel-to-reel tape recorder, a rare piece of equipment in those days, and Young and Riley jumped at the opportunity to use it, improvising across a range of found objects to make new sounds. Riley, who met Young when they were both graduate students in composition at the University of California, Berkeley, writes that *2 sounds* has a "ferocious, almost vocal quality [. . .] a kind of Shiva energy."[2] Riley's Shiva analogy is intriguing for it points to how the initially destructive sound transforms to become, by virtue of its ongoingness, restorative in some fashion.

The first time I heard the piece loudly echoing in the concrete and stone stairway in Salzburg, I was pretty desperate for it to end. After listening more carefully in subsequent performances, I began to associate the deeper and larger swells with stampeding elephants. But unlike in the movies (*The Lion King*, for example), that sound doesn't actually peak or recede; it just continues, contrasted to the higher screeching tone. Musical compositions' narrative structure of climax and resolution implying that *something is happening* is absent. The usual temporal framework disappears. Instead of a sound unfolding through time, the listener has the sensation of that sound filling the space with a density that is palpable. Then the piece just stops; the sound friction evaporates, and the resulting quiet is expansive, magically filled in Salzburg with light from the windows and the distant sounds of birds and voices.

In his artist's statement about *2 sounds* included in the materials collected for contemporary performances of *Accompaniment*, Young describes how the live friction sounds were produced by scraping wood or metal against concrete or wood. He references John Cage, who "introduced us to the importance and detail of a world of sounds that we might formerly have thought of as noise." Young speaks of wanting to "get inside" a sound, a method of listening that he expounds again and again throughout his writing. "Many of the sounds generated in this way produce very unusual sets of harmonics that I enjoyed listening to for long periods of time." While in residence during Halprin's summer workshop in 1960, Young gave a talk to the dancers and artists assembled. His "Lecture 1960" was subsequently published in the winter 1965 issue of *The Drama Review* (now *TDR*). The last section details his evolving conception of sound as both audible and spatial—sound as an environment that can envelop the listener.

> Along with the new sounds, of course, we found new ways of producing them, and we also reconsidered sounds we had never previously listened to so closely. [. . .] These experiences were very rewarding and perhaps help to explain what I mean when I say, as I often do, that I like to get inside of a sound. When the sounds are very long, as many of those we made at Ann Halprin's were, it can be easier to get inside of them. [. . .] I began to feel the parts and motions of the sound more, and I began to see how each sound was its own world and that this world was only similar to our world in that we experienced it through our own bodies, that is, in our own terms. I could see that sounds and all other things in the world were just as important as human beings and that if we could to some degree give ourselves up to them, the sounds and other things that is, we enjoyed the possibility of learning something new."[3]

For Young, sound, precisely when it is released from the strictures of musical composition (including authorship) and stands on its own, can become one of many animating forces in the world. As this

chapter explores, sound—including improvised music, folksongs, and sonic environments—and the musicians who made it became another way for Forti to access vibrational energies in the world.

Along with Yvonne Rainer, Trisha Brown, Robert Morris, and others, Simone Forti participated in Halprin's 1960 summer workshop. While there, she heard Young and Riley develop their work, including *2 sounds*. Many of these artists went to New York City in the fall, where they continued to be involved in intersecting circles of influence, witnessing one another's work in small loft or studio spaces. That year, Young was responsible for curating a series of new music and performance events at Yoko Ono's studio on Chambers Street. He invited Forti to show something in spring 1961. In addition to her Dance Constructions such as *Huddle, Slant Board, Hangers, Platforms*, and *Censor*, Forti premiered *Accompaniment to La Monte's "2 sounds" and La Monte's "2 sounds."*

In her 1974 memoir *Handbook in Motion*, Forti notes that she spent a lot of time listening to Young's music in those days. "He was working with sustained tones: sound that had a lot of distinguishable parts within it, yet the parts were present all at once, and the sound didn't change very much in the course of its duration. The music had a sense of natural, untampered existence, and I was grateful to hear it" (1974, 34–35). By then Forti had developed the curiosity as well as the patience to listen to this experimental music with an attention to the small changes happening in the midst of the atonal drones. Although she and Young tried to improvise together some, their schedules never really aligned. (She was a day person; he was a night owl.) Discussing the genesis of the piece in an interview with composer Tashi Wada, Forti says that, though she was never particularly interested in musical accompaniment to her dancing per se, she "got a kick out of doing an accompaniment for music." She characterizes *2 sounds* as "like a cliff, or the wall of a mountain, so I like standing with it." Forti also asserts her role as an intermediary between the audience and the music. "I feel that I facilitated hearing it by being visibly present listening to it."[4] Her instructions for *Accompaniment* in *Handbook in Motion* are strikingly matter of fact, and she does not elaborate at all on the kind

of noise composition involved. What she does make clear is that the piece is meant to be an *accompaniment* to the main event: Young's music. She actually specifies that the rope should be hung off-center, preferably in a corner, so that it does not compete for attention. After a list of necessary equipment, Forti explains:

> The piece begins when a person gets into the rope. A second person turns on the tape, slowly turns the person in the rope round and round and round until the rope is completely wound up and walks away. The sound fills the space. The rope unwinds, then rewinds on its own momentum, unwinds and rewinds on and on until, finally, it becomes still. The unwinding ends many minutes before the tape is over. The person remains in the rope, hanging plumb and listening. (1974, 64)

Neither in the 1960s nor more recently for the purposes of reconstruction does Forti specify how to perform this "listening" for the duration of the piece. In a 2016 interview at the PHI Foundation for Contemporary Art in Montreal, Forti says *2 sounds* is "very strident and it has to be played very loud." She delineates the role of the performer, who: "listens and it becomes a very meditative piece. The sound has a lot of interest in it; the performer listening allows the audience to just kind of relax and listen too."[5] Clearly, those minutes of stillness and focus can make all the difference in the world in terms of how the audience hears *2 sounds*. In his retrospective essay in *Simone Forti: Thinking with the Body*, Morris describes Forti's presence in that seminal performance of the work at Yoko Ono's loft. "After she stopped moving, still in her rope sling listening, she listened for us, and we were calmed by her stillness and could allow ourselves to listen (endure?) with her."[6]

When I saw Forti perform *Accompaniment* in Salzburg in July 2014, I was mesmerized by the intensely dynamic quality of her presence in the rope. There she was, suspended and balanced on one leg for more than ten minutes. Relaxed but focused, she seemed to need very little effort to maintain her balance or her grip on the rope. I began to sense that the sounds were enveloping her—surrounding her and support-

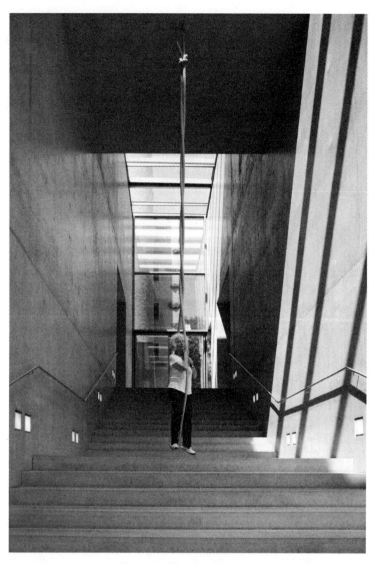

Simone Forti performing *Accompaniment for La Monte's "2 sounds" and La Monte's "2 sounds"* in Salzburg, Austria. Photo by Rainer Iglar. At the exhibition *Simone Forti: Thinking with the Body*, 2014. Courtesy of the Museum der Moderne Salzburg.

ing her. It was as if every cell in her body were a tiny ear, absorbing the sound on a molecular level. Dance scholar Sally Banes was similarly impressed when she witnessed Forti perform this work. In *Subversive Expectations: Performance Art and Paratheater in New York 1975–85*, she notes: "Forti's concentration is like no one else's. As she turned in a slow-motion pirouette and, finally, just stood there in air, listening to the crashing sounds, her silent there-ness became radiant."[7]

In contrast to Forti's "radiant" presence, the performances of the work when it was presented as part of "Judson Dance Theater: The Work Is Never Done" show at MoMA in 2018 and 2019 were disappointing. Once the rope had finished twisting back and forth, the contemporary dancers (the casts changed) just stood statically, obviously waiting for the sound to stop. There was no sense of engaging with the physical density of the sonic environment, nor was there any dynamism or three-dimensionality to their listening. As a result, the audience's experience was also flat, and most people either quickly moved on to the next room or scrolled their phones as they waited politely for the loud shrieking to end. Even though Forti and Sarah Swenson, MoMA's project coordinator for reconstructions, worked to help the younger dancers understand the historical moment in which these works were first performed, the attentive listening critical to the success of *Accompaniment* alluded them. Rather than tuning in to the complexity of the live friction sounds, they seemed to tune them out.

Tuning, for Simone Forti, is a state of being—a "finding of certain forces" as she writes in *Handbook in Motion* (1974, 16). The word "tuning" encompasses both a musical sensibility and an existential disposition. In its archaic form, "tune" literally meant "to sing," and throughout her life, Forti has enjoyed singing Italian folks tunes and composing nonsensical ditties. "Tuning" is a gerund that calls forth the ongoing experience of oscillation and the adjustment of vibrations—a recognition that sound can never be static. Like a dancer's body, musical instruments require constant tuning. In addition, tuning can also move across several registers, both physical and metaphysical, to suggest an attention or responsiveness to something. To be *in tune* with the world requires a harmony of purpose. This

meaning of tuning leads us to the kind of deep listening that Forti demonstrated in her 2014 performance of *Accompaniment*. In the 2018 PHI Foundation interview, Forti recalls: "Something important that I learned from John Cage is that he had wanted to be able to hear a sound and not have the distraction of what he expected the next sound might be."[8] The release of expectations is critical in any kind of improvisation but particularly important when one works within a structure that involves repetition or continuous sound. Forti's attentiveness to *2 sounds*—as if hearing it for the first time—demonstrates her uncanny ability to "get inside" the sounds Young composed.

Researching the ways in which sound—songs, noise, music, and the found sounds in natural and urban environments—weave their way through the tapestry of Forti's development as an artist has made me much more aware of the sonic environment and its role in her oeuvre. From the listening at stake in *Accompaniment* to the whistling in *Platforms*, the shouting/singing match with shaking nails in *Censor* to the elaborate score of *Face Tunes*—not to mention the extended collaborations with musicians such as Charlemagne Palestine and Peter Van Riper and the twenty-first-century releases of *Al Di Là* (2018) and *Hippie Gospel Songs* (2018)—sound is clearly an animating force in Forti's life and work.

As composer Wada points out in his 2018 interview, however, "[m]usic and sound are perhaps the least explored threads of Simone's work." Forti concurs: "Sound is more of a surprise, since I'm perhaps less aware of it generally—but then, when I am listening, it's such a fresh surprise. Like this morning, hearing the rain outside and enjoying it."[9] Wada is the producer of *Al Di Là*, a collection of Forti's sound pieces from the 1960s and 1970s, and in this interview he expresses his satisfaction with the "raw and diaristic quality" of Forti's voice on the album. She agrees, comparing it to picking up a writer's diary. "I like that the album, as an experience of sound, takes the listener through different environments and attitudes, from abstract vocalizing to the sound of a vacuum cleaner or an urban street . . ."

In the delightfully quixotic 1990 interview with Banes that was videoed as part of Ellen Webb's and David Gere's Talking Dance

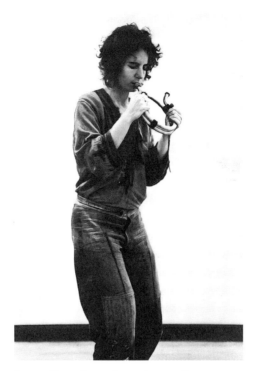

Simone Forti playing her molimo in Rome, 1972.
Courtesy of Fabio Sargentini, Archivo l'Attico.

Project, Forti explains the role of music in her experience. Discussing her improvisational work with musicians such as Palestine while she is moving and gesturing next to Banes, Forti reveals how much she enjoys working with a musician over a period of time so that they can develop something together. Forti alludes to the fact that she rarely uses prerecorded music, especially not the "great" works by Johann Sebastian Bach or Ludwig van Beethoven. Much to the amusement of the audience, she slyly adds in her faux naïve voice: "I mean, I would want them to work *with* me." Shifting gears, she mentions her own music which, she asserts, has always given her a lot of pleasure. But, she insists, "I pretend I don't do it, so I don't have to think about it. It just sort of happens."

Inspired on the spur of the moment, Forti proceeds to make music happen right then by getting the audience to sing the tune of the Beatles song "The Fool on a Hill" while she sings an old Italian folk song on top of the melody. This combination was first staged in 1968 as part of *BOOK*, a dance that projected black and white slides of her home and was prefaced by these two songs. In *Handbook in Motion*, Forti recalls "The two made a harmonious and amazing blend" (1974, 81). This spontaneous vocal performance in the midst of an interview is a wonderful example of how Forti delights in building a sound world of her own choosing.

Although both Young and Palestine vehemently refute the assignation of *minimal* music, preferring to use the term *maximal*, their work does fall under the umbrella of Minimalism in music as articulated by Eric Salzman in his book *Twentieth-Century Music*. Salzman uses the term "texture" to describe the kind of materiality of sound that results from an improvisatory development of tone clusters and sound density. He notes how experimental music in the mid-twentieth century included elements that have been part of non-Western traditions. "The idea of a non-dualistic music grounded on simple patterns and repetition, regularity of pulse, economy of means, clear (if extended) structures, and transformation by slow incremental change is common enough in other musics of the world, but it has permeated Western music on a large scale relatively recently."[10] This new awareness of music from other countries expanded the imaginations of many mid-twentieth-century composers.

The process of researching and writing this chapter has heightened my own awareness of the constant overlay of sounds near and far. I remember taking a break one day to stretch out on the couch. Very quickly I became aware of the regular beat of my heart, the watery gurgles of my stomach fluids, the scattered calls of birds outside my window, and the faraway drone of an airplane overhead. I was fascinated by the natural variation and compositional elements in this sound world. It was a window into what I was exploring, including the radical discoveries of John Cage and the many composers who followed in his considerable wake. According to Randy Coleman, a

professor of composition at the Oberlin Conservatory of Music for many years, the significance of this experimental work (what was called "new music" in the 1960s and '70s) is that it forces musicians from all musical genres to pay attention, to learn how to listen in the absence of the usual musical signposts. In an interview, Coleman asserted: "Whether you like it or not, it is going to change how you listen to music, how you experience music. [. . .] That's what it is about. It's about galvanizing attention and focus."[11] He also acknowledged that there are no short experimental pieces, that most of this kind of music requires a commitment to get "hooked up," to find the motivation and the curiosity to stay with it.

"I am sounds [. . .] I am the moment that passes and the layers of sound, the singing and the buzzing sounds, the car sound. I am all these sounds, paper and and and a car horn" (56N). Written during her February 2001 Logomotion workshop in Athens, Greece, this journal snippet highlights the extent to which Forti envisions sounds as coextensive with her experience in the world. In a similar vein, a journal entry from 1993 links the ambient sounds flowing through her cabin at Mad Brook Farm in Vermont with singing during her time in Italy.

> Resonance. My Italian touring comes into play. Re ri re ri son suonanza resonance. The heater comes on with its sound, its clicks tich ta ta do da do da de do de da do de do de. And the exact pitch of the exact moment. (89N)

Listening, getting inside sounds, becoming sounds, locating sound in her environment, these are the practices that inform two other Dance Constructions from Forti's seminal 1961 concert. Unlike the taped score of *Accompaniment*, *Censor* and *Platforms* generate their own sound as part of the performance. The instructions for *Censor* in *Handbook in Motion* are dryly cryptic: "One person shakes a pan full of nails very loudly, while another sings a song [of their choosing] very loudly. The volume should be in perfect balance" (1974, 66). Forty-four years later, writing the liner notes for *Al Di Là*, Forti is more forthcoming about its origins.

Censor was inspired by an experience in the NY subway. A train on my habitual route would always make a terribly loud screeching while careening around a particular curve. One day I spontaneously sang as loud as I could as we turned that corner. None of the other passengers gave any indication of having heard me.

While at the restaging of her Dance Constructions in Salzburg, I witnessed Forti teaching *Censor* to the young contemporary dancers from the Salzburg Experimental Academy of Dance. I remember a whole discussion about the sound quality of copper versus steel nails and the importance of the right kind of metal pan (tin). In the Salzburg reconstructions (performed regularly inside the museum and once outside in the center of town that opening week), the two performers stood about five feet apart, looking at one another singing and shaking nails as loudly as they could. Photos from those performances show the audience gathered around holding their hands over their ears, a direct reaction to the "very loudly" aspect of the score's instructions. In the retrospective essay "Between Two Continents: Simone Forti's *See-Saw*," art historian Meredith Morse calls it a "sound competition" in which the singing becomes a shout while the shaking becomes louder. "The work pits the sounds of vocal materials themselves, the muscles of the throat and chest, against the sound properties of metal."[12]

It is striking that the available recording of *Censor* on *Al Di Là* is not particularly loud. In fact, the shaking pan of nails sounds weirdly diluted, falling into the same rhythm as Forti's Italian song and sounding more like background percussion than a dynamic feature in its own "noisy" right. The recording was part of The Box gallery's presentation of Forti's work in a 2012 show entitled (appropriately enough) "Sounding," and it is possible that this muting happened during the post-performance production. In any case, I was fortunate to witness a brilliant live performance of *Censor* during the Judson show at MoMA in 2019. In the modest gallery space where some of Forti's Dance Constructions were performed, the two dancers stood quite close to one another. Locking eyes, they sang and shook with

defiant fierceness, sonically battling one another and upping the aural ante. The mutual building of energy was tremendously exciting, and when they stopped, the audience burst into spontaneous applause, the only time I witnessed clapping during the whole series of Forti's reconstructions.

If *Censor* shares with *Accompaniment* the strident, noisy sound that was a feature of 1960s experimental music, *Platforms* reveals the sweet and lyrical side of Forti's musical palette. Described by Forti as both a sculpture and a musical piece, *Platforms* consists of two light-colored, rectangular wooden boxes (without bottoms) of unequal sizes placed at an angle about five feet apart. Two performers enter the space and get under the boxes, essentially echo chambers, they begin a whistling call and response of sorts. In the program notes to the video *Simone Forti: An Evening of Dance Constructions*, Forti acknowledges that the piece, usually performed by a man and a woman, has "overtones of romantic love."[13] This aspect is reinforced by the instructions in *Handbook in Motion* that the man is to help the woman under her box before getting under his own. By the time of the Judson reconstructions at MoMA more than half a century later, Forti allows that the two performers could be two women, two men, or a man and a woman. Regardless of who is performing it, the very structure of the piece builds on a tonal harmony that lends itself to a sense of intimacy. Forti explains why:

> Each takes his/her time breathing in, and on each out breath softly but clearly whistles whatever tone comes to mind. There will be moments of silence and moments when their tones overlap or seem to answer back and forth. I have thought of this Dance Construction as a love duet. The audience listens to this delicate music in the presence of these two thoughtfully placed platforms.[14]

There is a wistful, longing quality to this piece, which Forti says conjures one person lying in bed, thinking about another person lying in a bed far away.

On the page opposite the written instructions for *Platforms* in

Handbook in Motion, there is a photo by Peter Moore of an audience member listening to a performance of the work at Loeb Student Center at New York University, NYC, in 1969. The man is sitting on a second-floor balcony, his legs dangling over the edge. His hands are folded as if in prayer and his eyes are closed. There is a meditative quality to his posture. He is clearly focused on hearing the whistling in the distance. Down on the first floor are two wooden boxes, with audience members clustered around the perimeter of the space. Most of the early performances of this ten-minute sound piece took place in spaces with wooden floors, amplifying the resonance in the space. In the twenty-first century, the Dance Constructions were most often restaged in contemporary galleries of art museums with concrete floors, sometimes requiring that one end of the boxes be lifted a few inches to ensure that the performers could hear one another—and that the audience could hear them. Because the Dance Constructions performances at MoMA were embedded within a larger exhibition on Judson Dance Theater, a piece such as *Platforms* lost much of its delicate and meditative quality as people strolled through the exhibit and talked, often unaware that there was something going on under the wooden boxes.

In her book *Centering in Pottery, Poetry, and the Person*, artist M. C. Richards reflects on her poem entitled "Hands . . . Birds." Richards, an artist, poet, and important faculty member at Black Mountain College in the 1940s and 1950s, was an early colleague of John Cage's and was interested in asking many of the same questions as he about the nature of indeterminacy, silence, and sound in the environment. Like the beginning of Forti's *Handbook in Motion* wherein several words can float on the otherwise blank page, this poem is printed with just two words on the page: "Hands" on the top left and "Birds" on the bottom right, with a diagonal of open space between them. In her discussion about this work in *Centering*, Richards muses:

> Two nouns, two sounds, with a long silence between. A long
> time of silence which is, on the page, a long space of emptiness.
> *Hands* is an image. *Birds* is an image. Between them, a long

wordless flight. Each reverberates in the stillness. The reverberations intermingle.[15]

There is something about the simplicity of this poem and Richards's thoughts about space and sound that reminds me of *Platforms*. In addition to sound, Forti is interested in silence and stillness, the movement equivalent of silence in a dance performance. In a journal entry from the late 1970s, Forti notes, "so much communication is pause. So much dancing is pause, stillness, stillness in which to listen, stillness in which to remember the movements that went before, to see them again in memory" (50N). Taken together, these comments help us look past the task-based "construction" aspects of *Platforms* to the less visible traces of breath and lyrical exchange resonating in this work.

Memory and listening feature prominently in two other sound pieces Forti composed and performed in the 1960s. Both *elevation tune* (1961) and *Face Tunes* (1967) were musical scores derived from everyday experiences, and both contained, in Forti's words, a "ghost" or "trace" of a time or person. In *Handbook in Motion* Forti writes that *elevation tune* is a recording of her movement up and down stairs as she went from her apartment on the sixth floor to the subway, to her work (also on the sixth floor), and to the many rehearsals and performances she attended that week. Those busy comings and goings contrasted with the next week, which Forti spent sick in bed.

> At the end of two weeks I drew up a musical staff and placed the different stations up and down the scale. I came out with what I called an elevation tune. One day I handed the elevation tune to La Monte to hear what it sounded like. He whistled it to me, and in a palpable sense it had very much the feeling of those two weeks. It seemed to me that it was their ghost. (1974, 71)

This was a moment of transition for Forti as she moved from one marriage (with Morris) to another (with Robert Whitman). The score played by Young seems to have disappeared, but we can imagine how the range of musical notes up and down the scale yielding to a flat tone might aurally summon that moment in her life. Although never

formally recorded, *elevation tune* was a method of tracing physical states through sound in a manner that produced their emotional resonance.

Face Tunes has been performed and recorded by Forti at numerous times throughout her career. The original sound-making machine (with slide whistle) that Forti created for it still exists. The machine has been on display in a variety of venues in the twenty-first century, including at Forti's "Sounding" retrospective at The Box and at the Museum der Moderne Salzburg. Often, there is a video of Forti demonstrating its use right next to the actual artifact. In the liner notes of the *Al Di Là* compact disc, Forti recalls: "At the time I made this piece I had been contemplating the phenomenon of how the face of someone one is falling in love with appears uncannily attractive." She decided to draw a series of profiles, and then attempted to match sounds to the shapes. At first, she approached a computer engineer to see if it was possible to feed the profile into a computer program, but in the end she decided to build her own homemade system. The setup consists of a scroll of paper with the profiles positioned horizontally, the forehead of one face leading into the neck of the following one. There is a single straight line drawn across the paper that corresponds to a constant zero tone that is played throughout the piece. The profiles line up on the page such that the bridge of each person's nose touches this midline, with the noses above and the neck below. A stylus (or stick) drops down from the slide whistle, allowing the player to follow the lines of each profile as they play the slide whistle, generating sounds associated with each face.

In *Handbook in Motion*, Forti mentions that she was intrigued by the fact that a familiar pattern (chin, lips, nose, forehead) could also have infinite variations. "As form seemed to be the storage place for presence, I hoped that the act of translating a coherent aspect of a set of faces to a corresponding form might awaken a more primitive level of pattern or ghost recognition" (1974, 76). During a 2012 interview at The ZKM Center for Art and Media Karlsruhe in Germany, where the *Face Tunes* apparatus and video were on display as part of the "Moments: A History of Performance in 10 Acts" exhibition, Forti

explains that she felt it was possible to unconsciously experience the "ghost presence" of someone "by playing the tune of their particular profile."[16] Listening to *Face Tunes*, I find it hard to differentiate the sounds of specific features, because each new breath also changes the tone of the whistle. In addition, there is the constant background whirring of the machine's motor turning the scroll. What is fascinating are the moments when the tones align in range. This relationship between a point of reference and the pattern of a particular face creates an intriguing mix of drone with a more lyrical, almost melodic, overtone.

The same year she made *Face Tunes*, Simone Forti created *Cloths* (1967). In *Handbook in Motion* she writes: "This is a piece in which no one ever appears." After describing how the performers hide behind three big, black rectangles, each with layers of fabric stapled to the top which the performers periodically throw over, Forti discusses the sound.

> There are two tapes of songs. I recorded these by asking many friends to sing me their favorite song. I chose about eight that sounded the most like singing when you're hardly aware you're singing. [. . .] Along with the tapes, each performer sings a song from time to time. Periodically, from behind one of the frames a cloth is flopped over. There is a general overlapping of songs live and taped, interspersed with silences, and times when only one song is heard. (1974, 80)

Of course, much of the sound effects rely on the song the performers choose (and whether they are decent singers). When Forti performs the piece, she invariably sings at least one Italian song, the kind you sing when you are hanging up the laundry in the sun on a spring day.

The combination of (mostly) sweet songs and the ghostly presence of the voices behind the cloths evokes a traditionally domestic scene—a woman's world. Although the piece begins with three black rectangles, the different colored and patterned cloths that the performers throw over made me think of sewing baskets and quilt squares. The songs, divorced as they are from the singers' faces, carry a

haunting quality, a vocal wistfulness. *Cloths* was made at a time when Forti was struggling with the dissolution of her second marriage—the one that had promised the pleasures of domesticity. This marriage to Whitman, however, turned out to be more complicated. In talking to the press about *Cloths* on the opening day of her 2014 career retrospective in Salzburg, Forti spoke of the dream she'd had in which her husband didn't want to see her again. She said that instead of leaving, she hid, and that this piece represented a kind of symbolic disappearance. That was a sad, fraught moment in her life, and the piece still evokes a melancholy element of that absent presence.

When it was first performed in 1967, *Cloths* was advertised as a "new minimalist conceptual" piece. On the one hand, it is true that, like her Dance Constructions, this piece has a specific written score that uses simple objects and indeterminate sounds. Depending on who is singing and what songs they choose to sing, the piece can be ironic, funny and irreverent, or lyrical and vaguely nostalgic. But unlike the various Dance Constructions that were built with rope and plywood, *Cloths* has fabrics with intricate patterns, bright colors, and different textures and weights, which lend themselves to a more emotional, personal meaning. Forti told me that originally the material came from Brown's sewing basket. Looking at the mix of fabrics thrown randomly over the top feels a bit like looking through Grandma's old doll clothes. In addition, since the performers can't see as they throw the fabric over, there are really interesting effects when fabric gets caught or swags asymmetrically. For this reason, I was surprised at how vehemently I reacted to the video of *Cloths* that was filmed at the 2012 show at The Box. After shooting about four minutes of the ten-minute piece from the audience's perspective, the videographer began to walk around the space and behind the performers, capturing them crouching behind the frames. I found this footage awfully intrusive and deeply insensitive to the intention of the work itself. The powerful and haunting aspect of the piece instantly evaporated with this behind-the-scenes moment. While it is true that in a piece like *Huddle*, Forti encourages the audience to walk around

the living sculpture, *Cloths* needs the frontal perspective to fulfill its own promise.

In *Cloths*, the vocal sounds are disassociated from the bodies making them. Listening, one can tell that some voices are live—there is a certain urgency manifest in the air, even in the quiet songs—but we can't put a face or body to them. The songs come from elsewhere, untethered from a culturally readable figure. In *Throat Dance* (1969), the visible process of making the sounds is precisely the point. Forti's description of *Throat Dance* in *Handbook in Motion* mentions four sections of the sound work, each staged in a different part of the space, and gives quite detailed instructions for how she accomplishes these nonverbal sounds.

> It is a matter of getting a great degree of constriction in the throat and increasing the air pressure very gradually until it just passes the threshold of being able to pass through the constriction. I can't keep this balance of pressure and constriction constant, but I do my best, producing a flutter of clear, piercing squeaks. Another type was a loud double sound achieved with a throat posture that must be close to purring. The third was rhythmic pitch leaps, and the fourth of a similar order. (1974, 92)

While this work seems only to have been performed once, in Italy as part of the "Danza Volo Musica Dinamite (Dance Flight Music Dynamite) Festival at Rome's L'Attico gallery in June 1969, it builds on a vocal repertoire that Forti had been developing for a while. Brown was so impressed with Forti's vocal improvisations during Halprin's summer workshop in 1960 that she recorded Forti's voice as an accompaniment to her 1962 solo *Trillium*.

Around the same time, Forti participated in a "Variety Program" sponsored by the American Theatre for Poets. Jill Johnston, a cultural critic at the *Village Voice*, briefly discussed Forti's performance of non-textual sounds in a comprehensive review of several different events and happenings. "SPEAKING OF the unspeakable, of signaling through the flames, Simone Morris sounds like that when she sings.

Wild, untamed noise from the center of a burning pit, the living gut."[17] An enthusiastic viewer and occasional participant in various experimental goings-on in the early 1960s, Johnston was not easily shocked, so Forti's vocalizations must have been pretty far out to elicit such a response.

There are only a few black-and-white photographs of *Throat Dance*, taken by Claudio Abate, but they give some visual context for Johnson's description of untamed noise. In these images, Forti is dressed in white and bent over, hands on her thighs as if to support the force of her vocalizations. Her head is titled forward, and it looks as if she is calling up sound from deep inside her gut. Since the throat can serve as a conduit from the heart to the mouth, one gets the sense that Forti was using sound to excise a matter of the heart. According to the liner notes of *Al Di Là*, "Largo Argentina" is one example of the kinds of throat dances that Forti was doing around this time. In this nine-minute vocal improvisation recorded in the late 1960s, Forti's voice shifts from a high vibrato (an o..o..o..) to a lower, more guttural sound (Uh...h..h...h). Then she moves into a deep Ah..h..hh with a crackling edge and finishes with a high piercing o..o.oooooo. Clearly, *Throat Dance* used the action of the body to produce an extraordinary range of vocal soundings.

In addition to *Al Di Là*, another album, *Hippie Gospel Songs*, made its appearance in 2018, appropriately on vinyl. Originally recorded in 2012 as part of the "Sounding" show, this collection of very short and refreshingly simple folk tunes (the album is less than ten minutes long) was transcribed to sheet music by Palestine in the early 1970s. In the liner notes to the album, Forti relates how these songs came to her around the time of the Woodstock festival, adding "I mainly sang my songs while driving in my blue car, The Blue Angel, back and forth among the orange groves between CalArts and the nearby town of Piru." With one exception, the songs are situational, derived from Forti's everyday experiences. There is "Lullaby to an Ant," an anthem to the ant Forti saved from drowning in her parents' pool one summer, and "Ocean Song" about the time her father had a brief (and fortunately successful) bout with cancer. ("They told me you were dy-

ing, but I would not believe.") There is also an Italian folk song. But in some ways, all the songs here are influenced by traditional folk songs, not only Italian but also American and English. The melodies sound familiar, and occasionally there is a "wish you God's speed" thrown in for good measure. In various interviews, Forti recalls that, when her family returned to Italy for a year when she was twelve, she learned a number of Italian folk songs from her cousin, and she speaks of how from her bedroom window she could hear students walking arm in arm on the street late at night, singing with gusto. Listening to this album, one gets the sense that as Forti pays attention to the sound in her environment, songs blossom in her imagination.

As I mentioned in the previous chapters, Simone Forti identifies the dance state with those magical and "delicious" moments of being caught up in the improvisational play with forces in the world. She associates this experience with a "state of enchantment" that she describes as a "kind of being be-songed" (2003a, 130). Recognizing the root of enchantment as *"chanter"*—to sing, in French—Forti envisions that singing is one way to cultivate that special state of grace. In his recording "Lecture on Nothing," John Cage captures an important aspect of Forti's sensibility when he asserts: "Everybody has a song which is no song at all: it is a process of singing, and when you sing, you are where you are."[18] Forti further reflects on this relationship between dancing and music in a journal from the early 1970s (the one she was keeping as she was preparing the manuscript for *Handbook in Motion*).

> I was missing all the dancing I'd been doing in Woodstock. So I gave thought to what kind of dancing I wanted to do, and to how I could create the conditions for this dancing to happen. I think there's a state of dancing, like there's a state of sleeping, or of shivering. Some people have a shyness towards entering that state, but everyone does it sometimes. Often, at parties, people drop their shyness, and enter a dance state. And when I'm in a dance state, the movement that comes out through me enchantes [*sic*] me. [. . .] Melodies are like that too. And they just come.

Illuminations

Creating an environment of
sustained timbres, he enters into
the sound, listening and responding,
giving utterance to the live forms
which emerge.

Round and round in a circle,
she enters into the momentum
listening and responding. The
body begins to go through
adaptations changing form,
changing force, and so, changing
the circles, banking on the
currents of gravity, momentum
and mind.

*Open
Gardenia*

A group centering.
Each flows with his own
yet reinforcing others
with waves of energy.

Simone Forti's *Illuminations* and *Open Gardenia* flyer. Getty Research Institute, Los Angeles (2019.M.23).

God knows from where. So I wanted to find my way again, to
often being in a dance state. (14N)

Right underneath this passage (and most likely added at a later date
since it is in pencil, not pen) is one word—Gardenia—referring to the
Open Gardenia events that Forti organized at CalArts in the fall 1971.

The very first Open Gardenia was held on November 5, 1971. It
seems that attendance was sparse. In a journal entry written later
that night, Forti mentions being nervous and "uptight" during the
event but asserts that she learned a lot. Despite her early trepidation,
by the next week word had spread sufficiently, and there were about
twenty people in attendance. In her journal after the second event,
Forti writes: "We must thank the spirits. Very beautiful." Helped by
some soft colored lights, the evening's open improvisation began with
a base of music, including electronic sounds and a flute player. Folks

sang along to the eastern-inspired drones generated by the synthesizers, and eventually people began to move into the central open space. After about an hour, the energy began to consolidate, and the dancing became increasingly dynamic. Forti notes:

> Then the spirit swelled and many high spirited waves of music and dancing. I got a chance to do a lot of heavy hand[ed] spinning. There was a lot of dancing. Very free and beautiful. Sometimes we were like flying . . . skipping . . . running . . . in circles concentric and in both directions . . . passing each other at a flying pace. We made music and danced till 10. (1974, 111–12)

Forti calls these improvisational sessions filled with music and dance an "open market-place," where people could gather and experiment with new forms of sound and motion. The communal setting was important for Forti since it created an alternative venue for people studying non-Western forms of music. "I felt that we reflected a larger grass-roots [sic] receptivity to more communal and non-Western musical attitudes, and that we needed each other if we were going to make any progress towards finding some common-denominator base of operations" (1974, 109). After a few fledgling sessions, Open Gardenia began to take off as more people participated and it became something of a scene. Sound played a critical role in setting up the atmosphere of experimentation and play. In a journal entry that was printed in facsimile in *Handbook in Motion*, Forti expresses her pleasure.

> As I approached the door of C105 I could hear a drone. The Bukla [sic] cynthecizer [sic]. People started coming. I recognized the flute player and the tamboure player from last week. Vicky played some little clear bells. I sang a drone . . . a few of us sang drones . . . with some soft and regular variations. As many as twenty or so people came. Everyone listened very well. Made room for each other's sound. (1974, 110–11)

Although there are few details about what kinds of movements are involved, Forti does mention walking, circling, spinning, and run-

ning as a group. She writes that the overlay of music and dance in the room creates a "moirey [moiré] effect, coloring the accent of focus, reinforcing certain inherent gravities, filtering others" (14N).

Despite the success of Open Gardenia music and dance improvisation sessions like the one described above, and despite her commitment to the communal aspects of the workshop event, Forti soon realized that she needed to forge a stable relationship with one musician in order to hone her dancing while being immersed in a multidimensional sonic environment. In her journal, she acknowledges the traditional dynamic in which music accompanies dance and then questions what dance could give back to music.

> I know something of what music does for dancing. I don't know what dancing does for music. But it must return something. Some energy. Maybe some sense of the material roots of, body roots of musical sound. (14N)

A decade after having created *Accompaniment* to a composed piece of music, Forti wanted to explore the possibilities of improvising in real time with a live musician.

Fortunately, she met sound artist Charlemagne Palestine while both were trying to set up a concert for Pandit Pran Nath in California.[19] Although neither Forti nor Palestine became the kind of devoted student of Pran Nath that Young was, they each had worked briefly with the Indian classical singer and raga master teacher, giving them a key point of reference in common. They shared an interest in his slow progression through clearly vibrating tones and Pran Nath's patience with tuning in to a certain pitch for a long time. Before recounting the context of their initial collaboration and the development of their ongoing series of improvisational performances, *Illuminations*, I want to think about the implications of another aspect of enchantment—that of chant. Ubiquitous across medieval European, Asian, Muslim, and Jewish religious traditions, chants are usually a repetitive sequence of one sound or a limited range of sounds. Often sustained for long periods of time, chanting requires a conscious focus on one's breathing since many of the tonal vibrations originate deep inside

the chest. With its ritualistic and spiritual connotations, chanting is not unrelated to the drones that Forti mentions with regard to Open Gardenia. In their mutual pursuit of "harmonics" (both musical and metaphysical), Forti and Palestine embraced a mystical side of 1970s counterculture, exploring through their work together states of physical and musical consciousness that bordered on trance-like states of being.

Towards the end of *Handbook in Motion*, Forti recounts meeting Palestine and speaks about the terms of their mutual engagement. She writes about how they were on parallel tracks—what he was doing with sound waves she was doing with balance and momentum in circling. She describes the beautiful room they worked in—a large music hall with a hardwood floor, a high ceiling, and great acoustics. They dubbed it the "Temple." Forti and Palestine would start simply and slowly, giving each new exploration the space and time it needed to develop. Discussing her reaction to his playing and the way it engaged her mysterious response, Forti writes:

> The aspect of Charlemagne's music that most inspired my imagination was his melodies. Sometimes their texture of repetitions and evolving variations are so close that the term melody doesn't seem to apply. But the pitch combinations seem to draw their integrity from the organic sympathy that exists between the throat and the heart. His predominant time sense is kind of ongoingness. (1974, 120)

Beginning in a state of "calm receptivity," Forti would start walking, and Palestine would play a tone or sing. "When Charlemagne and I work together he centers through pitch and I center through balance. And his sound and my movement form part of each other's effective environment, which gives motion to our equilibriums" (1974, 131). Feeling the live sound resonate within the space, they slowly built a structure wherein each was following their individual curiosity while being aware of the other's activities.

Besides reminiscences by Forti and Palestine and several handmade posters from that time, there is little documentation of their early

collaborations. What we do know is that they shared an appetite for ritual and improvisation, carefully constructing and adorning (in the case of Palestine) a material and psychic threshold through which they could enter into the unknown. They also had the patience required to let their work develop. In an interview on the website Fifteen Questions, Palestine declares: "I have always felt and heard and mixed the sounds in my world as liquids not as solids. Sonic liquids are material that is endlessly transformable."[20] Then, too, they were both deeply committed to the intersections of the physical and the metaphysical, allowing basic material tasks such as walking or alternately striking two keys on the piano to lead to a magical, potentially sacred state of being. To borrow a phrase from composer Pauline Oliveros, they both exhibited "deep listening." And each had extraordinary focus.

We have seen audience descriptions of Forti's "radiant presence." Palestine also seems to have a riveting manner in performance. In a review of Palestine's intriguing mix of sound and art, critic Tom Johnson describes such an event. "One evening, at an informal loft concert, he just walked around for a long time, eyes closed, singing short tones, listening to the echoes, and captivating [a] small audience by the intensity with which he pursued the task."[21] Working on the margins of their respective professions at the time, Palestine and Forti nonetheless shaped a new kind of virtuosity, one that was about attention and listening rather than displays of technical precision and traditional forms of artistic prowess.

The title of the preface to *Charlemagne Palestine: Sacred Bordello* by Antonio Guzman is, tellingly enough, "Blood on the keyboards/ Brooklyn Boy/Choir Boy/Golden Boy/Old Boy/Bad Boy."[22] An eccentric figure from his early adolescence, Palestine was born in 1947 in Brooklyn, New York, into an observant Jewish family. He sang traditional music as a youth. Although he was not particularly religious in his later life, he was deeply influenced by the sacred, resonant space of the wooden synagogue he attended in his childhood. At age thirteen, Palestine ventured to Manhattan to attend the High School of Music and Art, where he became interested in crossing over the usual

divides between the fine and performing arts. Still in high school, he managed to pick up a job as a carillonneur at an Episcopal church in midtown, where he was allowed to play both traditional music and his own improvisations on the church bells. Palestine recalls: "They had a Carillon [*sic*] with a traditional clavier and for me it was like a continuation of my singing in the synagogue, it was something I had to do every day. There were oak levers and pedals which you have to play very physically; you smash your fists on the levers which move clappers with counterweights that hit the bells above your head."[23]

Palestine also had a membership to MoMA, which was practically across the street from the church, and he used to go there often to wander through the rooms devoted to Impressionism. (Monet's *Water Lilies* became a favorite haunt.) Through video and sound artist Tony Conrad, Palestine met the composers Young, Riley, and Morton Subotnick, who invited him to CalArts in 1969. While there, he began to work with early synthesizers to produce ongoing and slowly evolving waves of sound. It was at CalArts that Palestine first played a Bösendorfer Imperial Concert Grand piano. Its deep, rich tones deeply impressed him, and it became his instrument of choice. He honed his technique of hitting two notes in rapid succession and using the pedal to create an ongoing river of notes; that method became a key element in his piece "Strumming Music," which he performed in the 1970s.

In a 2014 interview with Steve Dalachinsky published in *Bomb* magazine, Palestine recalls the musical education that he gave himself by listening to an eclectic assortment of records he borrowed from the Donnell Library Center in New York City.[24] In addition to Igor Stravinsky's *The Rite of Spring* and compositions by the likes of Karlheinz Stockhausen and other new music composers, Palestine had access to field recordings by ethnomusicologists studying Polynesian rhythms and Native American music of the Hopi people. He addresses the role of ritual in his work, noting that in the Jewish tradition one "davens" while singing, always rocking or moving the body in response to the song. Palestine claims not to identify as a "musician" per se but asserts provocatively:

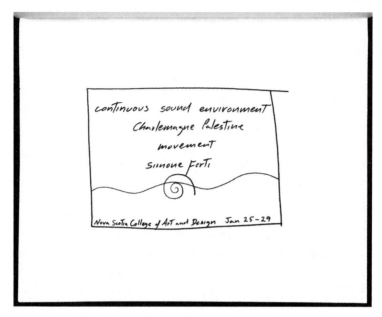

Simone Forti's Notebook (7N) draft of a poster for "continuous sound environment," 1972. Getty Research Institute, Los Angeles (2019.M.23).

> Sometimes I enter a world where sounds do things that could resemble music, but again I prefer curiosity: I move. I groove. I sit. I fall. I sing. I sming. I ring. I ding. I flip. I flop. I schmip. I schmup. For me those are all part of gestamutkunst [*sic*]—total art.[25]

Palestine's sound making and installations refuse the either/or of so many art categories, embracing instead both sides of the equation: minimalist/maximalist, resonance/dissonance, sacred/profane, motion/stillness, succession/simultaneity, noise/silence. Palestine affirms this fluidity when he claims: "My music is more a sensual, liquid, physical experience."[26]

In January 1973, Simone Forti and Charlemagne Palestine performed together at the Nova Scotia College of Art and Design. One of Forti's notebooks contains a revealing sketch for the poster or flyer

for the event. Palestine is credited with creating a "continuous sound environment," and Forti, with creating the "movement." The drawing underneath their names is quite sparse, simply an undulating wave with a small spiral in the middle. It looks vaguely nautical, like an image of a wave and seashell, but I suspect it represents sound waves and Forti's favorite vortex pattern. Although there are no clear dates on the journal entries, and Forti has warned her archivists about her habit of picking up old journals and writing in them, it seems likely that she wrote the following reflections around the same time. On the page directly after her handmade calendar for her time in Nova Scotia (November 1972 through January 1973), Forti lists the elements of their collaboration.

> music—enchantment
> > motor energizer
> phasing of materials
> charisma effect (imparts the valuable union of different systems
> > of consciousness)
> tension between music and ideas
> balance, gesture, evolution
> ritual slow start "the Temple"
> the center me the edge CP
> I cherish the movements
> I can remember and
> return to again and
> again (14N)

From their first performances in the early 1970s in California through to their appearance together in 2018 at The Box, Forti and Palestine have followed essentially the same ritualized score for their improvisational journey together. Usually, they begin with Palestine making an incantation and walking a slow circle of the space. As he sits and begins to play the piano, filling the red-lit atmosphere with repetitive sounds that slowly vary in tone and intensity, Forti starts walking, circling the space and eventually moving in and out of the floor, crawling or rolling. Sometimes he sings, sometimes she sings, at

times they sing together. But always, they provide space for the other's imagination, listening to what will arise from their mutual devotions.

In October 2014, Forti and Palestine reprised their perennial collaboration *Illuminations*, this time in Paris at the Louvre. Billed as *Illlummminnnatttionnnssss!!!!*, their improvisational performance had the comfortable, laid-back feeling of two old people who had worked together for a long, long time. The event was staged in the large open space right under the iconic glass pyramid designed by I. M. Pei in the center of the museum's courtyard. The glass ceiling reflected the city lights and the night sky, as well as the theatrical lighting, which created a warm red glow in the space where the audience was arranged in a horseshoe shape around the performance area; some sat on the floor. Palestine's piano was adorned with his fabulous array of stuffed animals and scarves, strung up like laundry in the streets of Naples. He created an altar of sorts out of an open suitcase (the old-fashioned box kind) with some of his special creature mascots lined up for the occasion. There was a soft but clear tone playing on the synthesizer, periodically renewing itself in the background as the audience filtered into the space. Forti, who was seventy-nine at the time and increasingly affected by the onset of Parkinson's disease, conversed quietly with Palestine, who was dressed in his signature two hats (one on top of the other), assorted scarves, and wildly printed jacket. Her aura of calm was disturbed only by the slight shaking of her head.

Forty-three years after their first collaboration, Forti and Palestine retraced the basic pattern of their work together. Palestine walks along the periphery of the audience, toning and baptizing the performance space with his particular mix of vocal sounds, combined with rubbing the top of a glass (with cognac in it) to create a sustained tone. He sings in a high, slightly nasal voice, which at first sounds off but gradually becomes more tuned to the glass. Soon, it becomes possible to discern shifts and slides of sound that could be syllables of a language of his own making. He takes his time, pausing to turn to the audience and acknowledge with a nod of his head that we are all in this together. Forti enters the space after his benediction, tracing a smaller circle in the center. At first, she seems cautious, tentative,

and the audience gets ample time to observe her Parkinson's vibrating through her head and hands as she descends to the floor, rolls across it slowly and then gets up. There is a wonderful moment of silence as she stands and regains her balance. Then Palestine begins his strumming music on the piano, playing two tones in alternation. The sweet sounds accumulate as he adds the pedal to increase the resonance. Forti strides in a circle around the space, stepping in time with the music which slowly begins to accelerate.

A few minutes later, however, there is a remarkable transformation. Forti walks over to where she had left her shoes, puts them on, and begins striding purposefully around in a circle. It is like she has just slipped back into the current of the flow she describes in *Handbook in Motion*. Suddenly, her whole body is swept up in the vortex of movement. Her arms extend to catch a current of air as she banks around the edge of a turn. Her play with momentum and flow is emphasized by the loose silk jacket she wears. The ripples of the fabric help to visually manifest the invisible forces of gravity and air that motivate her dancing. There are moments when she speeds up, almost losing her balance, but just then her kinesthetic memory seems to kick in, pulling her back onto the circular pathway as she rides, once again, the wave of centrifugal force. Palestine's music fills the space and sustains her energy, welling up to support her banking into each figure eight. That first round finished, Forti returns to the piano and dons a microphone. She begins to whistle her favorite *Al Di Là* song, and Palestine plays along. Eventually, he and she begin another circle, this time arm in arm, singing and whistling in a tender call and response.

Six months before performing in Paris, Forti and Palestine reprised their collaboration at MoMA in NYC. Brian Seibert, reviewing the concert for the *New York Times*, called them "an odd couple" and noted that "There was some dissonance between her [Forti's] gentle radiance and Mr. Palestine's theatrics." Nonetheless, he adds: "as she walked in circles and tilted into figure eights playing with momentum, there was a clear connection between the nature of that activity and what Mr. Palestine was doing at the piano: gradually accumulating harmonics."[27] Seibert points to Palestine's "eccentric sense of

ritual" as he describes his regular costume of two hats, an abundance of scarves tied at his neck, and the menagerie of stuffed animals that were "arranged as if in a shrine." The tension between the minimalist aspects of Palestine's use of two tones in continual repetition and Forti's use of pedestrian movement with the maximalist layers of ritual pastiche is manifested in the layering complexity of movement and sound, which includes humming, the drones from the glass, and what Seibert calls the "unpleasant noises." Although historically Forti and Palestine have been associated with the category of minimalism in dance and music, their work together expanded way beyond the sparse or conceptually defined work usually associated with that genre of art making. Palestine famously eschews the term minimalism, calling himself a "maximalist," and though Forti never incorporated traditional modern gestures into her dancing, breath, emotion, and expressivity all have a place in her movement vocabulary, however untechnical it may seem at first.

Rituals link Forti's and Palestine's interests in creating work. Rituals are built out of simple gestures and exchanges, repeated on specific occasions. Rituals often become more complex as they evolve over time. Rituals carry a determined sequence of events but allow for individual twists to the prescribed event. And rituals almost always involve some kind of transformation in order to be considered successful. Although neither was particularly observant in a traditionally religious sense, both Palestine and Forti came from Jewish immigrant families, a fact that gave them a common source of spirituality. Their collaboration takes place at the intersection of the mysticism of Judaism and that of the 1960s counterculture. Palestine describes it as "a sort of sacred secular art form that was a little bit trance-y."

In a discussion occasioned by her 2016 solo exhibition "Here It Comes" at Vleeshal Markt and Vleeshal Zusterstraat in Middelburg, the Netherlands, Forti explains: "We were both kind of mystics, especially Charlemagne—that's one aspect of it. And so the work had a mystical exploration of physical properties in the universe looked at for beauty."[28] In the same conversation, Forti claims that her interest in banking and circles was related to the Star of David, as well as

aspects of numerology. Repetition and the slow aggregation of sound and movement led, over time, to altered states of being that resembled trance. In fact, *Illuminations* could be considered a performative ritual that follows a set pattern yet has infinite variations. This ritualized foundation to their collaborative improvisations is most likely the reason why they were able to seamlessly reprise the work decades later.

The 2014 MoMA performance of *Illlummminnnatttionnnsss!!!!* begins much like the one at the Louvre. Forti and Palestine talk and hang out as the audience gathers in a casual circle around the open floor space. There is a background drone sound playing softly that phases out as Palestine begins to "play" two glasses, one with cognac and one with water. He alternately rubs the rims of the glasses, listening to the slight difference in their tones. The sound they make is clear and delicate. Palestine takes one glass and, after raising it in a gesture of welcome, circles the audience, offering each person in turn an opportunity to hear the sound and smell the cognac swirling. It is an incantation of sorts and serves to bring the audience into the ritual space. Instead of being mere onlookers, they have been duly initiated as participant-observers. As in all rituals, they are now witnesses, and their attention makes a difference to the success of the event. As Palestine continues to make the rounds of the audience, Forti slowly rolls across the floor, gradually extending her arms and legs like a newborn as she revolves from side to front to side to back. It strikes me as a brave beginning, a deeply intimate and vulnerable way to put herself out there, especially for an aging dancer with Parkinson's disease. Rising to all fours, Forti backs out of the space to sit at the side as Palestine returns to circle the space, singing a harmony of his own invention. Given his age and eccentricities, Palestine plays the role of postmodern shaman quite well, calling out to the spirits in odd, nasal tones. Forti returns to the space, rolling across the floor at a glacial pace and creating, for me, the image of a landscape unfolding over time.

The shamanic vibe increases as Palestine circles Forti, crouching down closer and closer to her while he brings the sound of the glass to her level. He steps carefully, with a slight rhythmic bounce in his legs. As she rises, they linger face to face, creating a sweet moment of

silence and stillness. Palestine returns to the piano and begins to play four gentle notes. Four more notes are surrounded by silence, and then he breaks into a strumming sequence as Forti starts walking in a circle, banking towards one outstretched arm and then the other as she traces a figure eight on the floor. Sometimes the vortex spits her out, moving her backwards, other times it propels her forward. At one point, she brings her two arms in front of her, raising them to the sky with the delight of a child seeing stars for the first time. Then Forti breaks stride abruptly and grabs a sketch pad. Using the gestures of her body to make lines that she, in turn, traces with her movement, Forti dances with a sense of awkward whimsy.

Meanwhile, Palestine starts layering sounds from his computer, quilting a hodgepodge of voices and songs together. All of a sudden, the solemn and sacred atmosphere turns irreverent and vaguely comic. Eventually, Forti ends her solo and Palestine turns off his sound machine while she begins to sing very softly in Italian. The song is "Al Di Là," whose lullaby-like melody creates a tender moment as she circles the space. It seems like a perfect (maybe too perfect) resolution to their improvisation, and the audience is poised to clap when Forti starts up a boisterous tune that Palestine gleefully joins. They parade around the space like two old drinking buddies, singing joyfully and purposefully off-key. In their recent performances, like the ones described above, Palestine's big teddy-bear presence contrasts wonderfully with Forti's more gentle countenance. It is hard to reconstruct what *Illuminations* was like in the early 1970s when they performed together in California, Nova Scotia, Italy, and Germany. But judging by the videos of more recent versions of *Illlummminnnatttionnnssss!!!!*, Palestine and Forti shared a vision of a journey through sound and movement that led them to a state of grace—not as a spiritual achievement but rather as an activity of mutual listening.

> Charlemagne and I have always been like brother and sister [. . .] We had a strong friendship. In the 1970s I was married to a musician and graphic artist, Peter Van Riper, and that was a very different relationship. We travelled together and did tours

together. That work was based on other material, he was a saxophone player and also played many other small instruments. At that point I had been spending a lot of time in the zoo watching different body structures that resulted in different movement and trying some of it on my body structure—understanding my movement in certain ways by studying movement in other species.[29]

After finishing the manuscript for *Handbook in Motion*, Simone Forti moved back to NYC where she soon reconnected with Van Riper. Van Riper had been Forti's housemate along with visual artist Alison Knowles and others when Forti was living in California and Van Riper was teaching at CalArts. The coincidence of sharing that living space created a connection. Forti remembers that Van Riper would help her by taking a publicity shot or fixing her car, for instance. In her journal from the early 1970s Forti addresses a letter to Van Riper that gives a sense of the depth of their friendship.

> Dear Peter, It is night time and I am afraid. Afraid that I'm riddled with tragic flaws. This time it's the I-King [*sic*] that set me into this tailspin. In my mind I step quietly into your space, I sit quietly, and slowly my mind empties. The hours pass and I know better. The sky begins to show some light and I am on my way. Thank you, brother. Love, Simone (14N)

By the end of 1974, Forti and Van Riper were married, and from 1975 to 1980 they lived together, worked together, improvised together, went to parties together, and performed together, touring all over the country, as well as abroad.

A sound artist and graphic designer, Van Riper (who was born in 1942 and died in 1998) was raised in a very musical family; his mother was a concert pianist and his father avidly collected records—sometimes buying as many as eight to ten records a day. Growing up in Detroit in the 1950s gave Van Riper a fantastically broad musical education. Even as a teenager, he played in jazz bands and in after-hours clubs in the city. Van Riper attended several universities, mov-

ing from studies in international politics to art history to art school and finally back to music. Along with Lloyd Cross, Van Riper started Edition, Inc., a gallery in Ann Arbor, Michigan, dedicated to show-casing the new technology of holograms.[30] He also experimented with laser projections, particularly in his 1968 work *Sound, Light, and Air*. In NYC, Van Riper was working for the architect George Maciunas, a founding member of Fluxus. Through Maciunas, Van Riper and Forti were able to buy into an artist live/work cooperative in SoHo. Located on Broadway between Prince and Spring streets, the Forti/Van Riper loft is a magnificent space with a large open studio banked by tall windows overlooking the street. For many years, Movement Research, Inc., held its classes in this studio, and it is where I took several workshops with Forti in the 1980s.[31]

Like Forti, Van Riper believed in the importance of cultivating a music state in which the focus and energy of the performers can ac-tivate the viewer's/listener's perception of sound and space, or rather how sound occupies space. Van Riper speaks of how continuous tones create a sound wave that "stands" in the room. Influenced by Cage's Zen-inspired aesthetic, as well as Fluxus and other innovations in the experimental music scene, Van Riper developed his own direction in live performance, creating sound environments in which his body and movement (as well as that of Forti) are a significant feature in craft-ing the sound-space. In many of his performances, Van Riper circles around the periphery of the space, playing a variety of hand-made or found instruments. He attends to the different acoustics created when he moves from the center to the edge of the space or turns in a circle. One of his favorite actions is spinning in place while blowing long, continuous notes on his soprano saxophone. This movement creates an interesting Doppler effect, in which the sound drifts away and then returns as he turns.

There is a fabulous moment in one of their 1976 performances at the Kitchen in New York City in which Van Riper has visibly suc-cumbed to the enchantment (his "music state" combined with Forti's "dance state") he experiences while blowing and spinning. After fi-nally slowing down, he gleefully runs around in tiny circles, just like

SIMONE FORTI
PETER VAN RIPER

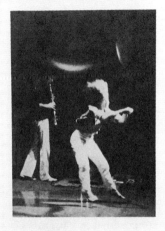

Individual and collaborative pieces involving
movement and sound
August 18 and 19, 1978 8 P.M.

PROJECTS: PERFORMANCE in Summergarden
The Museum of Modern Art
8 West 54 Street
New York, N.Y. 10019

Admission is free
Seating is limited

Forti's movement is based on studies of the
relationship between the structure of the body
and the forces of gravity and momentum.
These studies entail comparative observations
of animal locomotion.

Van Riper plays his own music on soprano and
sopranino saxophones, recorder, mbira thumb
piano, and other ethnic instruments. He is
involved with music, conceptual performance,
graphics, and holography.

PROJECTS: PERFORMANCE is an August Projects
series in Summergarden presenting artists
whose work involves aspects of performance.
SUMMERGARDEN, made possible since
its inception in 1971 by grants from MOBIL,
is a series of free weekend evenings and
events in The Museum of Modern Art's
world-famous Sculpture Garden.

Flyer for Museum of Modern Art perfor-
mance, 1978. Courtesy of The Box, Los
Angeles.

a little kid expressing joy over an unexpected treat. Van Riper also works with found metal objects, swinging hollow tubes or chains that allow him to lean out against their weight and experience centrifugal force. Van Riper has said that his creative work is about chance, change, attention to space, and perceiving light and sound as waves. Many of the same ingredients drive Forti's and Van Riper's kinetic and musical collaborations.

In 1975, Forti and Van Riper began to perform *Big Room*, an evening-length piece structured around sections of solo and ensemble improvisations. They continued to perform that basic structure for the next five years. In the section dedicated to Forti's artistic oeuvre in *Terpsichore in Sneakers: Post-Modern Dance*, art historian Banes writes:

> The structure of *Big Room*, with its blocks of music and movement material put into gear in different orders and combinations —sometimes with nonverbal signals, as when one starts a certain sequence with the expectation that the other will follow, or sometimes simply when one calls out to the other the name of the desired bit—creates a sense of mutual play between the two, a sense of trust and shared exploration, relying on preferences of the moment while paying attention to the present needs of the partner. To the audience, sitting in a horseshoe surrounding the dance, the actions seem to consecrate a special space for the dance's unfolding.[32]

Given the consistency with which they kept the basic units even as the order changed, *Big Room* lies on a continuum from composition to improvisation. In some sections, the music and the movement are remarkably similar from performance to performance. Other sections seem to have more flexibility in terms of how Forti and Van Riper interact. Most often, *Big Room* is listed with the subtitle "new dance/ new music" and the press release states that "Simone Forti's and Peter Van Riper's collaborative work in dance and music is partly improvisational and partly based on pre-established materials including solos and sound and movement integration."[33] There is an interesting coherence to how their musical/movement explorations fit together—

one can feel the time spent in the studio together, just hanging out, experimenting, and dialoguing together. This can give the work a comfortable but also slightly insular feel. Watching videos of different versions over a period of several years allows one to see the stability of the overall form and to notice the micro-improvisations that develop within each section.

During their fall 1977 tour of Europe, Forti and Van Riper performed at the Centre for Contemporary Arts in Glasgow, Scotland. The documentary film of that show is a grainy, black-and-white, single-shot video, but one can still see how their work develops through solos and duets and witness the audience's reaction. The piece begins with an invocation by Van Riper, who is playing an African thumb piano called a mbira. Forti sits nearby, listening intently to the muted sounds, calmly absorbing the music, the space, and the audience. Van Riper plays several single notes and then listens to how the sound travels in the open gallery space. He then plays a few more notes, gradually building a little song. There is a tentative quality to his efforts, as if he were testing or tuning in the room. This approach adds to an already laid-back atmosphere. One gets the sense that Van Riper is offering up his sounds for the audience's contemplation rather than directing their focus with a more traditional musical prelude. Once he finishes, Forti casually gets up and walks over to the open space to begin her own solo. Lying down, she proceeds to roll slowly and fluidly across the floor in a series of "crescent" rolls in which her body rolls while keeping the shape of a crescent moon. (I remember learning these rolls—which we called "croissant" rolls—in a workshop with Forti in the 1980s. They are much harder to coordinate than they look.) Forti has said that this moment of rolling across the floor conjures a feeling of being the moon crossing the night sky. Her overall demeanor is relaxed, and it almost feels as if we are watching someone roll over in their sleep. Then she stands and arches her back, facing the ceiling. She breaks that pose and walks somewhere in the space to assume another pose, crouching or crawling, for instance. Eventually she returns to where Van Riper is seated and they collect themselves to begin an extended duet.

This first duet takes on the quality of a side-by-side intimacy, that of two married artists working on their own investigations within the same space—alone together. Forti begins by walking in big circles, then moves into tracing a figure eight, her arms leading her into each banking curve. Meanwhile, Van Riper walks around the space playing high, squawking tones on his horn. Forti moves back and forth from striding to crawling, easing her way in and out of the floor with remarkable agility. The next section, "zoo mantras," Forti executes in silence. Van Riper is on the side, watching intently as she crawls in slow motion, researching just how much curve in her back she needs in order to swing her hind leg forward. Hopping or crouching, as well as crawling or striding, Forti brings the audience's attention to the kinetic miracles in different forms of animal locomotion. At one point, Forti stands up but keeps her arms reaching as if she were still crawling on the floor. This movement, in turn, shifts into a wing-like coordination, her elbows pulling her arms back and out, her back arching slightly as the arms swoop forward and down. For a split second, I see her turn into a great white heron spreading its wings in flight. With a breath, she extends her arms overhead, and in one smooth twist she sinks to the ground and begins to crawl over to the side as Van Riper prepares for his spinning and toning solo.

In terms of the layered integration of sound and movement, the next duet section seems to be the most connected. Van Riper is playing a light-hearted song on a little brass flute as Forti cuts fast diagonals across the space, running and skipping as if she were about to do a handspring. Instead, she resolves her momentum by hopping a few steps and then pushing backwards to land on her back as her legs jab at the air above her. She gets up and does it again and again. This is the most energetic part of the evening, and Van Riper seems to meet the activity with a sweet series of fast trills. The evening ends with a final duet section that ritualistically closes the space. Then they simply walk off to the side, and, as the audience claps, they return to bow, arm-in-arm. As they bow again, Van Riper leans out and they have a brief moment of counterbalance. It is a mark of their artistic and life partnership, the casual ease with which they enter and exit a performance.

Thinking about the 1970s from fifty years hence, it becomes clear that this was a time before art practices had been institutionalized and artists were funneled into choreographic showcases at a limited number of theatrical venues. Instead, there was a strong grassroots network of artists and gallery owners who created opportunities for others to show their work—places such as Ono's loft or Fabio Sargentini's L'Attico, for instance. Forti's experimental work in the 1970s often took place in dance studios, school auditoriums, small galleries, loft spaces, church halls, on the street, and even on the beach. There are several wonderful photographs of Forti and Van Riper performing *Big Room* as part of the "Art on the Beach" series in 1978, produced by the public arts organization Creative Time in the landfill site that would later become Battery Park City. The black-and-white images show a scattered grouping of spectators, some sitting or lying on the sand, others standing. Forti is rolling or sitting in the sand while Van Riper is playing his saxophone behind her. Of course, one can imagine that the sounds of the waves and gulls calling would add to the environmental soundscape. Other photographs of *Big Room* show the white gallery spaces in which they performed. Seldom do we see the work in a traditional venue complete with theatrical lights. It all seems wonderfully informal, as if they were just transferring their working process to another studio space. Most photographs reveal that the audience (usually between thirty to fifty people) is seated on three sides, some on the floor, some on folding chairs set up for the occasion.

It is not entirely clear to me why Forti and Van Riper decided to call the version of *Big Room* they performed at the Kitchen Center for Video and Music in November 1979 *HOME BASE*. One explanation was included in the program notes reproduced in the addendum to the second edition of *Handbook in Motion*:

> HOME BASE is in the format which we have been using in all our work in our traveling. Always the performance is composed of various materials, some dating back several years, some just emerging, and is tailored to each situation in consideration of the space, the floor, the acoustics, the place, the time. New York is our home base. (1980, 145)

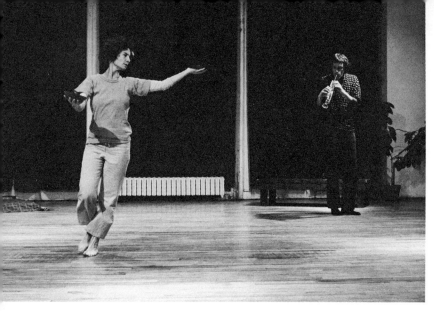

Simone Forti and Peter Van Riper in *Home Base* at the Kitchen, New York City, 1979. Photo by Paula Court. Getty Research Institute, Los Angeles (2019.M.23).

In a self-published chapbook of prose poems entitled *Angel* (1978), Forti evokes the interweaving of dwelling and art in their home studio. "During the winter nights Peter made recordings of the boiler driven steam tapping and banging ongoing in the iron pipes, the sound of the iron pipes forced to expand, crossing thresholds of expansion, iron tight against iron, bang, bang, blending with the constant passing of cars on Broadway in the night of winter" (1978, 10).[34] Clearly the sounds of their living space, as well as the sounds of Van Riper's music, created the sonic texture that filled their home and fueled their work. But there is a slight note of melancholy in *Angel*, as well.

> The air is soft and pleasurable and active, passing in and out. The lights are on, then off. Except for one, illuminating from below the great green fern, its long fronds full of breath. While the muffled tapping of steam bothered pipes, of metal popping is lulling, further inducing to waiting. (1978, 2)

Knowing that there were difficulties in their relationship at the time of the Kitchen performance, however, it is hard not to perceive a sense of longing in the new title *HOME BASE*. Waiting at the window, wistfully watching for Van Riper to come home (because sometimes he didn't) reveals one of the more difficult aspects of their relationship. Forti has spoken often of her desire to find a home—to feel at home—whether in NYC, Mad Brook Farm in Vermont, or in Los Angeles, where she lived growing up and to which returned later in her life. A journal entry from 1996 is telling in this regard.

> *Home* has the sound of the earth. The very word. HOME. Fills the mouth. The most familiar food, it fills the mouth with the sound of food. . . . Slow down Simone, home. Home. Sit. (24N)

The video of *HOME BASE* was filmed during a run-through, without an audience. This might explain why there is an oddly wooden quality to some of the sections, for it is quite difficult to improvise without a live audience. Interestingly, however, this version is the one that Forti notates in the second edition of *Handbook in Motion*, published in 1980. In contrast with the performance of *Big Room* in 1977, during her solo in the video she holds two bowls of rice, forcing her to attend to the physics of moving with her hands always upright. Speaking of the need to revitalize her circling, which had become a bit rote, Forti writes:

> After a time the patterns became imprinted in my memory, and as that happened I seemed to lose the ability to simply play with those fine points of balance. It came to me that I should hold two small bowls of rice as I circled. My movement was new again. The image was different. To keep the rice from flying from the bowls I had to take the curves with a new simplicity and clarity. (1980, 147)

There is an extraordinary moment in this section when she holds the two bowls aloft while she lowers herself to the ground and rolls across the floor. Leaving her bowls on the side, Forti then begins to spin to Van Riper's long tones in double sound, an image that is mirrored by Van Riper's own spinning.

The program continues with "garden," a duet in which Van Riper plays bird-like sounds on a recorder and other instruments. Forti begins by looking, reflecting, and then placing her body in different areas of the space as if she were deciding where to put a plant or an object. "I place a stone here, I place a stone there, here a bush, there I jump this way that way, taller bushes" (1980, 148). It is curious to watch, knowing she is modeling aspects of a landscape without necessarily knowing which elements she is invoking. Forti is not interested in trying to imitate a stone, just as she is not interested in trying to imitate an elephant. Forti clarifies this perspective when she declares: "It's not so much that I make myself look like a stone. It's more that, in placing myself, I become something that has the presence of a stone (1980, 148–49).

Van Riper's sounds here are evocative of bird calls, flutes, and sticks that announce a creature and then wait for a response. There is a lot of space and silence between these wildlife sounds that gives a freshness to the space. The gentle tension between abstraction and representation is pushed further in the next section, "twig," a solo in which Forti visibly takes on the demeanor of curiosity that she witnessed in gorillas at play. Climbing on and off a low sturdy table, grabbing the twig/stick with her toes or her mouth, Forti is obviously inspired by creatures that are as comfortable on their back as on all fours, rolling and sitting with ease. She explores the possibilities of play with the twig in a manner that alludes direct representation but embraces a cross-species identification. At the end of this section, there is a wonderful denouement in which she climbs behind the table and then sits upright to face the audience, gesturing like a scribe with the stick as she traces a long, graceful arc across its surface.

Given the care with which Forti notated the November 1979 version of *HOME BASE* in the second edition of *Handbook in Motion*, I find the videotaped run-through oddly uninspired. The order of the sections is correct, but the energy within each section is pretty flat. Having seen Forti perform on many remarkable occasions and having seen successful performances on videotape, as well, I am tempted to attribute this lackluster run-through to the fact that there was no

audience present, no life energy in the room to meet and greet. But it would be disingenuous not to acknowledge that *Big Room/HOME BASE* had its share of lukewarm press reviews. For example, a 1977 review by Daniel Cariaga in the *Los Angeles Times* begins, admittedly, with a cheap shot. "Calling the dance works of Simone Forti minimalist doesn't make them less boring. It simply puts them in historical perspective." The writer goes on to describe the sequence of events and the interaction between the sound and movement involved. But one gets the sense that nothing really connects, which is odd since Forti is usually a very generous performer. Cariaga expresses his general disappointment:

> Neither the style nor the dance is engaging. The flow of each piece and its connection to the total may or may not exist as the result of careful planning; one can view the finished work in any chosen light. Still, what one is given to see is repetitive, largely uneventful and of small visual interest.[35]

It is not my intention in this book to delve into the psychosomatic ripples of what was an increasingly painful relationship between Forti and Van Riper, but one can only imagine that some of that conflicted energy had to affect their performances. It is impossible to avoid the fact that after six full years of performing extensively together—sharing home and studio and the intimacy (and jealousy) of lovers—Forti and Van Riper separated. By the early 1980s, Forti was teaching and touring by herself, performing in the US and abroad. The one exception was the New York premiere of Forti's *Jackdaw Songs*, a group piece performed with live music by Van Riper that was presented in 1981 at the Performing Garage in NYC.

In light of this complicated history, it is intriguing that in 1991, a full decade after the end of their mutual home, they performed together at the Warren Street Performance Loft run by Cynthia Novack and Richard Bull. Billed as "New Dance/Music," the evening was composed of a solo music and visual performance entitled "Seeing/Hearing" by Van Riper, an improvised solo by Forti, and a collaborative performance shared by the two artists. Their duet begins with

Forti in the center of the studio and Van Riper sitting in a corner behind an eclectic suite of percussion instruments. He hits a gong and listens to it resonate across the space. Forti waits to feel the sound waves and then moves from the floor to standing, slowly stretching up to reach something in the sky. Her struggle is clear, even if the object of her interest is not. Then she begins to tell a story about preparing a garden for winter and describes the herbs spreading through the dirt as Van Riper approaches, making sounds with metal balls (with bells inside) swirling in a big willow basket. Forti calls out to Canadian geese flying overhead and imitates a dog barking across the valley as Van Riper crouches down next to her.

The small space highlights Van Riper's presence, circling, standing nearby, or crouching down at her level, and he seems more animated than I have ever seen before. There is a sweet moment near the end of their duet when Van Riper approaches Forti while shaking a seed rattle and she reaches out, almost touching the instrument. As he retreats, she takes on the sound he is making with her arms, waving them back and forth in time with his motion. Their playfulness expands exponentially as Forti becomes increasingly animated, rushing around the room as Van Riper matches her motion with his own. This peak of energy eventually resolves into a tender place of stillness and silence as they end the piece and take a bow, arm in arm.

In "Far Stretch—Listening to Sound Happening," her contribution to a collection of essays entitled *The Creative Critic*, composer Ella Finer describes the multidimensionality of our sonic environment. "Listening constellates the sound of times, spaces, and contexts, marking similarities and significant differences in the act, and this attentive listening to the complexity of correlating times is key to this method I am working with here, a method which relies on keeping faith in the absence of fact, of feeling the trace elements of something in the air, on the air, of listening to the materiality of vibrations and hearing imagination as information."[36] Finer's "method" of hearing and feeling traces in the air is particularly useful for perceiving the role of sonic environments in the development of Forti's dancing.

Simone Forti has often spoken of how her artistic directions

emerged out of her life situations, and this was particularly true in terms of her relationship to the musicians and composers with whom she collaborated. Incorporating the "live friction sounds" of La Monte Young's compositions in the 1960s, working with Charlemagne Palestine's continuous-strumming music in the early 1970s, and with Peter Van Riper's eclectic melodies on horn and percussion from 1975 to 1981—all these experiences heightened Forti's sensitivity to sound as a dynamic force that had kinetic reverberations. Perceiving sound as physical waves that travel through space as well as time gave Forti a platform on which to amplify her own dancing explorations. We have seen how Forti envelops herself in the soundscape, be it recorded on tape, improvised live, or composed of the sounds in the room, such as the clanging of pipes on a winter's night or the sounds of the cars driving down Broadway outside her window. Even with the more conceptual of her early pieces such as *Censor* and *Face Tunes*, Forti sought out the enchantment of a dance state by immersing herself in the vibrations of the sounds surrounding her. Listening attentively, she heard kinesthetic experiences layered within each note and its resonance. Towards the end of *Angel* she describes these elements: "Overlaid over *Plumbing Music* is the sound of a sound-recording of the water in the shower, sounding in the recording like a brook or small waterfall and recorded in that sound and sounding within it is the sound of singing in the shower, naked and female, and sounding like a girl in a skirt by a brook" (1978, 21). Deep within the poetic cadence of this sentence is the recognition that sounds speak in their own language. Tuning in to them allowed Forti to create her own song.

Geographies of a Group

A green leaf at bottom of quiet pool. Above, on surface, water striders. One scratching its hind leg with its foreleg. Shadow of something across surface, a bird? A butterfly? No, a leaf. [. . .] At this pool, I smell fish. Smelled it the minute I got here from the pool below, the pool that the waterfall falls into, that pool which is something, which you can mention to someone and they'll say, "Yes, I go to the waterfall, I sometimes bathe there." Light through pools, light through falling water, roots and rocks, little island beach pebble mound. [. . .] Seeing the fractured rock face shunting water one sheet here one there my eye follows sharp edges. My teeth try the stone I breathe the falling water and am the soft air smelling of me, the bright tree root curve of sun-soaked moss, pulsing circles of light hopping water. And only by the grace of that which holds me still do I hold still." (2003a, 63)

This stream-of-consciousness writing was penned at Mad Brook in the 1990s when, after years of visiting Steve Paxton and Lisa Nelson at Mad Brook Farm, Forti settled into a decade of rural living in this northern Vermont community. As we have seen, Forti spent the 1970s and early 1980s attending to the play of forces (including sound) in her environment and exploring different kinds of locomotion—circling, banking, and crawling being key interests. In the same way that she researched animals not in order to *imitate* their movement but rather in order to *animate* her own somatic experience, Forti began in the mid-1980s to engage artistically with the natural world by creating a series of land portraits. Drawing kinetic inspiration from rocks, brooks, trees, mountains, woods, and open fields, she made solos and group pieces that evoked the human relationship to a sense of place.

In addition, she took up gardening, reveling in the physical labor and creating a series of gardening journal solos that were inspired by her experiences with clearing, planting, following the various underground battles of herbs invading another's territory, watching insects, and the like. Describing her move to Vermont, Forti recalls: "I got my hands into the dirt for the first time, bathed in cold streams, and got lost in the woods" (2003a, 59). As the writing about her favorite brook attests, she immersed herself in these environments, saturating her perceptions—breathing, seeing, smelling, touching, tasting, and generally soaking in the ecological forces of weather, plants, and animals swirling around her.

As she became more committed to living outside of New York City, Forti began to work with larger groups of movers in her performances, eventually creating "Simone Forti and Troupe," a project-based dance company. From 1986 to 1991, Forti and the troupe created what she called "land portraits." Forti describes how the group would spend time in an area, reading about the natural ecology and social history of the place, and how this research would inform their dancing. Returning to the studio, they would build their impressions into a coherent piece that followed a set score but allowed for open improvisation and interaction, as well. These performances would often begin with a physical rendering of the actual geological evolution of the land itself, and then focus on certain aspects of the cultural and social histories of that place. Forti notes:

[W]e mainly focused on land portraits. Going to different locations, spending time in the environment, reading about the social and natural history of the area, letting these kinds of information influence our dancing, our improvising. We worked in solos and groups of various configurations reflecting how different ones of us had shared particular experiences. One of us, David Rosenmiller, knew a great deal about geology. Our land portraits always included a choreographed reenactment of how the land in that spot had moved and formed, indeed, was still moving. (2003a, 59)

By integrating the earth's forces with those of human society, Forti was able to meld geological frameworks with narratives of the peoples who live(d) on the land to create layered portraits of a place—exploring the past as a way to understand the present.

This chapter maps out the contours of Forti's work with the natural environment in the context of her work with larger groups of dancers. These explorations into the dynamics of group choreography are a significant aspect of her artistic oeuvre but one that has been sorely neglected in the critical literature and various retrospectives documenting her career.[1] For this reason, I include discussion of two earlier works—*Planet* from 1976 and *Estuary: a nature fantasy* from 1979 —before analyzing the various evening-length pieces, such as *The Foothills* (1986), *Green Mountain* (1988), *Touch* (1989), and *To Be Continued* (1991) that she created with Simone Forti and Troupe. To provide some historical context, I trace the roots of Forti's interest in the natural environment as a source of movement to her early involvement with Anna Halprin's process of working in the outdoors. I also explore how Forti harnessed a combination of conceptual and vibrational elements in the improvisational scoring that provides the basis for these evening-length works. Her use of language and the development of her system for what she calls "moving the telling" are central features of these later compositions that combine the renderings of the natural contours of the land with the social histories of various inhabitants.

While she is cultivating these group works, Forti is also frequently teaching workshops in the US and abroad. At this time she really comes into her own as an inspirational teacher, extending scores such as *Scramble* that initially served as warmups for her workshops into mini-group scores for improvisations that could be performed for the public. Indeed, she often included the students attending her workshops in the informal performances held at the end of an intensive workshop. These three strands: a commitment to evoking the natural world, an interest in crafting group work, and her pedagogical methods of designing scores that go beyond their specific tasks to cultivate a group cohesiveness, are interwoven in the fabric of Forti's evolving life and career as an improviser, choreographer, and teacher.

Even though she is constantly engaging with groups of students and professional dancers at this time, Forti has always been and will always be a consummate soloist. It is from her own kinetic imagination that she sources the work that leads into the troupe's work with land portraits. That Forti can perceive and be animated by the invisible geological forces that create mountains and boulders is wonderfully apparent in an excerpt from a film in-process by Pooh Kaye that features Forti dancing in the hills of southern California.[2] In one long shot, we see Forti's back as she is facing a line of red granite rising spectacularly out of the ground. In the background, we see a deep green forest on the slopes of a mountain. Forti stands still for a moment, held by the power of that magnificent landscape. Suddenly, we see a strong, abrupt twist ripple up from her hips through her back and into her arms before she draws her fists in with a fierce gesture that speaks to the solidity of the rock in front of her. Another shot shows Forti on the ground of an arid landscape, reaching her arms and legs towards the brilliant blue sky as her voice-over enthusiastically exclaims: "I like how the rocks are *pppushed* up. I just like the feeling that things are still moving around, being pushed up, pushed on end." Her words draw the viewer's attention to how her body captures the power of that invisible force right in her gut. Next, we see Forti in a bright room with wooden floors, moving around with other participants in her workshop. Her voice-over describes how, while walking in the studio a couple of days later, that image of the boulder can flash into her kinetic consciousness as she is seized by that physical sensation of its solidity. All of a sudden, her body goes taut, her torso rigid, and time slows to a glacial pace as she embodies the living energy of the rock from the kinetic traces of that afternoon in the desert.

In May 1993, after she was no longer working with her troupe but was still living at Mad Brook Farm and teaching around the world, Forti was filmed while drawing inspiration from another brook, this one in northern California. Part of Halprin's film series *I Am Nature*, "Face at Cascade Falls" reveals how Forti absorbs the particular elements of an environment and translates those experiences into an improvisational performance.[3] The short video begins with the sounds

and sights of a tree-lined waterfall. We see the clear water rushing over the flat rocks and then flowing down over Forti's hand pressed into the stone at the bottom of the riverbed. We hear her voice reciting a poem while the film moves from the water to Forti tracing the lichen-covered surface of a large rock.

Again listening, to pitches of water in spaces
The gulps of many pitches
Under the constant surface, rushing
A higher pitch / the lower gulps
As if conversing. What saying?
Ongoing and articulate
Taking time with articulations, like small drums under rock ledges
Ledge drums, articulating below surface rushing sound

In a brilliant bit of filmic editing, a close-up of Forti's hand traveling across the surface of a rock and cupping the irregular edge is accompanied by her voice sounding the beats of her poem. It is clear that she is evoking the cadence of the water falling. In a later shot, Forti shows Halprin a sketch that she made while sitting next to the waterfall. She points out that the top lines denote the shshshsssh sound of the water on top, and then sings the rhythms of the deeper beats towards the bottom. By the time the film focuses on Forti's improvising amidst the tall redwood trees that surround a natural amphitheater in a park near Halprin's home in California, viewers recognize its source in the multiperceptual research (the drawing, singing, physical contact with rock and water) that animates Forti's dancing. Gazing up at the redwoods, Forti extends her body and arms to embrace these majestic conduits between earth and sky.

In order to participate in the filming of "Face at Cascade Falls" Simone Forti had to travel from her favorite brook at Mad Brook Farm in Vermont to another one near the Halprin family compound in Kentfield, California, where, almost four decades earlier, she had danced among the madrone trees in the open air—rain or shine. As I discussed in the first chapter, Halprin's husband, Lawrence Halprin, a landscape architect and ecologist, built an expansive outdoor dance

deck set amid the trees that grew on their land. By all accounts, it is a magical place for dancing that embraces the lush landscape of northern California. It was here that Halprin moved further away from her American modern dance training and into her environmental and experimental performance work of the 1960s, embracing the landscape as a source for movement material. Cultivating this state of receptivity to the surrounding environment while working with Halprin allowed Forti to shift seamlessly from perception to movement without having to consciously analyze her impressions.

In a later recollection, Forti describes how the dancers working with Halprin improvised with the impressions from their forays into the woods, mixing what they had observed with their kinesthetic and emotional responses to the experience.

> Then we would return to the workspace and move with these impressions and feeling states. The crinkly bark of a tree might be quite still. But one's eyes would scan its texture with a rhythm that might show up in the crinkling and flickering of the surface of one's back. Then as the surface of the back came into focus in the mind's eye, the whole body would become alive with more tree trunk information. Perhaps a certain woodiness in the neck, a certain flickering tonality in the solar plexus. With a tilt of the head, eyes focus at the edge of the canopy of trees. This process brings particularity. (2003a, 54)

That fluid exchange between visual image and bodily sensation is a key skill for any improviser and one that Forti has honed over the years. For instance, it is her ability to capture the forces at work in an animal's gait rather than trying to "be" a goat or a bear that makes her improvisational material extraordinary. It is this sense of *recognition* rather than *representation* that pulls the movement away from mimesis.

Similarly, in interviews and her own writings, Halprin is adamant that her work is not representational, that she is not trying to dance an image of the sky, for instance. Rather, Halprin is interested in how the natural environment provides what she calls "artistic patterns," some-

thing that she modeled for Forti during their time working together. Like Forti, Halprin is interested in making dances that embody the *forces*, not simply the *forms*, of nature. Long before immersive theater and dance became fashionable, Halprin was taking her dancers into unusual environments—small caves on the mountain or a steep embankment or huge boulders—to see what kinds of relationships would develop between their human bodies and the natural sites.[4] When she began working with her troupe, Forti would follow a similar method of gathering kinesthetic impressions.

Although Forti acknowledges the importance of being outdoors and would also immerse her dancers in specific landscapes in order to develop work, she is less precious about the spiritual power of nature than Halprin. In her book *Moving Toward Life: Five Decades of Transformational Dance*, Halprin frequently refers to what she calls our "kinship" with the natural world. Halprin considers the human body a microcosm of the earth and shares with many cultures a belief in the healing energy of the earth. From the late 1970s through the beginning of the twenty-first century, Halprin created works with titles such as *Return to the Mountain* (1983), *Earth Run* (1985), and *Circle the Earth* (1986–1991), not to mention her annual *The Planetary Dance*, in which communities across the globe gather for a dancing ritual to honor the earth. It follows a very simple score that everyone (from children to the elderly) can participate in. Halprin conceives of the participants as "cocreators," and although she creates the basic structure, she allows each group a lot of leeway so that they can add their own rituals or specific ceremonies.[5]

The Planetary Dance, for instance, begins with a simple score of running clockwise in a circle (usually outside). To the constant beat of the drums, the participants run until they begin to get tired, at which point they can cut in to create a smaller, slower circle running counterclockwise. This cutting in to make smaller and slower circles alternates between clockwise and counterclockwise until there are more and more movers in the center. One of the intentions of this piece is to dedicate your moving to someone or some animate being as a way to connect to an energy beyond the material experience of

running. The fact that this dance/ritual is performed on the same day at many sites across the globe has deep significance for Halprin, who feels that these public rituals can actually make a material difference in the conditions of the world. While Forti draws inspiration from nature, her artistic palette would grow beyond a focus on the natural world to include the complex politics involved in the social history of humans within a specific landscape.

In her written reflections and interviews about her time with Halprin, Forti likes to tell the story of working with Halprin one afternoon when Halprin gave the group the task of all moving in the same direction around a circular pathway on the dance deck.

> We started out very slow, and over a period of an hour gradually picked up more and more speed until we were running. We ran for some time and then started to slow down. The slowing-down process was much faster than the speeding-up process. Within this general speeding up, running and slowing down there were several minor speed-ups and slow-downs. We finally came to a stop and collapsed on the ground." (1974, 29)

One can imagine this score creating a particularly interesting dance over time. My experience in similar improvisations has been that even when everyone begins with their own pace and individual patterns of walking, eventually a common rhythm is established. Listening to everyone's footfalls and breathing creates a beat that it is very hard not to follow. There is a kinesthetic pull established that does begin to get faster and, like a tide, sweeps one along in its undertow. Something as simple as a defined spatial pattern and directions "to see what happens" can create a wonderfully interesting group dynamic as people coalesce in clumps or break out, charging forward with a couple of others in their wake.

This walking-in-a-circle score is something Forti explored in her own solo dances (along with crawling, banking, and figure eights), and, when she came to make her first large group piece in 1976, she used a similar format to structure the beginning of the dance. *Planet* premiered at P.S.1 Contemporary Art Center in Long Island City,

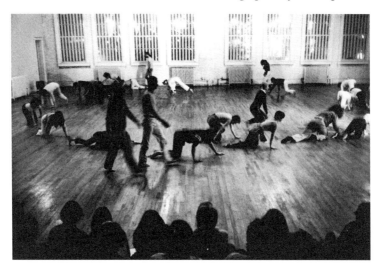

Planet at PS1, New York City, 1976, Photo by Peter Moore © Northwestern University. Courtesy of The Box, Los Angeles.

Queens, on October 29, 1976, with a cast of more than thirty dancers and the taped sound score *Plumbing Music* by Peter Van Riper. The press release mentions that Forti has performed worldwide and that her performance is being produced in conjunction with the Institute for Art and Urban Resources. It describes *Planet* as a large group work based on animal movements. In a journal entry written two years after the premiere (when she was working on her next group work, *Estuary*), Forti calls *Planet* "an epic about evolution" and claims that it was "very much about the evolutionary process, about animals, about this planet over time" (12N). Unfortunately, there are no surviving videos of the piece, nor are there many critical reviews of this kind of experimental dance in nonmainstream venues. But there are a few photographs by Peter Moore and a short but notable description by dance historian Sally Banes, who also participated in the performances of the work.

Moore's photograph of the first section of the dance is very evocative. The black-and-white photograph gives us a wide shot of the old gym at PS1 that was used as a performance space. Against a backdrop

of tall windows and a bank of old radiators, we see an oval-shaped outline of people, most of whom are crawling on their hands and knees along the wooden floor. (Of the twenty-two visible participants, only four are walking upright.) A closer inspection reveals that several are in the process of transitioning between crawling and striding, with their hips raised and knees hovering just off the ground. Two individuals have their limbs splayed out, their bodies close to the ground in a movement sequence that seems reminiscent of the homologous locomotion of reptiles in which the head and the tail curve to the same side. In her essay on Forti ("Dancing as if Newborn") in *Terpsichore in Sneakers*, Banes describes this scene matter-of-factly: "*Planet* is a large group piece that begins with about forty performers crawling, sitting, taking the crawl up to a walk and going back into the crawl."[6] In terms of the movement materials she introduced for this dance, Forti notes: "I was already doing a lot of transitioning to crawling, on the belly like a lizard, back up to running, and doing it in a circle."[7] In the moment captured by Moore's photograph, we see both individual actions and a larger cohesiveness. Although some are in single file, most are in clumps of three or four, each person looking straight ahead or at the floor. They are all dressed casually, in t-shirts and jeans, and most are barefoot. Not a single person exudes a "dancer" demeanor, nor does anyone's movement seem self-consciously performative, even though everyone is intently focused on their own movement. In fact, they look like ordinary people who are carefully retracing the movement origins of their evolutionary heritage. Their bodies are relaxed, but their sense of purpose is clear.

Two years before she choreographed *Planet*, Forti presented a solo entitled *Crawling* at the Sonnabend Gallery in NYC that combined the building blocks of her dance making in the 1970s: crawling, animal movements, and circling/banking. The sound for the piece is a series of animal stories that Forti recites, including observations of two bears wrestling (what she describes as a "rough and tumble love-play") and an encounter with a snake (to whom she gives a "wide berth"). There is an extraordinary video of this solo performed at the Dance Today '75 festival in Tokyo, Japan in 1975. What makes this

video particularly intriguing is the fact that, because each part of the text was first recited in English and then translated into Japanese, Forti had to slow her movement down considerably to accommodate the extra time. In addition, the video is shot close up, so the viewer almost feels as if Forti were trying to teach the details of the movements as she executes them.

The solo begins with Forti emerging into the light while crawling slowly enough that we can discern each shift of weight from hand to knee. In her description of this section of the dance as performed in New York City a year earlier, Banes articulates what the video captures: "In the crawling explorations, one sees an analytic intelligence at work as Forti combines each term in the sequence, making us aware by watching, as she is by feeling, of the minute shifts of weight that happen as the hand reaches forward, of the necessary curve in the spine that allows one knee to advance."[8] Later, as Forti continues to crawl around the stage, she hesitates for a moment and then brings her foot forward, shifting her pelvis higher to move on hands and feet and then into an upright stance. Having demonstrated the details of this shift in level, Forti proceeds to move fluidly into crawling and then back up to walking without losing the rhythm of her stride. There is a considered quality to each section of the dance as she transitions from crawling and walking into hopping, and then to an expansive wing-like movement of her arms while standing. Pooh Kaye, who worked extensively with Forti during these years and performed in both *Planet* and *Estuary*, asserts that Forti based her first forays into group choreography on her solo movement vocabulary. Watching this video of *Crawling* can thus help us to imagine the before and after implicit in Peter Moore's photograph of *Planet*.

In a 2016 videotaped interview at the PHI Foundation for Contemporary Art in Montreal, Forti discusses making *Planet*, including the fact that she taught various workshops at her studio, which allowed her to recruit a large group of people whom she refers to as "the chorus."[9] Describing the beginning of the piece, she stands up and starts to demonstrate the transition from walking to striding to crawling and, after questioning whether she can still do it at eighty-

one, she executes a pretty fabulous splayed crocodile maneuver. Then she gets up and walks the perimeter of the space, gesturing to mark the different actions and recalling the overall effect of so many people changing their gaits, as well as changing levels: "So someone might be turtling along and someone else runs by and someone else is going down to hands and knees and someone else is just sitting for a while." In her journal documenting the process of making *Planet*, Forti included a separate, typewritten page that reflects on the piece after the performances were over. Here is her detailed description of the beginning section:

> They came in one by one, not filing in, but in groups or singly, giving a staggered effect, sometimes four people from the right as two people came from the left, sometimes larger clumps of people striding in walking quickly, some slowly according to their own ways of walking, their own way of striding. [. . .] Each person at their own timing so that the crawling and the striding and the making transitions between the crawling and the striding was staggered. Some people were striding quickly almost running, some running, some walking slowly, some leaning down, reaching with their arms to make the transition to crawling, keeping in the awareness of the body, the opposition of the arms and legs which remains intact from striding to crawling. (22N)

Eventually the chorus drops out, leaving a core group of performers who enter into their specific animal movements. Kaye, who had replaced injured Paul Langland at the last moment, animated an ostrich; Forti, a lion; David Appel, a monkey; Banes, an elephant; and three young bears were portrayed by Anne Hammel, Appel and Kaye. In addition, Terry O'Reilly and David Taylor played with the movements of crocodiles and their humorous way of climbing on top of one another to bask in the sun. The core group also performed a huddle and careened through the space singing high-pitched ululations before moving onto circling and banking. Then the larger group began to join in until the whole place was filled with people leaning into gravity and circling around one another.

In July 1976, Fort started a new journal in which she documented her various interests: "I begin with two projects in mind: The set of multiplex holograms and a big-group performance" (22N). Having turned forty-one in March and still deeply involved with her romantic and artistic partnership with Van Riper (1976 through 1979 were some of the busiest years of their collaboration), Forti reflects in this writing on her work to date and registers a desire to craft a dance on a large scale. At one point, she compares this "big dance" to the project of writing her 1974 memoir *Handbook in Motion*:

> The scale, the many parts with various natures. A survey over different times, different methods of working [. . .] One aspect of Handbook that interests me now is its organization of time, starting in the near past, jumping to the distant past, then to the present. That seems like a kind of spring action. And it reminds me to look for the center and from there to build the beginning and ending. (22N)

A few pages later, she mentions watching Jimmy Carter's acceptance speech at the 1976 Democratic National Convention and notes the sweep of rhythm and timing in his southern cadence. "Unhurried, with rhythmic pauses, each phrase of similar length. The impression was of centered energy flowing without obstruction" (22N). With *Planet*, Forti was much more consciously involved with the question of pacing and flow, both within and between sections of the dance, than she had been in earlier work. Under the heading "Ideas about Planet" she writes obliquely about "actions which can have differing effects on each other according to when, at what point in time, they intercept" without specifying which actions she is referring to. But she also alludes to (in true epic form) the "last appearance of some performers happening along the way, even early, as the death of one, and the continuing imprint of they're [*sic*] having been there in the beginning" (22N).

It is clear from the writing in this journal that Forti is grappling with how to organize the various sections in this group work. Reading, one feels the tension in Forti's artistic consciousness between the

vibrational and the conceptual—between what she terms a "harmonic awareness and a structural awareness." Even as she culls the movement vocabulary from her own solo research to teach to the larger group, Forti is looking to stage an event that ripples beyond the performances themselves. She seems less satisfied with improvisation as a state of being in the present and more interested in developing a conceptual schema that reaches into the past with an eye to the future of the human condition and the wellbeing of the earth. Several months after the performances of *Planet* at PS1, she again writes: "I need a big project." This time, she contemplates making a film that would be "an epic about animals, plants, spirits, people, time." These interests take her beyond the stage or gallery space as she ponders "big outdoor formations" of groups moving together. Although she will never again try to stage her vision of an "epic about evolution" or choreograph for such a large cast, Forti's artistic appetite for working with a group of performers had been whetted.

A paragraph after briefly describing *Planet*, Banes sums up her discussion of Forti's oeuvre to date by concluding that:

> Forti is a dancer who is emblematic of a moment in cultural history when a new naturalism daily seeks to uncover the secrets of the body and of various ecologies. [. . .] With her studies of caged animals, houseplants, the geometries of the body, and discoveries of the maturing infant; with her compact body formulating and articulating comfortable shapes and movements, natural looking but riveting to watch; Forti makes dance another instrument in the ideology of organic living.[10]

Banes's comments point to the ecological and cultural contexts in which Forti was making dances in the mid-1970s. But she also alludes to Forti's concerns with crafting an epic vision of life on earth. It is hard to judge the success of *Planet*; the piece remains a bit of a mystery in terms of documentation and critical reviews. Commenting on her process in general, Forti has said that she trusts that if something interests her, it will interest a viewer—a level of confidence that not everyone has. But perhaps the best evaluation of the performances of

Planet is to be found in her journal, scrawled on the back of a page of notes for the stage manager. In a bottom corner, dated November 1, 1976, a certain John F. from PS1 writes: "Dear Simone Forti, today is monday, the day after the last performance of 'planet' it is so quiet now although inside of me, i feel all the sounds and movements that occurred here last night. that piece left such an impression—one that i'll never forget. thank you" (22N).

As is true for many of her dances (for instance, *Planet* was originally referred to as *Island*), *Estuary: a nature fantasy* was not the title of Forti's second group piece until much later in the process of making it. When I asked Kaye about the title, she replied that she thought the title was self-explanatory in the sense that an estuary is a place where the tide comes pouring in and deposits sea creatures and shells or stones into a small space where they exist together until the next tide carries them back out to sea.[11] This estuarine image recalls Halprin's comments about the arrangement of stones in tide pools being like perfect compositions and is echoed in Forti's journal tracking the experience of creating this new group piece. Right after a sketch with human figures curled up, captioned "rock beach," she writes:

> A rock here, over there a rock and by it another and another, a rock there, and there and over there. Here a rock and over there and next to it others next to others, and a rock over there and there and there, that one among those and down over there those others and this one and this rock and this one here. (12N)

This passage reads as if Forti were transcribing into words a rocky shoreline. Much later in her 1979 journal documenting *Estuary*, she is still searching for a title and notes that the new piece is "less single-minded" than was *Planet*.

If *Planet* was about geological time and the evolution of creatures across the millennia, then *Estuary* is about place, "a place where individuals of a community interact," as Forti writes in her journal. This communal aspect of the dance is highlighted by artist Harriet Feingenbaum's prominent set . Arranged in two porous walls set on the diagonal, the woven wooden branches evoke reeds or a forested

spider web that the performers sometimes cut through but mostly travel around. Like an allée of trees banking a road, the set creates a central hallway that widens as it reaches downstage. Although Forti eventually decides on the title *Estuary*, which directly evokes a place in nature, in her journals she frequently uses the terms "piazza," "plaza," or "commons" to emphasize the social aspect of this arena.

> I see the stage as a piazza, as the commons of the individuals in the piece. As if they had come out of their private houses, out of their private chain of events, to offer the cultural manifestations of their various qualities. And so doing, reflect their lives and the stories which might be going on between them in their daily lives. The audience is privy to these community rites. (12N)

As in *Planet*, much of the movement vocabulary in this dance comes from her solo movement research. Nonetheless, in *Estuary* Forti becomes increasingly focused on the quality of movement (what she calls the "quality of concentration") that various performers bring to the physical material she is teaching them. The contrast of these movement personalities provides a narrative potential that constitutes a new element in the group work. In her journal, Forti describes the "precise steady focus" of O'Reilly, the "playfulness" of the hopping trio, the "very human softness" of Joanne Fridley, and the solidity of Taylor. Turning her attention from the natural sources to the social ones, she ponders the inherent narrative in their relationships. "And yet it seems that all the parts, in relation to each other, can show their story side. [. . .] I put the word story in my mind as a kind of lens through which I read out the juxtaposition of qualities as a story inherent in those contrasts" (12N).

Estuary is Forti's first evening-length choreography for a group. It is structured from a series of eleven smaller sections and runs for seventy-five minutes with an intermission. Forti produced the show at the Merce Cunningham Studio in Westbeth, New York, with minimal theatrical lighting. Van Riper provided the live sound score using many of the same pieces he composed for *Big Room*. *Estuary* begins with Forti walking slowly down the wooden gauntlet

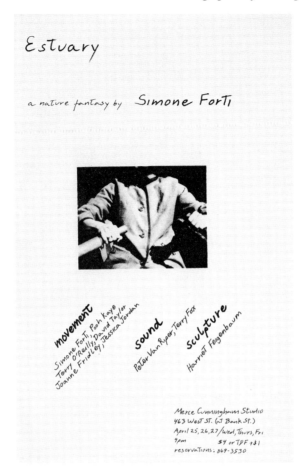

Estuary flyer, New York City, 1979. Courtesy of The Box, Los Angeles.

towards the audience. Hers is a meditative pace, and she seems to be listening to Van Riper's energetic playing of the soprano recorder backed by the mbira, absorbing the space around her. Forti deliberately walks to different places in the room and takes a position on the floor, either curled up like a ball (or rock) or lying on her back and stretching her arms and legs towards the sky in her snake plant pose.

This quiet sensibility soon turns playful as Forti is joined by Kaye and a young girl, Jessica Jordan Nudel. Together, they do a "hopping trio" traversing back and forth along the set's runway. Using her partners as launching pads, the girl then executes "Spring Dance" ("spring" being the action, not the season) by coiling in on their thighs and then springing into the air and falling and rolling on the ground. This scenario repeats until she gets tired and rolls off to the side as the larger cast enters. At some point during the rehearsal process, Jessica must have grabbed Forti's journal to write (in irregular kiddie-print) a synopsis of her movement. It reads:

> Curve side up and wiggle.
> Around and wiggle.
> Down up and wiggle and down.
> Up down and wiggle.
> Across floor up and wiggle.
> Drop down jump and summer salt. (12N)

Although I am not exactly sure what movement she means by "wiggle," the poetic rendering of the launching, landing, and rolling clearly evokes the pleasure of playing by the sea, and "jump and summer salt" is probably a phonetic spelling of "somersault."

Next, O'Reilly enters to perform Forti's crawling solo in a wonderfully slow and austere manner (what Forti calls his "precise steady focus") before Taylor joins him in a rambunctious contact improvisation rolling duet. This is part of the last section of the first half, aptly titled "three simultaneous studies." After intermission, a few other dancers join the core cast and they all create the fast-moving "stream" section that begins the second half of the show. Moving through the whole space and flowing from one side of the set to the other, the dancers get caught in the little eddies that pull them into a vortex of spinning before spewing them out into the larger current of movement through the space. Eventually, they all settle in a pool of deep water, where they release into the floor, shifting to stillness. After Taylor performs an extended solo with fans, which turns into a duet (that I will soon analyze in detail), there is a sleepwalkers duet by Forti and Fridley. *Estuary* ends with what Forti calls a "crest climb," in which the child

Jessica climbs over people's hunched-over backs as they create a continuous ridge by cycling around the line from last to first. There is something very sweet about this last image, but as a final moment it seems to have ventured pretty far away from the tide pool of the title.

While there is no cohesive storyline that pulls the different sections of *Estuary* together, some interesting mini narratives are woven throughout the piece. One is the subplot of watching, dancing with, and caring for Jessica, which culminates in all the adults supporting her ascent and descent as she climbs across their backs. Another is the metamorphosis of *Fan Dance* (1975), a solo that Forti performed after *Planet* in the PS1 concert and later gave to Fridley and Taylor in *Estuary*. Tracking the changes in this dance allows us to understand how Forti's interests at the time were beginning to morph from scores that set up abstract movement to structures that focused on a more interpersonal frame of reference as she brought the natural and human environments together.

Describing Forti's 1975 solo *Fan Dance*, Banes highlights "Forti's sense of awe and closeness with the world of nature, with its mysteries and shadows."[12] Forti, dressed in black, manipulates two rattan fans that are straw-colored on one side and painted black on the other. At times, Forti completely disappears into the shadows when she turns the black fans outwards and hides her face. As she twirls the fans around her body, she circles a green fern placed on a ladder, at times addressing it "almost as if in ritual worship" Banes writes. In the 1979 performances of *Estuary*, Forti staged a similar solo on Fridley in the first half, and then again on Taylor in the second half. The differences in their movement personalities are striking, all the more so as Fridley joins Taylor's solo and they create a duet that hints at a romantic narrative in its use of space and gesture. About ten minutes into the first half, Fridley enters from stage left to the lively sounds of Van Riper's soprano recorder. She traces a spiraling route as she twirls the large, leaf-shaped fans around her body, at times covering her face with them. The sense of mystery that Banes saw in Forti's solo continues in this section as Fridley spins in a circle that expands and eventually carries her over to the other side of the set. It is unclear whether she is blessing the space or casting a spell, but her eyes follow the fans as

she reaches them high in the air and then spirals them down to the ground. While she moves with a soft fluidity and weaves soundlessly in and out of the woven branches of the set, she seems mesmerized by the power of the fans themselves such that it is unclear whether she is moving them, or they are moving her.

In contrast, Taylor's fan dance solo begins with him blasting in from the side. He circles the edge of the performing space, his heavy footfalls making a thudding sound on the wooden floor. Taylor is a tall man, and when he spreads his arms holding the fans, he seems like a giant raptor swooping in for the kill. Even when he calms down to a slower tempo and his movement becomes more fluid, its execution still has a martial feel. As he spins, he plays with his weight and momentum, willing to tempt the edge of control and balance. He executes a series of barrel turns with the fans whipping out at his sides. At one point, he spectacularly alights on the window ledge and, soon after, rushes down the gauntlet to leap—practically landing in the audience's lap. As he moves over to stage right, Fridley joins from stage left. They dance across the room from each other, using the fans as semaphores to communicate across a distance. After a few minutes, they approach one another, their twirling of the fans creating a serpentine and slightly coy journey to one another. Taylor covers his face with the fans as Fridley circles him, and they play with placing the fans in the negative space created by the other's movement such that when he lifts his fans around her head, she fans his legs. Sometimes they separate and enter their own orbits, but even then, they maintain eye contact. Eventually, their circling gets smaller and smaller, and together they retreat into a corner while the next section begins.

Towards the end of her journal for *Estuary*, while she is still searching for a title, Forti compares it with *Planet* and writes about how it has "elements in action in a community, a community of humans with a totemistic focus" (12N). Those strands of nature, community, and some aspects of mysterious rites come through in performance. Yet it is unclear to me just how artistically successful *Estuary* was as a group composition. There are many disparate sections that are strung together, and the set—beautiful as it was—got in the way of an effective use of the space as it forced the action into two separated halves.

In addition, the piece was long and oddly paced; several solos ran close to ten minutes that could have been edited to half that time, while the moments when many people were onstage and much was happening were allotted only a few minutes. Jack Anderson, a fairly conservative (in terms of aesthetic preferences) dance critic for the *New York Times* called it "not very compelling," noting that it may have been "one of those dances that are more fun to be in than to watch."[13]

In her journal documenting the process of making the work, Forti recognizes that she is at the mercy of scheduling and has to work with whomever she can get on a certain day. "I realize that a lot of my decisions about the parts about the movements, are determined by the necessity to call rehearsals when I can within people's schedules, and then to give each person material to work on the whole time that rehearsal is going on. In a way, it's the sense of responsibility that I feel in the workshops that I rely on in rehearsal" (12N). Unlike many of her other journals, the one dedicated to *Estuary* is filled with lists of sections and people and assorted to-do lists. The times when she actually writes about the content of the piece are few and far between. In her mind, it was about a community dealing with natural forces, but that aspect did not necessarily come through clearly in the performances.

I consider *Estuary* part of Forti's compositional learning curve. Although she would continue to make pieces with others, such as *Jackdaw Songs* with Van Riper and a cast of eight dancers (The Performing Garage, 1981), and *Spring* with Susan Rethorst and Z'EV (Danspace Project, 1983), it was not until she received a residency commission from the Yellow Springs Institute for Contemporary Studies and the Arts in 1986 that she decided to pull together a group of five dancers under the banner of Simone Forti and Troupe. Meanwhile, however, she traveled extensively and taught in the United States, Europe, Australia, and Japan. Her CV is filled with the places and dates of her workshops, often followed by the addendum "taught workshop and gave performance with workshop participants." In the seven years between the staging of *Estuary* and the making of *The Foothills* with her troupe, Forti honed her group compositional skills while teaching across the globe.

The first sentence of Forti's contributor notes for the Fall 1984 issue of *Contact Quarterly* simply states: "Simone Forti has been an influential figure in the development of postmodern dance and the workshop process." This intriguing term, "the workshop process" denotes a mode of learning that is experimental, most often based on a series of proposals or scores that the participants investigate together. In general, movement workshops last from two to four hours and proceed very differently from a traditional dance technique class in which the instructor stands at the front of the studio, demonstrating a movement phrase that the students then attempt to execute in the same fashion. Rather, workshops are more like spaces for open exploration and individual movement research, often focusing on perception and attending to states of physical sensation and kinesthetic proprioception. They create opportunities to generation new movement material, often through improvisation, and offer possibilities for the compositional framing of those findings.

A collective of experimental dance artists founded Movement Research, Inc., in 1978 as "a center for new ideas in movement training and composition," incorporated as a nonprofit organization in 1980.[14] For more than forty years, Movement Research has been one of the most robust organizations in the New York City downtown dance scene to sponsor this kind of *workshop as process*. In a *New York Times* article by dance critic Jennifer Dunning previewing the 1987 Movement Research benefit performance, Lisa Kraus is quoted describing how "Movement Research works on the dancer as a whole being and an artist."[15] Similarly, Simone Forti is quoted addressing the disciplinary cross-fertilization that she believes is a crucial aspect of the organization. She sees "the value in working with ideas and developing perceptions and kinesthetic awareness." She continues: "In a way, I see us as an environment where there is not a lot of pressure to package, to produce quickly. It is a more nurturing environment." Based on my experience taking classes, teaching, and briefly working as The Studies Project coordinator at Movement Research, I believe the organization sponsors a nonheirarchical collaboration in the ety-

mological sense of the word—as colaborers, working together to pursue kinesthetic inquiry.

Forti taught for Movement Research from 1980 to 2015, clocking in many, many hours as a teacher, mentor, honored guest artist, and avid supporter of its mission. She also made her studio available for workshops and jams before Movement Research found a permanent home on the lower east side of Manhattan. Movement Research is unique in its commitment to improvisation as a form of movement invention as well as a mode of performing. The original mission statement is comprehensive regarding the organization's vision, and the last sentence declares: "The goal is to create an environment that will allow students and faculty to focus deeply on their study and develop their own resources through consistent feedback and exchange."[16] With its powerful blend of study and searching, "movement research" aptly describes Forti's artistic sensibility—she is interested in deep research that combines the empirical and the ineffable, and, of course, movement is her preferred medium.

In her discussion of Movement Research workshops by Forti, Mary Overlie, and Ping Chong, published in *Contact Quarterly*, Laurie Lassiter describes the overall experience as both "laboratory and choreographic tool," mixing the image of dancer as artisan with that of mad scientist, the kind of alchemy that Forti would surely appreciate.[17] Lassiter describes a typical session of Forti's weekly three-hour "movement workshop" in which Forti leads a warm-up meant to get everyone's blood and creative juices flowing. A physical direction to walk or run through the space in different directions may morph into an improvisational score as Forti layers on other elements such as attending to tempo or the relating to others in the space. She may then introduce a "flocking" or herding score in which the group tries to move together without any one leader dictating what they do. Lassiter quotes Forti: "The problem is to create a structure that the people can transcend. Something else happens beyond the structure."[18] An example of such an activity might be what Forti calls "found scores" that she describes as "working from forms that one perceives in the

environment, such as a heap of clothes or a complex of reflections in a window. To an extent it's a process of synesthesia, intuitively shifting from a retinal to a kinesthetic experiencing."[19] This idea of immersing oneself in an environment and then allowing the striking visual elements to translate into bodily gesture would become a hallmark of Forti's compositional approach to the land portraits that she created with her troupe in the late 1980s.

Another example of a task-based structure that lends itself to developing from warm-up to performance score is a movement game called *Scramble*. Forti first experimented with this structure in the early 1970s in the Open Gardenia events she organized at CalArts and has honed it over the years. The instructions are deceptively simple: move quickly through the studio, finding the spaces between two people and sliding through them without touching either person. As the score progresses and the participants become more comfortable with the speed, they begin to relax and allow their kinetic reflexes to take over any decision making needed to avoid collisions. Then, something truly magical happens. In a 1984 essay (which precedes the interview mentioned above), Forti describes in detail the experience of this score.

> In my workshops, I've evolved a movement game I call the scramble. I've done it with anywhere from five to twenty-five people. I can imagine it with hundreds. Essentially, the directions are for each person to go darting through the spaces between the other people. The whole group starts to scramble and the experience is exhilarating. How is it exhilarating? There's the sense of moving through a new medium. Not just air, not water, but a dynamic shifting field of spaces and solids in constant articulation, and one experiences oneself lunging and darting, twisting and falling through this constantly shifting environment. *The environment is of individuals. The experience is of group.* (1984, 10; emphasis added)

In an interview, David Zambrano (who would eventually join Simone Forti and Troupe) recalls the first class he took with Forti

at the American Dance Festival in 1983. The first thing she did was a scramble to warm everyone up for more open improvisations. A young dancer from Venezuela, Zambrano had been struggling to fit his dancing into the conservatory model of dance training. When Forti sent them moving quickly through the space, dodging one another, he felt like he had found the right teacher for his kinesthetic appetite. He exclaimed, "Immediately, I clicked with Simone."[20] Her workshop was his introduction to a fruitful intergenerational connection during which he learned how to teach improvisation, how to craft scores for improvising group work, and how to perform spontaneously. He still uses a version of Forti's *Scramble* which he calls "passing through" to guide his work with larger groups and finds that the activity transitions easily into a performance score.

In a conversation in the spring of 2020 (during the Covid-19 quarantine), Forti recalled how this score was inspired by the fact that in 1970 Forti was learning how to drive on the LA highways. She mentioned that she still gets "miffed" at the way people swoop in and out of lanes on the freeway but also acknowledged that sometimes that weaving happens in a "very kinesthetically natural way." This experience led her to imagine the possibility of a similar structure of weaving in and out of spaces with other people, but in a contained space, rather than just moving in one direction.[21] While the instructions for this score are simple enough, the results can be quite complex, especially if the participants have a developed sense of their own proprioception and are schooled in moving in a three-dimensional, multidirectional manner. But this is a reflexive skill that not all dancers possess.

I was honored to witness Forti teach *Scramble* to a large group of students from the Salzburg Experimental Academy of Dance while she was mounting the Dance Constructions as part of her 2014 career retrospective at the Museum der Moderne Salzburg in Austria. Like many participants in her Movement Research workshops, these young dancers had significant training in contemporary postmodern forms of dance improvisation, and they took to Forti's work like fish to water, an apt metaphor considering that Forti often compares *Scramble* to "the ancient dance of schooling together"—like fish in the sea.

Most of the international cast had trained together for more than a year, and their level of comfort in careening through the space was remarkable. After they had been doing the original task for a while, Forti began to enumerate options that they could explore, including pulling out of the whirl, watching for a while, and reentering when one felt ready. Eventually, Forti told the cast if they came out, they should stay out. It was extraordinary to see the space become empty after so much movement. In my journal entry about that experience, I compared the effect to the last bit of water draining out of a sink or bathtub. At first there is water swirling around, and then suddenly it is gone.

Later that week, the group performed *Scramble* for an audience in an outdoor courtyard just off the museum's main gallery, which was filled with the materials—slant board and hanging ropes—for the performances of Forti's Dance Constructions. It was a beautiful day with clear blue skies and the mountains of Austria floating in the background. I stood up on a wall to watch their performance, and the raised perspective gave me a new appreciation for the score with all its changing spaces and dynamics of speed punctuated by an occasional stillness. With the random mix of lively colors in the dancers' outfits (Forti performed in a bright blue shirt that echoed the sky) and the artful combination of gathering and scattering, the whole piece was thrilling to watch. At one point, the group was spread out, and yet there were fascinating correspondences as two or three dancers entered their own little vortexes at the same time.

What I particularly enjoyed about seeing *Scramble* outside on the museum's terrace was its exquisite slipperiness, its ever-changing movement pathways. It was like seeing the physical embodiment of a metaphysical sensibility, a fluid state of becoming and becoming again. There were amazing moments of spooling in which one dancer, riding the wake of someone else's momentum, cut in tightly to a small circle, and the one just next to them spiraled out like a ripple spreading through the water. Still images from this performance show how many bodies are banking, really slanting as they loop around the periphery of the space before heading back into the fray. The piece

ended with the group gathered in the center, standing still, reflecting the timeless quality of the distant mountains.

Huddle is another score that Forti often teaches in workshops and frequently uses in the informal performances she presents with workshop participants. After she had moved back to Los Angeles at the end of the 1990s to care for her aging mother, Forti began guest teaching in the dance program at the University of California, Los Angeles (UCLA). Professor David Gere, who teaches "Arts Encounters," a large general education course with colleague Meryl Friedman for the School of the Arts and Architecture, related in an interview a delightful story of Forti teaching the *Huddle* to a group of more than two hundred students from across the university. When Forti visits a class, rather than give a lecture, she gives students the opportunity to experience their learning physically, typically dividing into small groups and navigating the score for *Huddle*. The score includes the need to take some physical risks and share support, often an important bonding experience for the class. Gere spoke of literally hearing gasps from many of the nineteen-year-olds when Forti demonstrated with the teaching assistants. They were astonished that a person with an aging body, white hair, and Parkinson's disease could conjure such spry energy. Her complete commitment to the situation at hand as well as her open and joyful sense of wonder—not to mention her willingness to perform spontaneously for the students—is indeed striking. Gere described it as a form of "ephebism," an Africanist term for moving with youthful energy, no matter your age. "Usually, you can see it on her face. There's this moment [. . .] she's ready through ephebism—that youthful energy again, this elixir; she feels refreshed and ready."[22]

It is this inviting combination of maturity and youthfulness, wisdom and curiosity that underlies Forti's reputation as a master teacher. In an article on Forti's teaching, Craig Bromberg notes that Forti's movement workshops are highly regarded. "Indeed, while her dances have been performed all over the world for the last twenty years, Forti is now known almost more for her teaching than for her performing. The improvisational structures and amateur naturalism that mark

her work have now become as essential to many dancers as classes in formal technique."[23] A frequent refrain from her former students and collaborators is how inspiring and brilliant Forti is as a teacher. In an interview, Kaye pointed to the interesting paradox of Forti's pedagogical style. Forti is both physically clear and specific about the details of the movement material she is presenting and quite loose about how a dance might incorporate those moves in the improvisation. Timing and spatial directions are open to interpretation and play within the score, while the contralateral mechanics of crawling or pelvic tilt in banking, for instance, are not. "Rather than teaching set movements, or set patterns, she'd give you the dynamics to make the movement happen. And then you were responsible for the patterns," Kaye recalled.[24]

Contemporary dancer and troupe member K.J. Holmes took improvisation classes with Forti at her loft in the mid-1980s and recalled, "there was something about her recognizing something in me, I think, that really drew me to her. I loved the classes." Later, when Holmes was having a hard time working with "moving the telling" (a form in which verbal storytelling intersects with dancing), she conferred with Forti, who was "always so generous" about her difficulties. After observing Holmes for a while, Forti declared, "You know what it is? It's because you are a haiku. You are a haiku, and your way of moving is not that linear kind of way."[25] So Forti suggested that Holmes create five lines like a haiku and structure movement in that manner. In the interview, Holmes spoke with awe about how she experienced this moment as both a personal revelation and an affirmation of her own style of poetics. She felt deeply honored when Forti asked her to work with her as she was gathering her collaborators for what would become the troupe. In remembering their first time working together, Holmes offered:

> I think she is so smart because the people that she chose to be part of the group were very particular about their own movement explorations. David Rosenmiller brought in a lot of environmental and ecological studies, and then David Zambrano brought

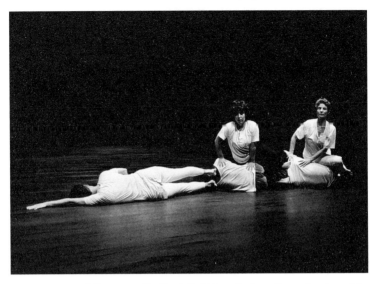

Simone Forti and Troupe in *The Foothills,* Yellow Springs, Pennsylvania, 1986.
Photo by Deng-Jeng Lee. Courtesy of The Box, Los Angeles.

in these movement patterns, and Lauri Nagel brought in a lot of
poetics, and then I had a lot of the release work and relationship
of language to the environment. It's really smart.[26]

In August 1986, Simone Forti and Troupe (Forti, Nagel, Holmes,
Zambrano, and Rosenmiller) were granted a residency at the Yel-
low Springs Institute, where they developed and performed their first
work, *The Foothills.* In the typed manuscript of the proposal that Forti
submitted to apply for the residential fellowship, she articulates the
vision and process that would provide the foundation for most of the
troupe's pieces throughout its existence. "The initial working process
would entail spending time in the surrounding countryside observ-
ing movements and landforms which would become an influence in
the choreography and doing some reading about the history of the
area" (18N). Tellingly, as the process evolved, her journal reflects a
shifting of perspective from "I" to "we." In response to the facetious
question "What am I/we trying to do?," Forti crosses out "my" and

writes over it "our"—"To broaden *our* experience of a location and of *our* relationship to its history." This experience of collaborating with a group was deeply meaningful for Forti—it gave her renewed inspiration and enriched her choreographic palette. In an interview many decades later, Forti remembers that experience fondly, noting that ". . . we went there to that place [the Yellow Springs Institute] and it just seemed natural to do a portrait of it, and I was very happy with how we worked and with the process that I came up with as the director and with what we did, so it was natural to keep doing more things together."[27]

While the troupe members were involved with immersing themselves in the environment and in creating scenes and movement motifs, Forti took on the role of director, using her choreographic eye to refine particular moments from their improvisations for the performance, ordering the scenes, selecting what visual images they would use, and usually inserting a solo in which she told the story of some human aspect of the history of the place. It is important to note that these land portraits were not nostalgic evocations of a long-lost wilderness. Rather, they were complex layers of geological history and human story. In a discussion with Claire Hayes published in *Contact Quarterly* under the title "Dancing in Earth Context," Forti says, "I feel the need to make a connection with the land within the real context of today's post-industrial age [. . .] trying to reach in both those directions—to the earth's forces and to the forces of our society" (1987, 11). Stretching her work to include not only other people but also history and language, Forti began to explore landscape and a sense of place—broadening her creative palette to include other perspectives besides her own. Unlike her early work with Halprin that centered on the observation of nature for abstract movement inspiration, Forti began to engage with the social and political implications surrounding our human footprint on the land.

Founded in 1975, the Yellow Springs Institute was designed to give artists, including performing artists, the space and time to cultivate precisely the kind of work Forti was beginning to research with the troupe. A nonprofit organization, the Yellow Springs Institute sought

to "establish an interdisciplinary laboratory for creative individuals whose work interprets aspects of contemporary experience, encourage creation of works that expand artistic boundaries, enlarge cultural understanding, and employ art and artists in the life of communities."[28] The founding director, John A. Clauser, was an architect who was deeply invested in the important connections between ecology, artistic creativity, and a sense of community. Holmes remembers him as an encouraging visionary who would come to rehearsals and talk about the importance of artists in creating a better future for humankind.

Yellow Springs is a small historic village in the township of Chester Springs, Pennsylvania. Its cluster of wooden houses and larger gathering halls with big wide porches flank each side of the road. On one side is a big hill leading up to the woods, and on the other is the stream, the source of the sulfur spring that gave the town its name. Originally the land of the Okehocking people, it was known in the early days of the American colonies for the medicinal quality of its water. Yellow Springs was also the home of the first revolutionary war hospital; its stone foundations today house a medicinal herb garden. For almost a century (1861–1952), Yellow Springs was a summertime painting and sculpture colony run by the Pennsylvania Academy of Fine Arts. The academy employed a landscape designer who tried to replicate the kind of picturesque landscape that painter Claude Monet and the Impressionists favored. Before the institute took it over, it was the site of a religious film studio. The remnants of all these previous lives of the village are lodged among the weeds and the stream that now border the remaining buildings.

While in residence at the Yellow Springs Institute, the members of Simone Forti and Troupe frequently worked outside, witnessing the life of woods and stream. In an interview, Holmes recalled:

> We spent a lot of time looking, and we would all find a place
> that we were going to return to and just observe nature, and then
> write about it and talk about it. There was a stream and Simone
> has this amazing ability to re-play what she hears in the environ-

ment, like listening to water, and then singing it. It was like our eyes, we were using our ears, our voices, our words, creating.[29]

Perceiving with all their senses, the dancers would return to the studio and find ways to animate their impressions. Often, they would begin by telling the group what they had observed, and the witnesses would pick up on the intuitive gestures that each speaker made as they related their memory of a moment that captured their kinetic imagination. In "Dancing in Earth Context," Forti articulates the key concern in moving from observation to motion.

> It means developing a technique for how to get from this research to movement. A technique that isn't the left side of the brain laying out a formal representation of what we have experienced, but one which involved an awareness of the movements of our senses—how we slow down, how the eye follows the ridge of a mountain say, and how, when the eye follows it, the head follows. The body is responding to the movement of the eyes. (1987, 10)

One night while they were there, a big tree fell down in a thunderstorm. Zambrano used that image to create a repetitive motif of standing still and then suddenly falling over. The final piece connected these movement impressions from the earth into a longer narrative that interwove the kinetic structures of the geography with the story of its occupants.

In addition to observing and then animating the natural landscape, the troupe investigated the rich history of the area, which had been the site of two important revolutionary war battles. Forti notes that the land was rich in iron.

> I got interested in how the iron came out of the ground and had been made into cannons and cannon balls, and how there were as many as a thousand unmarked graves right where we were working because it was the site of the army hospital. So there was a sense of the earth, the human activity on the earth, the coming

round of the earth coming out as iron, and folding back in as people. (1987, 10)

As they accumulated their impressions, the troupe began to craft a process that would serve them for many of their land portraits. Usually, they would begin a piece with a reenactment of the geological formation of the mountains. Then, there would be different sections of moving based on their kinesthetic memories. These were divided into solos and duets, sometimes with the group echoing the movement in the background.

Finally, there was usually a solo performed by Forti in which she would move and talk, relating an aspect of the social history of the place the group was evoking.

> As I speak, I'll be the various parts so for instance in that section of the dance where I was talking about the iron coming out of the ground, I started by licking my arms and licking the taste of the iron, then suddenly I was the cannon, my arms stretch forward forming the barrel, and boom I shot my body out through my arms, hurling myself across the stage and landed, thud, a cannon ball lodged in the field. (1987, 11)

Thirty-four years later, in her discussion of their residency at the Yellow Springs Institute, Holmes spoke of being amazed by this improvised solo. "I just remember her re-enacting a story of a British captain or general or something, drinking and then throwing the cannonballs. So, she's a general drinking and throwing her head back and drinking a big bottle of something, and then, all of a sudden, she's a cannonball being shot across the space, and [I recall] being amazed by that."[30]

The work the troupe was crafting at the Yellow Springs Institute that summer fit awkwardly into the prevailing aesthetic of dance in NYC at that time. Holmes called it "a huge shift" to bring *The Foothills* back to the city after their bucolic time away. She notes: "I think at that time in the city, in the mid-1980s, performing there was so much about [. . .] performing the energy of New York. And it felt in

some ways really radical to bring in something that was from outside that had a whole other sensibility than a lot of the kind of high-energy states that a lot of the downtown dance was exploring at that time."[31] Indeed, in the mid-1980s there was a peak in extreme virtuosic dancing. Perhaps Elizabeth Streb's PopAction team is the epitome of that moment, but even the Trisha Brown Dance Company and the Bill T. Jones/Arnie Zane Dance Company were stretching the bounds of postmodern dancing with dynamic phrasing coupled with full-bodied choreography that did not skimp on leg extensions and luscious backbends. Likewise, downtown dancers such as Yoshiko Chuma and Jennifer Monson were pushing (sometimes quite literally) the limits of fitness and endurance. Even in contact improvisation, there was an emerging group of professional dancer/teachers whose emphasis on virtuosic shoulder lifts and fast dancing with momentum created a whole new level of technical expertise. This high-energy sensibility came with its own degree of professional competitiveness as companies vied to get visibility and a prize gig at the Brooklyn Academy of Music's annual Next Wave Festival.

This was also a moment when Forti began to reevaluate her position in NYC as she spent more and more time in Vermont. In "Dancing in Earth Context" she mentions the kind of "receptive" mode of perception that she feels naturally in the country and contrasts that to the "frantic" and "consumerist" mindset she finds in the city. By September 1987, when she is weighing her options, she writes in her journal: "If I look at this from the point of view of my heart, I see that clean air and freshness of nature makes me happy, are very important to me. The farm in Vermont, the community there, that land, the mountains and brooks, the sky and stars and snow are very important to me" (15N).

Before she relocates to Vermont, however, Forti crafts another piece with the troupe. *Roadcut* took as its subject the natural world of NYC, looking past the concrete jungle to find places of wildlife and magic in the midst of the hustle and bustle. The troupe performed it as part of Movement Research's the Presenting Series at the Ethnic Folk Arts Center, and research included reading about the natural history of the

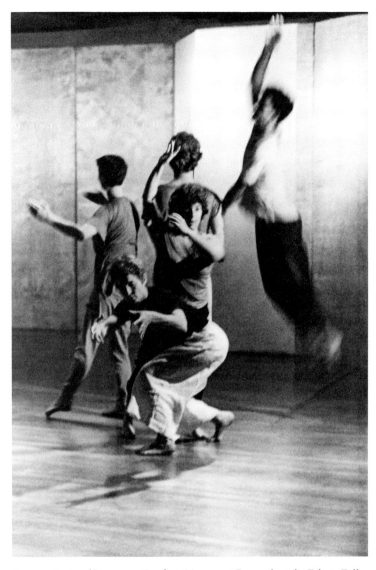

Simone Forti and Troupe in *Roadcut*, Movement Research at the Ethnic Folk
Arts Center, New York City, 1986. Photo by Peter Moore © Northwestern
University. Getty Research Institute, Los Angeles (2019.M.23).

beautiful island before the European settlers laid claim to its strategic position. In preparation for the performance, the troupe took a ride on the Circle Line cruise to see the nighttime skyline and spent a night sleeping on a roof in order to witness the sunrise in the morning. Referring to these experiences, Forti acknowledges that "Somehow we were in a very receptive mode. We were in the perceptual mode that I am naturally in when I am in the country, but which usually changes when I am in the city" (1987, 10).

Two years after crafting *The Foothills*, Forti brought the members of her troupe up to Mad Brook Farm to create a land portrait of that area, situated in what is fondly referred to as the "Northeast Kingdom" of Vermont. There, the troupe followed a similar process to the making of *The Foothills*, going out into the woods, fields, and streams to observe the natural environment and then bringing their impressions back into the studio to generate movement and, increasingly, language. In *Green Mountain*, the dancers share the speaking with Forti, at times interweaving their separate stories into a poetic rendering of place. In addition to their speaking, there is a taped interview with old-timer Ed Verge, who recites the legendary history of the St. Francis Raid, a grim moment in the French and Indian War. Using text in *Green Mountain* allows Forti to explore the contours of the geological past, as well as human history and how conflicts between peoples have marked the landscape of that region. This is when Forti begins to use the phrase "moving the telling" to describe her compositional method of bringing body to story. In her journal from March 8, 1988, she riffs on her aesthetic objectives: "Am I looking for a general picture? For a few potent images that I will use in dance narrative, in moving the telling?" (41N).

Like most of Forti's group work, *Green Mountain* is composed of discrete segments that, while improvised in terms of specific movements, are set in terms of the experiences and images portrayed. Often, the order of these scenes is not finalized until the very end of the process of creating the performance. According to her journal notes, Forti was clear about the beginning sections and her final solo but

kept shifting the sequence of the middle sections. Nonetheless, as it was performed at Dance Theater Workshop in May of 1988, *Green Mountain* is composed with a nuanced understanding of overall dramatic pacing. There are stunning moments of group cohesiveness or shared action as the dancers interweave, describing an experience or an element of the landscape that was significant to them. In an interview, Holmes reminiscences about Forti's skill in balancing the individual with the collective. "[S]he so celebrated the individual within the group, so again really highlighting each of us differently, but then how we were as a group." [32] In addition to the skillful weaving of solo and group, Forti's use of space in this piece seemed much more consciously crafted than in her other troupe pieces. There are striking shifts between intricate details of fauna on the ground articulated in a lively sense of the present moment and a meditative attention to the vastness of the mountain landscape.

After an opening duet-as-prologue, *Green Mountain* begins in earnest with rock dance, a group section that sets up the continuum between people and the land. Cultivating a common breath rhythm, the five dancers move from the edge of a circle to face one another center stage, sweeping in and back out to the periphery like a wave. This wash of gathering and separating shifts after someone raises a flat stone overhead and another strikes it with a big sweep of their arms like one would strike a gong. Keeping the same rhythm of breath and oscillating between moving and stillness, the dancers settle into a series of tableau as they pass the large stone from person to person. The sound of feet moving and the rock being struck is augmented by the clinking of small stones that one person drops into the hands of another. The moments of stillness and silence between these actions gives one the impression that this community ritual has been going on for time immemorial. The section ends when someone drops the rock with a thud, and everyone falls to the ground. Moving from the heft of rock to the flow of water, the group next lines up on a diagonal to create a face cascade. As one after another falls head first into their neighbor's hands and then onto the floor, the image of a human wa-

terfall spills across the stage. Although the images so far are generally abstracted, it is clear by now that in this piece people and the natural environment are mutually connected.

The space clears as Forti and Rosenmiller begin the first of their two "moving the telling" duets. With arms open wide as if he were measuring distances, Rosenmiller crouches down and talks of the geological foundations of the area and how the Clyde River flows through its valleys. Forti, in contrast, focuses on the human stories, including one about the St. Francis Raid, in which a village of native Abenakis was attacked during the French and Indian War. In her notes for *Green Mountain*, Forti writes of how this historic event is still raw in the stories people tell of those who fought for the land several hundred years ago. "The way it becomes mentioned suggesting that it still sits heavily . . ." (41N). Another section ensues, in which Nagel recounts the experience walking, climbing, and sleeping on a boulder. The others in the group support the soloist through sound and gesture, stretching to become the trees in the woods or imitating the sloshing of boots in the wet, heavy snow.

An extended duet between Forti and Rosenmiller follows. Melding language and movement, this scene is stunning in its seamless and improvised exchange of physical gesture and kinetic story. At one point, Rosenmiller drops to the ground just as Forti gets up from it. He is talking about seeing the new shoots of green sprout up among the dried leaves as she looks out into the distance. His micro focus on individual plants contrasts to her simple arm gesture, which draws our attention to the expansiveness of the horizon. In another moment, their arms parallel one another while they speak from different perspectives of the edge between field and forest. The stillness and timelessness of that moment quickly evaporates, however, as Forti begins to animate the melting snow and the mythic moment ("on a Tuesday at 2:30 in the afternoon") that the ice breaks on the river. Energized by the memory of ice, rocks, and assorted tree branches crashing and churning down the swollen river, Forti plunges to the ground and rolls, gets up, and plunges again.

Whereas Rosenmiller continues to *describe* the landscape, marking

its contours with his arms, Forti actually *becomes* the river, mobilizing its force through her body and her extended vocal register. Sounds, not words, carry the intensity of the moment. In an interview with Kent De Spain published in his book *Landscape of the Now: A Topography of Movement Improvisation*, Forti discusses her strategy when performing. ". . . you can stand outside of an image and describe it, or you can go project yourself into it and then see what perceptions you have from there: on your skin, what you're smelling, what you're seeing, how you're feeling."[33] Later, two video monitors show close-ups of the raging water as the unseen dancers carry and roll the monitors through the darkened space.

The brief mention of the St. Francis Raid is amplified in the next group scene. A tape-recorded conversation between two local residents (including Verge) enumerates the excruciating details of the massacre of native peoples and the near starvation (including tales of cannibalism) of the foreign attackers. During this recitation, the dancers create a series of tableaux, almost as if they were mirroring the historic dioramas in an old-fashioned natural history museum. Eventually, they form a line down front that slowly creeps upstage to surround and menace a hopping, squawking creature portrayed with admirable zest by Zambrano. The silence and slowness are accentuated by the lights dimming to shadows, leaving the audience with a chilling image of restrained aggression.

Green Mountain served as a creative threshold for Forti as she transitioned into a decade of living in rural Vermont. Through making this dance with the troupe she came to explore the place she had visited so often, a landscape that really resonated with her. She was ready to put down some roots, digging into the soil with her fingers, as well as her creative imagination. This depth of feeling towards the place is manifest in her short but powerful solo that ends the piece. After a duet between Holmes and Nagel, the lights dim and Forti runs onstage. She stops, crouches, and touches the ground, drawing the audience's attention towards her hands as they gently pat the earth. Her hands seem to be channeling energy from deep underneath as her fingers tingle with excitement. Entranced, they search for the

right pathway. It is as if they have a mind of their own and Forti is just trying to keep up with them as they intertwine and weave their way downstage. One hand passes through the fingers of the other hand, threading between and around in a circuitous route across the floor. Forti follows her fingers as they lead her onto her back and then splayed on her belly. As she comes to a final stillness, the design of her body seems to reflect a map of a delta or watershed. As the lights fade to black, there is an audible sigh of amazement as those of us in the audience recognize we have just witnessed something miraculous.

On a page in Forti's journal listing the various sections of *Green Mountain*, this final solo is entitled "source." Although it only lasts a minute and a half, it is an extraordinary kinetic articulation of the origin of a stream. Growing from the smallest trickle to a fast stream which flows around and over rocks, and then widening out to a meandering river, this image of "source" spreads from her fingertips to her whole body. By the end of this short solo, one gets the sense that Forti has just danced the life story of her favorite brook. Writing about a research trip the troupe took to the waterfall near Mad Brook Farm, Forti describes being amazed by the power of gravity and the force of the water as it gathers momentum in its descent down the rockface. Later, she traces its humble source.

> In one place, it simply emerged from among the leaves left from the fall and formed a new trickle or spring. I drank from there. So delicious. I thought that this pure taste of cold clearly emerging water would be the measure of the piece we are working on. May our dance carry some of the pure taste of that water. (41N)

Watching her final solo of *Green Mountain*, one gets the impression that Forti allowed the essence of that "source" to flow in and fill her body with the "pure taste of cold" and bring her to a dancing state that bordered on ecstatic.

In a journal writing, Forti explains that she can find a dancing state in the midst of the steady rhythm of walking. "Recently I've found it [the dancing state] in hiking up the mountain, hiking down the mountain, feeling the strength in my legs, using the swing of my

upper torso, my shoulders, my arms to help me swing along up or down the mountain" (52N). As part of her research for *Green Mountain*, Forti traveled up to Mad Brook in March 1988, hiking up Little Hedgehog Mountain in snowshoes with a friend.

> We saw rabbit and squirrel tracks, coyote tracks. We saw a tree with an old bear-claw mark. We saw owl shit and rabbit shit and partridge shit. We saw a few single birds and a group of little birds came to yell at us. (41N)

The friend pointed out the different kinds of trees, but Forti explains that the names themselves mean very little to her unless she knows the meaning of those differences directly. Her body needs to make sense of the typologies the way it does with animals, for instance. Later that summer, Forti writes about coming upon some deer tracks. ". . . I love to feel the tracks with my fingers, feel the sharpness of the two points of the foot, their negative image in the mud, so much *presence*" (41N, emphasis added).

As she spent more and more time in Vermont and eventually relocated there, Forti grew to love the land and the pace of life at Mad Brook Farm. Enduring the harsh winters, gardening in the brief summers, following the changes of light and seasons, she came to know that natural world from the inside out—its dangers as well as its pleasures. In conversations and in an excerpt from *The Bear in the Mirror*, Forti tells the story of getting lost in the woods one winter night and having to spend the night curled up in an improvised shelter of pine boughs. "I love these woods, full of life, full of decay" (2018, 67). Living with the land, she cultivated an intimacy with the environment that went beyond mere observation to include aspects of sound, smell, and touch, affecting her body and her life. In the present, when arts institutions across the country regularly cite land acknowledgements to honor the original, indigenous inhabitants, people whose lands were forcibly taken from them by US settlers, I find the depth and nuance of Forti's land portraits a living affirmation of this process— one that is actually inhabiting and giving meaning to the gesture.

It is this recognition of the presence of the natural world as vibra-

tion and not vision—life and not image—that connects Forti's feeling for the land in Vermont with Nan Shepherd's meditation on the Cairngorm mountains in Scotland in her memoir *The Living Mountain*. When Forti dances the feeling of rock (as in the video by Kaye) or the meandering journey of a source (as in the final solo of *Green Mountain*), she is physically embodying what Shepherd captures so well in her poetic renderings of the experience of walking and seeing, living and breathing the mountain. Like Forti, Shepherd finds nuance and delight in moving water as she registers its many qualities, including "the slow slap of a loch, the high clear trill of a rivulet, the roar of spate." [34] Like Forti, Shepherd finds enchanting the state of being that is conjured "after hours of steady walking, with the long rhythm of motion sustained until motion is felt, not merely known by the brain, as the 'still centre' of being." [35] It is this sense of deep interconnection with the natural landscape that gives Forti's land portraits a powerful, dynamic edge.

Fifteen months after performing *Green Mountain* at Dance Theater Workshop, Simone Forti and Troupe created what would be its last land portrait—although not its last performance. Suitably enough, the troupe performed *Touch*, its last land portrait, outdoors at Wave Hill in the Bronx on August 18 and 19, 1989. The dancing was presented in the evening, taking advantage of twilight and the magical lighting that comes with sunset in late summer. (For the Saturday night performance, nature also provided some rain.) Wave Hill is a nineteenth-century estate that was occupied by the likes of Mark Twain and the extended Roosevelt family before being converted into a public horticultural garden and arts center in 1965. Built on land originally inhabited by the indigenous Lenape people, Wave Hill overlooks the Hudson River and offers dramatic vistas of the New Jersey Palisades across the river. There are several formal gardens on the property, but most of Wave Hill is cultivated as a natural landscape showcasing indigenous plants. The centuries-old trees are incredibly tall and majestic, and a broad hill sloping down towards the river provides a natural amphitheater for performances. During the summers at the end of the twentieth century, Wave Hill hosted a series of

site-specific performances called Dancescape, the context in which the troupe performed *Touch* that August.

In many ways, *Touch* is the logical extension of the troupe's land portraits in that the dancers are fully immersed in the environment they are evoking. The audience also gets to be drenched (sometimes literally) in this play of natural forces, sharing the haptic experience of sky and earth, trees and water that inspires the dancing. *Touch*-ed by the dancers' awe-inspiring intimacy with nature, Jennifer Dunning, dance critic for the *New York Times*, called the event "spellbinding." "*Touch* was a perfect instance of [Forti's] gift not just for dance that springs from natural impulse, but for highly sophisticated, adroit timing and scene setting."[36] The piece begins with an immersive prologue in which the audience is led down a path and into the woods, where they catch glimpses of dancers hanging from trees or frolicking in the undergrowth. Unexpectedly darting in and out of the fauna, the dancers seem like woodland sprites or creatures from a children's fairytale. Dunning describes the atmosphere as a kind of "secret game" evoking "those haunted summer dusks when children play wild outdoors games too late." Brought back to the hillside for the remainder of the performance, the audience faces a serpentine backdrop of tall trees that provides little semicircular stages for the various vignettes that comprise the evening's adventures. The drawn-out drone sounds and chanting of Charlemagne Palestine's music beautifully accompany the different sections. This soundscape is punctuated by the periodic passage of planes overhead.

The expansive environment of Wave Hill allowed the troupe (which then included Nagel, Holmes, Zambrano, and Eric Schoefer) to work with speed and scale in a way that would have been impossible in a traditional theatrical venue. From the first moment when Holmes and Zambrano come bursting out of the woods in black robes whose voluminous fabric looks like bat wings flying through the air to the moment when the whole cast runs up a hill and engages in a fast and frenetic *Scramble*, the pleasure of moving with speed and momentum is breathtaking. There is an open, generous attitude in their movement that invites the audience to get caught up in the dancers' physical exu-

berance and kinetic joy. The immense scale of the hillside and massive trees render the dancers tiny in comparison. One small element in a much larger landscape, they move in and out of the swaying trees, at one point popping up through the foliage such that the branches resemble large hoop skirts. When the dancers stretch their arms wide and look up to the sky, their gestures expand to join the seemingly infinite dimensions of the outdoors.

There is a remarkable scene early on in which four dancers travel around a little inlet of trees, moving quickly and scrabbling the air around them as if they were creatures with paws. All this activity stops suddenly as they simultaneously drop to the ground in a line, each person curled into a yogic child's pose. The impact of their stillness is riveting, and they remain there long enough for the audience to notice the movement of the trees behind them. Eventually Nagel comes out of the woods and starts to climb across the others' backs as they cycle to the front to continue the line of support. Modeled on the "crest climb" in *Estuary*, this section creates a topography of bodies that rise and fall with dancers' breathing. Once Nagel finishes climbing over this human mountain chain, the dancers break apart and spread out, running up the hillside and into the trees.

Holmes stays behind and begins a lyrical ode to the little dell of trees. Reaching up to the sky and then settling comfortably into the earth, she acknowledges the support of gravity. Eventually, she curls and sits up, flinging an arm that pulls her up and into a spiraling, crouching movement. She is clearly dancing with and for the trees next to her as much as for the audience across the hill. Running over to encircle Holmes, the other dancers next engage in a rollicking game of follow-the-leader. Forti stops in the center of the hill, and the rest of the group spreads out to either side. As she stands with a sense of deep solidity, arms spread wide and gaze focused on the horizon, the others slowly creep back in towards her. They could be glaciers shifting over time. This geological imagery crystalizes as Forti launches into a monologue about the foundations of the Palisades and the formation of the Hudson River oh so many eons ago. *Touch* ends as darkness

overtakes the field, leaving the shadow of Forti's final spinning as an afterimage flecked with fireflies.

Making *Touch* was a deeply satisfying experience for the troupe. They were close enough to home to continue their lives, but the trips up north to explore the area (including the banks of the Hudson River and the old native Lenape caves) still felt like a radical departure from the streets of Manhattan and Brooklyn. In an interview, Holmes reflects on the group's journey and recalls: "I think that there was such appreciation for [the fact] that we had established a sense of troupeness, groupness, and it wasn't all the time. So, it [*Touch*] was really a chance to merge together again and feel how we each had individually grown."[37] Working with the troupe over a period of four years, Forti succeeded in creating a group process of research and immersion such that they could all share in the mutual creation of a dancing state. In the interview "Dancing in Earth Context" she speaks of the importance of being receptive to those environments, of "finding a way to open our senses to the nature of this place and in a way to be open to the spirits of the land, to be open to the many interweavings of forces, among them human society, the tides, the sun. . . ." (1987, 10). Presenting *Touch* at Wave Hill was a great opportunity to extend the experience of gathering impressions *from* nature to performing *in* nature and, in retrospect, it served as an appropriate finale for the land portraits series the troupe constructed from 1986 through 1989.

Although it was not a land portrait per se, Simone Forti and Troupe created a final piece together in 1991. Presented by the Danspace Project at St. Mark's Church in NYC in April, *To Be Continued* brought the group more fully into the process of working with language—speaking while improvising—that Forti had been refining in her solo performances over the previous five years. Instead of immersing themselves in a natural environment as their primary source of inspiration, the troupe now took up the tools that Forti had been honing with her own News Aminations (the subject of the following chapter). Besides talking while dancing, these tools included drawing and writing as bridges that took the performer from objects to em-

bodiment, free associating across memory and metaphor. In an article published in *Contact Quarterly* discussing the process of making this piece, Forti explains: "We had been using a dance/narrative form I've been developing that I call 'moving the telling.' In this process we focus on chosen subject matter—a person, a memory, a landscape, a news story, the wrinkles on a shirt, etc.—as our point of reference and allow the spontaneous impulses for movement and for speaking to manifest so that they supplement each other intuitively and naturally" (1994, 13–14). Her use of thematic content that moved back and forth from impressionistic to representational would continue to animate further performances.

Getting all the troupe members comfortable with improvising language and movement together required that Forti invent activities to break the verbal ice, so to speak. One of these workshop exercises was "words on the diagonal" which she calls a "kind of game" in which someone calls out a word for the person whose turn it is to use the word as inspiration as they move down a diagonal pathway. Forti remarks, "The sudden word calls up images, you can almost see the player bounce the word around in his or her body, getting a feel of the ideas that rush in, and getting started on one of those ideas" (1994, 17). Although this score did not, in fact, translate into material they would use in the final composition, it was key to training their associative and textual muscles. But Forti insisted that their bodies and dancing energies were also warmed up "so that when we would start to speak, we would be well into a movement mode in our blood and in our mind" (1994, 20).

Like the other pieces built with the troupe, *To Be Continued* is composed of a series of structured improvisations. One of these is what Forti calls "still lifes," in which the dancers sketch an object or a person and then try to animate the drawing.

> The eye moves, the hand moves. The body embodies, the hand moves and the body's embodiment shows in the drawn line. And then the body can continue on its own, embodying a detail while the speaking gives the large shape or the context, or the other way around. (1994, 15)

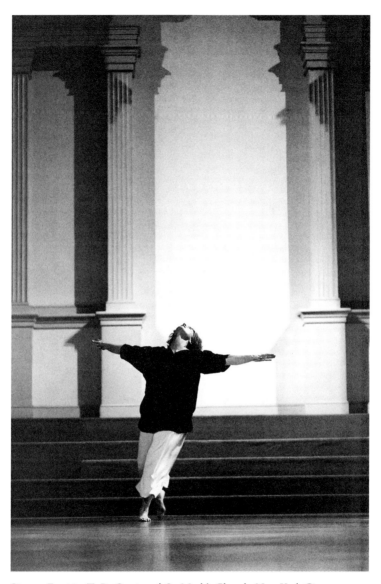

Simone Forti in *To Be Continued*, St. Mark's Church, New York City, 1991.
Photo © bill leissner.

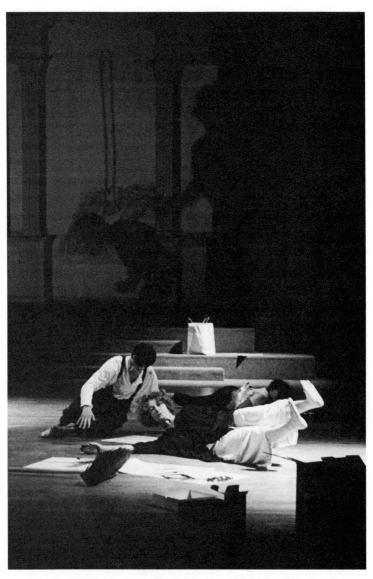

Simone Forti and Troupe in *To Be Continued*, St. Mark's Church, New York City, 1991. Photo by Peter Moore © Northwestern University. Getty Research Institute, Los Angeles (2019.M.23).

Another section is "portraits," which was based on memories of specific people and moments. Forti notes that "the portrait process is more complex, more mysterious. Memories come that are of events, stories, details of the subject's environment, their ways of moving or thinking" (1994, 18). At this time in Forti's life, she begins doing portraits (in writing, drawing, and dancing) of her father, clearly an important figure in her childhood. There is an extraordinary photograph by Bill Leissner taken during the performances at the Danspace Project of Forti doing a portrait of her father in a hot air balloon in World War II. Obviously caught up in a "dancing state," her arms are spread wide like eagle wings and her face is reaching towards the sky as she moves with enough speed to make her pants fly out. Members of the troupe recall that Forti's individual solos in their shows were always very powerful—she was totally committed and fully immersed in whatever memory or image she was working with. Sometimes Forti's "moving the telling" solos provided a striking contrast to those of the other performers, who were younger and less comfortable with speaking. Indeed, Jack Anderson's review of the show suggests that most of the time they were "muttering" their text.[38]

Building the piece as a group required not only that the dancers be comfortable improvising movement and language together but also that they be cognizant of the other stories occurring at the same time. These "simultaneous stories" insist on a particular kind of awareness to what is happening in the whole space. Forti elaborates on the skills involved. "It takes listening to the general sound of the other, and sensitively building a rhythm with silences and room for separating and blending the stories. Amazing coincidences emerge, no doubt helped by the peripheral hearing of a word from the other story which makes yours take an unexpected jump of focus" (1994, 20). This process of "moving the telling" as a group is very much like being in a conversation in which people use gestures and words to physically "nod" agreement, what Forti describes as the "uh huh" position. "It's an exercise in listening, nodding as comes naturally in conversation, maybe asking for more information or clarification, and also taking action to embody aspects of the emerging story, diving in on an

impulse to become the easy chair the storyteller can sink into while remembering an uncle" (1994, 20).

It is ironic that the process the troupe developed in preparing *To Be Continued* was not, in fact, to be continued. Soon after their performances at the Danspace Project, the members of the troupe shifted into other pursuits, and Forti's energies also shifted to developing her solo performances of News Animations and her gardening journals. Nonetheless, the exercises that Forti crafted in rehearsals with the troupe would become staples in the Logomotion workshops that she led over the next three decades. Leaving her focus on the natural environment but not on issues of climate change, Forti began to seriously research another kind of landscape—the physical dynamics of the news. Moving and speaking as a way of navigating body, mind, and world would occupy her imagination and her dancing as she dove into the dangerous currents of contemporary geopolitics.

Animating the News

I've started doing the
News Animations
They give me a
feeling
Of something
To live for

It was a hot and sticky day—July in North Carolina. I was visiting choreographer and filmmaker Pooh Kaye at the American Dance Festival (ADF). Kaye was sharing an apartment with Simone Forti, who was also teaching that summer of 1987. We climbed the stairs and entered the darkened living room. There was Forti, sitting on the couch, staring at the Iran-Contra hearings on television. A large stack of newspapers was piled by her side. Engrossed in the minutia of the congressional questioning, she barely acknowledged our presence. We headed to the kitchen and grabbed a bite to eat. When we left a little while later, Forti was still sitting on the couch, intently following the proceedings. Kaye and I rolled our eyes at one another as we closed the door. Little did we realize that Forti was avidly preparing for a performance of her News Animations later that week.

The ADF faculty concert took place on July 7, 1987. The audience, many of whom were studying with the artists featured in the concert, was boisterous and friendly, shouting to one another across the space. You could feel that they were giddy with anticipation at seeing their teachers perform. Finally, the house lights dimmed and Forti entered the darkened stage from the upstage left corner carrying an unwieldy pile of newspapers. In the performance, her pathway is erratically il-

luminated by a flashlight dangling from a string attached to her waist. Dropping the papers one by one, she arranges a circuitous route, creating a serpentine river of daily headlines. Every now and again she hesitates, looks at the pathway she is making, and then adjusts the direction of a paper with her toes. At one point, she seems to be trying to read the paper between her feet, moving her head in time with the swinging of the light back and forth. Her timing is brilliantly comic, and the audience laughs at her antics. She takes her time with this preamble, backing up and then surging forward, dropping more papers along the way. Then Forti stands still, allowing the swinging of the flashlight to settle before she reins it in and shines it directly at the audience. Some people laugh nervously, as if not quite sure what to make of the situation. Soon, we hear what sounds like the plaintive wail of a train horn but is actually Sarah Knowles playing a loud, long note on the accordian. The offstage musician randomly repeats this strand of sound which, rather than punctuate the action onstage, emphasizes other spaces and other realities offstage.

Forti turns the flashlight off, and the stage lights rise to reveal a floor strewn with newspapers and Forti in the middle, dressed in an oversized bright orange t-shirt and yellow sweatpants pulled up to her knees. She stares out intently as she holds a newspaper in her hand. Forti takes her time, looking at the newspaper as if she were just now reading it. A moment later, she starts rummaging around in the papers, muttering to herself (and the audience) about how a CIA operative claimed defiantly that "If we build a canal in Nicaragua, we don't want the Russians to have control of it." Forti lets the audience take in the absurdity of the statement and then looks up with an endearing blend of false naïveté and a sardonic smile, sending the audience into fits of laughter once again. Visibly puzzled, she mentions looking at the globe and then tries to construct one out of newspapers. She drops her futile, amusing attempt to make a round out of a rectangle and begins to describe the topographical features of Nicaragua, all the while moving the papers into a facsimile of a lake in the center of the stage.

"Then there is Peru," she mentions as she moves to another spot on the floor. Forti physicalizes the plight of indigenous peoples leaving

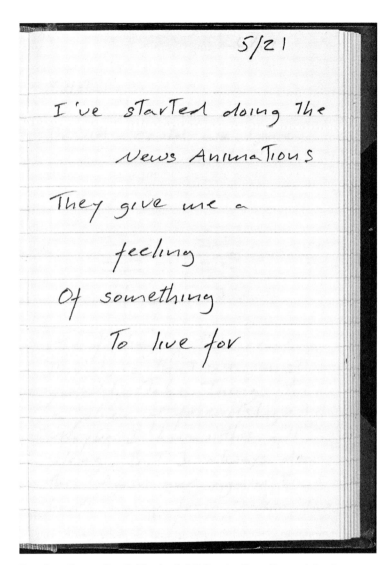

5/21

I've started doing The
News Animations
They give me a
feeling
Of something
To live for

Page from Simone Forti's Notebook (18N), 1984. Getty Research Institute, Los Angeles (2019.M.23).

the mountains and flocking to the cities for work, indicating their migration with her fingers traveling like little people down her neck, across her breasts and down her belly. It is a very funny image, and the audience's amused response covers over her mention of the fact that the Peruvian government doesn't officially recognize their status as citizens once they move out of their ancestral homelands and into the urban centers of the country.

Shifting registers, Forti gets up and returns to an earlier topic. "Meanwhile, now in Russia, they're changing systems—and they are doing what we have been doing. They're taking out the safety net." With this pronouncement, she crouches down, stepping her feet further and further apart until she falls over. With a deadpan expression, she gets up and repeats the action, this time intentionally slipping on the papers, losing her footing and falling flat on her face—just as if she were in a slapstick routine. It starts out as a funny moment, but then the physical reality of her lying there splat takes on a more tragic tone. Forti gets up slowly, her eyes fixated on the papers on the ground. She looks out to the audience and shifts topics again. We are now in the Middle East as Forti recalls flying over the Persian Gulf and having to land to refuel. She mentions the image of "waves of young men" crossing the desert as she backs up to one corner and sends her body running, falling and rolling on the diagonal. She tries it again and again, her words and movement tumbling through the papers as she finishes with a back roll and falls splat on her belly. What could be a serious moment takes on a ridiculous cast because of Forti's manic timing and the ironic glances she shoots at the audience, who respond with gleeful eruptions.

Forti switches subjects once again to talk about the world economy and money being sent beaming around the globe—from Mexico to London to Iran to Switzerland. Beam, beam, beam. She points and looks in different directions with each beamed transmission of funds speeding across the world that convert oil to arms to luxury yachts. Leaning awkwardly back on one leg, she grabs her side, mentions something about liquidity, and declares that Switzerland is like the economic spleen of the world, sending the audience into gales of

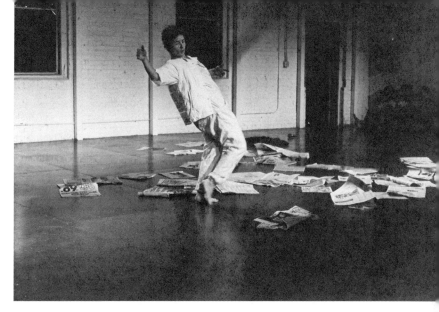

Simone Forti performing News Animations, L.A.C.E., Los Angeles, 1986.
Getty Research Institute, Los Angeles (2019.M.23).

laughter. She decides to repeat the line, grabbing her other side. Soon, she is back down on the floor, shooting her feet in the air as she rolls backwards and talking about pumping the oil out of the ground. "They pump it up, pump it up." It is another hilarious moment. Forti makes the most of comic juxtapositions of words and movements like these, milking the audience's amusement at seeing a woman in her fifties scamper about the stage and go to such lengths to physicalize the news. And then, without much ado, she gets up and bows—the news report is over for the evening. The audience explodes with hoots and loud applause.

Throughout the early performances of her ongoing series News Animations, Forti plays out the geopolitics of Central and South America and the Middle East on her own body. For instance, lying down on the floor with her legs splayed, she locates the Persian Gulf below her crotch in an ironically sexual manner. She shades in the coastline of Iran by swiping up and down her left side. Adjusting her position, she points out Iraq's "little finger" of a coastline and the way Kuwait is situated at one end, "like a tonsil." Using repetition to accumulate a

momentum of words and gestures, Forti unveils the crazed underside of world events in which money, oil, and power circulate like the fluids in her body. She also maps the geological legacy of the area, contorting her body to demonstrate the subterranean "pockets" of oil to be found at the edge of the continental shelf. It is a fine line that Forti balances here—reaching out to the manic edge of tragedy to find a comic sensibility and yet simultaneously using her body to physicalize the implications of threatening or even deadly situations. Whether dealing with personal experiences or political situations, Forti is interested in engaging a relationship between dancing and the world around her.

In a 1986 interview with critic Craig Bromberg, Forti describes how she uses the movement language of the 1960s to "say" something about the world. "I finally realized I wanted to talk about *things*." She continues:

> I see the oil tankers in the Persian Gulf and then I see the hu-
> man waves of Iraqis and Iranians and then I see the oil derricks
> pumping oil and then I see the Ayatollah. I become these forces.
> I've found my way at last to representational work, but in a truly
> kinetic way.[1]

In Forti's description, we can trace the seeds of integrating language in performance to her early work on what she calls the "Nez plays" (Zen spelled backwards) with Anna Halprin. Forti recalls that at the end of her time working with Halprin's group, she would often find herself running around and screaming "Say what you mean! Say what you mean!" as she was no longer interested in the nonsensical language they were working with at the time. Although the verbal materials Forti is dealing with in the News Animations are obviously connected to the real world and thus different from the more absurd-ist, Dada-inspired use of text perfected during her days performing with Halprin, the improvisational process of selecting images and riffing on certain themes is strikingly similar.

The short essay at the beginning of *Oh, Tongue*, a loose collection

of autobiographical writings edited by Fred Dewey, is entitled "On News Animations," and in it Forti gives an overview of her practice animating the news:

> I've been dancing the news. Talking and dancing, being all the parts of the news. The movement is very gestural, the kind of gesture that happens when one is speaking, explaining and describing, but here the gesture takes on the whole body. What is being explained is a personal vision: that flickering, fluid vision of the world that we each have, that vision which is fed by the news media. It's a dream-like vision, with visual, kinetic, and verbal components. (2003b, 3)

Watching Forti, we can see when a kinetic image lights up her mind as she performs a News Animation. There are often clear moments onstage when a topic will spark Forti's imagination and movement appetite, and she will ride that theme, with variations, for a while. Certainly, the geopolitics of the Persian Gulf was one theme that made its way through multiple performances of the News Animations. More recently, Forti has focused more on her family's history and tales of visiting relatives in Italy to think about differences in cultures and the rise of nationalism across the world.

Forti continued to perform the News Animations well into the second decade of the twenty-first century. Infinitely renewable—for the news is always changing—they have provided a scaffolding for her solo improvisations for many years. Although she was tackling content for the first time through the early performances of the News Animations, Forti kept the subject matter fully embodied, bridging the talking and the dancing, the thinking and the doing, the inquiry and the actions. In the main essay for the "Issues Issue" that she guest edited for *Contact Quarterly* (written soon after she had begun performing the News Animations), Forti notes: "And as I run it all through my body, I can see how it falls together in my mind, in my imagination, in my feeling" (1990, 32). Referring to her interest in curating an "Issues Issue" in a retrospective writing in *Oh, Tongue*,

Forti uses the term "state" (referencing her notion of "dance state") to describe the interweaving of speaking and moving that she was developing at the time.

> It's not about taking issues as subject matter, though it can manifest that way. *It's a state*, [. . .] It's a focus on the interplay between the mind, the body, and the world. It's a direction I'd like to see, though I don't know what the work would look like. But I find the world so interesting. And so much a factor in all my perceptions. Mind, body, world. Even grammatically it seems more vital. More full of surprises." (2003b, 122–23)

On the one hand, it seems almost too tidy, too facile to claim that Simone Forti's artistic journey goes from the more conceptual events, such as her 1960s Dance Constructions, to the vibratory experiences of her 1970s improvisations, and then interpret her work with News Animations as a natural synthesis of both the *conceptual* and the *vibrational*. And yet, in a manner of speaking, her performances of the News Animations are indeed a fascinating combination of both. Of course, each stage of Forti's career includes aspects of both elements. Certainly, her early improvisational training with Halprin included a responsiveness to nature and the environment, as well as to other people's movement investigations. That did not completely disappear when she began working with the conceptual instructions for pieces such as *Slant Board* or *Hangers*. Likewise, her improvisational scores based on circling were structured by formal concerns, even as they attuned to her vibrational experiences while moving.

In an essay focused on the work of Robert Morris in James Nisbet's book *Ecologies, Environments, and Energy Systems in Art of the 1960s and 1970s*, the author references Forti's News Animations in terms that address this intersection of energy (vibrational) and political framing (conceptual), connecting contemporary politics with the process art of late-sixties sculpture and body art.

> Her animation is mostly attuned to the ways in which her body expresses geopolitics, translating back into motion events which

themselves have already been translated into the text and pictures of newspapers. [. . .] This is a performance, therefore, that propagates information through the varied modes of transfer to be found on the written page, in the turn of a leg, in a shout and a shudder. It brings together different kinds of informing and their different temporalities.[2]

In this relationship of what Forti calls "mind, body, world," there is a very potent interweaving of thinking and doing, ideas and sensations—*concepts* and *vibrations*. I consider her work an *engaged poetics*, in which improvisation allows Forti to access "what's on my mind before I think it through, while it's still a wild feeling in my bones," even as she uses embodied language to communicate the political urgency of the topic she is addressing (2003b, 136).

Beyond specific performances of News Animations, Forti has also used the format of talking and moving to explore many aspects of her life, including her family history, contemporary political moments, her childhood, and her relationship with nature, as well as group processes in performance. In workshops such as Moving the Telling and Logomotion, she trains people to interweave ideas, words, and movement such that memory, sensation, and language combine in associative and imaginative ways. She has also developed a form in which she riffs on the metaphorical associations at play when she selects three words at random as a template for her improvisation. Reflecting on the practice of moving and speaking, Forti notes: "Speech that comes out of movement carries information we don't usually have access to" (2003b, 124).

For much of the 1990s, Forti was living at Mad Brook Farm in Vermont. Inspired by her connection to rural living, she performed a series of what she called "gardening journals" in which she narrated the earth-based dramas of planting and weeding and the life of insects and wild animals found in the woods surrounding her house. (Who knew oregano could be such an aggressive colonizer?) At the end of the twentieth century, Forti relocated back to Los Angeles. Through her classes at the University of California, Los Angeles (UCLA) and pro-

fessional workshops around the world, Forti continued to work with News Animations. These solo performances developed alongside and reflected her growing political awareness and evolving engagement with critical issues concerning the environment and global warfare in her improvisational performances. She also began to acknowledge her own white privilege and economic security as she witnessed more and more homelessness on the streets where she lived.

Forti recounts in a variety of interviews and autobiographical writings such as *Oh, Tongue* how the practice that became the News Animations emerged out of two life situations. The first was the death of her father, Mario Forti, in 1983. An avid reader of multiple newspapers each day, her father's role was to keep the whole family abreast of important issues and critical world events. Forti notes that her father read the *Los Angeles Times* and the *Wall Street Journal*, as well as the London *Times*, and credits his newspaper habit with alerting him to the fact that the Italian authorities were beginning to curtail the movement of Jews in 1938. Forti was three years old at the time of their departure. After her father died, Forti felt increasingly responsible for decisions concerning her family's financial wellbeing. She decided to continue his legacy, keeping up with current events and global politics by reading and watching the media coverage on television. In addition to her responsibilities to her family, she became increasingly aware of the implications of her role as a United States citizen.

The second push towards performing the news occurred in a workshop that she organized in 1985. Aptly entitled "Work in Progress," it was an opportunity for artists of all kinds to use one another as support to try out new directions and get feedback. In *Oh, Tongue*, Forti recalls:

> This is where I met Bernice Fischer. She was looking for ways to access her feelings about the information that was coming to her through the news media; she had joined, thinking that working with movement might help her. The ways she had us work with the news opened doors for me. My father, the family's official knower of the news, had recently died and I had started follow-

ing the news myself. I started dancing the news. Talking and dancing, becoming the ships, the lands, the peoples, the strategies, the connections. It was a practice that helped me remember bits and broad strokes of information. And as I ran it through my body, I could see how it all fell together in my imagination, in my feelings, in my thoughts. (2003b, 137)

Initially, Forti found that she had a hard time keeping names, facts, and histories clear when she read the news. She realized that by embodying the situations described in the news she was able to make sense of various situations. She explains: "Being a dancer I see and understand things through movement. I even see the news as pressures, wedges, and balance shifts, and anyway, so much of the language of the news media is in terms of physical dynamics: the dollar in *free fall*, Lebanon as a *slippery slope*, Iran sending human *waves* against the invading Iraqi army, and so on" (2003b, 4).

But keeping up with the news is not only an intellectual practice for Forti. It is bodily as well. A journal entry from the mid-1980s gives us a sense of her investment in the phenomenological aspects of this practice.

There's the newspaper itself, the journalism, the printing, the events themselves, the selection and representation, the editing, the publishing, and the politics of it, the inevitable reflection of some sort, of the movements and events. And there's the sitting down with a newspaper. The regularity of the activity [. . .] I think the newspaper plays a part in that sensory perceptual system which connects our individual bodies with the larger world body. (27N)

The tactile aspect of the newspapers is clearly very important to Forti. In early versions of the News Animations, she begins walking on stage with a big pile of newspapers. In a journal entry written right at the beginning of her process of crafting and conceptualizing her new approach, Forti recaps the experience of handling the papers in language that suggests those first moments of the performance are

Simone Forti's "anatomy map," 1985. Getty Research Institute, Los Angeles (2019.M.23).

a way to somatically soak in the news, to swim (sometimes almost literally) in the material fact of their existence.

> First the newspapers themselves . . . a pile about a foot high to
> be carried in or pushed into view . . . made into a path. Maybe
> only in the light of the flashlight . . . The flashlight hanging from
> a string around the waist . . . the light flooding on the feet . . . a
> pool of light playing on the feet and newspapers . . . and on the
> hands working the newspapers into a path under the feet . . . the
> papers furthest back brought to the front to continue the path
> and so on. Backing and filling, smoothing, working, newspaper
> path, light on feet. (27N)

As a mature artist in the midst of several life/work transitions in the mid-1980s, Forti embraced, at first, the power of her comic abilities in this new narrative form. Language helped her connect to the audience in a way she had not before. When she performed a similar News Animations three months later in New York City at the Second Annual Festival of Women Improvisers in Kraine Gallery, some of the same riffs about the Persian Gulf and the politics of oil as it is played out on her body appeared again in that show. As America got involved in the Gulf War, however, Forti began to reassess her playful physicality and tendency to go for the comic element in her actions. In fact, for several years in the early 1990s, Forti consciously stopped performing the News Animations because she felt that she had become a bit too "smartass" (her word) and that she was just playing for the laughs. She realized that some of her favorite sections, such as the human waves crossing the desert, were, in fact, serving more as an opportunity to run on the diagonal and throw her body recklessly and roll and splat in a way that would make the audience laugh, rather than to draw attention to the tragic plight of those untrained and unarmed young men sent to fight in the desert. She began to feel as if these moments weren't really acknowledging the awful cost of human lives.

In an interview with me in July 2014 during her first retrospective show at the Museum der Moderne in Salzburg, Austria, Forti discussed why she decided not to include the ADF video in the group

of New Animations she sent over to be displayed in the context of that show.

> Well, certainly with News Animations, I used to be a little bit smarty-pants. And now I'm more—I've softened and I feel it more emotionally. I've become more aware of the devastation that the US causes, which makes me feel more a sense of responsibility. It's like it pertains to me more, because I'm kind of living my nice life off of this whole situation in which my county—and the US is my country—is acting wastefully and stupidly and [. . .] irresponsibly.[3]

Implicit in this statement is a recognition of her own privilege—the very fact of her comparative safety and comfortable lifestyle—a perspective that continues to inform her work as it develops from the mid-1980s to the twenty-first century. In a journal entry from 2004, Forti acknowledges "but I profit, drive my car around guzzling petrol. I am one of the bad guys too" (95N).

Watching the News Animations is like reading the newspaper in some ways. At first one tends to scan the different articles, jumping from page to page, reading a bit here and a bit there, maybe later going back to an interesting piece and taking the time to read it more thoroughly. In performance, Forti's ability to free-associate across many newsworthy topics, drawing imaginative connections between areas or subject matter, is amazing. These disparate themes work out their own coherence, however, through the medium of her body. Even as she switches topics and shifts from the latest news cycle to her garden or to her father, Forti's living, breathing, moving corporeality provides a somatic foundation of coherence. In an interview with Austrian curator Sabine Breitwieser, she talks about cultivating the experience of motor centers and verbal centers working together. But this dialogue between moving and speaking is not always coherent or rational. Forti explains:

> In performance, I give expression to fragments of thought in the order in which they arise rather than in a formulaic way. So

things like stars and ants get collapsed in with the rise and fall
of the dollar. Patterns of thought and patterns of how my body
moves can interrupt one another. Sometimes I can recognize a
physical feeling—like a heavy softness in my arms—before I
recognize the thought that is forming, or a sudden thought can
throw me to the ground."[4]

The interweaving of odd or ironic strands of subject material—the
curious logic of moving from stars in Vermont to sand in the Middle
East, from the weeds in her garden to yet another hostage crisis—
lend an aura of magical thinking to Forti's performances, even as her
aging body gives her words a certain gravitas. Writing a journal entry
inspired by the selection of three words, one of which was "method,"
Forti writes: "Wow. So I do have this method and it is a method of
investigation, of following after [. . .] things that are not *on* but *in* my
mind. Not at the front but in corners, hovering just under the ceiling
or under the stairs, the back stairs . . ." (85N). This work preserves
the wonderfully animate qualities of Forti's earlier studies of natu-
ral forces while adding layers of representational meaning through
text.

In tracing the development of the News Animations, it is illumi-
nating to compare an early 1986 attempt at "dancing the news" with a
performance in 2003. Not only did Forti's relationship with the news
change as the emotional and political stakes were once again raised
after the terrorist attacks of September 11, 2001, but also her facility
with integrating her dancing with language increased exponentially.
In *Oh, Tongue*, she writes about how her speaking has influenced her
way of moving, of how the impressions of the subjects animate her
kinetic sensibility.

I'm so used to talking while I'm moving, rolling, running.
Movement seems to make the words so human, human as in
bread-eating. It gives protection to the speaking and makes it
softer, deeper. You can say hard things because it's just how you
feel them in your bones. (2003b, 123)

In addition to being more comfortable with dancing while speaking, she becomes increasingly self-reflective about her own privilege in face of increasing income inequity and the loss of America's own "safety net." As she becomes more overtly political in her speaking, she is also aging, and the increasing fragility of her body gives these statements density and pathos.

One of the earliest videos of a *News Animation* is an informal rehearsal recorded at Mad Brook Farm during the summer of 1986, a full year prior to her ADF performances. In an open studio space that was obviously under construction, Forti tentatively tries out some material. She begins with a certain hesitation, placing a pile of newspapers in the center of the floor. She decides to sit on them and looks up at the camera (held by Lisa Nelson) with what looks like a sense of trepidation and mumbles something about why she had so much trouble last time. She mentions not having much of a relationship with the news at the farm, "[. . .] because this place [*pause*] somehow has its own." Her voice drops off as she lies down on her belly and presses her hands into the floor. She feels the wood and we see her attention go directly to that physical reality as she declares "I can put my hands right into it [Mad Brook Farm] in a certain way."[5]

After this preamble, Forti takes a moment to gather her focus and begins again with "When I was traveling from country to country, I was always happy to find an English language newspaper." For the following few minutes, Forti's voice is unsteady, and it almost seems as if she is on the verge of crying. The words seem hard to get out. As she talks about the reassuring "familiarity" of finding the *International Herald Tribune* and following the "familiar" stories in English, she picks up a paper and smooths it open, stroking it over and over again with her hand. For a moment, she gets lost in the tactile experience of feeling the newspaper, and then she looks up and begins to talk about flying over the Persian Gulf. Weirdly enough, however, Forti's body remains curiously static at the beginning of this early version of a News Animations, as if she were having a hard time simultaneously moving and following the narrative thread of her verbal text.

In contrast, the Bennington College performance of the News

Animations (which took place on March 28, 2003, as part of her teaching residency there) begins with a long sequence of movement without any text. Forti enters the stage looking around and up towards the sky, focusing the audience's attention on an elsewhere outside of the proscenium arch. She backs up to one corner and begins to crawl, using her gaze to lead her movement from side to side. Eventually, that gaze initiates a roll on the floor, while her focus remains on the sky. She pauses, matching stillness with silence and bringing the audience's attention to her embodied experience. As she crawls backwards, she drops her head and then stands up slowly, touching her legs tenderly, caringly. It is a very poignant moment, a breath of time in which the audience can reflect on both her fragility (she is in her late sixties) as well as her resilience (her joints are obviously still quite supple).

A jolt from some unseen force throws her to one side, but she recovers her stride quite literally as she throws open her arms and begins a little strut down one diagonal of the stage. She speaks for the first time. "We were marching right down Hollywood Boulevard. [pause] We felt so strong . . . We felt so strong" Rather than tell the story of her participation in an anti-war demonstration, Forti fragments her narration, splicing in segments of pure movement that capture with abstracted gestures a taste of the pleasure and power of that experience for her. For instance, there is a moment when she is swaying back and forth, eventually raising her right arm to sweep it in a wide arc from side to side. It is a beautiful movement sequence whose full meaning crystalizes several minutes later when she repeats the same gestures while speaking of someone on the top of a building waving a big cloth. "Waving. Waving. Waving a big cloth."[6]

Unlike the News Animations from the mid-1980s, in which the physical gestures closely paralleled the narrative she was delivering, in this 2003 performance Forti crafts a wonderfully elusive yet incredibly evocative relationship between the words and movement. In a short writing originally published in *Movement Research Performance Journal*, Forti emphasizes the evocative power of this slippage between words and meaning, gesture and stance.

To shatter sense through nonsense creates gaps, space. It feels to me related to air. To laughter. When elements are sprung out of context, they engender new experience. The mind is delighted with the unforeseen, unlikely pairings, is a bit unhinged for a split second then rushes in to fill the vacuum with, "Umm, hum, of course. A steamship lodged in a rosebush, I see it."[7]

In her 2003 performance, fragments of statements and the poetic repetition of certain words slip and slide around and between her dancing. For instance, in the silence right after she has declared "Now what," Forti brings the audience's attention to the subtle movements of her fingers and hands weaving in and out of one another. She holds her hands slightly out from her body, as if offering their wisdom to the group. As she continues to move her fingers around the invisible worry beads in them, Forti speaks haltingly: "I, I, I certainly can't . . . I certainly can't . . . I certainly can't . . ." Yet underneath this refusal as confession, we begin to perceive a counter song, one with a more hopeful sensibility: "But I can, I can . . . I certainly . . . But I can, I can, I can . . ." While the audience can't be entirely sure what she is referring to in this moment, her kinesthetic ambivalence contrasts markedly with the powerful swaying strut that Forti introduced earlier and to which she returns from time to time. Each of these experiences are part of her lived reality, and the fact that she allows both the communal euphoria of the demonstrators walking down the street and the personal doubt to dwell for a moment on the stage reveals the challenges we all face, lending a sense of shared humanity to her idiosyncratic work.

The difference in potency between the 1986 and 2003 performances of the News Animations is, I believe, the direct result of fifteen years researching and teaching this work. Of course, the best way to understand an evolving practice or new method is to share it with others. As we have seen, the initial idea for the News Animations came out of a workshop that Forti was facilitating. As she began to teach this material, she became increasingly aware of the complexities of layering language and movement. In time, she developed a series of new

workshops that she titled Moving the Telling and then Logomotion. Here is a description written by Forti for a Logomotion workshop:

> Always, words and movement work together towards what we need, building our understanding and our expression. By speaking and moving at once, following our impulses and responding to the resulting dynamics and images, we integrate various aspects of our knowing and give expression to a fuller spectrum of our world. The workshop will include a warm-up practice to awaken our kinetic juices and mindfulness, and timed writings to put us in touch with our wild thoughts and observations. We will focus on improvisation, including exercises for perceptual and compositional awareness and for developing an intuitive flow between our movement and our speaking. (2003a, 62)

Long before different ways of knowing became trendy pedagogy in the academy, Forti was training people to move between an embodied sensibility and a verbal one. Integrating language and movement is not a question of simple addition. The whole is much greater than the sum of its parts, but getting to that integration of speaking and dancing requires a recognition that the body has a mind of its own.

Carmela Hermann Dietrich was pursuing her MFA at UCLA in 1998 when she first met Simone Forti, who was teaching classes there. Hermann Dietrich asked Forti to be her "guide" through the process of bringing language into dancing. In her wonderfully thoughtful essay "Learning to Speak," she describes the arc of their relationship as it evolved from teacher/student to mentor/mentee, to mutual collaborators. For their first improvisational performance together, Hermann Dietrich and Forti decided to use the Mildred E. Mathias Botanical Garden at UCLA as inspiration. After spending time in that environment, they went back to the studio and did a timed writing, sharing their impressions with one another before moving together. In her discussion of what it was like to absorb Forti's process, Hermann Dietrich articulates a crucial difference between talking *about* a place and speaking directly *from* that place. "You are still communicating about the place, but your words are inspired by your experience of the

place; you become the place, feel it as you talk about it, and the way you speak changes." Later in this essay, Hermann Dietrich relates how she overcame her fear of speaking extemporaneously within an improvisational performance. Working with Logomotion, she realized that dancing was always gratifying for her precisely because it wasn't verbal—it didn't contain words.

> When I spoke, I felt cut off from my body, from myself. Dance had always taken me to a deeply physical world. Once in, I never wanted to emerge. There was either talking or there was dancing. Feeling or thought. The two didn't connect.[8]

Of course, many dancers, especially younger dancers, feel similarly —that dancing is antithetical to words. In an interview, French dancer Claire Filmon spoke about how odd it was for her to begin using language in performance. She remembered being a very talkative child, but years of traditional dance technique had trained it out of her. She mentioned that the mindset was: "Dancers don't talk. We do as we are told to do; move how the choreographer tells us."[9] Even college students will talk about how movement is its own language and therefore doesn't need words to explain it. Indeed, it is true that many people are attracted to dance precisely because they prefer a kinesthetic expressivity to a verbal one. In fact, it can be quite challenging for most dancers to use words in a manner that carries real emotional power and is not just random, monotone speaking while gesturing abstractly. In a very poignant passage in her essay, Hermann Dietrich reveals how she had to learn how to *feel* language in her body before she could access her voice in performance. She had to find a way to allow the words to penetrate her body and her being. Eventually she developed a practice of "timed talking"—a verbal version of "freewriting"—in which she would speak nonstop for a set amount of time without pausing or editing.

> For me this was the beginning of being able to know my thoughts, to appreciate the nonlinear direction, the random changes of subject, the childlike feelings. I no longer felt bound by pre-thought-out ideas. I was learning to follow what came

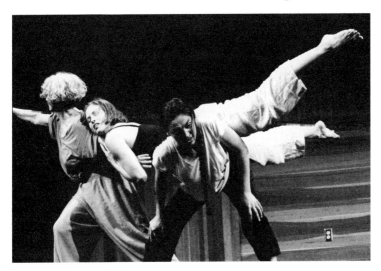

Simone Forti with Carmela Hermann Dietrich and Claire Filmon in *Turtles All the Way Down*, Mark Taper Auditorium, Los Angeles, 2000. Photo by Carol Petersen. Getty Research Institute, Los Angeles (2019.M.23).

to me in the moment, to give up control. This was the beginning of my ability to do Logomotion.[10]

Learning to speak within an improvisation can be incredibly intimidating. It is a practice that needs to be cultivated with intention.

Forti's extensive writings about her own practice, combined with those of her colleagues and students, give us insight into the thoughtful and meticulous training behind her seemingly spontaneous forays into life and art, moving and speaking. Dewey, the director of Beyond Baroque literary/arts center in LA from 1996 to 2009, highlights the critical value of the News Animations as a model for full-bodied engagement with the world. In "Embodying the World," an essay in *Simone Forti: Thinking with the Body*, Dewey points to how Forti joins the conceptual and the vibrational to create a practice that connects ideas to feelings.

For me, Forti had put things back where they belonged. Language is not only a structure in our minds or embedded in dead

text. It is enacted, through the body, in a physical accounting that is born live, facing stakes we all face in a shared world. Forti's texts capture this risk and living presence.[11]

As an editor, Dewey was instrumental in bringing Forti's second memoir, *Oh, Tongue,* to print (published by Beyond Baroque Books). For Dewey, Forti's News Animations and her interest in engaging the world through her own idiosyncratic artistic practice presents a model for the integration of imagination and the real, for a poetics of live performance that is increasingly important in our digital, virtual world. Dewey refers to her "ethical, investigative engagement with the world" and attributes that sensibility to "a radical notion of animation—the embodying of things by giving them a living, moving life before us, born of observation and description." He continues:

> [Forti] started to develop a type of work she calls *Logomotion,* which joins together words and movement to create a mode of discourse that combines reporting, description, gesture, and the communicating of personal and worldly fact, and that she describes as "moving the telling." [. . .] The moment of movement, she realized, could be built on impressions and gestures derived from pressing public matters and the broad landscape of the world.[12]

Dewey's point, I believe, is to highlight the lived pathos inherent in allowing the media to actually penetrate one's body—moving past the skin and down into one's bones. Forti also frequently uses that term—bones—to talk about what it feels like to take on meaning through her body. It is this combination of the conceptual categories of commentary through irony and wit with the frank vulnerability and vibratory feeling states (in both gesture and speaking) that give the News Animations an extraordinary impact.

The importance of her somatic relationship to speech—the tongue, mouth, and throat—in Forti's Logomotion work crystalized in a short bit performed at the LA Improv Dance Festival in 2009. The larger piece included a duet with Kirstie Simson, but here I want to focus

on Forti's three-minute solo because it highlights how her mouth and tongue come alive to make her speech physically expressive while she performs. After a short stomping and clapping prologue in which Forti commands the stage, she says "words," and then curls her hands around her mouth. Looking up, Forti calls out "Words—You can take a word and bend it," and she twists her hands as if she were kneading the words like bread. She gestures towards her open mouth again and then spreads her fingers, making her hands into little mouths opening wide. "Words—words." In her charming, faux-naif way, she starts talking about how amazing it is that one can talk and walk at the same time. But soon words fail her, and she is caught up in physicalizing the sounds, "Ahh—ohhh " and then letters: "H—O—HO!" She rolls on the floor as she signs the letters with her whole body: "H—O—HO!"

Forti riffs on the pleasures of writing, using her chin to trace the letters on an imaginary paper in front of her. It takes an effort of her whole body to write two letters, and she seems elated as she stands back and speaks their unison in a simple, one syllable word—"HO!" Her arms spread like wings, and Forti references an Italian expression that means "torn open throat" as she wrestles with her desire to source language from inside her body. She returns to "HO!" pulling the sounds out of her chest and throat. "HO!" transitions into a different word when Forti shifts the emphasis to "oh" which becomes smaller and softer as she caresses the sounds coming out of her mouth. "Oh—oh—oh." She looks up at the audience and ends with a final declaration: "A word—you can eat it. You can make [pause] you can make a HO! out of bread." In an afterword to a limited edition of *Oh, Tongue* published in 2010, Dewey writes that, in choosing the title, Forti reconnects the text with the act of its delivery: "Tongue is a word for a body organ, for both speech *and* language [. . .]"[13] Dewey also notes that the tongue is the mediator between inside and outside, body and world.

In April 1986, several months before Nelson filmed her rehearsing an early version of the News Animations at Mad Brook Farm, Forti and Nelson taught together at the Theater School in Amsterdam.

There, they worked together on improvisational states, as well as the perceptual investigations that Nelson was shaping into what she terms the "tuning scores." These explorations incorporated Nelson's interest in video technology and the choices performers can make in how they use their eyes. Nelson encourages students to experience the differences between using their eyes (like a camera) to lead their movement through space or relaxing the eyes deep in the sockets and allowing one's gaze to scan the room and take in whatever visual material arises as the body moves through space. In a typed manuscript entitled "Report on Forti/Nelson workshop," Forti mentions doing a *News Animation* before an audience for the first time. She refers to her desire to communicate what interests her right now in a manner that is both "kinetic and direct." By co-teaching with Nelson, Forti was exposed to multiple ways of using her gaze to draw the audience's attention to close or far-away spaces. She notes: "Lisa's work with the active aspect of perception gives me many clews [*sic*] and tools to help me be clear about the nature of my perceptions of the subjects I'm exploring."[14]

For her part of the Amsterdam workshops, Forti brought attention to kinesthetic experiencing and introduced what she calls "movement memories" (later referred to as "movement memory snapshots"). These are short moments that stay lodged in one's mind because of the power of a physical action or image. It could be a falling tree or a bird swooping down, or simply the gesture of a mother reaching out to hold a child's hand when crossing the street. They're moments that carry a powerful kinetic impression, and Forti frequently uses them as a points of departure for her improvisations. An example of a movement memory that Forti gives in her workshops is the story of being at a party in Vermont and having a woman tell her of seeing a young bear with loose skin "like a puppy" in the backyard. In the book chapter "Animate Dancing: A Practice in Dance Improvisation," Forti explains: "She took three bounding steps without losing conversational distance from me, letting her flesh bounce on her bones. I saw the snow, the young bear lunging, bounding" (2003a, 62). In a 2013 intensive weekend workshop in Portland, Oregon, Forti explained movement memory snapshots to the participants. She suggested that

they not give the audience the entire context of a situation, like how usually your aunt hosts Thanksgiving dinner, but this year was different because the house was being renovated, and that's why you were driving in the snow when the car skidded off the road and you saw mud fling out from the tires. Instead, she said, use one snapshot, such as the mud flinging out from the tires. Dive into that one image, see it and feel it with your body.

Forti begins her essay by evoking this process:

> The stage. Walking out. "They see me now. Let them see me, get used to the sight of me. Quiet down. Open." I choose a place. I stand there. I glance at the audience. To see them, for them to see my face, my whole stance, just a look of recognition that I consider a hello. I begin. With what presents itself. A memory, a shape in the performance hall. [. . .] I return in my mind's eye to the northern slope of Bald Mountain on which I live. I look around and—pronto! Something happens. I see snow. I jump and curl in air. Hand and feet in air. Heavy rattle winter wind smashes dry sunflower stalks. Again. Again, smash, jump! Snow thud fall from laden roof. Feet slide out, thud. Whole body, thud, flat to floor. (2003a, 53)

In this marvelous description of a movement memory snapshot, Forti shows how an image can grab ahold of her imagination to inspire her movements. Just opposite this opening passage of "Animate Dancing" in the collection *Taken by Surprise: A Dance Improvisation Reader*, is a black-and-white photo taken by Isabelle Meister of Forti, curled and twisted midair, hair flying (it is the same image that graces the cover of the book). This shot could easily illustrate those first few moments of her performance and how Forti gets caught up in an energetic movement memory snapshot of the snow on Bald Mountain. She articulates the vibrational quality of that improvisational experience:

> More than that I identify with what I see, I take on its quality, its nature or "spirit." It's an animistic process. When dancing, I somehow return to the memory of the source experience and

I become what I feel or see or hear, or even what I think. The impressions animate me. In my feeling, I lose the distinction between the things I sense out there, my perception of them and myself. (2003a, 131)

In the midst of explaining her process during the lecture-demonstration part of her weekend workshop in Portland, Oregon, Forti illustrates how she enters that magical and animistic space. She pauses for a moment to remember a movement memory snapshot, and then launches into a moving/talking animation of how a dog was galloping on the beach, playing in that strip of sand where the waves lick the edge of the beach. In a split second, her hands, body, and face take on the energy of that small creature playing at the edge of the sea. It is quite an incredible moment, one that lasts less than a minute but whose afterimage has stayed with me for a long time.

This "animistic process" is evident in the various performances that focused on her gardening and rural experiences when she was living at Mad Brook Farm in the 1990s. At the time, Forti was less apt to confront politics in performance, having decided to take a break from running the news through her body. I was privileged to see her perform a gardening journal at an A Capella Motion faculty concert in Northampton, Massachusetts, in 1995. A summer two-week intensive exploration of improvisational forms, A Capella Motion took place at Smith College from 1982 to 1996 and included workshops in all forms of improvisation, including contact improvisation, Authentic Movement, different somatic therapies, and other related classes. Each year, the faculty would perform for the delight of the audience, which was mostly composed of students and friends. (In 1995 Forti performed twice, allowing her to reference the first improvisation in the middle of the second one, to hilarious effect.)

The first performance began with Forti walking out with a big metal wash tub and placing it in one corner on the floor. Soon she is talking about weeding and worms (a favorite topic of hers at that time). Crawling and wriggling on the floor, Forti becomes a worm moving through the tall grasses that she is weeding. Her body all

aquiver, she describes the grasses' long, sturdy roots, and while sticking her forefingers straight out she says, "I always think of them as being very young and very male—and very sharp." This phallocentric reference in the midst of stories about weeds and mud and worms sends the audience into fits of laughter. But soon, she is back to being a worm, darting across the stage and talking about how fast worms actually move. The vision of an older woman running like a worm amuses the spectators as Forti plays the novice gardener, carefully saving all the worms and insects she disturbs while preparing and planting her garden.

Later that fall, Forti performed a version of a gardening journal at the 1995 Improvisation Festival/NY. On this occasion Forti titled her piece *Animations*. Deborah Jowitt reviewed the concert for the *Village Voice*, and her astute observations about Forti's ability to transform the stage into a field are telling.

> She starts talking about a New England landscape, mapping it with her body, talking breathlessly and with a kind of rapture about her garden. Sentences tumble out half-formed, start again. "I'd like to burrow like a mole," and she's down there digging, worming her way into what's no longer hard floor.[15]

Forti evokes her movement memories, sharing her experience with the audience by painting a landscape through gestures and a few well-chosen words. Jowitt uses the term "rapture" to describe Forti's ecstatic reminiscences and ends her review by recognizing how Forti can shift perspective from the gardener to the worm.

> Forti's ample, resilient body seems to merge with the growing processes she describes; at the same time, she's the gardener shivering with delight at the richness of it. [. . .] This piece flourishes in improvisation: memory and sensual experience rubbing ideas into life.[16]

Over the course of my dancing career, I have taken multiple workshops with Simone Forti, including her class at A Capella Motion and a two-week Logomotion intensive that Forti taught while in residence

LOGOMOTION
A ONE-MONTH INTENSIVE WITH
SIMONE FORTI
EXPLORING MOVEMENT
AND LANGUAGE

OCTOBER 6 – 31, 1997
9:30 a.m. – 1:30 p.m.
Cost: $160
Enrollment limited to 15 participants, full month commitment required.

FORTI STUDIO
537 Broadway,
New York

Movement and language come together to create unique meaning, reveal the movement of mind and offer images of the world. Simone Forti's practice of improvisational dance/narrative will be the core of the workshop. Also, we'll take time for participants to work with their own and each other's ideas, longings and glimpses into potential directions of exploration in the realm of movement and language. The mornings will include a warm up to awaken our kinetic juices and mindfulness, timed writings to put us in touch with our wild thoughts and observations, exercises for perceptual and compositional awareness, and for developing a natural and intuitive flow between our moving and our speaking. Some afternoons and evenings will be available for developing emerging work, and at the end of the month we'll invite our friends to some informal showings in the studio.

Simone Forti began working with dance improvisation and the workshop process in the 1950s with Anna Halprin. From her early minimalist dance-constructions, through her animal studies and news animations, she has followed an inner voice, keeping her eye on the natural world. Over the past ten years Forti has been exploring the place where the moving body and the verbal mind come together. In 1995 she received a Bessie New York Dance and Performance award for sustained achievement.

"Over the past several years I've had the good fortune to travel far and wide, teaching and performing. Often someone would ask how they could continue to study with me, and I had no satisfactory answer. My decision to start offering a yearly month-long workshop is inspired by the wish to connect with people who would like to work with me in a more continuous way, and by the understanding that this will broaden and energize the work."

Logomotion poster, 1997. Getty Research Institute, Los Angeles (2019.M.23).

at Oberlin College in January 2005. I remember one day in particular. First, we warmed up as a group, moving through the space in different directions, weaving in and out of one another. This was essentially a version of her score for *Scramble*, which Forti used quite often to get everyone's blood moving on cold winter mornings. Next, she asked us to remember a special place from our childhoods and to describe to a partner all the physical details of the place, while moving through space. Our partner(s)—sometimes we had more than one—moved with us. Forti called these partners "back-up" dancers and said they physicalized the typical listener, who nods their head and says "uh huh," or "yeah, right" to show that they are following your line of thought.

There was something very palpable about feeling one's partner

physically supporting one's experience just by being there, without necessarily engaging with the topic directly. Personally, I found that presence incredibly freeing, and it generally seemed to help the participants find more ease with the moving and speaking. Forti gravitates towards early life memories in her teaching because she believes that childhood is a time when our verbal and physical expressivity are equally active, before we are taught to be still while talking. Later in that session, we wrote about the experience, sharing our texts with our partners and then with the class. There were days in the workshop when we would write and dance interchangeably, vibrating between verbal and movement memories with such frequency that they seemed eventually to meld into one sensibility rather than remain two qualitatively different experiences.

In her workshops, Forti uses the writing practice popularized by Natalie Goldberg in books such as *Writing Down the Bones: Freeing the Writer Within* and *Wild Mind: Living the Writer's Life*. This is a form of free writing in which one writes for a set amount of time, such as twenty minutes. The point is to keep moving the pen on the page, to get used to writing without judging whether it is good or bad. For Goldberg, a "wild mind" is unleashed from the restrictions of conventional discourse. It allows one to give up the tight editorial control in order to find an authentic voice and fully enter the process of drafting language. Forti was first exposed to the practice in a workshop with Christina Svane, an improviser and writer who teaches in Europe and the US. But even though Forti uses this free-writing practice in her workshops and to warm up before performances, it would be a mistake to think she uses words in her improvisations in a stream-of-consciousness, unfiltered manner. Quite the opposite. Her use of language in performance may be spontaneous, but it is not uncrafted. In the weekend workshop in Portland, Oregon, in the fall of 2013, Forti spoke of how this writing practice puts her in touch with her "wild" thoughts while they are still "undomesticated." Like her drawings and descriptions of animal movement, this free writing is research that prepares her for performance. It is not the event itself.

Forti has written extensively about how working with Halprin was

akin to the explorations she encountered in art school. In both cases, students were guided into an inquiry or presented with a problem rather than taught *how* to move or *how* to paint. This is precisely Forti's pedagogical strategy, as well. She tries to guide the students into situations in which they can access different kinds of skills, from writing to speaking to moving. In "Animate Dancing" Forti recalls her art teacher Howard Warshaw addressing the importance of recognizing the three perspective that are always in relationship when one makes any kind of artwork.

> That which you're looking at or referring to. The way you're perceiving or approaching it. And the actual thing you're making. (2003a, 59)

This braiding of shifting perspectives is visible in Forti's more successful and often magical *News Animation* performances. As an audience member, you can see her mind working, but you never know where it is going to travel. In the same paragraph, Forti articulates how her dancing/speaking improvisations evolve.

> When I am moving the telling of some material, I am as affected by my own movement as by the subject. There is a feedback and a responsiveness that is set up in my dancing body, in my dancing mind. I still have all the concerns of space, of timing, or movement interest. There are moments when I purely get lost in the movement. In the sound and rhythm of the words. I often feel that movement is like paint and words like pencil, or vice versa, together on a canvas. They can contrast or follow one another, with a time lag or contrast of perspective, a detail against a broad indication. (2003a, 59)

One example of this practice comes from a performance Forti gave as part of the weekend workshop in Portland, Oregon. Forti is speaking about being in the ocean just a week before. She arches back with her arms spread out to either side, face to the (presumably blue) sky. She is floating luxuriously, lulling in the gentle waves, and the audience is fantasizing right along with her. But then she shifts and declares "but

it was more like this" and starts getting tossed about, crashing from side to side as the audience erupts in knowing laughter—this was the Pacific Ocean after all. In this example, Forti uses her conceptual wit to juxtapose her sensual perceptions and has a good time playing with the audience's expectations. This is the beauty of combining words and motion—together they provide a palette of meaning to communicate across the registers of body and language.

Over time, the very act of writing—not simply the use of language in performance—became increasingly important to Forti. In a journal entry from 2003, she exalts in the pleasure of it all:

> Writing itself. Something about the ink, the marks, the accumulation of marks. What it means, what it will mean, [. . .] And so it feels, feels, feels important to write. (19N)

Writing was a daily *practice* for Forti. For several years in the 2000s, she started every morning with a timed writing in her notebook. It was a *process*: She would use free writing as a method for preparing herself for performance, a way to see what was on her mind. It influenced her *pedagogy*: More and more, Forti used writing in her workshops to develop materials to work with in classes. And it was *political*, a statement of her engaged stance. It also allowed her to narrate her own her-story and that of her extended family.

Her writing took on a life of its own as she wrestled with finding a voice that would be as meaningful as her performances. Ironically, considering how invested she is in it, writing with intention is an elusive kind of shadow in her journals, something that is right next to her but always a bit beyond her reach. This is intriguing since she is, in fact, writing—in her journals, for *Contact Quarterly*, in several short chapbooks, and in the various international journals and collections on improvisation that published versions of "Animate Dancing"—not to mention her own books such as *Handbook in Motion, Oh, Tongue,* and *The Bear in the Mirror.* But throughout her journals, she registers a hunger to write differently—to write something more substantial, something meaty, something with real grit. Even in her December 2022 oral history interview with curators at the Museum of Contem-

porary Art in LA, she laments not finding the ease with writing that she has with dancing and performing.[17]

In June 2019, I spent five days at Forti's apartment, reading through almost all of her notebooks and journals as they were being prepared to be deposited with the rest of her archives at the Getty Research Institute. Throughout the late twentieth century and the early twenty-first century, Forti's journals carry refrains about her *longing* to write, her *desire* to write, the *need* to be writing. Even before she grew older and had less of a hunger to be moving, she spoke of writing with a sense of wistfulness. In a journal entry from the early 1980s, Forti declares: "I long to write something big and plain" (52N). Around the same time, however, she also notes: "Writing is such a mystery! I long for it but actually find my writing . . . well it's just not direct . . . not concrete like my movement" (50N). Before language became a foundation for her process and words wove their way into her performances, Forti seemed less concerned about striving to achieve a certain type of writing. Even after working on *Handbook in Motion*, writing seemed to be a more casual pursuit, and she was able to patiently wait for her muse. In a notebook from the mid-1970s, she acknowledges:

> The tide that tries to bring me a way to write is out. [. . .] Let the tide pull way back and throw till way up. I'll be here with my pen." (59N)

In a journal entry from 2010–2011, however, Forti records a much greater urgency in her "desire that my voice be a voice that is needed. The desire that my voice be among the voices that are needed" (109N).

As a dancer and writer who has been inspired by Forti's combination of language and movement, I am particularly intrigued by this underlying tension throughout Forti's later notebooks. It seems that she desperately wants to write something profound, to follow a topic into a deep, rich study, yet she is unsure how to go about finding a subject that will fully engage her. Even with freewrites, Forti can struggle to find a way to begin. Sometimes she uses "I remember," sometimes she begins with "I am" or "I desire," but she talks regularly

about being at a loss for a subject. In a 2004 freewrite prompted by the topic "Hopes and Fears," Forti acknowledges:

> I hope to do good writing and to bring my writing to the level of my dancing [. . .] I do love words. Especially hand-written words. Chinese calligraphy I have seen has sent me through the roof (with admiration, not anger). (95N)

For a while in the early twenty-first century, she uses the chance method of selecting three words at random from a dictionary to begin writing. This is also how she prepares for her staged improvisations. In performance, however, her skill at weaving words and movement is much more active and nuanced than her writing in the freewrites. Overall, there seems to be a thread of insecurity that winds its way through her various discussions of writing. At times she wonders whether she is smart enough, intellectual enough, erudite enough? She reads James Agee's *Let Us Now Praise Famous Men* and notes how his writing is "painfully beautiful" (108N). In a late 1990s journal entry written at Mad Brook Farm, Forti remarks rather wistfully, "I'm so amazed at Agee's writing—so intimate I can taste and smell [his experience] . . . and so I think why not that intimate taste of an older woman" (35N). Later, she suggests that if only she could remember names and dates with more facility, she could write with more ease.

There is an intriguing tension here between the kinds of structuring that a longer work requires and the improvisational mindset that she cultivates in her performances and in her life. Indeed, there seems to be some friction—a bit of a rub really—between the freewriting that Forti is so familiar with (she can write for ten, twenty, even forty minutes at a time) and the kinds of rhetorical strategies, editing skills, and reflection required to build a longer essay or a coherent nonfiction book. When Forti compares painting to choreography and watercolor to improvisation, she recognizes that there is a measured process to composition that is, in the end, less interesting to her. After all, an overly active editorial faculty is antithetical to spontaneity; self-criticism can inhibit being fully present in the moment. Forti is

a consummate improviser, incredibly adept at cultivating a magical "dance state" in performance in which she draws the audience into her somatic experience. Yet the question that Forti often tackles in her journals is: How do I translate this sense of enchantment in dancing into a coherent written essay?

I believe that Forti is able to harness this connection in writing that is poetic and performative, rather than expository. Her journals are filled with poetic lines that are clearly written quickly, little improvisatory flights of fancy language.

> *feel of word in mouth*
> *drunk on ink*
> *fast tumble of associations*
> [. . .]
> *riding the line of the fence*
> *chasing after my thoughts*
> *ink going into your bloodstream*
> *Bic does the job* (95N)

When I evoke the term performative, I am not necessarily referring to language used in performance but rather to writing that has a kind of embodied, alive edge to it—writing that functions in a way that exceeds its literal meaning. For instance, I think of Gertrude Stein's writing as performative in that representational meaning is less important than the experiential impact of her use of language—how the words wash over the reader to remind them of the body doing the writing and the body doing the reading. Even as printed text, Stein's writing *speaks*. In her seminal book from the 1960s, *Centering in Pottery, Poetry, and the Person*, M. C. Richards remarks on Stein's "glorious resonance of language" and references Stein's famous line: "a rose is a rose is a rose" to say: "It is not a statement, it is *presence*" (emphasis added).[18]

This kind of presence is evident in Forti's writing in a collection of short pieces published in the Winter 1987 issue of *Contact Quarterly*. Casually entitled "A set of notes written in the few days before and after new year 1985," this series of paragraphs seems like freewrites in

which Forti, inspired by a thought, allows her mind to flow wherever the current takes her. New ideas swirl in little eddies along the side of the river until the main stream of thought brings her back to the subject of writing. For instance, the first paragraph begins "I so much need a writing project now, that I'm going to have to come up with one." But that thought immediately leads to a new image of building a stone wall, and the rest of the paragraph iterates the experience of picking up, moving, and placing the heavy stones on the wall. The reader is brought along into the pleasure of feeling one's body and physical labor. "Squatting, wedging fingers around a rock, up, tail to head all at once lifting, paying attention to the lifting, doing it a new way, in an old way, straightening the legs by trying to reach them down into the earth, one more stone, feel the wall with the looking, see its accumulation, review the day's stones with the eyes, with the hands, jolting pressure to settle the stones, to see that they're well settled" (1987, 12).

As it takes the reader on a voyage through the landscape of her mind, the writing weaves and wanders its way through various terrains. One theme that keeps reappearing, however, is the issue of writing, or rather Forti's relationship with writing. With a Steinian cadence she broaches the subject:

> Even just this writing now nourishing me, accepting me, even now just this. Trusting now this process as other times I trusted the standing and the crawling, the wandering in the room, in the big empty studio, the shifting and lolling twisting on the floor, on the sweet wood floor, the rolling over and trusting to the enjoying that would lead to some finding, now the trusting to this sweet little typewriter. And the posing of the question, basically now the same question writing or dancing, the question. Slowly posing the question, knowing that the question will pose itself. (1987, 12)

In this journey, Forti drops little hints of what she is working towards. The reader follows these word crumbs, stepping with Forti from stone wall to video to otters playing to stacking wood to the feel of digging

hands into clay. Eventually, Forti lands in a really interesting spot. Like stones, concepts of form and content seduce her to pay attention, to pick them up. She notes, however, that she sees "the space around the solid." Forti follows this liminal space that surrounds the solid object of concept, turning ideas on their side.

> I remember that in dancing, moving moving moving does bring movement. Not only of limb, but movement of mind. At last movement of mind does come. With writing, I'm not sure. (1987, 14)

Clearly it is easier for Forti to follow her mind while in motion. The question is, What happens when one wants to leave that familiar experience of movement that can feel so solid—so material ("I can dig my hands into") to find another kind of dancing—of ideas on the page?

> I suspect that the turning to writing is a step in maturing. Is coming from a longing for maturing. A sense of a need of maturing. And a need to look outward. Language as communication. (1987, 14)

Communication is the bridge that crosses over writing and dancing. It is interesting to me that Forti seems here to envision the move to writing as an aspect of maturing. In the New Year of 1985, Forti was about to turn fifty, and her father had recently died. Time brought with it a growing sense of responsibility—to her remaining family and as an American citizen. This weight, like the stones she picks up to build the wall, brought language into her world in a new, more grounded way.

At the end of the 1990s, I had the opportunity to work in an editorial capacity with Forti's writings. I was gathering materials for a collection of essays on "improvisation in dance and mind" that I coedited with David Gere entitled *Taken by Surprise: A Dance Improvisation Reader* (2003). She sent me various pieces, loosely held together like a bunch of wildflowers tied with a string. Some were freewritings, some were mini histories of her career, some were about

her practice of the News Animations. I tried to honor the spirit of Forti's improvisational performances and also bring a suitable structure to the writing. I brought her writing into the studio and cut all the pages into their separate paragraphs. Then I crouched, crawled, and rolled around the floor, arranging and rearranging the paragraphs, reading them aloud and allowing the language to inspire the order, all while attending to my somatic experience of moving. I tried it several times, on different days, finally arriving at what seemed like a good read with an effective structure. That essay became "Animate Dancing." It has been translated into French, and Forti has revised it in English for a variety of publications.

The most recent reenvisioning of this seminal writing appears in *Oh, Tongue* under the title "From Animate Dancing to Writing." In the last two paragraphs of this version, Forti comments on her progression from dancing to writing. "My journey over the years has come through moving and speaking, through writing as preparation for performance and writing about dance, to writing as a primary relationship to the page and the reader" (2003b, 141). She closes the essay by explaining that *Oh, Tongue*'s genesis came when she shared a snippet of her recent writing with Dewey while they were hiking in the California mountains.

In his contribution to the Salzburg retrospective catalog *Simone Forti: Thinking with the Body*, Dewey tells the story of first meeting Forti when artist Jeremiah Day brought her into Beyond Baroque. She became involved with this self-described "place dedicated to the possibilities of language," finding a supportive community of workshops and like-minded collaborators. Dewey had seen Forti's work in NYC in the 1970s and was deeply inspired by her work with the News Animations and their sense of urgency about the world. The first piece of writing Forti showed Dewey was an imagined conversation between herself and her deceased father. Entitled "Father, Daughter," it stages these dialogues in four different locations: by the pool, in the study, on Hollywood Boulevard, and in Geneva, Switzerland—places that were significant in their lives together.

Forti begins "Father, Daughter" with a short preamble in which she

explains that people in Naples, Italy, speak with their dead, asking for help and advice. Even though she is a "Florentine Jew," she decides to talk to her father as a way of processing her life and to clear her mind. Over the course of a conversation that ranges from literature to philosophy to family history to chess problems to the latest news, Forti delves into two important issues with her father—her desire to write and her relationship to the political climate and her budding activism. Throughout these exchanges, however, her father rarely provides any answers to her questions and concerns. Most of the time, in fact, he responds with more questions. It is not until the very end of their fictional dialogue that Mario Forti asks outright, "But why do you want to write?" His daughter replies:

> I don't know, I want to. It's like wanting to chew bread. [. . .] I want something with a longer arc. I guess that would mean subject matter. Something that coheres for a longer time. (2003b, 29)

After a bit of consideration, the daughter adds, "What interests me now is politics."

Politics is the source that feeds all three decades of the News Animations. Unlike many of her peers such as Yvonne Rainer, Steve Paxton, and Robert Morris, Simone Forti was not particularly involved in the Vietnam era anti-war demonstrations—a fact that she admits to with some embarrassment these days. Caught up in her relationship with Robert Whitman and focused on helping him with the creation of his imagistic happenings, Forti was less attuned to the civil unrest fomenting in the country at the time. Even later in life when she was becoming more engaged with issues in the world, she still voiced a sense of trepidation that being politically active might jeopardize the wellbeing of her remaining family. Perhaps this is part of her refugee legacy. It can be dangerous to resist the powers that be. After all, although her family safely escaped fascist Italy, her uncle was killed fighting in the resistance. In "Father, Daughter," Forti discusses this history with her father, alluding to a family rumor that the uncle's girlfriend turned him in. The voice of her father is typically evasive; he leaves this question, as so many others, dangling in the air. But Forti

persists, explaining both her new sense of activism and the accompanying anxiety to her father. She writes:

> I want to tell you that I marched in a demonstration against starting a war. I was shouting "No blood for oil." I was in the street shouting. It's the first time I've ever done that. The whole thing was like a dream. All of us lining the curb along Wilshire Blvd., holding posters up, I made one in Spanish, "No a la Guerra," because there weren't any in Spanish, and we were making the "V" for victory to passing cars, shouting "We want child care" in answer to the megaphone blaring "Bush wants warfare," our answer "We want welfare." (2003b, 21)

Forti's childlike excitement at being a part of this public demonstration fades later that evening, however, and she ends this part of the conversation with the admission that she felt pretty uncomfortable about her participation in the event once she had returned home.

In her writing and in her performances, Forti takes the notion of a political stance quite literally. With the same acuity with which she approached her animal studies, she analyzes politicians' stances for what they reveal about the person. In the very brief editor's note for the first "Issues Issue" of *Contact Quarterly*, Forti writes that a political stance is: "[a]n awareness of the complexity of motivation that can include concern with self-image and a dose of the heroic stirring in the breast at being a part of the great march towards a better world" (1990, 3). These tongue-in-cheek references to heroism and "the great march towards a better world" remind me of her own stance in the 2003 News Animations performed at Bennington College, which I described earlier. She begins with "We felt so strong" and opens her arms full and wide, marching down the diagonal of the stage—down Hollywood Boulevard. Not all politicians are pompous, however, and in her "Body, Mind, World" essay published in *Oh, Tongue*, Forti articulates in detail a change in a politician's stance. Referring to former Soviet Union president Mikhail Gorbachev's address to the United Nations, where he spoke publicly for the first time about Soviet environmental disasters, she writes:

In naming that complex of problems, the stance changes. I really mean the stance. The physicality of that standing. The mode of the body fluids and organs that leads to that stance. The look of it and the feel of it. And the feel of looking that way. (2003b, 112)

Considering the interrelationship between external (muscles) and internal (organs) aspects of a political stance reflects, I believe, a way of looking at people and their bodies that comes from Bonnie Bainbridge Cohen's Body-Mind Centering, a somatic practice with which Forti is familiar. Not only did Forti take a workshop with Cohen, but she also followed the evolution of Cohen's work over the years through the interviews published in *Contact Quarterly*. Body-Mind Centering is a somatic practice built on a combination of Western and Eastern medical science including the study of anatomy and various energetic states, taking into consideration not only muscles, nerves, and bones, but also fluids, organs, the respiratory system, and the endocrine system, among others. When Forti speaks about a stance—whether that of a politician or of an animal—she is invoking a state of being, not just the postural muscles. Reading the *New York Times* (my paper of choice) each day, I sometimes try to imagine how Forti would take on the latest news cycle, using her body to make sense of our world. I can almost see how Forti would take on the "political stances" of contemporary leaders both in the US and across the world.

Forti's own sense of political urgency grew exponentially after September 11, 2001, and the fall of the World Trade Center towers. She had left NYC and Vermont and returned to live in LA. She was teaching Logomotion as well as writing and movement workshops at UCLA and at a local community center. As an American, she felt implicated in the degradation of the planet and became increasingly interested in her extended family's history, as well as American history, which she feels we tend to neglect. These subjects spread out in her writing and in her performances like a landscape that she navigated with each *News Animation*. In a journal entry written while she was teaching a Logomotion workshop in 2002, she comments:

Starting to feel new ground under feet. That new ground has to
do with political awareness. How to approach sideways my ques-
tions. Or fast like running into a cold ocean. (83N)

Sometimes, Forti takes the familiar pathways in performance, going
over well-trodden ground such as her riffs on the Persian Gulf and the
world economy. Other times, she brings in new materials and forges
a different route through her interweaving of body, mind, and world.

A quick perusal of the bookshelves in her apartment shows they're
filled with art books and catalogs of recent shows by her artist friends.
Combined with the various references to reading in her journals,
they suggest that Forti is a rather eclectic reader. In her journals, she
writes about reading Agee's *Let Us Now Praise Famous Men* and Milan
Kundera's *The Unbearable Lightness of Being*. She also references *The
Federalist Papers* on several occasions, both in her journals and in per-
formance. Written by Alexander Hamilton, James Madison, and John
Jay and published in the newspapers, *The Federalist Papers* explain the
importance of a centralized power and argue for the ratification of
the Constitution of the United States of America. They were written
at a time when states' rights versus a central government was a very
contentious issue. First published as articles and later compiled as a
book, the writings detail the different branches of government and
how they balance each other, ensuring that no one group has total
power. Bogged down with the weight of their eighteenth-century syn-
tax, they can be hard to absorb for a contemporary reader. Like many
writings from that time, they are often meant to be read aloud. There
is a performative quality to these texts that comes from a culture of
public oration.

In the Portland, Oregon lecture-demonstration (part of the week-
end workshop), right after acknowledging that she was not politically
aware as a young woman, Forti briefly mentions *The Federalist Papers*.
Then she walks toward the audience and begins to move, feeling her
limbs, reaching one arm out, and shifting into a hip to create a taut di-
agonal the stretches across her body. "I don't really understand the ins
and outs of our legal system, but I can understand it in my body," she

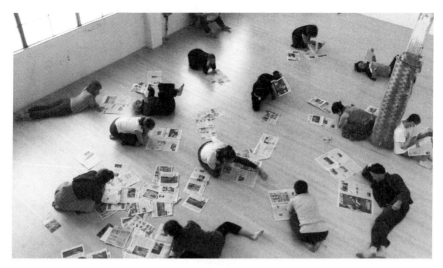

Video still from Logomotion workshop in Portland, Oregon, 2013. Courtesy of Eric Nordstrom.

declares. As she is articulating different joints, Forti proceeds to reference the intricate relationship between the legislative, judicial, and executive branches, including their system of checks and balances. She talks about "feeling" these different "arms" as a kind of tensile arrangement of poles and wires that hold our government together. As she speaks, she stretches and shifts, using her bones, muscles, and ligaments to navigate the tensile relationship of head with hip, or arm with foot.

I find it quite amazing to be reflecting on and writing about the News Animations at a historical moment when nationalistic tendencies and Covid-19 have shaken up so many taken-for-granted assumptions about lives, communities, and economies across the globe. Even though I am studying performances that are now more than a decade old, Forti's discussions of dictators, antisemitism, fear of crossing borders, and the sanctity of our Constitution seem extraordinarily prescient. I was struck by a final comment that Forti made at the conclusion of the Portland, Oregon, workshop. The group had spent the afternoon reading newspapers and had just performed their

own versions of the News Animations. As she was bringing everyone into a final circle to conclude, she suggested that these kinds of exercises might help people clarify their relationship to the news media, however they got their information. She encouraged people to "accept your feelings toward it." Then she delivered what seemed like a dharma talk. "It is not necessary when you make art to reference politics, social justice, etc. But I think whatever you make, it is good to have a reference of the background—whatever is there—in relation to what you are making." Forti concluded the session by asserting that the world both affects and is affected by what we do. Dancers need to think beyond the body-mind duet and include the world in their practice.

News
 1) As info on which to make life decisions
 a) Time to flee
 b) financial
 2) Take action/activism
 effect large scale change
 3) Entertainment and comfort
 5pm hear the news, drink a
 glass of wine
 Ritual
 4) Voyeurism see the desperate,
 The dying, see war
 5) Compassion
 Feel with others
 catharsis
 6) Project yourself into the situation
 and imagine what you would do
 7) Interest in figuring things out
 Like working on a puzzle by
 reading between the lines
 8) Black humor: Michael's Tale
 9) Defining one's self by the position one
 takes on issues

In the above journal entry, we witness a fascinating summary of
the various pleasures and challenges in Forti's embodied relationship
with the news. With the exception of No. 8 (the reference completely
eludes me), I have seen Forti directly address or allude to every item on
this list in a performance or workshop context. She frequently refers to
the fact that her father was able to get his Jewish family out of fascist
Italy. Her discussions of political demonstrations evoke the power
of comradery among the people out in the streets. She also has been
known to question the efficacy of those mass demonstrations, won-
dering whether they really do make a difference to the larger power
structures in the world. In interviews and in performance, Forti talks
about her daily ritual of relaxing in front of the news at the end of the
day. Certainly, her News Animations performances model the deeply
physical side of compassion—the ability to literally put oneself in
someone else's shoes. For example, in the middle of her performance
in Portland, Oregon, Forti was talking about a recent hostage crisis,
and she paused for a long moment, walked over to where she had been
pointing, and pondered what it would be like to substitute her older
body for a younger hostage. It was a deeply compelling moment that
left no question about the value of each body, young or old. And she
regularly addresses the melding of the literal with the symbolic in
adopting a political "stance" as a way of defining oneself—and one's
self-interests.

In August 2002, Forti performed a *News Animation* at the Bates
Dance Festival, where she was teaching a workshop. Interestingly,
this version stages its own meta-commentary by frequently referring
to the history of the News Animations in the midst of improvising a
new one. Forti begins in silence, moving fluidly across the back of the
stage. Then she pauses, walks over to a big pile of old thick rope coiled
downstage. She lifts it high into the air and unceremoniously throws
it over her head. The rope lands around her neck, and some pieces fall
down around her shoulders and arms, confining her movement. She
grabs one fraying end and begins sweeping it back and forth across
the stage. She looks out at the audience and says: "I used to do the
News Animations all the time. I just found the whole stories—I don't

know—so full of action." She pulls the layers of rope off her body and rearranges them like a backpack on the ground, humorously commenting on "so much stuff" as she refers to both the news and the heavy rope lying at her feet. Freed from her burden, Forti shifts gears energetically, looking up and pointing to an imaginary sky as she tells us that, south of the equator, you can see a lot more stars. Circling the stage, she elaborates why this is so and talks about the Milky Way.

She returns to the rope and announces that she quit doing News Animations towards the end of the Gulf War. She reflects on the closeness of that war and underscores the horrific terminology "human waves." She backs up as if she were going to launch herself down the same diagonal that she used so many times in physicalizing those human waves. But this time she hesitates and instead of running, she walks, using her hands to mime the tumbling of bodies as she notes the sad loss of lives. Reliving a muscle memory of earlier News Animations, she speaks of blood and oil, grappling with the rope and swinging it away from her. The rope is heavy, and it takes quite a bit of effort for her to get it spinning as she counterbalances its weight with her own. Forti talks about how it's different now. The scene shifts again and she is hiding behind the rope and remembering a dream of hiding from soldiers as a child. The rope becomes her shelter, consolidating a striking image of an older woman curled behind a lump of twine on the floor. Forti connects that moment with today as she talks about how they are still bulldozing villages in Gaza.

Suddenly we are in the woods in Vermont, a shift that seems odd until she describes seeing the rabbit tracks skittering here and there and then the fox tracks. As she mentions "tufts of fur," her hands gently flick the air in front of her, like she's tracing the last moments of a dying creature. She keeps this gesture going even as she switches topics and riffs on the invasion of mint in the chamomile patch. She tells us that the oregano is also a serious herbal aggressor and describes with her body how it will try to take over and "kill everything else." Grabbing the rope, Forti becomes a worm squiggling out of the ground. She looks up and advises the audience that if they find a worm in a clump of dirt, it is important to move that clump over

to a shady area, "so that the worm can go out by itself, because they *hate* to get dirty." The audience laughs, happy to have a comic release from the earlier pathos of war and destruction. Forti finally manages to completely disentangle herself from the rope and finishes with one last movement memory snapshot from a trip to Italy.

In his afterword to the second edition of *Oh, Tongue*, Dewey invokes the political power of live performance in describing Forti's News Animations. In language that reflects Forti's own sense of rooting into new ground, he writes:

> To speak what happens while moving, to "move the telling," is more than sports and athletic concern with muscles and pyrotechnics, more than a safe preserve of conceptual art or writing and art as a rarified activity. It is about a freedom that seeks to preserve, to tell, to give us back the experience of seeing and touching what is near and far, to show what a human can do and say. Somatic thinking and language ground us. They exemplify and root.[19]

Forti's utterances carry the weight of her living experience. As her tongue searches for words, her body provides the insights that inspire her language to keep moving. This is the essence of what I am calling Simone Forti's "engaged poetics." Watching her perform, the audience witnesses the powerful measure of her realization that, even after three decades, the News Animations are still "something to live for."

Constructing a Legacy

There is a wonderful moment during the lecture-demonstration part of Forti's fall 2013 weekend workshop in Portland, Oregon, in which she surfaces from the historical narrative about the origins of her early work to face her audience. Dressed in dark pants and a black sweater that accentuates her white hair, she takes a few steps away from the audience to mention, with a certain chuckle in her sweet voice, "Incidentally, the Museum of Modern Art is interested in buying *Huddle*." Amid the spontaneous laughter in the audience, an incredulous voice pipes up, "How do you *buy* that?" The question hovers in the air as Forti nonchalantly continues: "We've been talking about it for about three years now. And I think we'll just keep talking about it because it is an interesting conversation." With a light step, her head moving with a slight but constant Parkinson's disease vibrato, she approaches the audience as if speaking to a curator and quips, hands on her hips in a jaunty manner, "You've got it baby!"

Clearly, Forti is bemused that an art museum wants to purchase an improvisational score that was first performed in 1961 and published in her memoir *Handbook in Motion* in 1974. This acquisition is particularly remarkable given that, in the six decades since it was first conceived, it has been performed by folks all over the world. As an exercise in group support, *Huddle* is one of Forti's most renowned and widely disseminated works. As an improvisational structure made of human bodies that dancers take turns climbing over, it is also not an obvious artwork for a museum to buy. The Museum of Modern Art (MoMA) in New York City eventually acquired Forti's Dance

Constructions (including *Huddle*), and the context of this exchange is one of the many threads weaving its way through this chapter. But first let's return to Forti's workshop in Portland.

A few minutes after her comment about MoMA buying *Huddle*, Forti responds to a question from the audience about the pleasures and pressures of being an elder. She notes that she appreciates the support and recognition she has achieved and feels that she can still perform in a way that can communicate a certain poetry of image, movement, and word. Backing away she adds: "What sucks is that right now I'm kind of famous, and there is this Simone Forti [she reaches her arms up to indicate a frame in front of her] that I've become the secretary to." The audience laughs heartily as she nods her head and brings her hands together, intertwining her fingers. It is clear that this level of fame is burdensome (she mentions several requests per week for interviews) yet also energizing. Pausing to reflect on her legacy, Forti drops her shoulders in an admission of exhaustion but then shifts to a broader, more inspired stance as she describes some of her new work. She bends down to knock on the floor for luck as she affirms that it is "a good period of my life."

This lecture was the opening event in a weekend improvisational workshop billed as "a rare intimate" opportunity to study with Forti.[1] Held October 4–6, 2013, at the Ship Gallery Studio in Portland, Oregon, the workshop itself was bookended by two public events—the lecture-demonstration at the beginning and a performance on the last evening. In between, the participants were led on a whirlwind journey through Forti's improvisational sensibilities, including group structures such as *Scramble* and *Huddle*. Participants were also introduced to her Logomotion work and the News Animations. Sitting in an introductory circle on the first morning, Forti begins with a discussion of her well-known trinity—*body, mind, world*. In describing how verbal communication often sponsors physical gestures and how our kinesthetic system underlies our experience of world events, she loops her hand in a circle from her belly to her mouth to gesture out towards the audience as she cycles through several repetitions of those three words—body, mind, world. In this triangular relationship, personal

poetics interweave with historical experience and political realities. Over the course of the weekend, Forti encourages the participants to *feel* the world in their bodies and to find ways to integrate sense impressions and movement memories with their sociocultural contexts.

In her teaching, Forti shifts back and forth from very detailed instructions to more open-ended improvisational inquiries. For instance, when she taught *Huddle* to Oberlin College students in January 2005, she emphasized the sense of interconnectedness and the shifting resistance needed for the group to support the person climbing on top. By October 2013, as she was both preparing for her first major retrospective at the Museum der Moderne Salzburg in Austria and in deep discussions with Department of Media and Performance Art curators at MoMA, Forti was increasingly specific in her directions about how to climb up and the correct way to descend (feet first, not headfirst!). She spoke about how larger bodies can be accommodated because one's weight is spread out across the tensile web of the whole group. She also insisted that the group not try to cover over awkward moments ("the struggle is interesting to watch") and asserted that the form was visually intriguing even when no one was climbing over.

In the Portland workshop, she took the time to address anyone's questions and concerns about safety and support; whereas a decade earlier, she would often just have students try it before there was any discussion about the correct way to climb. Listening to Forti explain all the possible places to put a foot or a hand, my sense was that over the last decade *Huddle* has lost much of its improvisational sensibility and has instead become a vehicle for directions about climbing and descending. Perhaps the fact that Forti had been teaching this score more frequently in the context of reconstructions of her work in art museums served to make her so detail oriented, but I also attribute this caution to her concerns with safety as she thought about this important piece of her legacy. In teaching *Huddle* over the first two decades of the twenty-first century, Forti progressively shifted from telling people *what* to do (per the simple instructions from the original score published in *Handbook in Motion*) to dictating *how* to

do it (giving specific directions that constrain the improvisational possibilities).

On the other hand, in preparation for a Logomotion activity in the studio that weekend, Forti sent the participants out into the streets in pairs to walk and observe without a lot more instruction. Coming back together after an hour or so, the partners took turns diving right into a "moving the telling" duet in front of the others. Predictably, some of the moving was hesitant, and the speaking was halting at first. After a while, Forti got up to perform with her partner, Eric Nordstrom (who was also the workshop's videographer). As captured on a video, this informal duet reveals Forti's genius as a funny, confident, and compellingly down-to-earth performer. Playing against the foil of her partner's inexperience in moving while speaking, Forti's cunning surfaces right away. She knows precisely how the potent combination of image and language will affect her audience.

Take, for instance, the moment when Forti slides on top of Nordstrom as he sinks down to all fours. Keeping her cheek pressed to his back, she refers to her college boyfriend and says, "I think we got together because we got *very* drunk together." Leaving a moment of silence for emphasis, she then continues in a deadpan manner, "I bet that happens a lot in college." Tongue-tied, Nordstrom sighs, which quickly becomes self-referential, as if he were remembering just such a situation from his college days. He remarks, finally, "well, that was a telling silence." Later, they are discussing the spinning leaf they observed together that seemed to match the rhythm of Forti's vibrating head. As the timer indicating the end of the improvisation beeps, Forti mentions that children are often scared when they see her Parkinson's. In a high-pitched voice, she mumbles while walking off, "Yeah, they think: 'There's that shaky lady.'" It is a wonderful example of her typical display of performative power and self-deprecation, and the participants chuckle along with her.

The next day, when she was teaching the News Animations work, Forti brought out a pile of newspapers and told the class to take a section or two, spread out, and read. She noted that they were to attend to how they related to the news or images in the paper, using

the stories as a point of reference for their own feelings. After about thirty minutes, the participants paired off to have a moving conversation about their respective reading. She encouraged them to keep moving as they spoke and to see what came out of that conversation. After a little while, she had them perform short three-minute duets for the class. She acknowledged that moving and talking in a duet is a scary thing to do and reported that even doing a solo, which she would perform that evening, was scary. But she added, "You have to have some faith that something good will come of it." Something might happen in ways that will surprise and maybe even delight you. Walking off to the side to witness, Forti joked: "If I were you, I'd be scared now." The ice was broken, the participants all laughed, and a brave soul ventured out into the performing arena to begin.

After the second day of the intensive workshop, Simone Forti presented a public performance in the informal studio setting. The evening comprised two examples of moving and speaking solos separated by a series of *Huddles* executed by the participants. Simone also read some of her recent writing. Although this evening improvisation was not, in my opinion, one of her strongest performances, it did reveal the interwoven texture of her growing political awareness and her concerns about the economy and the environment, as well as her avid interest in her family's history in Italy. Forti begins by walking casually over to the upstage right corner. She turns to face the audience and takes a breath. Launching herself into the performance space, she immediately deflects the audience's attention on her by pointing her finger to something across the room. She moves closer, shifts her gaze to another spot, points, and follows her finger, opening up a sense of spaciousness all around her. Forti backs up and, pointing to the sky, she talks about the stars that are "so far away, far, far away." Matching time with space, she riffs on history and speaks of events that happened "long ago, long, long ago." Then she falls silent as she spins on a diagonal. Unexpectedly, she cries out "BOOM!, boom, boom," as she punctuates her explosive sounds with equally explosive movements. She faces different directions as she waves her arms in a chaotic display. Is she miming the big bang and feeling the beginning

of the cosmos in her body? Soon she leaves that swirl of chaotic energy and backs up to her original starting place to regroup.

Walking directly downstage, she addresses the audience: "I was born in Italy, and I've always thought Italy was Italy—L'Italia è l'Italia." She builds upon the history of her family and traces the parallels as Italy becomes a nation during her great-great-grandfather's time. This was a time of city-states and the patriarchal (not to mention phallocentric) power of tall towers built to impress the neighbors. Having established several threads of connections between family and state, she leaves that subject and shifts into a discussion of how the American "constitution was constituted." During this time in her life, according to her journals, Forti was reading *The Federalist Papers,* and she deftly interweaves political discussions of nation building in Italy, America, and among the Iroquois, describing their different approaches to civic structure.

Her voice trails off for a moment as she retreats back to her starting point and shifts into a description of male elk and their big racks of antlers. Forti leans forward, and her arms frame her head on either side as she demonstrates how they fight one another for dominance and control of the females in the herd. This image forcefully energizes her storytelling and movement as she imitates one animal fighting another. The pathos is signaled by her innocent telling of the ways in which elk with larger antlers have trouble navigating the woods. She plows into a wooden post in the room again and again while repeating, "they get stuck, they get stuck." Forti then segues into a riff about environmental destruction: "Just like our nuclear waste that we're stuck with." Here, Forti leans against the beam, lowering herself as she circles the post. She is quiet for a moment as the audience contemplates her last words.

Simone Forti once said she shifts directions like a jackrabbit— zigzagging back and forth from one project to another in an artistic career that was anything but linear. This performance reveals a similar pattern of thought as she darts from the heavy topic of climate disaster to talking about her sister walking her dog by the sea and realizing that a little seal was following them. Forti comically mimes both the

dog's galloping along the beach and the seal's parallel frolicking in the sea. Then she switches back to the stars and the long, long ago and far, far away. On cue, the workshop participants enter to begin two *Huddles* as Forti steps aside momentarily.

Soon, however, she is back weaving between the groups as she reads from her journal. Italy and her great-grandfather reappear; she sings a song in Italian and mentions the role of religion in political conflicts, declaring that "religion will help you know who the enemy is." The audience realizes that what she is reading aloud was, in fact, the inspiration for the earlier solo, as she details family members and thoughts about her history in a more expository manner. Next, she pulls out a pile of newspapers from the side and begins to spread them out across the space. She launches into a News Animation, beginning with the nuance of the word "water," pronouncing it several times to indicate the many possibilities of meaning—such as water as a scarce resource and water as home to fish. She ends with a picture of a pumpkin and references to a holiday that is about fun, scary things. She juxtaposes this image with the real scary things that are happening far away, far, far away as she looks off into the distance, reminding us of how she began the evening's performance with the simple gesture of pointing up to the sky.

I opened this chapter with a discussion of the Portland workshop because those two days in October 2013 touched on many of the emblematic concerns, aesthetic themes, and critical issues that underlie Simone Forti's artistic legacy. Forti continued to perform, teach, and write well into her eighties. At the same time, her interest in her family's history in Italy increases exponentially as she confronts her own aging and place in dance and art history. Her notebooks and performances in the twenty-first century are filled with references to her cousins' memoirs and various academic treatises on the Forti woolen business. When Forti begins her performance Saturday night by talking about all the interrelated parts coming together, she could easily be referring to her family history, as well as the city-states that eventually coalesced into the Italian nation.

Yet there is an ambivalence about Italy that runs through much of

the writing in her notebooks. In response to a comment about immigration in a 2014 interview with Sabine Breitwieser, she says, "I think I did much better in America than I would have in Italy. To be a signorina and then a signora in Italy—forget it" (Forti 2014, 18). She speaks of her own privilege and financial security and recognizes how she has constructed her own mythology about her family, particularly about her beloved father. Delving into her family's Jewish Italian heritage allowed Forti to shape her own sense of cultural history and artistic identity, particularly at a time when her growing reputation was increasingly molded by forces from the outside. Through her published memoirs and her writings' manifestations in various performances, Forti presents the underbelly of her experience, revealing the interior dimensions to her increasingly public persona.

Beginning at the turn of the millennium with Mikhail Baryshnikov's PAST*Forward* program of Judson Dance Theater reconstructions (which also included Forti's *Scramble* and *Huddle*) and running up to MoMA's 2015 acquisition of her Dance Constructions, Simone Forti saw her Dance Constructions from the early 1960s become canonized and, I argue, commodified by galleries and art museums around the globe. In 2004, the Museum of Contemporary Art in Los Angeles (MOCA) featured the Dance Constructions in performance at its gallery Geffen Contemporary at MOCA as an addendum to its massive show "A Minimal Future? Art as Object 1958–1968." In addition, several of the Dance Constructions played a prominent role in MoMA's 2018–2019 blockbuster show "Judson Dance Theater: The Work Is Never Done."

In 2009, Forti began to be represented by an art gallery, The Box in LA, a move that firmly situated her reputation in the realm of art making and art dealing. The Box's director, Mara McCarthy, and her staff played a crucial role in assembling, documenting, and situating Forti's work in ways that spoke to art museums, opening the door to MoMA's acquisition of Forti's Dance Constructions, as well as managing the Getty Research Institute's eventual acquisition of Forti's archives. In addition, Forti was honored by her first solo retrospective in 2014 at the Museum der Moderne Salzburg in Austria. This

important career survey and the gorgeous and extensive retrospective catalog exposed Forti's oeuvre to an international audience. Over the following decade, Forti's Dance Constructions were presented world-wide, with exhibitions in Sweden, France, Germany, Switzerland, Italy, and the Netherlands, as well as in the United States. Promoted by multiple exhibitions at The Box gallery, her holograms and other two-dimensional works were acquired by a variety of collectors and institutions. In 2023, she had a career retrospective at MOCA and was honored with the Golden Lion award for lifetime achievement in dance by the Venice Biennale, an annual international cultural exhibition in Italy.

In many ways, this late career revival was a mixed blessing—both welcome and challenging. On the one hand, as Forti noted in her lecture-demonstration in Portland, it was a wonderful and welcome sense of recognition. On the other hand, much of this attention is primarily focused on work she did over the course of one year in her twenties, binding her artistic career to Minimalism and a somewhat narrow view of her artistic journey. As she quips in her 2018 oral history interview with K.J. Holmes, "I don't want to use all my time teaching stuff I did in 1960. You know, I'd rather crawl on my belly on the snow in Chicago." (This last comment is a reference to *A Free Consultation*, a 2016 video collaboration with Jason Underhill, which I discuss below.)

Evaluating Forti's legacy is particularly complex; there is a critical tension between the canonization of her Dance Constructions by art museums and her own inimitable exploration of improvisation, including new collaborations with younger artists. While Forti is still performing the News Animations and teaching Logomotion workshops in Los Angeles in the twenty-first century, she is also adventuring into multifaceted projects that span a continuum of theater, movement, language, and, eventually, video. In this chapter, I balance a discussion of the institutionalization and commodification of Forti's work in the art world with a recognition of the connections she keeps to the dance world, including the deep emotional support she gives to and receives from her chosen family of collaborators. This

human network becomes increasingly important as she becomes an art-world star and museums clamor for her work. Thus, I explore and critique what it means to turn kinesthetic experiences into art objects for sale, and I present the expansive ways in which Forti inspires a new generation of artists involved with the reconstructions of her Dance Constructions. I chart how Forti has "arrived," so to speak, and how she is always, wonderfully in the process of improvising her next step.

It is clear from reading Forti's notebooks, however, that while this extraordinary recognition is indeed gratifying and brings many welcome opportunities to travel, teach, and perform, it was also physically and emotionally draining. The second decade of the twenty-first century was when the symptoms of her Parkinson's disease accelerated. Even though Forti carried on a full life and continued to be connected to multiple communities and friends, she was often lonely and experienced moments of depression, especially in the early evenings. While at home in LA, Forti frequently pines for a lover and writes imaginary conversations with her father. A 2013 notebook holds a poem, written eight months before the Portland workshop, that encapsulates that sense of longing for an intimate relationship and ambivalence about her stardom.

> She has become famous
> or an idea
> that holds her name
> runs rampant
> in the world.
> At bedtime
> she bids goodnight
> to her potted plants.
> There is no question
> of who she is
> to them (124N).

Forti's understanding of her own historical and artistic impact is an ongoing and dynamic process, a tangle of influence and being influenced. It is hard to frame a moving body, and it is difficult to

evaluate the legacy of a living artist. Yet as the millennium shifted and Forti moved back to LA, there is a marked evolution in how she begins to articulate her own history. In her notebook for the year 2000, Forti is working on a bio for an event in Paris. She writes: "Simone Forti started on the performance of dance improvisation in 1955 and started doing Tai Chi in 1970. A couple of years ago she moved to Los Angeles to be near her mother, and there she finally got into Contact Improvisation" (95N). This is one of the last times that Forti would choose to define herself solely within the context of various movement practices and her role in dance improvisation. Soon, her written biography would reference larger trends in the art world.

Throughout the early decades of the twenty-first century, art museums rushed to shore up their collections with examples of performances from the 1960s and 1970s. This process centered on the acquisitions of ephemera (sketches, photos, notebook entries) and the restaging of performance work. In terms of Forti's career, these institutions focused almost exclusively on the Dance Constructions and their relationship to the canon of Minimalist Art and postmodern dance. Forti simultaneously took part in and resisted that process. She both enjoyed the art-world exposure and resented the disproportionate emphasis on her early work. To trace the development of that process of becoming what she describes in the poem cited above as "famous or an idea," it is useful to compare two video documentaries that focus on her artistic work. Charles Dennis made "Simone Forti: From Dance Construction to Logomotion" in 1999, soon after Forti had moved back to LA and started teaching at the University of California, Los Angeles (UCLA), and ArtPix created "Simone Forti: An Evening of Dance Constructions," filmed at MOCA's contemporary Geffen space in 2004 and released as a commercial video in 2009.[2] Over the course of those five years, Forti's artistic persona evolved from that of an interesting dance teacher and quirky improviser known and loved within experimental dance communities to an artworld figure whose work was considered deeply influential to the development of Minimalism in art and postmodern dance in the US.

Filmed as part of the "Alive & Kicking: New Directions in Dance & Performance Art" series, "Simone Forti: From Dance Construction to Logomotion" has a casual, homemade quality about it. Less than thirty minutes long, it begins with a long shot of Forti walking with a group of students down a sidewalk on a blustery day. Forti pauses to point out something in a tree, and then the shot shifts to a close-up of her face. The wind is blowing her short hair across her eyes as she explains that "we are in the sculpture garden at UCLA" and introduces *Huddle*, which is being performed in the background as a piece which Forti describes as being "like a football huddle."As the camera shifts between long shots of the dance and close-ups of specific performers climbing over the human mountain, Forti recalls, "I originally called it a Dance Construction" and states that the first performance took place in a loft. She explains that a loft is an open industrial space but doesn't reference whose loft it was. Forti mentions that it was a piece that viewers could walk by and around, and she notes that it has found a home in sculpture gardens like the one they are in. I find it significant that Forti doesn't specify (as she will in the future) that Yoko Ono's loft was the original venue or that she staged *Huddle* in MoMA's sculpture garden in 1978. In 1999, it seems that a need to underline her connection to famous art world figures and institutions in order to highlight her artistic legitimacy had not yet become a standard part of her self-presentation.

In fact, *Huddle* is represented in this video more as a dance to be experienced than an art object to be seen. Several dancers are featured in voice-overs describing how the dance *feels* while doing it, not how it looks. One participant calls it "very organic and very—just human." Others invoke the wonderful sense of community that is established when people breathe together and physically support one another. Since the video was shot outdoors on a very windy day, wind noise is a constant accompaniment that adds to one's sense of being present at that moment. It is a little like watching a home movie of a birthday party. Another participant invokes a spoken-word cadence when she raps off-camera:

The huddle is softening, the huddle is surrendering. The huddle is supporting, the huddle is being supported. The huddle is exploring ways to get over the top of the mountain. The huddle is scary coming down the other side when it's steep. The huddle is open space, the huddle is closed space. The huddle is being together, the huddle is family. The huddle is a mountain—that's the huddle.

This section on *Huddle* lasts for only about five minutes. The rest of the video explores her Logomotion workshop at the Church in Ocean Park in Santa Monica, California, focusing on her improvisational practice of moving and speaking and her short performance inspired by choosing three words randomly from the dictionary. This would be one of the last times that her ongoing contemporary work was given more bandwidth than her early 1960s pieces in any public presentation. As the twenty-first century unfolded, Forti became increasingly entangled with the legacy of her Dance Constructions.

In contrast, the professional-quality video produced by ArtPix documents the reconstructions of six works from 1960 and 1961, categorizing them all as Dance Constructions even though two were originally presented in a different venue several months before the show in Ono's loft entitled "Five Dance Constructions and Some Other Things." In the video, *Huddle*, *Slant Board*, *Platforms*, *See-Saw*, *Rollers*, and *Accompaniment for La Monte's "2 Sounds" and La Monte's "2 Sounds"* were filmed in MOCA's cavernous Geffen space. An intriguing question and answer session followed these pieces, and Forti was in a mischievously humorous mood. These works were staged in conjunction with the MOCA exhibition "A Minimalist Future? Art as Object 1958–1986." Interestingly and significantly, I would argue, the immense catalog that documents that show and was published by MIT Press does not include any mention of these performances done in conjunction with it, nor does it list Simone Forti as an artist in the exhibition. In fact, her work is mentioned only briefly in one essay by Carrie Lambert (now Lambert-Beatty) in her revisionist reading

of the Minimalist strands in the work of Forti, Yvonne Rainer, and Trisha Brown.

In "More or Less Minimalism: Performance and Visual Art in the 1960s," Lambert underscores the "convergence of practices" between experimental dance and minimalist sculpture and painting. She suggests that Forti's *Huddle*, Rainer's *Shall We Run* (1963), and Brown's *Homemade* (1965) could be considered "handbooks in motion" (borrowing a term from Forti)—as guides to ways of seeing the performative aspects and internal complexity of Minimalism. While pointing to the importance of the dancers' body in this work, Lambert paradoxically eschews their experience of embodiment, preferring to elaborate on aspects of this kind of postmodern work from the outside. "Rather than focusing on the dancers' experiences—their freedom from imposed choreography, their physical intelligence in determining the surfaces and weights of the bodies, their modeling of an interactive social unit—we might best approach the piece, as Forti seems to, from the spectator's point of view."[3] This "framing" of *Huddle* as an art object to be seen rather than experienced strikes me as myopic. I want to suggest that an equally significant way of looking at this dance as living sculpture is by witnessing both the kinesthetic aliveness and its visual dimensions. This is to say that, like a mobius strip, form and experience—the inside and the outside—are enfolded within one another. Forti frequently states that *Huddle* is both a dance and a sculpture. However, only one of those terms generates interest in acquiring it from an art world perspective.

The ArtPix video begins with a brief introduction by Forti, dressed in a loose white shirt and tan linen pants, who tells the audience members seated on folding stools in the round that the various pieces will take place in different areas of the huge concrete gallery and that they will have to move to see them all. In her sly, humorous manner, Forti advises them: "So you are not going to stay the way you are." Recognizing the existential undertones of this instruction, the audience laughs. Nonetheless, most folks treat the evening as a series of mini-performances and sit silently observing each event. Caught between two different sets of expectations—that they sit and watch

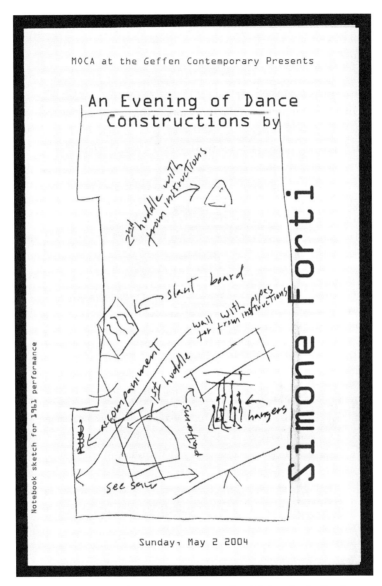

Flyer for "An Evening of Dance Constructions," MOCA at the Geffen, Los Angeles, 2004. Getty Research Institute, Los Angeles (2019.M.23).

as they are used to or move around as Forti is suggesting—no one walks by or around *Huddle*, the first work shown that evening. They simply sit and watch.

Set within the context of MOCA's 2004 show on Minimalism, Forti's work begins to take on the weighty aura of Art with a capital A. In fact, the evening's performance was the first time in decades that these pieces were seen together as a whole, collected under the rubric of the Dance Constructions. *Huddle* was the first Dance Construction shown, and the camera periodically zooms in and out, alternating a full view of this human mountain with extreme close-ups on arms, hands, and shoulders. This rendition by participants in her workshop was not the most interesting version of *Huddle* that I have seen, and I am not quite sure why it fell flat. Perhaps it was the fact that, for some reason, everyone was crouched down very low to the ground, with some supporters actually kneeling or squatting. This made it seem more like a group hug than a demonstration of climbing over a human mountain. Forti, however, was clearly animated by the evening, and she not only participated in this group dance but climbed over three times (more than anyone else). Perhaps she sensed a hesitation from the inside or was eager to make it interesting. In this situation, the serious attention of the sedate audience contrasted greatly with the casual, outdoors staging of *Huddle* in the 1999 UCLA sculpture garden. Nonetheless, taken together, these two videos present interesting perspectives on *Huddle*—as an experience of community and as an art object associated with mid-century Minimalism.

In the question-and-answer session following the 2004 showing, Forti acknowledges this difference in framing when she states, "We are looking at something from the past; it's something that has acquired a certain authority." She then contrasts that recent frame with a discussion of the improvisatory experience of making work when she was younger, sharing explorations with a community of artists—dancers, painters, poets, musicians, sculptors—who all went to see one another's work. When an audience member asked about the genesis of *Platforms*, Forti seemed momentarily tongue-tied. Shrugging her shoulders, she finally responded, "I don't know; I just thought it

would be wonderful!" She said the impulse to create the piece was intuitive, what she called a "visceral" sensibility. Forti refers to *Platforms* as a duet of listening and describes how the whistles can overlap or seem to answer one another in a call and response. Forti also recalls that during the rehearsals for the Geffen show they had decided to turn off the air conditioning to help keep the space quiet so everyone would be able to hear the thin sounds of the whistles. When she realized that the air conditioners were still going, she was concerned at first but soon became aware that she could hear both the whistles and the fans and that they created an interesting "composite" that made the piece a little more "complex in a good way." When I heard this last comment, I was once again impressed with Forti's extraordinary curiosity and commitment to living an improvisational life in which expectations about how a performance will go can always change. Given how often the Dance Constructions are classified by others as conceptual works, her response is telling in that it affirms that there are always two ways of seeing these pieces—inside and outside, conceptual and vibrational, abstract and emotional—old and new.

Once she began talking about *Huddle* in the post-performance discussion, Forti was on much more solid ground. This piece is the most well-known of her Dance Constructions and has had the most afterlives, so to speak. She expressed a continuing delight in finding it wonderfully "mysterious" and embracing the suspense of not knowing who is going to climb next and how the piece's nonverbal resolution will happen. It is clear that Forti is well versed in recounting *Huddle*'s origins. She has narrated that moment in her life and career many times, and it has become one of the central themes threading through the narrative of her career. As she relates the details of her life situation in the early 1960s, she reaches back with her right arm, as if literally pulling the memory of those days towards her. She speaks of how she had just made the transition from California to NYC and was desperate to connect with nature again. "I felt that the only natural (here she hesitates and circles her arm towards her belly and chest as if calling forth memories), the only *undomesticated* experience I had was my body, gravity, how I moved to do things, to lift something, to

go upstairs, and why this seemed to satisfy a longing . . . to just feel, the feeling of climbing or of bearing some weight." A single, simple action was supported by a felt need, once again demonstrating the interweaving of the conceptual and vibrational in Forti's work.

Throughout this discussion, Forti juggles her personal history and art-world reputation with her present experience. She mentions that she has never seen this many of the Dance Constructions together before and marvels at how much fun it was to do them in that big, open space. But she also acknowledges the radical differences of architectural setting and historical context. At one point she contrasts the original performance of her *Accompaniment for La Monte's "2 Sounds" and La Monte's "2 Sounds"*—in a very intimate space with a small audience—with the current experience in which there were many more people with their eyes focused on her. Tongue firmly in cheek, she remarks, "I felt like, I don't know, Joan of Arc or something—like there was fire underneath." The audience laughs at this incongruous image as she notes that the sound score for that piece resonates differently in such a vast, open space.

Another question about hierarchy in the arts precipitates a wonderful mini performance by Forti as she lowers herself bit by bit while stepping forward with a bounce. She mimes what she calls "moving under the radar" while spreading her arms towards the floor: "It's really good to be a little there. You can do your work. You can do your thing, communicate with your colleagues, and it's so nice not to have big things that are for sale." She adds, "It's nice not to be at the top of the hierarchy." The audience laughs at Forti's distinction between the art world and the dance world, but the implication about markets and value can cut deep, apparent in the fact that Forti's name and work was not included in the catalog for the big Minimalism show next door. Even within a contemporary context such as this 2004 exhibition, dance is often positioned as the performative handmaiden to so-called "real" art, serving these institutions' desire to capitalize on the experience economy that has become so important to museum programming in the twenty-first century. Things have begun to change, of course. Almost twenty years after this show, MOCA presented a

career retrospective of Forti's work in which the performances were an integral part of the show, not an afterthought.

Ironically, the next question at the 2004 Q&A revealed how gender hierarchy was ubiquitous in the art world at the time. Someone asked Forti how Robert Morris influenced her work. Morris's work was amply represented in the show "A Minimalist Future? Art as Object 1958–1986," and Forti readily acknowledges their connection as part of the history of her Dance Constructions. But it is also critical to note that, even in a twenty-first century exhibition on Minimalism, few women artists were represented—less than twenty percent of the artists in the show, in fact. After a long hesitation, she replied, "I think we kind of influenced one another" before describing her shift from painting to movement. Forti associates painting with a love of gestural movements and the pleasure of leaving a trace. But she never felt she would be successful as a painter. With a sense of humor, she suggested that what she was doing with Anna Halprin was essentially abstract expressionism, only without the need to buy paint or worry about what to do with enormous canvases that stacked up in the corner. She did acknowledge that being with Morris was inspiring to her young self because of his total commitment to making art, seeing art, and writing about art. But she brought the question about being an artist back down to a very personal level in concluding about that period in her career: "I realized that I could create a structure that would help me frame what I needed to experience."

In the five years between 1999 and 2004, *Huddle* shifted from being a teaching activity to being an important historic artifact. One major factor in this shift from homegrown studio experience to large-scale cultural exposure was the inclusion of Forti's work in Mikhail Baryshnikov's PAST*Forward* series produced in conjunction with his White Oak Dance Project. Founded in 1990 by the ballet superstar and the equally trendy contemporary choreographer Mark Morris, this boutique repertory company commissioned new works by some of the most famous late-twentieth-century choreographers, including (besides Morris) Paul Taylor and Twyla Tharp, and revived earlier works by modern masters, such as Martha Graham and Merce Cun-

ningham. PAST*Forward* was one of the company's last big touring projects before Baryshnikov disbanded his troupe to focus on building his own arts center in NYC.[4]

Imagined in collaboration with Judson Dance Theater alumnus David Gordon, PAST*Forward* was able to use the pop-star visibility of Baryshnikov to resurrect and produce works by the Judson Dance Theater members, including Gordon, Deborah Hay, Steve Paxton, Lucinda Childs, Brown, and Rainer, in addition to two improvised scores by Forti. The filmed prologue to this eclectic evening of works by these Judson luminaries is by Charles Atlas and is narrated by Baryshnikov. Discussing the 1960s, he declares: "The world shakes, rattles, and rolls. Elvis rules and the Beatle reign," and he contrasts that scene with his own adolescence in the Soviet Union (where he knew about American jeans but nothing about experimental art). Baryshnikov waxes lyrical about the '60s iconoclasts. His delight in their antics leads one critic to dub him "a born-again postmodernist."[5] The distance between his ballet training and the aesthetic concerns of the Judson choreographers is striking, but Baryshnikov's interest in their experiments serves to validate their position within the mainstream.

Building a powerful myth about this watershed moment, Baryshnikov declares: "There's a kind of philosophical earthquake that can happen when, all by chance, the right bunch of people are in the right place, telling each other what they think and showing each other what they do."[6] Part of his stated intention with this series was to expose the 1990s generation of dancemakers to their postmodern ancestors. Ironically, tension was built into the fact that, while White Oak opened the doors to a much wider audience, that audience was not always prepared for the choreographic austerity, pedestrian movement vocabulary, and casual demeanor of the performers. Nor did the White Oak dancers always understand what was being asked of them.

Unlike pieces such as Rainer's *Trio A* or Paxton's *Flat*, PAST*Forward* did not classify Forti's work as choreography; instead, she is credited with "creating" *Huddle* (1961) and *Scramble* (1970). Rather

than being a part of the official staged dances, *Scramble* was shown onstage as the audience was entering the theater, and *Huddle* was shown during intermission. One exception to this incidental marginalization of Forti's work was during the *PASTForward* run at the Brooklyn Academy of Music in June 2001, when Forti offered a short solo called "Study." It was billed as "An improvisation conceived and performed by Simone Forti (2001), inspired by bears, flamingos, and the painting of Willem de Kooning."

In "Misha's New Passion," a feature article for *Dance Magazine* (reprinted in her 2013 collection *Through the Eyes of a Dancer*), Wendy Perron points to the incongruity dancers, trained in ballet or classical modern techniques, trying to access Forti's "dance state" through simple, pedestrian movements. In rehearsal for *Scramble*, Forti encourages them to move as if they were "running to catch a bus" or flocking like birds. Based on moving in between and around one another, *Scramble* is a study in shifting attention while constantly moving. Like much improvisation, it requires skills in perceptual awareness and a willingness to feel the whole landscape of movement. Perron quotes Forti in rehearsal: "A mass in motion tends to remain in motion. The universe is carrying you. See if you can taste that moment."[7] This kind of talk may have struck some of the dancers as odd, especially if they did not have any previous experience in the somatic awareness that grew out of the Judson experiments in downtown dancing. This is one of the many inherent tensions that arise in the process of reconstructing Judson works on contemporary bodies.

Another interesting shift between the 1999 and the 2004 documentaries (the latter was released in 2009) is the evolution of Simone Forti's written biography. In the 1999 video, Dennis doesn't even include a biography about Forti. Oddly enough, in the written transcript of the video, whenever Forti is talking the voice is referred to as "unknown." Weird as this is, it is indicative of a certain grassroots community perspective. The assumption is that everyone who is interested in the video already knows who Forti is and will recognize her voice. Dennis's *Alive and Kicking* video series as a whole does not

attend to translating this insider knowledge for a wider audience who may be unfamiliar with these artists.

Two years later, however, when her work is performed in the PAST-*Forward* project at the Brooklyn Academy of Music, Forti has a new bio that quotes a *New York Times* critic regarding her influence on postmodern dance. The bio calls her work "minimalist" and finishes with a list of accolades. "Forti has performed and taught throughout the world and has received various grants including six NEA fellowships." Tied to the art world and well-known figures such as Morris and Robert Whitman, she is thus framed as also having "a critical influence" on Judson Dance Theater. By the time the ArtPix video is released in 2009, Forti has become a seminal choreographer. Even though improvisation informs almost every aspect of her life and work, her official biographies begin to refer to her as an artist, a dancer, a writer, and a choreographer. Somehow, the category improviser doesn't seem to fit into the art-history rubric, and that elision both fascinates and troubles me.

From July 18 to November 8, 2014, the Museum der Moderne Salzburg presented the first major retrospective of Simone Forti's artistic work, confirming Forti's status as an important figure in the art world. The Dance Constructions played a significant role in the public programming for this exhibition. Breitwieser, the museum's director at the time, had become familiar with Forti's work when she served as chief curator of MoMA's Department of Media and Performance from 2010 to 2013. One of her goals was to pull Forti out of what she called the "dance ghetto" and to showcase her work as a multimedia artist. "Her artwork is notable for its unparalleled freedom and multiple cross-references as if disciplines, genres, and demarcations were non-existent."[8] In practice, this meant translating a lot of the performance work into materials that could be mounted on a wall. In her acknowledgements at the beginning of the immense and beautifully designed catalog (*Simone Forti: Thinking with the Body*), Breitwieser writes: "Because of the interdisciplinary and ephemeral character of Forti's work, the list of works branches out in many directions, from initial sketches for performance, posters and hand-made invitations,

to objects and documentation in the form of photography and videos."⁹ Ironically, in walking through the galleries, it would be easy to think of Forti more as a visual artist than a dancer. While she is hailed as an interdisciplinary artist, her actual physical dancing takes a backseat in this narrative of influence and greatness. Traces such as preparatory sketches and notes and photographs don't lead us to a greater understanding of her performing career in improvisation; instead, many of these ephemera were mounted on the wall as abstract art in itself. This is not to suggest that these sketches aren't worthy of detailed inspection but rather to unpack how the experience of dancing disappears within an institutional focus on stable, signed artworks.

In his short but influential essay "Function of the Museum," Daniel Buren critiques the mechanisms that privilege museums as arbiters of so-called "great" art. He describes how the genre of retrospectives has what he calls a "flattening effect," creating a cultural and commercial narrative in which even lesser works are given value simply by being authorized by an important artist. I would argue that the same dynamic was in effect during the Salzburg retrospective, as well as more recent exhibitions of Forti's works. Hastily drawn sketches in notebooks, programs, posters, paintings, and videos were all treated equally—cataloged, framed and displayed—even when they were made in the service of research and preparation for performance. The institutional frame served to validate the two-dimensional things on the walls and the three-dimensional equipment placed in the rooms as "art," while the videos of the performances were positioned on low tables such that they were difficult to watch (especially given the lack of chairs to sit in while watching). In an interview before the show's official opening while she was busy teaching the Dance Constructions to a group of dancers, Forti shared her perspective. "[I]t's not as much a retrospective—the show that's up now in Salzburg—as much as it's a lot of documentation of the work and a lot of really nice peripheral things that happened along the way."¹⁰

Interestingly enough, one of those "really nice peripheral things" is a series of watercolors Forti created in 1966. Not only did they hold

a prominent place on the gallery wall, but they also are reproduced in the catalog, taking up eight full-color pages—more than any of her other series. And yet, these works were not particularly significant in the overall trajectory of her career. Forti describes her reaction upon seeing them on the museum's walls.

> And I look at the watercolors, and they're really nice, but, you know, they happened in a moment. Actually, I took a watercolor class with Ron Gorchov, who's an artist, and he had this big table full of this wonderful paper. And I had no idea that paper's expensive, that paper's usually not that big. And we could just go up and take a piece of paper at any time and do something on it. And in a few months, I made those watercolors in his class. And now they have a percentage of space here, as if that was really something I was really doing.[11]

Spending time with Forti during the week leading up to the opening of her retrospective allowed me to witness her conflicted reactions to the experience. She both embraced the attention ("I've gotten used to doing stuff in a star context.") and recognized its limitations.

During the press tour of the exhibition right before its public opening, Breitwieser kept returning to Forti's associations with famous (male) artists. In a particularly heartbreaking moment, Forti was describing the genesis of her piece *Cloths* (1967) and relating how it came out of her sense that her husband at the time didn't want her around; but instead of leaving him, she just hid. (In the catalog Forti writes: "This is a piece in which no one appears.") In the midst of Forti's explanation, Breitwieser injected, "Tell them who your husband was," and then proceeded to answer her own question by commenting that it was Whitman—the "happenings guy." Seemingly unperturbed, Forti started describing her interest in animal movement a moment later, swinging her head like a bear in an extraordinary and magical animation of that beast's movement that astonished everyone present.

In our conversation, Forti made an interesting distinction between her dance community and the larger art world. She described them as two political systems and said the improvisational dance community

relies on an ethos of shared values and shared work. For instance, dancers and teachers may share the administrative burden of organizing a festival or a summer workshop. Very often there is no one person in charge of making decisions but rather a team of facilitators. Forti linked the dance community to its democratic values and open aesthetic. She contrasted this way of working with the current art world. "You've got stars and you've got a lot of people making money off of the fact that there's a star, and the star is making money. So, there's a hierarchy that has a certain function in how that whole community works. [. . .] Whereas Movement Research or *Contact Quarterly* operates on [a system in which] we can trade places, the director of Movement Research is probably a dancer, or if not so right now, it's been handed down through dancers, was made by dancers." For Forti, her innovations in movement training and improvisational performance works are exponentially more important to her legacy than the drawings. "I feel the ephemeral is so much richer, that I have offered so much more."[12]

The Museum der Moderne Salzburg is an extraordinary building. Located high up on a cliff overlooking the old city and river, it is a huge concrete space with wide stairs ascending to beautifully lit open galleries. The first gallery has a wall of windows leading out to a terrace in the back of the building from which one can see the bucolic mountains in the distance. Most of the Dance Constructions were performed daily in this gallery throughout the exhibition. When not being used, the boxes, slant board, ropes, and metal pan for *Censor* were arranged artfully, looking like an artisanal version of some Minimalist sculptures. On the one hand, these wooden shapes and loops of rope are beautifully abstract when seen against the giant windows and blue sky beyond. On the other hand, there is something fairly disturbing about a long loop of thick "natural fiber" rope hanging on the landing of the stairs, halfway up to the museum galleries. This is another inflection point between performing the Dance Constructions and leaving their empty physical sets in the gallery as minimalist "objets d'art." As I described in the beginning of the "Tuning" chapter, when Forti performed *Accompaniment for La Monte's "2 Sounds"*

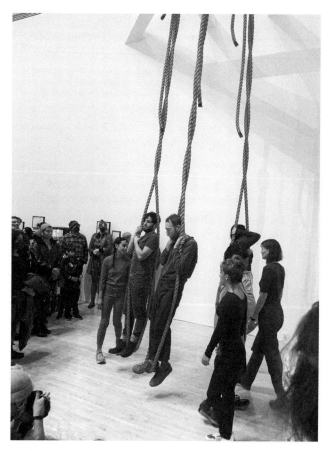

Hangers performance at MOCA, Los Angeles, 2023. Photo by the author.

and La Monte's "2 Sounds" on that landing, she held the audience in thrall as she focused so intently on listening, suspended between ceiling and floor, sky and earth. It was a remarkable experience. But looking at the empty loop hanging there throughout the whole four months evokes a different feeling entirely. One that, given the contexts of certain historical moments, can be disturbing.

Museums often highlight the Dance Constructions' connections to Minimalist art, leaving those structures in place when they are

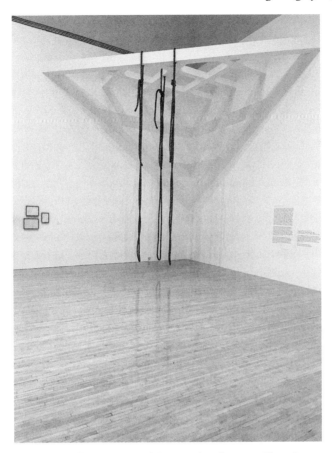

Hangers, installation view, MOCA, Los Angeles, 2023. Photo by the author.

not activated by live bodies. But how they might be inhabited can still be imagined, often in unexpected ways. Looking at the official photos from Salzburg, we can see a long, thick rope just hanging on the landing. It feels very different to look at an empty rope hanging in space than to see it when the loop at the end of it is activated in performance. Thus, I was not entirely surprised to learn that the American dancers who walked into a MoMA gallery with a similar setup of hanging ropes in 2018 were put off by the perceived unawareness that

the ropes may remind some audience members of lynchings and other racial violence in the US. It is a question of perspective. It is important for curators to see with double vision, recognizing that what at first might seem like a neutral abstract object could be read differently by a person not steeped in art history or attuned to a Minimalist aesthetic.

I experienced a similar disorientation when I entered the retrospective exhibit "Simone Forti" at MOCA in January 2023. The first gallery is a light-filled, airy, high-ceilinged space with beautiful photos of Forti by Peter Moore on the walls and two Dance Construction structures artfully arranged in opposite corners of the room. *Slant Board* is on one diagonal, and facing it across the room is the trio of ropes for *Hangers*. Visually, these objects can be pleasing in a minimalist kind of way. The ropes were hung in a triangle formation with theatrical lighting emphasizing their shadows on the walls behind them. In an interview published in the *New York Times*, Forti responds to a comment about how the Dance Constructions could pass as minimalist sculpture in the affirmative. "I'm looking at the ropes right now and I think they're beautiful. I also consider the performers and object together a sculpture."[13] Steeped in an aesthetic perspective, neither Forti nor the curators seemed aware that some audience members might see the ropes in a different light.

And yet. Given that the show in the next gallery in MOCA is a retrospective dedicated to Henry Taylor, an African American artist whose work frequently critiques the histories of lethal violence endured by African Americans in the US, it seems like an odd choice. After seeing representational paintings of Black lives (and lynchings) in the rooms dedicated to Taylor's work, I could not see the ropes in the Forti retrospective across the lobby only in terms of a Minimalist aesthetic. I am struck by how the (white) curatorial team that considers these thick ropes art objects could be blind to the blatant associations of ropes to lynchings of Black people—especially in January 2023. I realize that art institutions, particularly in America, are valiantly focusing on equity, diversity, and inclusion, and MOCA is no exception. It is wonderful to me that this art museum is free. I also recognize that the curators for the MOCA Forti retrospective

were able to hire a diverse group of performers (both racially and generationally). I am not suggesting that Forti's Dance Constructions such as *Hangers* not be performed, but I wonder how art institutions could think about the presence of these ropes in ways not sutured to the discourse of Minimalism.

In order to stage the Dance Constructions during the 2014 retrospective, Breitwieser collaborated with Susan Quinn, founder and artistic director of the Salzburg Experimental Academy of Dance (SEAD), and the dancers in the school's professional certification program. This was a brilliant move and one of the more successful elements of the 2014 retrospective. Even though Forti had not formally taught at SEAD before her July 2014 workshops, the dancers' training in contemporary improvisation afforded them the skills to really make Forti's scores into group pieces. Also, the fact that they had worked together for the better part of a year helped them give Forti's scores a level of cohesion not seen in many of the other retrospectives. I arrived in Salzburg four days before the show's official opening. When I walked into a rehearsal that afternoon, Forti had just given the eighteen or so young dancers the instructions for *Scramble*. Within minutes, she stopped giving directions and the room was filled with darting, swirling bodies, some running with a lot of momentum, others walking thoughtfully. It was beautiful to see how a wave of energy would ripple across the room as dancers picked up on one another's movement, swept up in the pleasure of catching someone's wake. Eventually, the whirling subsided, leaving just stillness, with only a few people left standing in the middle of the group.

If *Huddle* is the most famous Dance Construction in Forti's oeuvre, *Scramble* is the opposite, not quite unknown but never considered museum worthy. Developed a decade after the Dance Constructions, *Scramble* is treated as a warm-up score. (As improvised dancing that moves through space rather than on a structure, MoMA apparently had no interest in acquiring it.) Even though it was performed for an audience outside on the terrace of the Museum der Moderne Salzburg (and again in the Netherlands in 2016), the retrospective catalog does not mention it in a significant way. In his 2010 essay "The Body as

Scramble in Salzburg, Austria, 2014. Photo by Rainer Iglar. Part of the exhibition *Simone Forti: Thinking with the Body.* Courtesy of the Museum der Moderne Salzburg.

Archive: Will to Re-Enact and the Afterlives of Dances," André Lepecki conceptualizes dance reenactments as a fundamentally different kind of exchange than traditional reconstructions, and his description parallels the improvised score in fascinating ways. "[T]o understand dance as a dynamic, transhistorical, and intersubjective system of incorporations is to understand dance not only as that which *passes away* (in time and across space) but also as that which passes around (between and across bodies of dancers, viewers, choreographers) and as that which also, always, *comes back around.*"[14]

Scramble is indicative of Forti's position and generosity within a dancing community. She often says her role is to plant the seeds of a possibility, and here she gave the SEAD dancers the opportunity to engage in an improvisational structure that allowed them to move and grow together. It was a special gift—initiated by Forti, but ultimately not controlled by her—and their dancing showed their fulsome ap-

Scramble in Salzburg, Austria, 2014. Photo by Rainer Iglar. Part of the exhibition *Simone Forti: Thinking with the Body.* Courtesy of the Museum der Moderne Salzburg.

preciation of its myriad potential. In this sense *Scramble* realizes the economy that Lepecki attributes to reenactments: "They make dance return, only to give it away."[15] I felt as if the dancers were more fully in their bodies in that warm-up score than in some of the Dance Constructions, even though they spent more time learning the latter. Unlike *Huddle*, which is firmly canonized as Forti's signature piece from the 1960s, *Scramble* reflects what Forti calls her "lust for moving" that exploded out of her in the 1970s. It also evokes the powerful range of Forti's dancing life. In his short essay for the retrospective catalog, Morris writes: "Over the years it seems that for her there were down times, singing times, gardening times, solitary times, dry times, Tai Chi times, some good times, close animal observation times, mourning times, and then returning to movement times, returning to moving and speaking and thinking."[16] Out of all these times came abundant dancing. The critical question is how to acknowledge all of

that dancing, to find a place in Forti's legacy for the more abundant, spontaneous, improvisational movement in order to counterbalance the institutional focus on her Dance Constructions.

Many European dancers were first exposed to American experimental dance, especially investigations in improvisation as a performance form, in the late 1970s and the early '80s. Dancers in France embraced the aesthetic of John Cage and Merce Cunningham early on. For instance, the 1979 Festival d'Automne à Paris presented the Merce Cunningham Dance Company, Lucinda Childs's collaboration with Philip Glass and Sol LeWitt, Deborah Hay, and the Trisha Brown Dance Company—all in the same season! This same generation, many of whom spent time dancing in New York City, were enamored with Judson Dance Theater and dove into contact improvisation. Forti was able to ride this American wave to Europe, as well, eventually teaching regularly in schools such as the Center for New Dance Development and the Theater School in Amsterdam, as well as the Centre nationale de la danse in Paris, where a Nuit Blanche tribute was held for her in 2000.[17] Also in 2000, *Nouvelles de Danse*, a dance journal produced by Contredanse in Bruxelles, published a French translation of Forti's *Handbook in Motion* (*Manuel en mouvement*).

Forti's unique combination of curiosity and generosity in her workshop format was (and continues to be) a much welcome respite from the highly technical and often competitive focus of much dance training in Europe. In addition, her history of working with improvisation as both a compositional and a performance form brought a new perspective to many dancers interested in dance's role in the experiments of the 1960s and 1970s. In an interview, Claire Filmon, a French dancer, and one of several people assigned by MoMA to be responsible for restaging future Dance Constructions in Europe, spoke of how dancer Agnès Benoit had encouraged her to take Forti's Logomotion workshop in 1999 and how it introduced her to a new realm of dance improvisation. In the decades since, Filmon has collaborated, performed, and taught with Forti and continues to teach in a manner influenced by Forti's approach to moving and speaking.

Although he first met and danced with Forti in the US, David Zambrano has been living and teaching all over Europe for most of the twenty-first century. He, too, has been deeply influenced by studying and performing with Forti, and especially by her improvisational group scores such as *Scramble*.

Forti is known as a wonderfully supportive teacher and an innovative performer in the US, as well. Her workshops have informed generations of improvisers, and her scores are passed on as a bodily equivalent of an oral tradition. She has taught at popular summer festivals such as American Dance Festival, A Cappella Motion, and Bates Dance Festival, as well as in colleges and universities across the country. And, as noted in a previous chapter, she was a major force in the founding and development of Movement Research, Inc., a dance organization dedicated to just the kind of improvisational and experimental art making that is Forti's raison d'etre. In December 2016, Danspace Project and MoMA's Department of Media and Performance Art sponsored a weeklong Research Residency with Simone Forti to explore how to think about live reenactments as a method of keeping an artist's dance legacy alive.[18] One participant, Talya Epstein, commented on how familiar the structures of Forti's classes felt. "This type of training feels like the building blocks for a contemporary embodied experience." She describes that first day:

> We stand in a circle. We breathe. We follow Simone as she guides us through a qi gong [*sic*] based warm up. We hold hands and do leg swings. We disperse into walking around the room are told to find the spaces between bodies and move through those. This situation, which Simone calls a "scramble", [*sic*] finds its own pacing and rhythm based on the specific people in the room. She gives us all the space and time so that our group dynamic can unfold without too much outside meddling.[19]

Molly Lieber, another participant in the same workshop described her experience of encountering the powerful blend of movement material and the historic legacy of *Huddle*:

When doing *Huddle*, I felt safe in her assuredness. I was in a
big huge clump with half dancers I know and half I didn't and
I knew it would work, because the dance has been happening
for so long. So really it felt like the dance didn't depend on me
doing it at all, but that it had already been happening and I was
just stepping into it for a moment and feeling it. And it was still
amazing to me, that people I didn't know could climb over me
in this gentle context.[20]

Having acquired the Dance Constructions a year earlier, MoMA
curators were hoping to create a formative liaison with a dance com-
munity that also valued Forti's legacy. They envisioned that this re-
search residency was a way to understand the implications of live,
body-to-body transmission of the Dance Constructions, and it was
"intended to provide a platform for Forti to work closely with groups
of dancers or teachers who are to communicate the dances to new
performers or participants."[21] The official press statement describes
the goals: "During the weeklong residency, Forti, invited guests, and
the public will engage in discussions and workshops to ensure that
this work is brought to the dance community and the new generations
who will carry it forward." Judy Hussie-Taylor, executive director and
chief curator of the Danspace Project at St. Mark's Church, credits the
many conversations between Forti, The Box director McCarthy, vari-
ous MoMA curators, and herself with helping to understand (at least
theoretically) how to try to preserve the sense of context and original
connection to practitioner communities, even as an art institution
formally acquires the work.

There are, of course, material limitations in these situations. For in-
stance, many of the Dance Constructions require built equipment (*See
Saw, Slant Board*) or functional rigging (*Accompaniment* and *Hang-
ers*) that were impossible to accommodate in the studio space at St.
Mark's. Then, too, the research residency encompassed two streams
of inquiry that fit together a bit awkwardly. On the one hand, Forti
was teaching her Body Mind World workshop, through which she
was interested in cultivating "a natural and intuitive flow between our

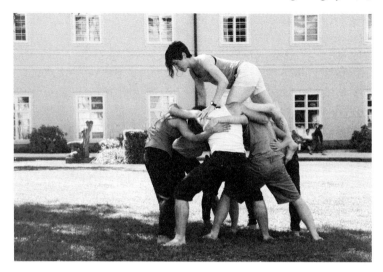

Huddle in Salzburg, Austria, 2014. Photo by Rainer Iglar. Part of the exhibition *Simone Forti: Thinking with the Body*. Courtesy of the Museum der Moderne Salzburg.

moving and our speaking." As in the 2013 Portland, Oregon, weekend workshop, she was hoping to create the ground for getting "in touch with our wild thoughts, questions, observations." The last line in her workshop description is crucial in understanding Forti's pedagogy: "By letting our body intelligence and our verbal mind interact, we will access a fuller view of our world, both personal and collective." [22] Although she did teach *Huddle* to the participants, the point of the workshop was not only to reconstruct her Dance Constructions or to focus exclusively on her early work. It was to understand her ongoing legacy as an artist.

Simone Forti has long called *Huddle* a sculpture and a dance and prefers that it be performed in situations where the audience can walk by it and around it, like a sculpture in a gallery rather than a dance performance in a theater. Very often, however, *Huddle* gets staged (as in PAST*Forward* and at the Geffen) in such a way that the audience passively sits and watches it. Understandably, Forti's description of the dance has changed over time, as has the piece itself. In her most recent

oral history interview (with MOCA associate curators Alex Sloane and Rebecca Lowery), Forti describes how in the '70s they used to just run at each other and jump onto the human mountain, climbing over and coming down any which way.[23] The shift from a more fearless to a more cautious, somatically aware approach is evident when comparing Huddles from 1974 at the Sonnabend Gallery, 1986 at the Yellow Springs Institute, and 1996 at A Capella Motion with the more recent restagings of the work.[24]

When Forti described *Huddle* in *Handbook in Motion,* she did not use the word sculpture, but she did note that in the original performance "each of the performers found six other people from the audience to get a second-generation huddle going until six were happening simultaneously" (1974, 59). In preparation for the MoMA acquisition, Forti wrote a more elaborate statement in 2011. She begins: "Huddle is a dance construction. It is an object which does not exist in a solid sense, but can be reconstituted at any time." Later in her statement, she specifies its life in two distinct artistic communities.

> To the world of the visual arts *Huddle* is conceptual and architectural, a work born fullfledged [*sic*] as an idea. Its material is a group of people. The action is right there to be seen, without refinement or stylistic filters. Perhaps, in the art world, it is understood primarily from the point of view of the viewer. To the dance world, as dance has developed in the subsequent years, it is primarily experientially somatic and social, more from the point of view of the participant, where even the viewer identifies with the participants and feels the experience through them. I think that at the time I made it, I saw it, felt it, in both ways.[25]

In her workshops, Forti explains the historical context of the early 1960s by talking about how artists working in different media interacted, socializing together and taking part in one another's work. They were exploring a mutual rethinking of conventional approaches to visual art, music, and dance. Her framing of *Huddle*'s dual perspectives was particularly emphasized in the weeklong research residency cosponsored by the Danspace Project and MoMA. Lauren Bakst, another participant in this dive into Forti's legacy, describes her ex-

perience of *Huddle*, making a distinction between "what it looks like" and "what it feels like."

> *What it looks like*: While watching others "huddle,"—the title functions as both a noun and a verb—I zoom in and out from micro to macro. I notice the adjustments of one foot in relation to another. I notice an arm wrapped around a back, the texture of shirt fabric under a hand. I notice what I'm seeing and also what I'm not—I'm not seeing the fronts of bodies; i.e.: I don't see faces. So instead of seeing parts that belong to specific individuals, I'm tuning into parts that belong to some kind of disjointed whole. If I blur my focus, I see an organism in an ongoing process of expanding its shape and returning, expanding and returning. But if I snap back, I find my gaze is present with the negotiations and constant re-organizations of the group as each member works their way around, up, and over only to return to the huddle again.

> *What it feels like*: Inside the huddle, it is dark. I have one hand wrapped around the back of the person next to me and another on my thigh. Our heads are all pointed toward the center, creating a shadowed enclave. It is hard to know exactly what is happening at any given moment. We are constantly adjusting, constantly ready—ready to support weight or anticipating our own path away from the center of the group, to move around, up, over, and return. I feel the support from the floor coming into my feet, and the tension between the sides of my body and the person's next to me. I am aware of my breath and the breath of those around me. We lean into each other to create a foundation, and at the same time an invisible energy force is being created in the space between all of us. I feel the weight of the group shift to negotiate each person who makes the climb, and I toggle between connecting to the strength of the group and the vulnerability of making the journey or of holding someone else's weight as they do the same. In the huddle, I'm not really thinking. I'm just doing.[26]

Although Forti may consider *Huddle* both a dance and a sculpture, it is critical to recognize that, while not mutually exclusive, these terms carry very different weight in the art world. The more the Dance Constructions are associated with Minimalist sculpture and with artists such as Morris, the more they become items with a monetary value and, therefore, property to be collected by an art museum. But this economy is contingent on maintaining their object status. This happens most often by diminishing the improvisational, communal aspects that are essential to their value as dances. Experiences such as the weight, breath, invisible energy, and vulnerability described above are not the terms that art institutions typically use to identify the work. Unlike the other Dance Constructions, whose equipment— rope, plywood, metal—remains in the gallery as abstract objects with Minimalist aesthetics, *Huddle* disappears after ten minutes. This vanishing, so typical of dancing, is perplexing to institutions that focus on art that maintains its status as object throughout the years.

Nonetheless, in purchasing the Dance Constructions, MoMA assigned a monetary and historical value to Forti's early work, much of which is based on its connections to Minimalist art and the development of postmodern dance. Regardless of specific curatorial predilections or goodwill, the institutional requirements are structured such that the museum needs to understand *what* it has bought. Thus, in the process of identifying, acquiring, and conserving the Dance Constructions, the museum's formal apparatus significantly changed the nature of the works' existence. In an interesting turn of phrase, one internal memo asks: "What is the current state of documentation/ fixation of the works, or is it up to us to create that, and if so, have we budgeted for the expense?"[27] Unlike improvisational approaches that are flexible enough to accommodate very different performative solutions, the museum needs to collect some*thing* that will continue to look the same (or at least be identifiable) over time. Herein lies the rub: This friction between inside and outside, living experience and historical form, choreographic concept and improvisational enactment is particularly (and intriguingly) fraught in the case of *Huddle*, which has no form outside of its performances. As Forti proceeded

through the process of describing and documenting that improvisational structure, the original open-ended instructions became increasingly defined directions, in which the *what* of the dance was further articulated (for better or worse) as a *how* to do it. In the artist interview with MoMA, Forti mentions that the acquisition allows the piece to have a life after her own life is over. She also mentions that the elaborate package of materials—teaching videos, her descriptions, historical photos, notebooks, and interviews with her—will help ensure that all of the Dance Constructions will be performed correctly.

Over the course of acquiring the Dance Constructions, MoMA received a handwritten and signed document from Forti entitled "Handwritten draft of Huddle Performance." In her 2018 dissertation documenting MoMA's acquisition, Megan Metcalf uses aesthetic philosopher Nelson Goodman's "allographic" and "autographic" categories to distinguish between, respectively, works such as musical scores and instructions that can be enacted by others, and original artworks such as paintings and sculptures that are singular and unique. Autographic art is tied to an artist's signature, both as the representation of their identity and as the stylistic traces that make their work recognizable and therefore valuable. Metcalf interprets this curious document, which Forti wrote in pencil on archival paper as a kind of certificate of authority—an artifact that remains in MoMA's collection when the dancing is over. It signals MoMA's ownership of a work that has lived in many communities and passed through many dancing bodies for more than sixty years.[28]

In a special issue of *Dance Research Journal* called "Dance in the Museum," published a year before MoMA officially acquired the Dance Constructions, Claire Bishop critiques (echoing Buren) the "one-way" traffic when dance enters the museum, writing that this is "always on the museum's terms." "[D]ance animates the galleries of the museum, but ultimately the museum flattens and homogenizes our experience of dance."[29] Bishop notes how "irresistible" the status of places such as MoMA is and how choreographers and dancers embrace inclusion in an exhibition as an indication of having arrived in the art world. But oftentimes they are sorely disappointed, especially

when museums do not have adequate facilities for warming up or or changing costume. As Thomas DeFrantz so vividly puts it in his essay in the anthology *Curating Live Arts: Critical Perspectives, Essays, and Conversations on Theory and Practice*, "In the museum, dancers are expected to be available with the nearness of strip-club go-go performers, with the intimacy of family and a loving encounter."[30] For Forti, MoMA's acquisition of the Dance Constructions signaled her shift from being in the shadow of Morris or being a footnote in the history of Minimalism to occupying center stage as an artistic innovator of many forms. Danspace Project executive director Hussie-Taylor applauds this critical recognition, welcoming the influx of resources that a big museum can bring to dance.

Athena Christa Holbrook begins her short essay "Second-Generation Huddle: A Communal Approach to Collecting and Conserving Simone Forti's *Dance Constructions* at the Museum of Modern Art" with a question: "What is collected when a museum collects performance?"[31] As a specialist in MoMA's Department of Media and Performance Art from 2015 to 2020, Holbrook spent years thinking about the unique challenges of preserving performance, including how to stage their live activations. What she found over the course of working with the Dance Constructions is that the assorted documents and ephemera—sketches, descriptions, videos of performances and rehearsals, interviews with the artist and teachers, etc.—revealed important trace elements of the original pieces but not the impact of their live performances. Her ideas about collecting performance radically shifted when she had the opportunity to participate in learning the Dance Constructions as part of the "Here It Comes" exhibition of Forti's work in 2016 at Vleeshal Markt and Vleeshal Zusterstraat in Middelburg, the Netherlands. Although she went to document the process from the outside, she was invited to learn the pieces from the inside. She found that this embodied perspective dramatically altered her views.

In her essay, Holbrook contrasts her "experience as documentarian" with that of "her experience as performer" in ways that mirror Bakst's distinction between "what it looks like" and "what it feels

like." Sentences such as "performers take turns separating from the group and climbing onto the mass, pulling their body across the top to the other side where they then rejoin the group" become saturated with another kind of knowing. "I felt an overwhelming sense of the communal body, a sense of boundless unity wherein the delineation of one's own body and another's gradually faded into a collective continuity experienced only in the most intimate of gestures."[32] Unusually for an administrator, Holbrook drew on her earlier experience in dance to absorb the embodied knowledge at the heart of these works. She continues: "In stepping into the role of performer, these performances have become part of my physical memory—I am both archivist and archive, documentarian and documented, a vessel for receiving movement and for transmitting it."[33] Interestingly, this new embodied perspective is not simply another neutral layer of information, for it forces her to reevaluate some of the institutional mechanisms from the point of view of a participant—as someone who was profoundly affected by its live enactment. Thus, she concludes, "Perhaps we have to redefine our understanding of ownership and institutional boundaries, shifting preservation from a private practice to one of public engagement."[34]

This shift from property (art as object) to public engagement (art as event) is reflected in Forti's choice of the term "guardian" rather than "owner" when she speaks of MoMA's acquisition of the Dance Constructions. Before she signed the papers, Forti spent years in conversation with The Box's McCarthy, Danspace Project's Hussie-Taylor, and MoMA associate curator Jenny Schlenzska, curator Ana Janevski, and chief curator Stuart Commer, crafting the terms of MoMA's stewardship. These include details about how often they will be displayed and who constitutes the group of trained teachers, overseen by Forti's longtime colleague Sarah Swenson, who is MoMA's project coordinator for reconstructions. Unlike artworks that may cost a lot to acquire but considerably less to maintain, the Dance Constructions require a considerable investment in time and people to bring to life.

At the time of their acquisition, MoMA curators had discussions about setting up an endowment to fund the periodic workshops and

performances required to maintain the pieces' status as living art. In this sense, it has been a wonderful boon for both MoMA and the Dance Constructions that there have been so many loan requests from other institutions. Holbrook estimates that, in the five years following their acquisition in late 2015, there have been close to a dozen requests for some or all of the Dance Constructions. Loans, then, have become a part of MoMA's conservation strategy. (Covid-19, of course, significantly interrupted this kind of exchange.) Holbrook notes that "the lending frequency has actually been really beneficial for the Dance Constructions and it's a way [. . .] to continue engaging with them in an active way and to continue to have performers all over the world learn them and kind of perpetuate that knowledge."[35] Calling this process a "living archive," Holbrook concludes her essay by asserting: "When a museum acquires live performance, they may collect a range of materials, instructions, and rights; but most importantly, they inherit the great responsibility of collective embodiment, of hosting memory and movement within the institutional body itself."[36]

The utopian promise of body-to-body transmission embedded in MoMA's acquisition of Forti's Dance Constructions was profoundly tested during the ambitious "Judson Dance Theater: The Work Is Never Done" show, which ran from September 16, 2018, through February 3, 2019. For four and a half months, five Dance Constructions (*Accompaniment for La Monte's "2 Sounds" and La Monte's "2 Sounds," Censor, Huddle, Platforms,* and *Slant Board*) were performed three times a day, three times a week. All of these bodies—the contemporary bodies hired to stage the "body" of Forti's early work, the institutional body (both the literal space and the figurative place of culture), and the bodies of visitors in the galleries—made for a thick stew of multiple and sometime competing needs. Unlike the performance programs dedicated to Judson Dance Theater artists Rainer, Paxton, Gordon, Childs, Hay, and Brown that ran for only one week in the huge atrium space, Forti's Dance Constructions were staged in one of the galleries dedicated to providing context for the development of that downtown scene. This meant that visitors were often milling about, strolling through, talking, and often not particularly aware of

what was happening, especially during the quieter pieces like *Platforms*, when I found that the whistling got lost amid the cacophony of other sounds. (In an interview Holbrook acknowledged that they had considered miking the boxes but decided against it.) In between performances, the structures remained in the space as latent objects activated only by visitors' imaginations.

I saw "Judson Dance Theater: The Work Is Never Done" at the beginning of its run and again towards the end. Each time, I stayed to watch at least two full renditions of each of the Dance Constructions, trying hard not to compare these performances with those by the SEAD dancers. Although MoMA does an open call for performers to audition, it also tends to have a group of professional artists that it uses periodically when performances happen in the galleries. Despite generational and other differences of background, all of the performers seemed to embody a specifically downtown, NYC cool demeanor, rarely smiling or even looking out at the audience. The performers entered the space from a door in one corner of the gallery and began with *Huddle*, the only Dance Construction in which they all participated. Once *Huddle* was finished, a few would break off to perform the other constructions while the rest watched. Sometimes the museum visitors would also stop to observe; other times, they hurried through the space, as if they didn't want to interrupt. Although there were texts on the walls that explained each Dance Construction, they were not verbally introduced, nor was the audience clear about whether or not to clap as each piece dissolved into another. In fact, the first day I was there, the only time anyone applauded was when two young men performed *Censor* as a powerful and thrilling sonic competition.

Nonetheless, by the end of the show, the Dance Constructions had become pretty stale, and even the curatorial staff checked their phones throughout the performative reenactments. In discussions with some of the dancers and a curator, it became clear that much of the earlier magic had gone and that the constant repetition of these improvised scores had rendered them body- and mind-numbing. In reference to Simone Forti's 2016 solo exhibition with performances in Middelburg,

the Netherlands, Emma Paza noted how museum acquisitions of experimental performance can alter the terms of their engagement, creating an "objectification" of the performers. She writes in the online journal *Metropolis M*: "Repetition nullifies the moment of concentration at the core of a piece in order to fit the structure of a collection."[37] For the performers, the difference between an experience of being "witnessed" as part of a group energy and that of being "watched" as part of a museum show is profound.

As scored improvisations from the early 1960s, the Dance Constructions waver between event and artifact, process and product. Although these historic constructions need to be enacted such that they resemble the original pieces, they also need to be refreshed from the inside, opening up the possibility of entering anew each time. As Swenson discusses in her online essay "At Work with the Dance Constructions," ". . . the Dance Constructions all possess certain characteristics in common, yet each has a distinct quality, intention, and origin: a dream, a memory, a yearning [. . .] And each one of the Dance Constructions requires a different physical skill set, while they all demand a certain demeanor, body awareness and energy—all anchored in the firm intention to stay present."[38] The discipline required to "stay present" in improvisation, to stay available to the experience you are having and not the one you had last time are aspects of the Dance Constructions that are often overlooked within institutional contexts interested in a live facsimile.

During a conversation with Bryony Gillard and Louis Hartnoll held at the end of her "Here It Comes" show in Middelburg, the Netherlands, Forti debunks the notion that improvisation is just a free-for-all.

> Improvisation is very rigorous because you're working with ideas. I think there's a common idea about improvisation, but as I listen to your question and I do what I need to do to give a good answer, I'm improvising. So, I'm calculating, figuring out, sensing the situation, keeping in mind what you need. There are a lot of elements that go into it, whether I'm improvising in an interview or dancing.[39]

In order to keep these dances alive and not just mechanically reconstructed, the performers need to give up expectations and give themselves over to exploring the unforeseen.

Of course, rigorous improvisation looks very different than technical dance. When Swenson trains dancers in the Dance Constructions, she emphasizes leaving the ethos of technical virtuosity behind, asking the participants to just do the action or accomplish the task at hand, albeit with a compositional awareness of what others are doing. The physical presence of the performer needs to be directed but not automatic. Only by staying available to the improvisatory potential can the performers realize the broader implications of these works.

For Holbrook, Forti's Dance Constructions foreground the nuances of meaning within these kinesthetic exchanges.

> Though simple in instruction and subtle in execution, the Dance Constructions contain a multitude of latent, intuitive qualities made manifest in the bodies and interactions of performers as they carry out their tasks. From these understated actions emerge the tensions of many dualities—the individual and the collective, presence and absence, motion and pause, structure and improvisation, struggle and repose—tensions which performers must mindfully balance without veering into an overdetermined performativity."[40]

In order for these kinds of details to become affectively visible for viewers, the participants need to commit themselves to the potency of improvisation as a ritual that can move simultaneously forward and backward, both reinvigorating the past through the present and allowing for the past to illuminate current circumstances. Insisting on this imaginative process encourages, in the words of art historian Meredith Morse, "not only replay but reinvestment."[41]

Yvonne Hardt's contribution to *The Oxford Handbook of Dance and Reenactment* begins with a question: "How can one reconstruct an improvisation?"[42] While she is specifically discussing an educational reenactment of Rainer's score for *Continuous Project-Altered Daily* within her university, her comments apply to other kinds of improvisational reenactments, especially those with a similar aesthetic. In

answering her own question, Hardt responds, ". . . one starts from the perspective that in reenacting a work that is improvised, the goal is less to recreate an ostensibly historical object by realizing the score, than it is to work with and through the score as a field of potential."[43] Taking a cue from Hardt, we can look at reenactments as sites of reflexivity, critique, and meaningful engagement with the present. This is not to deny the crucial importance of the historic, cultural, and aesthetic contexts of the past, nor do I presume that improvisation necessarily refreshes itself in an eternal present. Nonetheless, contemporary enactments of improvisational scores from the 1960s can still provide a platform for new negotiations, awarenesses, and discoveries, even as they honor past lives of their existence.

Ethan Philbrick provides a case in point in his 2018 essay "Huddling, Then and Now: Simone Forti and the Nonsovereign Collective." He frames the physical act of huddling and Forti's 1961 score *Huddle* in terms of their ongoing social and political potential as "a relational form of disorderly proximity."[44] Philbrick was a dancer in the 2016 "Body Mind World" workshop with Simone Forti, cosponsored by the Danspace Project and MoMA. As part of that workshop, he learned *Huddle* and *Scramble*, and he experimented with moving and speaking. A graduate student in the Department of Performance Studies at New York University at the time, he immediately connected the physical experience of supporting and being supported (with all its attendant awkwardness and struggle) as a "nonsovereign collective practice."

> Huddle is a score that asks a group to make a provisional, leaderless collective form that is constantly differentiating, entangling itself while also fragmenting. Unlike scenes of group formation that are about merger, cohesion, or the desire for a static collective frame, huddling is an impulse to split off from the inherited collective forms of politics and art and experiment through the creation of small nonhierarchical assemblies that disassemble just as readily as they assemble.[45]

The larger context of his exposure to Forti's work was the 2016 presidential election and subsequent fear and anxiety about the next four

years, as well as communal acts of resistance, starting with the world-wide Women's March the day after President Donald Trump's inauguration. Shortly after participating in that march, Philbrick taught a small group of his friends *Huddle*. After three separate run-throughs (the last two with music), the friends spoke about the weightbearing (sometimes painful) and interpersonal navigations of the score. One friend declared, "at its more pleasurable moments it was a moment of collective massage and support: kneading and needing."[46] Others were less enthusiastic about the forced intimacy. These insights were foregrounded in the coincidence of an extraordinary invitation that arrived in his inbox: "First, we marched. Now we HUDDLE. Gather your community and plan what's next."[47] Connecting the physical act of huddling with the political act of coming together in small groups, Philbrick articulates how this historic score became newly relevant for him.

> Forti's *Huddle* offers a way to practice cacophony, incoherence, and leaderlessness while coming together and finding provisional modalities of support and entwinement. It is a huddling together that falls apart so as to spawn more huddles. It is a score that doesn't attempt to last but is infinitely repeatable. [. . .] It is a score to practice what a nonsovereign collective formation might feel like—a headless, tumultuous entanglement; a corporeal planning session."[48]

Whether in a private conversation or in a public forum, Simone Forti often connects changes in her life with changes in her work. She relates a story about the time a friend gave her some sage advice: If you want to find a new direction for your work, you need to change some aspect of your life. Leaving Reed College and moving to San Francisco in the late 1950s brought her into a new world of professional artists, including her mentor, Halprin, and Halprin's husband, Lawrence Halprin, an environmental designer and landscape architect. Moving to NYC precipitated another shift in her work as she met her "need" to stage simple, task-like actions, eventually creating the Dance Constructions, among other things. Leaving NYC after a

difficult breakup with Whitman, her second husband, she traveled to Italy, where she spent time in the Rome zoological garden, Bioparco di Roma, and began her animal movement studies. After experiencing Woodstock and spending a year participating in a nomadic, hippie lifestyle, she had a stint at CalArts and studied Tai Chi with Marshall Ho'o. California gave her the space to experiment with circling, and she met her longtime collaborator Charlemagne Palestine. Moving back to NYC, she began an intense personal and professional relationship with musician Peter Van Riper. Eventually, she made her way up to Mad Brook Farm in Vermont (again as a method of resetting her life and work), translating her desire to spend more time in nature into Simone Forti and Troupe's land portraits and her own solo "gardening journal" improvisations. Sometimes these larger transitions in her life and work were the result of a conscious choice to make a change; other times, she felt they were the only option left.

In 1998, Forti made a final move when she returned to LA to care for her aging mother, who lived to the age of almost one hundred. By the time she died, Forti was once again firmly ensconced in LA. As she quips these days, "LA has been good to me." Not only did she land a regular gig teaching at UCLA (where she first met one of her main collaborators, Carmela Hermann Dietrich), but she also introduced her Logomotion materials in a series of workshops at the Church in Ocean Park located in Santa Monica. Through these sessions, she connected with other artists, including Terrance Luke Johnson, Swenson, and Douglas Wadle, with whom she formed the ensemble "The Sleeves." She also met Fred Dewey and became involved with his organization Beyond Baroque, eventually publishing her memoir *Oh, Tongue* with them. In addition, she reconnected to artist Dorit Cypis who had seen Simone in Halifax, Nova Scotia, when Cypis was an undergraduate studying at the Nova Scotia School of Art and Design.[49]

While all these new friendships were supportive and inspiring, perhaps the most significant relationship in terms of her artistic legacy was with The Box's director, Mara McCarthy. When they met in 2009, McCarthy had recently started her own art gallery and was

interested in branching out and hosting performance events and live installations, as well as art shows. Introduced by mutual friend Fred Dewey, McCarthy and Forti instantly hit it off and started talking about the possibility of working together, deciding on an exhibition format and performances by "The Sleeves" the week before its opening. Their first collaboration was "Work in a Range of Mediums" which ran from June 27 to July 25, 2009. In our interview, McCarthy recalled how they connected ("it's always been a very sympatico relationship"), attributing some of that chemistry to the fact that their birthdays are only four days apart and that they are both Aries.[50]

The show became a mini-retrospective of sorts, with work from the 1960s to the mid-2000s. Its inspiration may have come from Forti's move back to LA after a long career on the East Coast, or from the experience of sorting through boxes and recollecting what had been in storage for so long, or from entering her mid-seventies. Videos and photos of performances lined the walls, keeping company with drawings, paintings, notebooks, and a hologram, as well as the *Face Tunes* machine (invented and constructed by Forti in 1967). In designing the show with Forti, McCarthy was struck by how engaged and thoughtful she was about the placement of the show's different elements, particularly the basement space that gave a darker, more melancholy sense of mystery to the works there. McCarthy described Forti's ability to "curate" the space such that these images from different times fit into a fuller narrative of Forti's life. "[B]ut then to put those pieces together they did something together that they wouldn't have done separately, and it was really powerful. [. . .] She's just actually someone that can see what it should feel like in the space."[51]

In a review published in *Artforum*, Natilee Harren expresses beautifully the underlying link between all these disparate media: "Forti's work explores the limits of physical relationality, with the body imagined as a kind of tuning fork to the world."[52] The work in that show ranges from nostalgic lyricism of the early watercolors to biting social commentary in the News Animation performances on video. The flickering colors of the 1967 hologram *Angel* and the 1966 Baby paintings, as well as the abstract black marks of pigeon movements in the

1984 series "Great Thanks, Empty Hands," suggest traces of the past, ghostly tracks that gesture to the loves and losses of another time.

If "Work in a Range of Mediums" collects significant work from the past, many of the later shows at The Box, including "On an Iron Post" (2015) and "Time Smear" (2018), focus on Forti's more recent performance and video work. McCarthy initially aimed to make her gallery a platform for "underrecognized" artists, many of whom are women. Her astute culling from Forti's archives and formal representation of her Dance Constructions provided much of the groundwork for other galleries' and museums' larger exhibitions and acquisitions of Forti's work, both performance-based ones and drawings, holograms, etc. For instance, in 2011 The Box sponsored an archival video of all the Dance Constructions, including footage of Forti teaching them to UCLA students. This video was an important part of the materials MoMA initially collected. The Box helped Forti find the personnel and the motivation to organize her archive (which eventually was acquired by The Getty Research Institute) with an eye to its historical and monetary value. All in all, working with a professional art gallery—one that also attended to her writing and hosted live performances along with exhibitions—gave Forti the support necessary to launch herself onto a much larger global art platform. Forti knows this and is touchingly grateful, remarking in a casual conversation that she decided to sell her work not so much because she needs the money but because she knows it will support the gallery financially.

This kind of reciprocal arrangement allows for a bridging of art-world economics with dance-world exchanges and has helped Forti secure her legacy in her own indomitable way. Because life and art are so intertwined for Forti, her relationships with her helpers and collaborators are also very intertwined, the artistic blending easily with the social and emotional strands of her life. Forti attended Zanbrano's wedding as a "mother" of his choosing; Swenson, who has learned many of Forti's key solos, tends to her and to her work. This blending of roles is especially true of her relationship with Jason Underhill, who has been her administrative assistant since 2010 and a collaborator on various videos, and who will, in the future, be the Trustee of the

Simone Forti Art Trust. Underhill describes his presence shooting videos as a kind of witness to Forti's site-specific performing. "Filming her is like listening to music, you're just actually listening to what her body is doing."[53]

The show "On An Iron Post" opened on November 14, 2015, a month before MoMA formally acquired the Dance Constructions. Forti performed a News Animation at the opening reception. Although there were some smaller pieces of art, such as a metal sculpture that she had designed in 1961 that was finally produced in 2015, the major focus of the exhibition was video. There were videos of performance works such as her troupe's 1989 performance at Wave Hill called *Touch*, as well as two recent collaborations with Underhill, *Zuma News* (2013) and *Flag in the Water* (2015). Filmed in high-definition (HD) video format, these two screendances were projected on facing walls. Entering the large, darkened gallery space, one was surrounded by larger-than-life images of Forti grappling with newspapers in the Pacific Ocean or fabric in the Mississippi River. These impressive bodies of water took viewers beyond the moment of actual filming to mark a mytho-poetic sense of space and time. In the videos, as Forti attempts to keep the water-soaked newspapers in place or repeatedly dips the heavy fabric of the hand-painted flag in the river's current, her immediate experience of the task at hand is layered with the ongoing flow of the water.

The press release for "On An Iron Post" is a "Dear Father" letter. After telling her father about the very good wine she is drinking, she tells him about the exhibition. "The show's got lots of parts, like a day of experiences with different energies, lyrical, abrasive, adding up to something complex but without closing in on any particular meaning." In response to the unusual format of the press release, writer Andrew Berardini chose to fashion his review of the show as a letter, as well.

Dear Simone,

Your performances are the jump and splash of a brook, the color of a found leaf, a painted flag wrapping a woman as the river

dances around her. At 80, your nimble movements inspire. [. . .]
And here, for me, that is what your exhibition is about: flow.
The flow of water, of human events writ large, of time, of pure
movement. [. . .] And when I spent those hours in your show,
watching your performance at the opening, and all the passing
moments and stories in the videos, the flow of all that water and
time, everything looked like movement. The flowing brook over
stones, the color of a found leaf (did you catch it falling or was it
plucked from a rustling tree?), the flow of the river, and the shift
of the cloth of the flag. All of it movement and all of it moving.[54]

A year later, Forti and Underhill collaborated on a third video,
A Free Consultation (2016). They filmed this on the banks of Lake
Michigan in the dead of winter. Instead of moving with flowing water,
Forti crawls across chunks of ice, the sound of the wind competing
with the voices and static of the radio she carries in her hands. The
video was shot in one take, with every little editing. The opening
shot of the seventeen-minute HD video shows Forti, in black hat and
leather jacket, lying down on her side on a bed of rocks. The camera
zooms in on her face and hands. We see the age marks on her face,
the shaking of her hands. It is cold.

Forti tunes the radio to a talk station and proceeds to collect rocks
in a pile, choosing them somewhat randomly and yet placing them
with care. Eventually, she begins crawling slowly on her belly along
the icy rocks, past a large piece of driftwood, towards the lake shore.
The image of an older woman with a shaking head and hands crawling
on rocks and ice is tough to watch, frankly. And yet, this vision of age
and frailty is weirdly offset by the perky voice on the radio advertising
"a free consultation" for laser eye surgery. This contrast between the
static reception of a talk-radio station and the vulnerability of Forti's
struggling body resolves in one strikingly poignant moment about
halfway through the video. As Forti rolls onto her side, the camera
backs away to reveal the open expanse of rock, ice, lake, and sky. The
sound of the waves and the crunching of Underhill's footsteps on the
ice provide a sonic background for Forti's movement. She pulls herself

to her knees as the camera swings around to frame her profile, and we see her chin and hands quivering in tandem. It is a potent image of human survival amid a bleak and forbidding landscape, making it hard not to feel the impact of its existential dimensions—age as the winter of life.

Four years later, during the spring 2020 Covid-19 lockdown, Simone Forti emerges like a phoenix with a series of abstract paintings and a selfie that went viral. "Fire Bags Drawings" are a series of paintings on the ubiquitous paper bags that were a result of having her groceries delivered to her house. These ludic images (one of which includes her iconic crawling reptile figure) come from an artist whose creativity and curiosity are still finding their way in the world, despite various restrictions and the challenges of a degenerative disease. In an interview with MoMA curator Janevski, Forti explains:

> I was accumulating all these bags and wondering what to do
> with them. The idea of cutting them open and drawing on them
> just came to me and I felt right away that it would be beauti-
> ful. The color of the paper, the shape, the familiarity. And the
> context of the historical moment, a time to make do with what's
> already in the house.[55]

Making do is second nature for Forti. It is a form of improvisa-
tion practiced in everyday life, and she has made it into an art. For example, included in the MoMA magazine profile is a photograph of Forti in her homemade "masque-culotte." Here are her instructions:

> The masque-culotte is a very simple cotton mask made from
> a pair of underpants, preferably bikinis. You put your head
> through the waistband and pull a leg hole down to your nose.
> It takes a bit of experimentation. One can add a safety pin. I
> call it a masque-culotte.[56]

The accompanying photo is priceless: There is Forti in a blue sweater with a matching blue pair of underwear slung across her face, her wispy white hair held in place by the mask around her head and her eyes looking straight out to the camera. The image is witty and

ironic, the gesture tongue-in-cheek, the timing impeccable, the colors saturated, the audience expected, the artist assured. Forti finishes the interview which accompanied the photos in MoMA's magazine by describing her online exercise class, which she says feels a bit like "training for the marines." And, she adds, "I love it." Her body, like her indefatigable imagination, is ready for the next move.

At the beginning of 2023, MOCA presented a six-decade retrospective of Simone Forti's artistic career. This was a wonderful homecoming—the first major exhibition of Forti's career by an art institution in LA, the city where she grew up and to which she returned as an elder. I attended the opening weekend of the show, which included a press preview and a special member's preview, as well as the official public opening. In many ways, this exhibition paralleled the formats of previous representations. The first, light-filled gallery contained the structures for *Slant Board* and *Hangers*, with a central open space in which *Huddle* would be presented. There were the classic photos by Moore on the walls and videos of early performances, as well as two of Forti's holograms and various sketches and paintings. Two HD-video collaborations with Underhill were shown, one projected larger than life on the wall of the second room. The associate curators, Sloane and Lowery, were obviously infatuated with Minimalism and NYC in the 1960s and 1970s. In an oral history interview with Forti included on the museum's website, they kept bringing the conversation back to that seminal period, barely mentioning her work with Whitman or the improvisations with Van Riper, not to mention ignoring, once again, Forti's work with Simone Forti and Troupe.[57] Nonetheless, what was most extraordinary about this show was the heart-felt celebration of Forti's living legacy. It was abundantly clear right from the beginning that working with Forti was a powerful life experience for all involved.

The press preview began with the usual assorted introductions by the museum director and the show's curators. Just as they were finishing, Forti entered from the back of the gallery, and immediately her sweet presence lit up the room—there were sighs and smiles, clapping and cheering. Both sets of performers were on hand to activate the

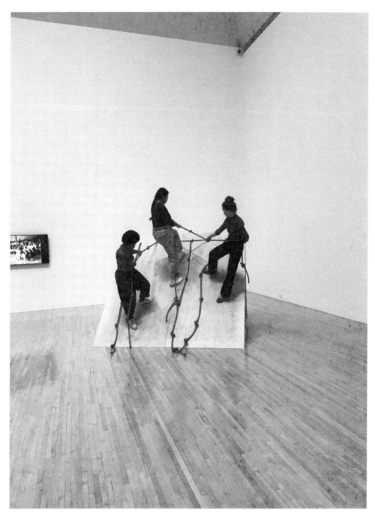

Slant Board performance at MOCA, Los Angeles, 2023. Photo by the author.

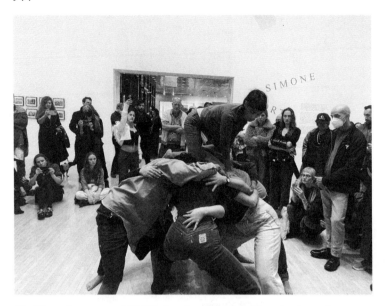

Huddle performance at MOCA, Los Angeles, 2023. Photo by the author.

three Dance Constructions restaged for the exhibition. After the first series of performances was over, the dancers all crowded around Forti, crouching alongside her wheelchair to express their gratitude for how she shared her work with them. I was standing a little distance away and was struck by the potent mixture of love and awe on their faces. Devotion would not be too strong a word to describe the spirit of that moment. Forti brings an expansive generosity to her engagement with her younger collaborators, and they return it with a genuine appreciation. I met and spoke with Chelsea Gaspard, a twenty-eight-year-old artist and poet who touched me with how sincerely she thanked Forti for allowing her to participate in this life-changing process. In a casual conversation, Gaspard spoke of *Huddle* as "the essence of being in an artistic community." She mentioned that this opportunity had come at a pivotal moment in her career and provided a "sanctuary" from the rampant commodification in the art world. Later, she commented on the work's "honesty and curiosity" and wrote in a follow-up email:

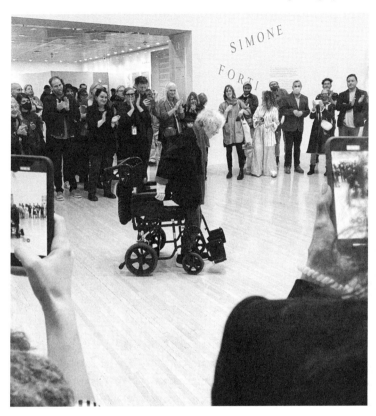

Simone Forti taking a bow at MOCA, Los Angeles, 2023. Photo by Dorit Cypis.

What I want out of life and art is to be in community, to collaborate, to be vulnerable, to grow, to share, and to listen. Sometimes with all the grandeur that is asked of us to be noticed, the art-making process can feel hollow and shaky. Simone's work is foundational and sincere; it's hard work and togetherness. This isn't the kind of work you can fake. You must be present and willing to be vulnerable and work alongside your fellow movers.[58]

In addition to the performers, Forti's dear friends and collaborators surrounded her throughout these events. At the members' preview,

for instance, people integral to her life and artistic success greeted her with tenderness. Not infrequently I would turn around to see Swenson and Hermann Dietrich or the show's curators crouching beside her, discussing the performance, or McCarthy and Underhill each holding one of her hands, congratulating her. Clearly, Forti was enjoying the adulation and when, during the member's preview, she rose up out of her chair to acknowledge the clapping, there was a brilliant smile on her tilted and shaking face. I was struck by how much love was in that room. That's when I recognized the full measure of Simone Forti's living legacy—to inspire others to step outside their own expectations and commit themselves to improvising a life in motion.

Dear Simone,

As I prepare this final manuscript to send off to the press, I find myself feeling a bit bereft. I will miss living with you and your dancing day by day. This book has been an inspiring journey of research and reflection. I have enjoyed the writing immensely as I tried to channel your dancing into words. I realize, of course, that the intimacy of this relationship is strangely one-sided. So today I want to tell you about two people in my life who I believe are connected to your living legacy. Not direct descendants, of course, more like sideways offspring who share your kinesthetic curiosity.

Do you remember that when we were in Salzburg together you gave me a bright blue scarf? I think you bought it and then decided it wasn't quite right. I wore it for years. One day, I was choreographing a duet with Dejaney, my ten-year-old dance partner from Girls in Motion, the afterschool program I run in public schools. During rehearsal, she grabbed the blue scarf and started dancing with it. We incorporated it into our duet, and after the performance I gave it to her, telling her about its original owner. Dejaney is in high school now, and I believe she wears it still.

The second person is my daughter, Isabel, to whom this book is dedicated. She saw you perform at the Electric Lodge in Venice, California, in 2016 and came with me to the party afterwards. Isabel is a winemaker, a farmer, and an artist. The dancing bear on the front of this card is a label she painted for one of her vintages. Although she doesn't dance, she is totally embodied and has a brilliant imagination. For her, as for you, the weather, landscape, animals, and plants, are animate forces with which to improvise. Her wines are deeply expressive, and she makes bread! The good, chewy kind that you can sink your teeth into. I think you would enjoy getting to know these two young women. In any case, I look forward to visiting you in LA this summer and reading sections of this book to you on your rooftop garden—with a glass of wine, of course.

Until then, I send you my love,

Ann C.A.

Notes

Introduction: Living Histories

1. Fellow artist Dorit Cypis explored this combination with Simone Forti in an online interview: "Between the Conceptual and the Vibrational," *X-TRA* 6, no. 4 (Summer 2004): 7–12.

2. I have maintained the numbering system for Simone Forti's journals that was developed by her assistants Jason Underhill and Catherine Vu as they prepared Forti's archives for the Getty Research Institute. These numbers do not necessarily correspond with a chronological sequence and, as Forti has often warned, sometimes she will pick up an old journal or notebook and write in it. When this happens it is often clear, because her handwriting has changed over the years.

3. As I detail later in this introduction, Forti has had a major retrospective in 2014 at the Museum der Moderne Salzburg in Austria. The Dance Constructions have been showcased in the 2018 exhibition "Judson Dance Theater: The Work Is Never Done" at the Museum of Modern Art in New York City. Her work was an integral part of the New York Public Library for the Performing Arts' 2017 "Radical Bodies: Anna Halprin, Simone Forti, and Yvonne Rainer in California and New York, 1955–1972." A 2021 exhibition at the Centro per l'arte contemporanea Luigi Pecci honored her connections to Prato, Italy, and in 2023 she had a career retrospective at the Museum of Contemporary Art in Los Angeles. Also in 2023, Forti was honored with the Golden Lion award for lifetime achievement by the Venice Biennale, an annual international cultural exhibition in Italy.

4. Michele Sarfatti, *The Jews in Mussolini's Italy*, trans. John and Anne C. Tedeschi (Madison: University of Wisconsin Press, 2006), 25.

5. Sarfatti 2006, 108.

6. Sarfatti 2006, 97.

7. Alexander Stille, *Benevolence and Betrayal: Five Italian Jewish Families Under Fascism* (New York: Penguin Books, 1991), 287.

8. Letters between Simone Forti and Carmela Hermann Dietrich from 2007 and 2008 were assembled by these close friends with an eye to possibly being published (they never were), and I was fortunate enough that Simone and Carmela sent me a copy.

9. From a collection of letters between Forti and Hermann Dietrich: December 20, 2007.

10. Delphine Horvilleur, *Vivre Avec Nos Morts: Petit traité de consolation* (Paris: LGF [Librarie générale française], 2021), 69–70.

11. Danielle Goldman, *I Want To Be Ready: Improvised Dance as a Practice of Freedom* (Ann Arbor: University of Michigan Press, 2010), 9.

12. Brenda Dixon Gottschild, *Digging the Africanist Presence in American Performance* (Westport, CT: Praeger, 1998), 51.

13. Susan Foster, *Dances that Describe Themselves: The Improvised Choreography of Richard Bull* (Middletown, CT: Wesleyan University Press, 2002), 37.

14. See George Lewis, "Improvised Music after 1950: Afrological and Eurological Perspectives," in *The Other Side of Nowhere: Jazz, Improvisation, and Communities in Dialogue*, ed. Daniel Fischlin and Ajay Heble (Middletown, CT: Wesleyan University Press, 2004).

15. Romain (Emma) Bigé, ed., *Steve Paxton: Drafting Interior Techniques* (Lisbon, Portugal: Culturgest, 2019), 168.

16. Judy Hussie-Taylor, interview by author on Zoom, July 21, 2021.

17. Wendy Perron, "You Make Me Feel Like a Natural Woman: My Encounters with Yvonne, Simone, Anna, and Trisha," in ed. Ninotchka Bennahum, Wendy Perron, and Bruce Robertson, *Radical Bodies: Anna Halprin, Simone Forti, and Yvonne Rainer in California and New York, 1955–1972* (Oakland: University of California Press, 2017), 88.

18. Steve Paxton, interview by the author on Zoom, September 3, 2022.

19. Paxton, interview by the author, September 3, 2022.

Movement Is Her Medium

1. It is wonderful that the Jerome Robbins Dance Division of the New York Public Library for the Performing Arts recorded two oral history interviews with Simone Forti, one in 1994 and another in 2018. The earlier interview is especially revealing, because it was recorded before Forti had solidified her own self-representation in terms that register with art-world impact. In the two interviews, she doesn't tell the same stories.

2. For more about the serious arts education at Fairfax High School, see

www.fairfaxhs.org/m/pages/index.jsp?uREC_ID=344370&type=d&termREC
_ID=&pREC_ID=994541.

3. Forti remarked with delight and a certain amount of pride on the fact
that she found an American Civil Liberties Union membership card in her
mother's wallet when she died.

4. Simone Forti, interview with the author in Oberlin, Ohio, December 3,
2015.

5. Daniel Hurewitz, *Bohemian Los Angeles: and the Making of Modern Politics*
(Berkeley: University of California Press), 2008.

6. Margaret Boyle interview with Simone Forti in the Reed College alumni
magazine, *Reed* 82, no. 4 (November 2003): 37. See https://rdc.reed.edu/c
/reedhisttxt/s?q=Reed%20magazine, and search on "Simone Forti."

7. The Reed College Handbook is available online. For more information
about that time, see https://rdc.reed.edu/c/reedhisttxt/s/r?_pp=20&query
=simone%20forti&s=c9fd6c5b1471e27bc47517b43fddd683d90d4f78&p
=20&pp=1.

8. Susan Rosenberg, *Trisha Brown: Choreography as Visual Art* (Middletown,
CT: Wesleyan University Press, 2017), 28.

9. Many years ago I was given by David Gere a copy of this interview on
VHS.

10. Simone Forti, interview by Claudia LaRocco, *The Brooklyn Rail* (April
2010), https://brooklynrail.org/2010/04/dance/simone-forti-with-claudia-la
-rocco.

11. Janice Ross, *Anna Halprin: Experience as Dance* (Berkeley and Los Ange-
les, CA: University of California Press, 2007), 81.

12. Ross 2007, 103.

13. Ross 2007, 104.

14. Simone Forti, quoted in Ross 2007, 126.

15. Ross 2007, 96.

16. Anna Halprin, quoted in Ross 2007, 98.

17. Ross 2007, 130.

18. Quoted in Meredith Morse, *Soft Is Fast: Simone Forti in the 1960s and
after* (Cambridge, MA: MIT Press, 2016), 48.

19. Morse 2016, 48.

20. Robert Morris, interview by Lauren O'Neill-Butler, *Artforum* (June 8,
2012), www.artforum.com/interviews/judson-at-50-robert-morris-31187.

21. Simone Forti, interview by Dorit Cypis, "Between the Conceptual and
the Vibrational," *X-Tra* 6, no. 4 (Summer 2004): 7–12, www.x-traonline.org
/article/between-the-conceptual-and-the-vibrational/.

22. Yvonne Rainer, *Feelings Are Facts* (Cambridge, MA: MIT Press, 2006), 217.

23. Steve Paxton, "The Emergence of Simone Forti," in *Simone Forti: Thinking with the Body*, ed. Sabine Breitwieser (Salzburg: Museum der Moderne, 2014), 59.

24. From the Simone Forti files in the Department of Media and Performance at the Museum of Modern Art (MoMA) in New York City. I am much obliged to Athena Christa Holbrook for her assistance when I visited MoMA for research.

25. Rainer 2006, 195.

26. Forti, interview by Claudia LaRocco, *The Brooklyn Rail* (April 2010), https://brooklynrail.org/2010/04/dance/simone-forti-with-claudia-la-rocco.

27. Sally Banes, *Greenwich Village 1963* (Durham: Duke University Press, 1993), 145.

28. Forti, interview by Dorit Cypis, 2004.

29. These letters are published in the catalog for the New York Public Library for the Performing Arts' 2017 exhibition "Radical Bodies: Anna Halprin, Simone Forti, and Yvonne Rainer in California and New York, 1955–1972," 149–57. See note 31 for book-publication citation information.

30. Rainer 2006, 196.

31. In Ninotchka Bennahum, Wendy Perron, and Bruce Robertson, eds., *Radical Bodies: Anna Halprin, Simone Forti, and Yvonne Rainer in California and New York, 1955–1972* (Oakland: University of California Press, 2017), 155.

32. I was privileged to have access to the acquisitions file that documented how the Museum of Modern Art (MoMA) in New York City was collecting the Simone Forti Dance Constructions and assorted ephemera. Although the acquisitions themselves had numbers, the file folder was simply named "Simone Forti." I thank Athena Christa Holbrook (then a collection specialist in the Department of Media and Performance) for locating these materials.

33. Steve Paxton, interview by the author, September 3, 2022.

34. Forti, introduction to Dance Constructions, in *Simone Forti*, ed. Breitwieser, 80.

35. Sally Banes, *Terpsichore in Sneakers: Post-Modern Dance* (Middletown, CT: Wesleyan University Press, 1987), 28.

36. In a casual conversation during the 2023 Forti retrospective at the Museum of Contemporary Art in Los Angeles, Sarah Swenson pointed out that these days (post–Museum of Modern Art acquisition) the performers have watches and make the pieces exactly ten minutes long.

37. Steve Paxton. "Performance and the Reconstruction of Judson," *Contact Quarterly* 7, nos. 3/4 (Spring/Summer 1982): 58.

38. Simone Forti files, MoMA.

39. Simone Forti files, MoMA.

40. These videos are now archived in the Jerome Robbins Dance Division of the New York Public Library for the Performing Arts. Thanks to division director Linda Murray for helping me locate the VHS tape that was in the queue waiting to be digitized.

41. Paxton 2014, 61.

42. Yvonne Rainer, "On Simone Forti," in *Simone Forti*, ed. Breitwieser, 72.

43. Liz Kotz, "Convergence of Music, Dance and Sculpture c. 1961: Reconsidering Simone Forti's Dance Constructions," in *Assign and Arrange: Methodologies of Presentation in Art and Dance*, ed. Maren Butte, Kirsten Maar, Fiona McGovern, Marie-France Rafael, and Jorn Schafaff (Berlin: Sternberg Press, 2014), 44.

44. On video in author's personal collection.

45. Quoted in Bennahum et al., *Radical Bodies*, 55.

46. Robert Whitman, *Playback*, ed. Lynne Cooke and Karen Kelly (New York: Dia Art Foundation, 2003), 202.

47. This film on DVD is included in *Playback,* the catalog of Whitman's 2003 career retrospective at Dia Art Foundation: Robert Whitman, *Playback*, ed. Lynne Cooke and Karen Kelly (New York: Dia Art Foundation), 2003.

48. Michael Kirby, *Happenings: An Illustrated Anthology* (New York: E. P. Dutton and Co., 1966), 141.

49. David Joselit, "eating and dreaming: Robert Whitman's 1960s happenings," in *Playback*, ed. Lynne Cooke and Karen Kelly (New York: Dia Art Foundation, 2003), 44.

50. Kirby 1966, 160.

51. Joselit 2003, 52.

52. Whitman, from a recorded interview at the end of the *Playback* DVD.

53. Kirby 1966, 161.

54. Joselit 2003, 52.

55. Whitman, from interview on *Playback* DVD.

56. Paxton, interview by the author.

57. Forti, from interview at the end of the *Playback* DVD.

58. Mariellen Sandford, *Happenings and Other Acts* (London: Routledge, 1995), xxii.

59. Simone Forti, interview with Claudia La Rocco, *The Brooklyn Rail*

(2010), https://brooklynrail.org/2010/04/dance/simone-forti-with-claudia -la-rocco.

60. I spoke to Fabio Sargentini during a visit to his gallery in Rome on September 20, 2022. I thank him and his assistant Elena Giacalone for being so welcoming.

Forces at Play

1. David Zambrano, interview by the author on Zoom, February 7, 2023. Zambrano, a longtime collaborator and dancer with Simone Forti and Troupe, described how, even before he knew Forti personally, someone suggested that he read *Handbook in Motion*. This book so inspired him that he signed up for Forti's improvisation class at the American Dance Festival in the summer of 1983. Their dancing histories have been intertwined ever since.

2. For more information about this unique educational adventure, see Garry Neill Kennedy's anthology *The Last Art College: Nova Scotia College of Art and Design, 1968–1978* (Cambridge, MA: MIT Press, 2012).

3. John Pearson, in discussion with the author, November 17, 2019.

4. Kennedy 2012, 247.

5. Julia Bryan-Wilson, "Simone Forti Goes to the Zoo," *October* 152 (Spring 2015): 35.

6. Bryan-Wilson 2015, 35.

7. John Berger, "The Basis of All Painting and Sculpture Is Drawing," in *Landscapes: John Berger on Art*, ed. and introduction Tom Overton (London: Verso Press, 2016), 27.

8. Berger 2016, 31.

9. Bryan-Wilson 2015, 27.

10. John Berger, "Why Look at Animals?," in *About Looking* (New York: Pantheon Books, 1980).

11. Bryan-Wilson 2015, 40.

12. Bryan-Wilson 2015, 39.

13. See *Chute*, a videorecording by Woodland Video (East Charleston, VT: Videoda, 1987). This video is part of a compilation made by Lisa Nelson and Nancy Stark Smith and distributed by Contact Editions.

14. Michael Pollan, *How to Change Your Mind: What the New Science of Psychedelics Teaches Us About Consciousness, Dying, Addiction, Depression, and Transcendence* (New York: Penguin Press, 2018), 288.

15. See Benedict Carey, "Tim Ferris, the Man Who Put His Money Behind Psychedelic Medicine," *New York Times*, September 10, 2019, D3.

16. See the PBS film *Woodstock: Three Days that Defined a Generation*, aired August 6, 2019, www.pbs.org/wgbh/americanexperience/films/woodstock/.

17. Mihaly Csikszentmihalyi, *Flow: The Psychology of Optimal Experience* (New York: Harper and Row, 1990), 71.

18. Csikszentmihalyi 1990, 110.

19. Ramsay Burt, *Judson Dance Theater* (London and New York: Routledge, 2006), 131.

20. The impressive catalog for the 2014 retrospective "Simone Forti: Thinking with the Body" at the Museum der Moderne Salzburg in Austria includes a whole section of Forti's *Illuminations* and circle drawings.

21. *Home Base* is also the title she used for a series of performances with Peter Van Riper, her third husband and musical collaborator, with whom she worked extensively in the 1970s and early '80s. I write about this collaboration in the following chapter, "Tuning."

22. For more information about the founding of CalArts, see Philip Kaiser and Christina Végh, *Where Art Might Happen: The Early Years of CalArts* (Munich: Prestel Verlag, 2020).

23. Simone Forti, interview by the author in Los Angeles, January 22, 2014.

24. Forti is quoted in Kent De Spain, *Landscape of the Now* (New York: Oxford University Press, 2014), 76.

25. Daniel Cariaga, "Simone Forti in Big Room," *Los Angeles Times*, January 24, 1977, F6D.

26. Sally Banes, *Soho Weekly News* (April 12, 1979), found in the Simone Forti clippings file at the Jerome Robbins Dance Division, New York Public Library for the Performing Arts.

27. Lewis Segal, "Forti and Van Riper at LAICA," *Los Angeles Times*, June 20, 1978, F9.

28. Marcia B. Siegel, *The Tail of the Dragon* (Durham: Duke University Press, 1991), 46.

29. Pooh Kaye, interview by the author on Zoom, May 11, 2020.

30. Siegel 1991, 46.

31. Siegel 1991, 148.

32. There are very interesting contemporary discourses around the Anthropocene, post-humanism, animals, cyborg bodies, biopolitics, and living with other beings on earth as more and more cultural thinkers begin to critique the ideology that places (some) humans above animals and considers Earth a sphere of raw material to be mined and used. This is not the occasion to explore the correspondences between Forti's work and these ideas, but I do note that recognizing other forces in the world requires a willingness to be patient and learn a "not-doing" that Forti, with her training in Tai Chi, develops into a deep skill in her improvisational practice. Certainly, her notion of "animism"

was prescient, and she models a practice of inhabiting the body that could be inspiring for some of these thinkers. See, for instance, Mel Y. Chen's *Animacies: Biopolitics, Racial Mattering, and Queer Affect* (Durham, NC: Duke University Press, 2012).

33. De Spain 2014, 155.

34. Elizabeth Kendall, *Dance Magazine* 48, no.12 (December 1974); found in the Simone Forti clippings file in the Jerome Robbins Dance Division, New York Public Library for the Performing Arts.

35. Forti, quoted in Banes 1987, 34–35.

36. Perron 2017, 180.

37. Forti, interviewed by Meg Cottam: "Meg Cottam Interviews Simone Forti," in the Judson project video archives, Bennington College; a VHS tape is in the Jerome Robbins Dance Division, New York Public Library for the Performing Arts. In this interview, Forti discusses her interest in divination. She describes how the word for guess in Italian is related to "divine" and talks about how one has to learn to trust other forces, to have one's antenna open for intuition in order to divine.

Tuning

1. John Schaefer, "Who Is La Monte Young?," in *Sound and Light: La Monte Young, Marian Zazeela*, ed. William Duckworth and Richard Fleming (Lewisburg, PA: Bucknell University Press, 1996), 32.

2. Terry Riley, "The Trinity of Eternal Music," in *Sound and Light: La Monte Young, Marian Zazeela*, ed. William Duckworth and Richard Fleming (Lewisburg: Bucknell University Press, 1996), 98.

3. La Monte Young, "Lecture 1960," *The Drama Review* 10, no. 2 (Winter, 1965): 81.

4. Forti, interview by Tashi Wada: "Interview with Simone Forti," *Bomb* 144 (Summer 2018), https://bombmagazine.org/issues/144/.

5. Forti, video interview and performance at the PHI Foundation for Contemporary Art, October 13, 2018, https://archives.fondation-phi.org/en/video /affinities-simoneforti-performance-conversation/.

6. Robert Morris, "Notes on Simone Forti," in *Simone Forti*, ed. Breitwieser, 47.

7. Sally Banes, *Subversive Expectations: Performance Art and Paratheater in New York 1975–1985* (Ann Arbor: University of Michigan Press, 1998), 159.

8. Forti, video interview at the PHI Foundation, 2018.

9. Forti, interview by Wada, 2018.

10. Eric Salzman, *Twentieth-Century Music: An Introduction* (Upper Saddle River, NJ: Prentice Hall, 2002), 213.

11. Forti, interview by the author on March 13, 2020.

12. Meredith Morse, "Between Two Continents: Simone Forti's *See-Saw*," in *Simone Forti*, Breitwieser, 39.

13. *Simone Forti: An Evening of Dance Constructions,* performances at the Geffen Contemporary at MOCA in Los Angeles in 2004; video produced by ArtPix in 2009, www.artpix.org/12Simone.htm.

14. Simone Forti files in the Department of Media and Performance at the Museum of Modern Art (MoMA) in New York City.

15. M. C. Richards, *Centering: in Pottery, Poetry, and the Person* (Middletown, CT: Wesleyan University Press, 1989), 68.

16. Forti, interview with staff of The ZKM Center for Art and Media Karlsruhe, March 9, 2012, www.youtube.com/watch?v=WzhpwjeAFJM.

17. Jill Johnston, *Marmalade Me* (Middletown, CT: Wesleyan University Press, revised and expanded edition 1998), 33.

18. John Cage, quoted in Kay Larsen, *Where the Heart Beats: John Cage, Zen Buddhism, and the Inner Life of Artists* (New York: Penguin Press, 2012), 239.

19. Pandit Pran Nath was an Indian classical singer whose ragas were influential to many of the new music composers, including La Monte Young.

20. Charlemagne Palestine, "Fifteen Questions Interview: The Bare Maximum / Mish-mashed and misunderstood," www.15questions.net/interview /fifteen-questions-interview-charlemagne-palestine/page-1/.

21. Tom Johnson, "Experimental Music Takes a Trip to the Art World," *New York Times*, December 5, 1976, www.nytimes.com/1976/12/05/archives /experimental-music-takes-a-trip-to-the-art-world-experimental-music.html.

22. Antonio Guzman, preface to *Charlemagne Palestine: Sacred Bordello* (London: Black Dog Publishing, 2003), 16.

23. Palestine, quoted in Guzman 2003, 44.

24. Palestine, interview by Steve Dalachinsky, *Bomb* 128 (Summer 2014): 28–35. https://bombmagazine.org/articles/charlemagne-palestine/.

25. Palestine, interview by Dalachinsky, 2014.

26. Palestine, quoted in Guzman 2003, 183.

27. Brian Seibert, "Italian Touch, With a Taste of Cognac," *New York Times*, April 15, 2014, www.nytimes.com/2014/04/16/arts/dance/simone-forti-and -charlemagne-palestine-reunite-at-moma.html.

28. Forti, in "Artists at Work: Simone Forti," interview by Bryony Gillard and Louis Hartnoll, June 6, 2016, featured on Afterall, www.afterall.org /online/artists-at-work-simone-forti#.XpSMI5qQxE5.

29. Forti, interview by Gillard and Hartnoll, 2016.

30. Peter Van Riper introduced Lloyd Cross and Simone Forti, and they proceeded to make a variety of holograms together. Although these were

forgotten for decades, Jason Underhill and Forti were able to have the old holograms restored, and now these beautiful moments of Forti dancing in the holograms are in art museum collections across the globe.

31. Cathy Weiss now owns the Forti/Van Riper loft and continues to hold "Sundays on Broadway" improvisational performances there, as part of her artistic organization WeisAcres.

32. Sally Banes, *Terpsichore in Sneakers: Post-Modern Dance* (Middletown, CT: Wesleyan University Press, 1987), 36.

33. Forti let me see press releases and programs in spring 2019, before her archives went to the Getty Research Institute.

34. Forti is describing how Van Riper created the piece *Plumbing Music*, which served as the sound score for the 1976 group work *Planet*, which I discuss in the following chapter.

35. Daniel Cariaga, "Simone Forti in 'Big Room,'" *Los Angeles Times*, January 24, 1977, F6D, archived in the Jerome Robbins Dance Division, New York Public Library for the Performing Arts.

36. Ella Finer, "Far Stretch—Listening to sound happening," in *The Creative Critic: Writing as/about Practice*, ed. Katja Hilevaara and Emily Orley (New York: Routledge, 2018), 136.

Geographies of a Group

1. It is extraordinary to me that major retrospectives of Forti's work have passed over any discussion or documentation of her work with Simone Forti and Troupe. In this chapter I offer a remedy to that omission.

2. Pooh Kaye, video excerpt from "Simone Forti AVI," https://vimeo.com/320547630.

3. "Face at Cascade Falls," archived in the Anna Halprin video collection, Jerome Robbins Dance Division, New York Public Library for the Performing Arts.

4. Janice Ross, *Anna Halprin: Experience as Dance* (Berkeley and Los Angeles, CA: University of California Press, 2007), 131.

5. Anna Halprin, *Moving Towards Life* (Middletown, CT: Wesleyan University Press, 1995), 229.

6. Sally Banes, *Terpsichore in Sneakers: Post-Modern Dance* (Middletown, CT: Wesleyan University Press, 1987), 36.

7. Forti, interview by the author in Los Angeles, June 3, 2018.

8. Banes 1987, 31–33.

9. In this interview, Forti discusses the genesis of *Planet* and describes how she taught the group to transition between standing and crawling.

10. Banes 1987, 37.

11. Kaye, discussion with the author on Zoom, May 17, 2020.

12. Banes 1987, 57.

13. Jack Anderson, "Dance: Forti Troupe," *New York Times*, April 27, 1979, C24.

14. For more about Movement Research, Inc., see https://movementresearch.org/about.

15. Jennifer Dunning, "Exploring the Limits of Dance," *New York Times*, April 24, 1987, C3.

16. Mission statement quoted from Movement Research, Inc., website.

17. Laurie Lassiter, "Movement Research Inc. and the workshop process," *Contact Quarterly* 9, no. 3 (Fall 1984): 26.

18. Lassiter 1984, 26.

19. Unpublished report on Forti/Nelson workshop at Theaterschool, Amsterdam. The report manuscript is dated May 21, 1986, quoted courtesy of Simone Forti.

20. David Zambrano, interview by the author on Zoom, February 12, 2020.

21. Forti, from discussion with the author on Zoom, May 17, 2020.

22. David Gere, interview by the author in Los Angeles, June 26, 2019.

23. Craig Bromberg, "An Ethic Clad in Genes," *Los Angeles Times*, May 25, 1986, X52, www.latimes.com/archives/la-xpm-1986-05-25-ca-6940-story.html.

24. Kaye, interview by the author, May 17, 2020.

25. K.J. Holmes, interview by the author on Zoom, May 15, 2020.

26. Holmes interview, May 15, 2020.

27. Forti, interview by the author in Salzburg, Austria, July 11, 2014.

28. The records for the Yellow Springs Fellowship for the Arts can be found at https://archives.nypl.org/the/21747, and for more information see the Yellow Springs website, www.yellowsprings.org/about/yellow_springs.html.

29. Holmes interview, May 15, 2020.

30. Holmes interview, May 15, 2020.

31. Holmes interview, May 15, 2020.

32. Holmes interview, May 15, 2020.

33. Kent De Spain, *Landscape of the Now* (New York: Oxford University Press, 2014), 134.

34. Nan Shepherd, *The Living Mountain* (Edinburgh: Canongate Books, 2011), 26.

35. Shepherd 2011, 106.

36. Jennifer Dunning, "Into the Woods with Wind and Rain in 'Touch,'"

New York Times, August 21, 1989, C14; archived at the Jerome Robbins Dance Division, New York Public Library for the Performing Arts.

37. Holmes interview, May 15, 2020.

38. Jack Anderson, "What's My Brother's Name?," *New York Times*, April 23, 1991, C11; archived at the Jerome Robbins Dance Division, New York Public Library for the Performing Arts.

Animating the News

1. Simone Forti, quoted by Craig Bromberg, "An Ethic Clad in Genes," *Los Angeles Times*, May 25, 1986, X52.

2. James Nesbit, *Ecologies, Environments, and Energy Systems in Art of the 1960s and 1970s* (Cambridge, MA: MIT Press, 2014), 178.

3. Forti, interview by the author in Los Angeles, January 22, 2014.

4. Quoted in *Simone Forti*, ed. Breitwieser, 35.

5. That awkward yet powerful moment was not included in the transcription of this early video of a News Animation informal rehearsal that was published as "News Animation No. 1" in *Oh, Tongue* (2003b, 7–11). This is just one example of the distance between how language is used in performance and how very differently it reads as text on the page.

6. News Animations performance at Bennington College March 28, 2003; video courtesy of Simone Forti.

7. Simone Forti, "A Family Tree Story," *Movement Research Journal* 9 (Fall 1994/Winter 1995): 2.

8. Carmela Hermann Dietrich, "Learning to Speak," in ed. Ann Cooper Albright and David Gere, *Taken by Surprise: A Dance Improvisation Reader* (Middletown, CT: Wesleyan University Press, 2003), 69.

9. Claire Filmon, interview by the author in Paris, September 20, 2021.

10. Hermann Dietrich 2003, 69.

11. Fred Dewey, "Embodying the World," in *Simone Forti*, ed. Sabine Breitwieser, 76.

12. Dewey 2014, 74.

13. Fred Dewey, "Editor's Afterword," in *Oh, Tongue*, second edition (Los Angeles: Beyond Baroque Books, 2010), 176.

14. Forti, "Report on Forti/Nelson workshop" (unpublished manuscript). It is possible that Forti meant to submit this to *Contact Quarterly*.

15. Deborah Jowitt, "Making It Up," *Village Voice*, January 2, 1996, 71; archived at the Jerome Robbins Dance Division, New York Public Library for the Performing Arts.

16. Jowitt 1996.

17. In December 2022, as they were preparing her 2023 retrospective,

Rebecca Lowery and Alex Sloan, associate curators at MOCA, recorded a video interview with Forti. See www.moca.org/exhibition/simone-forti.

18. M. C. Richards, *Centering: In Pottery, Poetry, and the Person* (Middleton, CT: Wesleyan University Press, 1964, reissued 1989), 144.

19. Dewey 2010, 206.

Constructing a Legacy

1. I thank Eric Nordstrom for recording the whole workshop for me on video.

2. "Simone Forti: From Dance Construction to Logomotion," produced and directed by Charles Dennis, Alive & Kicking: New Directions in Dance & Performance, University of California, Los Angeles National Dance/Media Project in association with Loisaida, Inc., 1999; and "Simone Forti: An Evening of Dance Constructions," produced by ArtPix, 2009; recorded in 2004 at the Geffen Contemporary at MOCA.

3. Carrie Lambert, "More or Less Minimalism: Six Notes on Performance and Visual Art in the 1960s," in ed. Ann Goldstein, *A Minimal Future? Art as Object 1958–1968* (Cambridge, MA: MIT Press, 2004),105.

4. Founded in 2005, the Baryshnikov Arts Center is a performance/studio complex at 450 West 37th Street in the Hell's Kitchen neighborhood of New York City.

5. Lewis Segal, "Tracing Postmodern Steps," *Los Angeles Times*, October 27, 2000, F1, F16.

6. From the program for PAST*Forward*, in the author's personal archives.

7. Wendy Perron, "Misha's New Passion: Judson Dance Theater," in *Through the Eyes of a Dancer* (Middletown, CT: Wesleyan University Press, 2013), 160.

8. In ed. Breitwieser 2014, 9.

9. According to Jason Underhill (Forti's assistant and collaborator), the extensive (and expensive) catalog for the retrospective really put Forti's work on the radar of international art curators. Of course, the Museum of Modern Art's acquisition of her Dance Constructions in 2015 also contributed to the exponential rise of her stock in the art world.

10. Forti, interview by the author in Salzburg, Austria, July 11, 2014.

11. Forti, interview by the author, July 11, 2014.

12. Forti, interview by the author, July 11, 2014.

13. Jori Finkel, "Simone Forti's Experiments Transcribing Bodies in Motion," *New York Times*, February 8, 2023, www.nytimes.com/2023/02/08/arts/dance/simone-forti-moca-golden-lion.html.

14. André Lepecki, "The Body as Archive: Will to Re-Enact and the Afterlives of Dances," *Dance Research Journal* 42, no. 2 (Winter 2010): 39.

15. Lepecki 2010, 35.

16. Robert Morris, "Notes on Simone Forti," in *Simone Forti*, ed. Breit-wieser, 75.

17. The video archives at the Centre national de la danse have hundreds of hours of material on Forti, including complete workshops and assorted performances.

18. Danspace keeps archives of certain workshops, and there is a wonderful and extensive documentation of Forti's December 2016 workshop. For more information, see https://danspaceproject.org/calendar/simone-forti-movement -and-writing-workshops-body-mind-world/.

19. Talya Epstein's comments on her experience of the December 2016 workshop are part of the documentation on the Danspace website: https:// danspaceproject.org/2017/02/07/talya-epstein-on-simone-forti-workshops/.

20. Molly Lieber's comments on her experience of the December 2016 workshop are also part of the documentation on the Danspace website: https://danspaceproject.org/2017/02/07/molly-lieber-on-simone-forti/

21. Judy Hussie-Taylor, interview by the author on Zoom, July 21, 2021.

22. The description of Forti's Portland, Oregon, workshop is also part of the documentation on the Danspace website: https://danspaceproject .org/calendar/simone-forti-movement-and-writing-workshops-body-mind -world/.

23. Lowery and Sloan interview with Forti, 2022.

24. The Museum of Contemporary Art show has a wonderful loop of all these *Huddles* from different decades, and it is striking to see Pooh Kaye run and leap onto the group. In another, a performer holds on to two people's legs and flips over as he comes down to the floor.

25. Simone Forti, unpublished statement, archived at the Department of Media and Performance Art, Museum of Modern Art, 2011.

26. Lauren Bakst's comments are archived on the Danspace website: https:// danspaceproject.org/calendar/simone-forti-movement-and-writing-workshops -body-mind-world/.

27. This memo was found in the Simone Forti files at that Department of Media and Performance, Museum of Modern Art.

28. Megan Gwen Metcalf, "In the New Body: Simone Forti's Dance Constructions (1960–1961) and their Acquisition by the Museum of Modern Art (MoMA)," (PhD diss., University of California, Los Angeles, 2018), 26–27.

29. Claire Bishop, "The Perils and Possibilities of Dance in the Museum: Tate, MoMA, and Whitney," *Dance Research Journal* 46, no. 3 (special issue on Dance in the Museum, December 2014): 66.

30. Thomas DeFrantz, "Dancing the Museum," in *Curating Live Arts: Critical Perspectives, Essays, and Conversations on Theory and Practice*, ed. Dena Davida et al. (New York and Oxford: Berghahn, 2019), 95.

31. Athena Christa Holbrooke, "Second-Generation Huddle: A Communal Approach to Collecting and Conserving Simone Forti's Dance Constructions at MoMA," in *VDR Beitrage* (2018): 118.

32. Holbrook 2018, 120.

33. Holbrook 2018, 121.

34. Holbrook 2018, 122.

35. Athena Christa Holbrook, interview by the author on Zoom, July 7, 2021.

36. Holbrook 2018, 123.

37. Quoted from Emma Paz's writing about the Dance Constructions for the art journal *Metropolis M*, www.metropolism.com/nl/.

38. Sarah Swenson's discussion of her 2019 reconstructions in Singapore was posted online on July 2, 2021. See www.nationalgallery.sg/magazine/at-work -with-the-dance-constructions.

39. Simone Forti's conversation with Bryony Gillard and Louis Hartnoll, entitled "Artists at Work: Simone Forti," is posted on the Afterall website: www.afterall.org/online/artists-at-work-simone-forti#.XpSMI5qQxE5.

40. Holbrook 2018, 119.

41. Meredith Morse, *Soft Is Fast: Simone Forti in the 1960s and After* (Cambridge, MA: MIT Press, 2016), 193.

42. Yvonne Hardt, "Pedagogic In(ter)ventions: On the Potential of (Re) enacting Yvonne Rainer's Continuous Project/Altered Daily in a Dance Education Context," in *The Oxford Handbook of Dance and Reenactment*, ed. Mark Franko (New York: Oxford University Press, 2017), 251.

43. Hardt 2017, 258.

44. Ethan Philbrick, "Huddling, Then and Now: Simone Forti and the Nonsovereign Collective," *TDR/The Drama Review* 62, no. 4 (Winter 2018): 183.

45. Philbrick 2018, 184.

46. Philbrick 2018, 193.

47. Philbrick 2018, 194.

48. Philbrick 2018, 195.

49. Dorit Cypis, conversation with the author in Los Angeles, January 14, 2023.

50. Mary McCarthy, interview by the author on Zoom, July 28, 2021.

51. McCarthy interview by the author, July 28, 2021.

52. See Natilee Harren, "Simone Forti: The Box," *Artforum*, www.artforum.com/print/reviews/200908/simone-forti-40716.

53. Jason Underhill, interview by the author in Los Angeles, April 2021.

54. See Andrew Berardini's review of Forti's show "On An Iron Post" on the e-flux website: www.e-flux.com/criticism/238123/simone-forti-s-on-an-iron-post.

55. Ana Janevski, "Simone Forti's Bag Drawings," was posted on MoMA's online magazine on July 30, 2020. Included are photos of bag paintings and a photo of Forti with her "masque-culotte." See www.moma.org/magazine/ (search on Janevski, "Simone Forti's Bag Drawings").

56. Janevski 2020, www.moma.org/magazine/.

57. Lowery and Sloan interview with Forti, 2022. See www.moca.org/exhibition/simone-forti.

58. Chelsea Gaspard, conversation with the author on February 12, 2023 and follow-up email.

Bibliography

Books by Simone Forti

Forti, Simone, *Angel*, chapbook of poems (New York: self-published, 1978).

———, *The Bear in the Mirror* (London: Koenig Books, 2018).

———, *Handbook in Motion* (Halifax: Press of the Nova Scotia College of Art and Design, 1974; 2nd ed., 1980).

———, *News Animations* (Prato, Italy: NERO Press, 2021).

———, *Oh, Tongue* (Los Angeles: Beyond Baroque Books, 2003b).

Forti, Simone, with Terrence Luke Johnson, Sarah Swenson, and Douglas Wadle, *Unbuttoned Sleeves* (Venice, CA: Beyond Baroque Foundation, 2006).

Essays by Simone Forti

Forti, Simone. "Dancing at the Fence." *Avalanche* 10 (December 1974): 20–23.

———. "A Chamber Dance Concert." *TDR (The Drama Review)* 19, no.1 (1975): 37–39.

———. "Full Moves: Thoughts on Dance Behavior." *Contact Quarterly* 9, no. 3 (Fall 1984): 7–14.

———. "A set of notes written in the few days before and after new year 1985." *Contact Quarterly* 12, no.1 (Winter 1987): 12–15.

———. "Issue Guest Editor's Note." *Contact Quarterly* 15, no.1 (Winter 1990): 3, 32–35.

———. "Thoughts on *To Be Continued*: A Sketch of a Dance/Narrative Process." *Contact Quarterly* 19, no. 1 (Winter/Spring 1994): 13–21.

———. "A Family Tree Story." *Movement Research Journal* 9 (Fall 1994/ Winter 1995): 2.

———. "Animate Dancing: A Practice in Dance Improvisation." *Contact Quarterly* 26, no. 2 (Summer/Fall 2001): 32–39.

————, "Animate Dancing: A Practice in Dance Improvisation." In *Taken by Surprise: A Dance Improvisation Reader*, edited by Ann Cooper Albright and David Gere, 53–63. Middletown, CT: Wesleyan University Press, 2003a.

Recordings

Forti, Simone. *Al Di Là*. Produced with Tashi Wada, Saltern, 2018, compact disc.

————. *Hippie Gospel Songs*. Box Editions, 2018, 45 rpm, single-sided, etched vinyl.

Unpublished Letters

Forti, Simone, with Carmela Hermann Dietrich. "Intimate Letters, 2007–2008," private collection.

Recorded Interviews with Simone Forti by Ann Cooper Albright

January 22, 2014, Los Angeles.

July 11, 2014, Salzburg, Austria.

December 3, 2015, Oberlin, Ohio.

June 3, 2018, Los Angeles.

May 18, 2020. Zoom.

Other Interviews with Simone Forti

Forti, Simone. "The Judson Project: Simone Forti." Interview by Meg Cottam, 1981. Video recording, MGZIC 9-662, archived at the Jerome Robbins Dance Division, New York Public Library. Also included on *The Judson Dance Project 1980–1982*. Directed by Wendy Perron. Series of seven videocassettes, VHS (New York: The Kitchen, 1983).

————. "Simone Forti: A Life in Dance." Interview by Sally Banes, February 5, 1990. Part of the Talking Dance project curated by Ellen Webb and David Gere. Theater Artaud, San Francisco. Video recording in author's possession and archived in the Dance Collection, New York Public Library, www.nypl.org/research/research-catalog/bib/b12171315.

————. Interview by Louise Sunshine. 1994. Dance Collection, New York Public Library, https://researchworks.oclc.org/archivegrid/collection/data/35422831.

————. "Simone Forti '57: A Poet of Movement." Interview by Margaret Boyle. *Reed* 82, no. 4 (November 2003): 37, https://rdc.reed.edu/c/reed histtxt/s?q=Reed%20magazine, search on "Simone Forti."

———. "Between the Conceptual and the Vibrational." Interview by Dorit Cypis. *X-TRA* 6, no. 4 (Summer 2004): 7–12, www.x-traonline.org/article /between-the-conceptual-and-the-vibrational/.

———. Interview by Claudia La Rocco. *The Brooklyn Rail* (April 2010), https://brooklynrail.org/2010/04/dance/simone-forti-with-claudia-la-rocco.

———. Interview by Alessandra Nicifero. 2015. Dance Collection, New York Public Library, https://researchworks.oclc.org/archivegrid/collection /data/1312759046.

———. "Artists at Work: Simone Forti." Interview by Bryony Gillard and Louis Hartnoll. 2016. *Afterall*, online journal of Research Centre of University of the Arts London, www.afterall.org/article/artists-at-work-simone -forti. [accessed April 17, 2020]

———. Interview by K.J. Holmes. 2018. Dance Collection, New York Public Library, https://researchworks.oclc.org/archivegrid/collection/data /1098060026.

———. "Interview with Simone Forti." By Tashi Wada. *Bomb* 144 (Summer 2018), https://bombmagazine.org/issues/144/.

———. "Simone Forti in Conversation with Jennie Goldstein." *Critical Correspondence*, online journal of Movement Research (October 18, 2018), https://movementresearch.org/publications/critical-correspondence/simone -forti-in-conversation-with-jennie-goldstein-1.

———. Interview by Alex Sloan and Rebecca Lowery. 2021. www.moca.org /exhibition/simone-forti.

General Bibliography

Albright, Ann Cooper. *Engaging Bodies: The Politics and Poetics of Corporeality.* Middletown, CT: Wesleyan University Press, 2013.

Albright, Ann Cooper, and David Gere, eds. *Taken by Surprise: A Dance Improvisation Reader.* Middletown, CT: Wesleyan University Press, 2003.

Anderson, Jack. "Dance: Forti Troupe." *New York Times*, April 27, 1979, C24.

Banes, Sally. *Terpsichore in Sneakers: Post-Modern Dance.* Middletown, CT: Wesleyan University Press, 1987.

———. *Democracy's Body: Judson Dance Theatre, 1962–1964.* Ann Arbor, MI and London: UMI Research Press, 1983.

———. *Greenwich Village 1963.* Durham, NC: Duke University Press, 1993.

———. *Subversive Expectations: Performance Art and Paratheater in New York, 1975–85.* Ann Arbor, MI: University of Michigan Press, 1998.

———, and Andrea Harris, eds. *Reinventing Dance in the 1960s: Everything was Possible.* Madison, WI: University of Wisconsin Press, 2003.

Belgrad, Daniel. *The Culture of Spontaneity: Improvisation and the Arts in Postwar America*. Chicago: University of Chicago Press, 1998.

Bennahum, Ninotchka, Wendy Perron, Bruce Robertson, Simone Forti, John Rockwell, and Morton Subotnick, eds. *Radical Bodies: Anna Halprin, Simone Forti, and Yvonne Rainer in California and New York, 1955–1972*. Oakland: University of California Press, 2017.

Benoit, Agnès. *On the Edge/Créateurs de l'imprévu: Dialogues on Dance Improvisation in Performance. Nouvelles de Danse* 32/33 (Fall/Winter 1997). Paris: Contredanse, 1997.

Berardini, Andrew. "Simone Forti's 'On an Iron Post'" E-Flux (December 21, 2015, www.e-flux.com/criticism/238123/simone-forti-s-on-an-iron-post.

Berger, John. "The Basis of All Painting and Sculpture is Drawing," in *Landscapes: John Berger on Art*, 27–32. Edited with an introduction by Tom Overton. London: Verso Press, 2016.

———. "Why Look at Animals?" In *About Looking*, 3–28. New York: Pantheon Books, 1980.

Berger, Maurice. *Labyrinths: Robert Morris, Minimalism, and the 1960s*. New York: Harper and Row, 1989.

Bernstein, David W., ed. *The San Francisco Tape Music Center: 1960s Counterculture and the Avant-Garde*. Berkeley: University of California Press, 2008.

Bigé, Romain (Emma), ed. *Steve Paxton: Drafting Interior Techniques*. Lisbon, Portugal: Culturgest, 2019.

Bishop, Claire. "The Perils and Possibilities of Dance in the Museum: Tate, MoMA, and Whitney." *Dance Research Journal* 46, no. 3 (Special Issue: Dance in the Museum, December 2014): 63–76.

Bissell, Bill, and Linda Caruso Haviland, eds. *The Sentient Archive: Bodies, Performance, and Memory*. Middletown, CT: Wesleyan University Press, 2018.

Breitwieser, Sabine. *Carolee Schneemann: Kinetic Painting*. Munich: Prestel, 2015.

———. *E.A.T. Experiments in Art and Technology*. Salzburg, Austria: Museum der Moderne Salzburg, 2015.

———, ed. *Simone Forti: Thinking with the Body*. Salzburg, Austria: Museum der Moderne Salzburg, 2014.

Bromberg, Craig. "An Ethic Clad in Genes." *Los Angeles Times*, May 25, 1986, X52.

Bryan-Wilson, Julia. *Art Workers: Radical Practice in the Vietnam War Era*. Berkeley, CA: University of California Press, 2009.

———, ed. *Robert Morris (October Files)*. Cambridge, MA: MIT Press, 2013.

———. "Simone Forti Goes to the Zoo." *October* 152 (Spring 2015): 27–52.

Buckwalter, Melinda. *Composing While Dancing: An Improviser's Companion.* Madison, WI: University of Wisconsin Press, 2010.

Buren, Daniel. "Function of the Museum." *Artforum* 12, no.1 (September 1973): 68.

Burt, Ramsay. *Judson Dance Theater.* London and New York: Routledge, 2006.

Cariaga, Daniel. "Simone Forti in Big Room." *Los Angeles Times,* January 24, 1977, F6D.

Csikszentmihalyi, Mihaly. *Flow: The Psychology of Optimal Experience.* New York: Harper and Row, 1990.

Dalachinsky, Steve. "Interview with Charlemagne Palestine." *Bomb* no. 128 (Summer 2014): 28–35, https://bombmagazine.org/articles/charlemagne -palestine/.

Davida, Dena, Marc Pronovost, Véronique Hudon, and Jane Gabriels, eds. *Curating Live Arts: Critical Perspectives, Essays, and Conversations on Theory and Practice.* New York and Oxford, UK: Berghahn, 2019.

DeFranz, Thomas F. "Dancing the Museum." In Davida et al., *Curating Live Arts,* 89–100.

De Spain, Kent. *Landscape of the Now.* New York: Oxford University Press, 2014.

Dewey, Fred. "Editor's Afterword: Simone Forti's Non-fictional Imagination." In Forti, *Oh, Tongue,* second edition, 173–208. Los Angeles: Beyond Baroque Books, 2010.

———. "Embodying the World." In Breitwieser, *Simone Forti,* 73–76.

Dunning, Jennifer. "Exploring the Limits of Dance." *New York Times,* April 24, 1987, C3.

Duckworth, William, and Richard Fleming, eds. *Sound and Light: La Monte Young and Marian Zazeela.* Lewisburg, PA: Bucknell University Press, 1996.

Dupuy, Jean. *Collective Consciousness: Art Performances in the Seventies.* New York: Performing Arts Journal Publications, 1980.

Finer, Ella. "Far Stretch: Listening to Sound Happening." In *The Creative Critic: Writing as/about Practice,* edited by Katja Hilevaara and Emily Orley, 135–139. New York: Routledge, 2018.

Fischlin, Daniel, and Ajay Heble, eds. *The Other Side of Nowhere: Jazz, Improvisation, and Communities in Dialogue.* Middletown, CT: Wesleyan University Press, 2004.

Fischlin, Daniel, and Eric Porter. *Playing for Keeps: Improvisation in the Aftermath.* Durham, NC: Duke University Press, 2020.

Foster, Susan. *Dances that Describe Themselves: The Improvised Choreography of Richard Bull*. Middletown, CT: Wesleyan University Press, 2002.

Franko, Mark, ed. *The Oxford Handbook of Dance and Reenactment*. New York, Oxford University Press, 2017.

Franko, Mark, and André Lepecki, eds. *Dance Research Journal* 26, no. 3 (Special Issue: Dance in the Museum, December 2014).

Gabriel, Mary. *Ninth Street Women*. New York: Little, Brown and Company, 2018.

Goldberg, Natalie. *Wild Mind: Living the Writer's Life*. New York: Bantam Books, 1990.

———. *Writing Down the Bones*. Boston: Shambhala Press, 1986.

Goldman, Danielle. *I Want To Be Ready: Improvised Dance as a Practice of Freedom*. Ann Arbor: University of Michigan Press, 2010.

Goldstein, Ann. *A Minimal Future? Art as Object 1958–1968*. Cambridge, MA: MIT Press, 2004.

Gottschild, Brenda Dixon. *Digging the Africanist Presence in American Performance*. Westport, CT: Praeger, 1998.

Guzman, Antonio, ed. *Charlemagne Palestine: Sacred Bordello*. London: Black Dog Publishing, 2003.

Halprin, Anna. *Moving Toward Life: Five Decades of Transformational Dance*. Middletown, CT: Wesleyan University Press, 1995.

Hardt, Yvonne. "Pedagogic In(ter)ventions: On the Potential of (Re)enacting Yvonne Rainer's Continuous Project/Altered Daily in a Dance Education Context" in *The Oxford Handbook of Dance and Reenactment*, edited by Mark Franko. New York: Oxford University Press, 2017, 247–65.

Harren, Natalie. "Simone Forti: The Box." *Artforum* 48, no. 2 (October 2009): 247–48, www.artforum.com/print/reviews/200908/simone-forti-40716.

Hermann Dietrich, Carmela. "Learning to Speak." In *Taken by Surprise: A Dance Improvisation Reader*, edited by Ann Cooper Albright and David Gere, 65–74. Middletown, CT: Wesleyan University Press, 2003.

Holbrook, Athena Christa. "Second-Generation Huddle: A Communal Approach to Collecting and Conserving Simone Forti's *Dance Constructions* at MoMA." *VDR Beiträge* 1 (2018): 118–23.

Horvilleur, Delphine. *Vivre avec nos morts: Petit traité de consolation*. Paris: Grasset, 2021.

Hurewitz, Daniel. *Bohemian Los Angeles: and the Making of Modern Politics*. Berkeley: University of California Press, 2008.

Hussie-Taylor, Judy, ed. *Judson Now*. New York: Danspace Project, 2012.

Janevski, Ana, and Thomas J. Lax. *Judson Dance Theater: The Work Is Never Done*. New York: Museum of Modern Art, 2018.

Johnston, Jill. *Marmalade Me.* Middletown, CT: Wesleyan University Press, revised and expanded edition 1998.

Joselit, David. "eating and dreaming: Robert Whitman's 1960s happenings." In *Robert Whitman: Playback*, edited by Bettina Funcke and Karen Kelly, 44–58. New York: Dia Art Foundation, 2003.

Kaiser, Philip, and Christina Végh. *Where Art Might Happen: The Early Years of CalArts.* Munich: Prestel Verlag, 2020.

Kennedy, Garry Neill. *The Last Art College: Nova Scotia College of Art and Design 1968–1978.* Cambridge, MA: MIT Press, 2012.

Kirby, Michael. *Happenings: An Illustrated Anthology.* New York: E. P. Dutton and Co., 1966.

Kotz, Liz. "Convergence of Music, Dance and Sculpture c. 1961: Reconsidering Simone Forti's Dance Constructions." In *Assign and Arrange: Methodologies of Presentation in Art and Dance*, edited by Maren Butte, Kirsten Maar, Fiona McGovern, Marie-France Rafael, and Jörn Schafaff, 31–51. Berlin: Sternberg Press, 2014.

Lambert-Beatty, Carrie. *Being Watched: Yvonne Rainer and the 1960s.* Cambridge, MA: MIT Press, 2008.

———. "More or Less Minimalism: Six Notes on Performance and Visual Art in the 1960s." In *A Minimal Future? Art as Object 1958–1968*, edited by Ann Goldstein, 103–109. Cambridge, MA: MIT Press, 2004.

Larsen, Kay. *Where the Heart Beats: John Cage, Zen Buddhism, and the Inner Life of Artists.* New York: Penguin Press, 2012.

Lassiter, Laurie. "Movement Research Inc. and the Workshop Process." *Contact Quarterly* 9, no. 3 (Fall 1984): 23–29.

Lee, Hermione. *Biography: A Very Short Introduction.* New York: Oxford University Press, 2009.

Lepecki, André. "The Body as Archive: Will to Re-Enact and the Afterlives of Dances." *Dance Research Journal* 42, no. 2 (Winter 2010): 28–48.

———. *Dance: Documents of Contemporary Art.* London: Whitechapel Gallery; Cambridge, MA: MIT Press, 2012.

Lewis, George. "Improvised Music after 1950: Afrological and Eurological Perspectives." In Fischlin and Heble, *The Other Side of Nowhere*, 131–62.

Lista, Marcella, ed. *A Different Way to Move: Minimalisms, New York 1960–1980.* Nimes, France: Carré D'Art, 2017.

Metcalf, Megan Gwen. "In the New Body: Simone Forti's Dance Constructions (1960–1961) and their Acquisition by the Museum of Modern Art (MoMA)." PhD diss., University of California, Los Angeles, 2018.

Morris, Robert. *Continuous Project Altered Daily: The Writing of Robert Morris.* Cambridge, MA: MIT Press, 1993.

———. "Notes on Simone Forti." In ed. Breitwieser, *Simone Forti*, 45–48.

Morse, Meredith. "Between Two Continents: Simone Forti's *See-Saw*." In Breitwieser, *Simone Forti*, 37–44.

———. *Soft Is Fast: Simone Forti in the 1960s and After*. Cambridge, MA: MIT Press, 2016.

Nesbit, James. *Ecologies, Environments, and Energy Systems in Art of the 1960s and 1970s*. Cambridge, MA: MIT Press, 2014.

Novack, Cynthia J. *Sharing the Dance: Contact Improvisation and American Culture*. Madison: University of Wisconsin Press, 1990.

O'Neill-Butler, Lauren. Interview with Robert Morris. *Artforum* (April 2012), www.artforum.com/interviews/judson-at-50-robert-morris-31187.

Paxton, Steve. "Performance and the Reconstruction of Judson." *Contact Quarterly* 7, no. 3/4 (Spring/Summer 1982): 56–58.

———. "The Emergence of Simone Forti." In Breitwieser, *Simone Forti*, 59–61.

Perron, Wendy. "Misha's New Passion: Judson Dance Theater," in *Through the Eyes of a Dancer*. Middletown, CT: Wesleyan University Press, 2013: 157–62.

———. *The Grand Union*. Middletown, CT: Wesleyan University Press, 2020.

———. "You Make Me Feel Like a Natural Woman: My Encounters with Yvonne, Simone, Anna, and Trisha." In Bennahum, et al., *Radical Bodies*, 174–87.

Philbrick, Ethan. "Huddling, Then and Now: Simone Forti and the Non-sovereign Collective." *TDR* 62, no. 4 (Winter 2018): 183–96.

Pollan, Michael. *How to Change Your Mind: What the New Science of Psyche-delics Teaches Us About Consciousness, Dying, Addiction, Depression, and Transcendence*. New York: Penguin Press, 2018.

Rachleff, Melissa. *Inventing Downtown: Artist-Run Galleries in New York City 1952–1965*. New York: Grey Art Gallery; Munich: Prestel Verlag, 2017.

Rainer, Yvonne. *Feelings Are Facts*. Cambridge, MA: MIT Press, 2006.

———. "On Simone Forti." In ed. Breitwieser, *Simone Forti*, 70–72.

———. *Work 1961–1973*. Halifax, Nova Scotia: The Press of the Nova Scotia College of Art and Design, 1974.

Richards, M. C. *Centering: In Pottery, Poetry, and the Person*. Middleton, CT: Wesleyan University Press, second edition 1989.

Rosenberg, Susan. *Trisha Brown: Choreography as Visual Art*. Middletown, CT: Wesleyan University Press, 2017.

Rosenthal, Stephanie. *Move. Choreographing You: Art and Dance Since the 1960s*. Cambridge, MA: MIT Press, 2011.

Ross, Janice. *Anna Halprin: Experience as Dance*. Berkeley: University of California Press, 2007).

Salzman, Eric. *Twentieth-Century Music: An Introduction*. Upper Saddle River, NJ: Prentice Hall, fourth edition 2002.

Sandford, Mariellen R., ed. *Happenings and Other Acts*. London: Routledge, 1995.

Sarfatti, Michele. *The Jews in Mussolini's Italy*. Translated by John and Anne C. Tedeschi. Madison, WI: University of Wisconsin Press, 2006.

Schaefer, John. *New Sounds: a Listener's Guide to New Music*. New York: Harper and Row, 1987.

———. "Who Is La Monte Young?" In *Sound and Light: La Monte Young and Marian Zazeela*, edited by William Duckworth and Richard Fleming, 25–43. Lewisburg, PA: Bucknell University Press, 1996.

Schneemann, Carolee. *Uncollected Texts*. Edited by Brandon Joseph. New York: Primary Information, 2018.

Segal, Lewis. "Forti and Van Riper at LAICA." *Los Angeles Times*, June 20, 1978: F9.

———. "Tracing Postmodern Steps." *Los Angeles Times*, October 27, 2000: F1, F16.

Shepherd, Nan. *The Living Mountain*. Edinburgh: Canongate Books, 2011.

Siegel, Marcia. *The Tail of the Dragon*. Durham: Duke University Press, 1991.

Silvana Editoriale Spa. *Gutai: Painting with Time and Space*. Milan, Italy: Cinisello Balsamo, 2010.

Stille, Alexander. *Benevolence and Betrayal: Five Italian Jewish Families Under Fascism*. New York: Penguin Books, 1991.

Whitman, Robert. *Robert Whitman: Playback*. Edited by Bettina Funcke and Karen Kelly. New York: Dia Art Foundation, 2003.

Young, La Monte. "Lecture 1960." *Tulane Drama Review* 10, no. 2 (Winter 1965): 73–83.

Index

Page numbers in italics indicate photographs.

375

About the Author

Dancer and scholar Ann Cooper Albright is professor of dance at Oberlin College and Conservatory. Combining her interests in dancing and cultural theory, she teaches a variety of courses that seek to engage students in both practices and theories of the body. Her previous book, *How to Land: Finding Ground in an Unstable World,* offers ways of thinking about and dealing with the uncertainty of our contemporary lives. She is the founder and director of Girls in Motion, an award-winning afterschool program at Langston Middle School in Oberlin, Ohio, and she is codirector of Accelerated Motion: Towards a New Dance Literacy in America, a National Endowment for the Arts (NEA)-supported website that facilitates active learning and the exchange of teaching strategies and resources to support educators who teach dance studies as a humanistic discipline. She is also a veteran practitioner of contact improvisation, has taught workshops internationally, and facilitated Critical Mass: CI@50, which brought three hundred dancers from across the world to learn, talk, and dance together in celebration of the fiftieth anniversary of this extraordinary form. Her work has been supported by the NEA, National Endowment for the Humanities, American Council of Learned Societies, Solomon R. Guggenheim Foundation, and Ohio Arts Council.